American Artifacts

American Artifacts

Essays in Material Culture

edited by

Jules David Prown and Kenneth Haltman

Michigan State University Press
East Lansing

∞ The paper used in this publication meets the minimum requirements of
ANSI/NISO Z39.48–1992 (R 1997) (Permanence of Paper).

Printed and bound in the United States of America.

Michigan State University Press
East Lansing, Michigan 48823-5202

05 04 03 02 01 00 1 2 3 4 5 6

Library of Congress Cataloging-in-Publication Data

American artifacts : essays in material culture / edited by Jules David Prown
and Kenneth Haltman.
 p. cm.
 Includes bibliographical references.
 ISBN 978-0-87013-524-8 (pbk. : alk. paper)
 1. United States—Social life and customs. 2. United States—Civilization.
3. Material culture—United States. 4. Americana. 5. Popular culture—United
States. 6. National characteristics, American. 7. United States—Social life and
customs—Study and teaching. 8. United States—Civilization—Study and
teaching. 9. Material culture—United States—Study and teaching. I. Prown,
Jules David. II. Haltman, Kenneth, 1957–
 E161 .A35 2000
 973—dc21
 00-008703

Cover design by Ariana Grabec-Dingman
Book design by Michael J. Brooks

Visit Michigan State University Press on the World Wide Web at:
 www.msu.edu/unit/msupress

The authors dedicate this volume to
the memory of 'Sam'

SHIRLEY MARTIN PROWN 1931–2000

Contents

Jules David Prown

Preface

THIS VOLUME CONTAINS one of my articles on material culture, and a collection of essays by current and former graduate students at Yale University who have taken my seminar on material culture, "American Art and Artifacts: The Interpretation of Objects." These essays are polished versions of papers written in that course.

When Charles F. Montgomery, my colleague at Yale (and onetime teacher), died unexpectedly in February 1978, I assumed responsibility for his graduate seminar in material culture, joining forces with Margaretta Lovell, who taught the companion undergraduate course. I had recently returned to full-time teaching following an administrative stint as Director of the Yale Center for British Art. Years earlier, while curating the collections of American art at the Yale University Art Gallery and teaching in the Department of the History of Art, I had written a brief article discussing the evidentiary potential of objects,[1] and remained interested in the subject. As part of the process of academic re-entry, I participated in the National Humanities Institute at Yale where I presented a paper on the interpretation of objects,[2] and received encouragement and advice, especially from Henry Glassie.

Given the establishment at Yale of a Center for American Art and Material Culture, I proceeded, with the help and cooperation of Professor Lovell, to revamp the material culture course, and continued to offer it in alternating years and then, as interest grew, annually. The theoretical underpinnings of the course were published in my article "Mind in Matter."[3]

The seminar "American Art and Artifacts" is constructed on an armature of two concurrent sequences of investigation which inform each other

through assigned weekly reading, object analysis and discussion of the reading in class, and individual student projects. The first sequence progresses through various categories of objects. The second introduces through reading and discussion a different approach each week—formalism, structuralism, semiotics, Marxism, archaeology, cultural history and cultural anthropology, social history and social anthropology, psychoanalysis and psychohistory, cultural geography, quantitative analysis, and technical analysis. The consideration of methodologies is necessarily of an introductory nature, simply making students aware of theoretical approaches available to them for subsequent use as dictated by their interests and needs. Since I am an art historian, the course rests methodologically on a base of art historical object analysis. In dealing with other theoretical approaches, I have been a learner along with my students, and the seminar has always been collegial in character.

A contradiction, or rather a redundancy, is built into the course title, "American Art and Artifacts." The term "artifacts" includes *all* human-made or human-modified things, which makes "art" a sub-category of "artifacts" rather than a separate and distinct category. Every work of art is an artifact, but all artifacts are not necessarily art. The implication in the title is that there is such a thing as art distinguishable from other artifacts. Art, however, is a culture-specific concept. In our culture we appropriate objects from other cultures that belong to other categories—clothing, jewelry, weapons, masks, architectural details, boats, etc.—and install them in our museums as "art," drained of their original purpose and invested with ours. I have retained the course title because it is descriptive for the uninitiate and precipitates early discussion in the seminar of the art/artifact issue.

For purposes of material culture study, any artifact can usefully be subjected to the kind of visual analysis we have traditionally applied to works of art. The goal of such analysis is to discover the patterns of mind underlying fabrication of the artifact. These patterns are often, indeed are usually, metaphorical in character. Artifacts can be or can embody metaphors for aspects of the human condition—states of being, activities, relationships, needs, fears, hopes. The metaphors articulate patterns of mind most usefully when they reflect beliefs of which the makers, individually or collectively (as society), were unaware or, if aware, unwilling to express openly, to verbalize. Over the years some students in my seminar have produced good papers that have identified metaphors and unpacked meaning, others have written disappointing papers in which the cultural potential of the artifact seemed obvious but the student would not or could not shake off the security of a positivist orientation in order to consider imaginatively

the metaphorical implications. The question arises as to the extent to which success in the cultural analysis of objects depends upon the qualities of mind of the investigator as opposed to the object or category of object. Are some artifacts or categories of artifact more expressive of culture, of mind, than others, or are all artifacts equally useful?

In "Mind in Matter," I arbitrarily divided the entire spectrum of artifacts—the material of material culture—into categories. This compartmentalization was a device to divide an enormous population of objects into more manageable segments with which to work and about which to think, but it also raised the question of whether different categories of objects would yield different kinds of information, and whether the study of certain categories of objects might in fact be more productive than others. The categories were art (paintings, drawings, prints, sculpture, photography), diversions (books, toys, games, meals, theatrical performance), adornment (jewelry, clothing, hairstyles, cosmetics, tattooing, other alterations of the body), modifications of the landscape (architecture, town planning, agriculture, mining), applied arts (furniture, furnishings, receptacles), and devices (machines, vehicles, scientific instruments, musical instruments, implements).

The preponderance of essays about devices in this volume is not an accurate quantitative or qualitative reflection of the results of material cultural investigations in my seminar over the years.[4] Also, the choice of topics in the seminar has been skewed by the fact that students were not permitted to select works of art (other than photographs) for analysis. This limitation was imposed because art could be analyzed in other art history courses; seminars were usually divided between art history and American studies students, with occasional students from architecture, history, divinity, etc., and I did not want non-art historians to feel at a disadvantage; and, most importantly, a primary purpose of the course was to explore the evidentiary potential of non-art objects.

Over the years, students have in fact most frequently chosen to study devices, with applied arts next in popularity. My subjective judgment is that the percentage of fruitful studies (about half) has been consistent across categories, and that all artifacts are potentially expressive of culture. In my discussion of the various categories in "Mind in Matter," I observed that devices had up to that time been the least forthcoming in terms of cultural insight because most of the writing on devices was of a technical, positivistic nature. I would now report that in the seminar the number of exceptional (not simply successful) papers was higher with devices than any other category. The potency of devices as material culture evidence has been the major revelation for me in terms of the categories of artifacts.

In their investigations, students were expected to follow the analytical sequence outlined in "Mind in Matter," and in each seminar, drafts of object descriptions and deductions were handed in and vetted prior to submission of the final paper. The requirement of following a particular analytical sequence should not be construed as arbitrarily rigid—it is rigid but not arbitrary. I would argue that the *process* of investigation—the sequence—is critical for the accuracy of material culture analysis, for making it hew as closely to the culture as possible, even if the explication is of the culture's fictions. Each step, each observation, each idea, affects what follows. Premature speculation colors thought, premature conclusions foreclose it. By pursuing different investigative sequences, a scholar may well arrive at other conclusions. The particular sequence of steps I prescribe prolongs the information gathering process and defers the judgmental process as much as possible.

While the analytical sequence itself can be used subsequently as a structure for writing, students have been encouraged to follow the dictates of the material, to make the steps of research disappear, and to strive for literary qualities of clarity and grace. It must be emphasized that the studies in my seminar, including those published here, are suggestive rather than complete. They were written as exercises in a pedagogically useful method involving close looking, hard thinking, and imaginative speculation designed to unpack cultural systems of belief which may not be evident through the analysis of verbal or statistical data. But they do not take the next step of applying whatever insights are gained, whatever questions are framed and hypotheses formulated, to explore in detail how these beliefs operated within the culture, enlarging our understanding of the culture and its behavior. Whether the end products are useful for cultural understanding or whether they are better considered solely as the explication of fictions remains to be determined; I am inclined to believe the former.

I would like to thank all of the students who have studied with me in the material culture seminar and contributed to the pool of ideas developed there. I am particularly grateful to the essayists who have contributed to this volume for their good humor, patience, and willingness to take on the extra work that it involved.

NOTES

1. "The Work of Art and Historical Scholarship," *Ventures* 8 (fall 1968): 56–61.
2. Those thoughts, honed during an informal seminar entitled "Art as Evidence" that I gave at the Institute several years later, were subsequently published in my "Style as Evidence," *Winterthur Portfolio* 15 (fall 1980): 197–210.

3. "Mind in Matter: An Introduction to Material Culture Theory and Method," *Winterthur Portfolio* 17 (spring 1982): 1–19.

4. Listing some of the other productive or promising artifacts analyzed in the course will perhaps adjust the perspective a little. They include daguerreotypes (especially one of a dead child), photographs of an Amerind house and of a Salish burying ground, and the following objects: family photo album, telephone booth, Colt revolver, 1939 issue of *Ladies' Home Companion*, mah-jongg set, souvenir Amerind doll, New York City subway map, early-nineteenth-century pitch pipe, outdoor telephone booth, luncheonette, street in New Haven, federal doorway, library courtyard, section of fence, mirrors, Victorian bourne, Afro-American quilts, seventeenth-century standing salt, Chippendale-style desk and bookcase, pack of cigarettes, Afro-American cane, Indian war shirt, Shaker dress, flapper era dress, Victorian dress, art deco radio, nineteenth-century surgeon's kit, pinball machine, bong, eighteenth-century tall case clock, French and Indian War powder horn, souvenir "dice" clock from Las Vegas, cross bow, mailbox, traffic light, elevator, fireplace, opera glasses, boom box, Big Mac, Western Saddle, flax wheel, sewing machine, art deco cocktail set, briefcase, scotch tape dispenser, eighteenth-century baptismal gown, slide projector, top hat, punk leather jacket, gas stove, gas pump, sneaker, fire hydrant, ant farm, Winchester rifle, TV remote control, see-saw, concertina, hot comb, pinball machine, camera, nineteenth-century hymnal, stereopticon views, prepared meal, eighteenth-century carpenter's plane, bronze gravestone, mounted elk head, cowboy hat, speculum, Lego set, sunglasses, bonnet, necktie, mustard pot, viewmaster, communion set, baseball, rubber chicken, buttonhook, post-its, miner's scale, Hasidic hat, "papoose" carrier, nineteenth-century inkstand, pepper grinder, etc.

Kenneth Haltman

Introduction

THE ESSAYS COLLECTED in this volume, intended for both scholars and students, exemplify the methodology they share, familiarly known as Prownian analysis, the history and theoretical underpinnings of which are elucidated by Jules Prown himself in the Preface and opening contribution to this volume. These essays share, as well, a spirit of imaginative intervention in the study of history. They constitute a sort of pedagogic sampler, an anthology of *essays* in the strictly etymological sense: experiments in or elaborations of a rigorously practical (as opposed to purely theoretical) approach to understanding things. At the crux of this book, underlying each contribution and informing the collective enterprise, lies a shared concern with the articulation of historical significance and its production. What questions are most fruitful to ask in one's work with an object and how might one best go about asking them? Whereas scholars will find value in particular historical interpretations proposed by contributors concerning a teapot, card table, cigarette lighter, cellarette, telephone, quilt, money box, corset, parlor stove, lava lamp, footbridge, locket, food mill, or Argand lamp, students will find value principally in learning from the models that these readings offer of how such interpretation can be carried out.

While only some of culture takes material form, the part that does records the shape and imprint of otherwise more abstract, conceptual, or even metaphysical aspects of that culture that they quite literally embody. These are the *objects* we as historians in the field of Material Culture seek to understand. Our investigations—analysis followed by interpretation— necessarily begin in the material realm with the objects themselves but gain analytic hold and open upon interpretation only through vigorous attention,

1

beyond their state of being, to these objects' cultural significance; attention not just to *what* they might be said to signify but, as importantly, to *how* they might be said to signify; to their gerundial *meaning* (active verb form: to bring meaning into being), to the *way they mean*, both phenomenologically and metaphorically. This method of investigation may be usefully schematized in the form of an annotated course assignment.[1]

Choose an object to consider.

All objects signify; some signify more expressively than others. As the list of objects studied over the course of time in a single university seminar attests,[2] the possibilities are virtually limitless—especially considering that no two individuals will read a given object in the same way. So how to choose? In an unpublished essay written a decade ago, Prown offered the following reflection on this subject:

> The reader may wonder, as I still do, how objects can be gauged for potential cultural expressiveness prior to subjecting them to analysis. Students in my seminar are asked to select the object on which they wish to work, the thought being that some sort of significant sympathetic vibration may occur signaling the potential for that particular individual to uncover some significant meaning in that particular object. I approve the selection, preferably after seeing the object, if I perceive or am persuaded of that potential. I have tried to define, with only partial success, just what it is that tells me—often quite clearly—that an object is culturally potent. It seems to depend on a linkage—formal, iconographic, functional—between the object and some fundamental human experience, whether engagement with the physical world, interaction with other individuals, sense of self (often expressed anthropomorphically), common human emotions, or significant life events.[3]

Prown goes on to suggest that "[t]he most persistent object metaphors expressive of belief" seem embedded in polarities, including but not limited to the following:

life/death (mortality)
male/female
privacy (seeing and being seen)/communication
power/lack of control
acceptance/rejection
security/danger (fear)

truth (reality)/deception (illusion)
natural/artificial
stasis (permanence)/change (transience)
pain/comfort
desire/frustration
protection/vulnerability
freedom/constraint
health/disability
giving/receiving

These polarities, he says, in turn find material expression in a language of formal oppositions, again including but not limited to the following:

smooth/rough
shiny/dull
hot/cold
soft/hard
light/dark
transparent/opaque
up/down
in/out
stability/instability
forward/backward
vertical/horizontal
straight/curved or crooked
light/heavy
thin/thick
clean/dirty

In searching out an object to interpret, these are factors to be kept in mind. Moreover, such polarities and oppositions offer effective analytic "hooks" of use in organizing insights.

Thoroughly describe this object, paying careful attention, as relevant, to all of its aspects—material, spatial, and temporal. Be attentive to details (for which a technical vocabulary will almost certainly prove useful), but ever keep an eye on the big picture. Imbue your description with the thick texture of taxonomy yet with the flow of narrative. Render it as easy and appealing to read, as effortlessly interdependent in its parts as the object itself. Producing a sketch or schematic drawing may further this process, but avoid wasting precious words at this point on introductions, conclusions, restatements of the assignment, or autobiographical confessions; just describe what you see. But be sure to enjoy the pleasures

in close looking—in translating material object into narrative description.

Material culture begins with a world of objects but takes place in a world of words. While we work "with" material objects, i.e. refer "to" them, the medium in which we work as cultural historians is language. When we study an object, formalizing our observations in language, we generate a set of carefully selected nouns, adjectives, adverbs, prepositions, and verbs which effectively determine the bounds of possible interpretation. This is why the words we choose in saying what we see have such far reaching importance. It is out of our paraphrase of what we see that all interpretation grows. Speaking of *pictures*, for which we might substitute *objects*, Michael Baxandall has noted: "We do not explain pictures: we explain remarks about pictures—or rather, we explain pictures only in so far as we have considered them under some verbal description or specification . . . Every evolved explanation of a picture includes or implies an elaborate description of that picture."[4] Description provides the bridge between the realm of the material and that of concepts and ideas.

The key to good description is a rich, nuanced vocabulary. Technically accurate language (nominative, for the most part) plays an important role in this, but ultimately not the most important role which is reserved, perhaps somewhat counter-intuitively, to descriptive modifiers (adjectives) and, most crucially, to terms expressive of the dynamics of interrelation (verbs, adverbs, prepositions). Only active verbs and descriptive prose cast in an active voice serve to establish cause and agency. As a means to this end, avoiding the verb *to be* (in all its forms: is, are, there is, there are) will help to make visible thematically-charged spatial and functional complexities otherwise flattened or obscured. Joseph Koerner, in arguing, here again in the case of visual images, that such description offers "the best access" to experiencing an object with immediacy, notes that evocative description can "register" the way an object "functions for one particular observer. Rather than saying *what* a visual image means, description tells us *how* an image has opened itself up to an interpretation."[5] As with images, so too with objects which constitute, according to Prown, the broader category into which visual images fall.[6]

This means, in addition to active verbs, narrative structure and meaningful transitions. As opposed to a passive inventory one strives to craft a narrative account in an attempt to recreate an object's visual and physical effect in words, what Robyn Asleson has termed a "fusion of visual analysis and verbal expression."[7] The degree of detail one records remains a matter of personal discretion, but thoroughness counts. While too much

information can be almost as bad as too little, anything left out of description is lost to interpretation forever. The longer and harder one looks, the better one sees; the better one sees, the subtler the connections one finds oneself able to make. And, as a general rule, as many insights arise *out of the process of writing* as out of that of looking. These observations can be summarized as follows:

- we do not analyze objects; we analyze our descriptions of objects
- writing *constitutes* analysis: we do not really see with clarity what we have not said that we have seen

Composing and revising an objective-as-possible description frees one to move from a narrow focus on the object itself to a focus on the relationship between the object and oneself as its perceiver.[8]

Elucidate your intellectual and sensory responses to your chosen object in the form of deductions, drawing insight and evidence from your own previous description.

The more self-conscious one becomes, the more complex one's relationship to an object becomes, physically and ocularly as well as psychologically and experientially. For the purpose of analysis, there is value in isolating different realms of deductive response so that these can be handled more circumspectly.

One way we respond to what we see in or experience of an object amounts to intellectual detective work.[9] We see articulation and deduce patterns of use; we see interaction and deduce relationship; we see expression and deduce reception. Another way that we respond is through our senses: tactility suggests texture of engagement; temperature degree of intimacy; and so on.

Countless deductions of this kind suggest themselves. The process operates, in fact, so quickly that its effects are naturalized, come to seem true by definition rather than as evidence of meaningful inscription or construction. Only if we slow this process down do we find ourselves enabled to recognize and so to evaluate, indeed question, the myriad conclusions we risk otherwise to draw uncritically; only thus can we control for our own—however well-intended—careless or precipitous or culturally-biased leaps to arguably wrong conclusions. Careful deduction buys at least the opportunity to consider a fuller range of possibilities.

Now elucidate your emotional responses in similar fashion, again drawing insight and evidence from your own previous description.

Having addressed an object intellectually, and experienced it actually or empathetically with our senses, one turns, generally not without a certain pleasure and relief, to matters more subjective. How does the object make one feel? Specifically, what in or about the object brings those feelings out? As these will be, to a certain extent at least, personal responses, the challenge—beyond recognizing and articulating—is to account for them materially. The point is to begin to recognize the ways in which the object has created its effect. These more emotional deductions serve as a bridge to speculation about meaning.

It is now possible to entertain hypotheses concerning what your chosen object signifies, what it suggests about the world in which it circulates or circulated—a world which, in some sense, metonymically, it represents. What cultural work might it once have accomplished or accomplish still? Out of what matrix of contested meanings—tensions, ambiguities, and contradiction—is its broadest meaning generated?

Whereas the transition from description to deduction flows so easily we need to slow it down, subsequent moves from deduction to speculation, because they involve—even require—creativity, can pose a greater challenge. But interpretive hypotheses, or *questions* about meaning, will flow just as organically out of our process of deduction provided that we open our imagination to embrace, beyond its material facticity, an object's thematic resonance. Description and deduction, really processes of enablement, make it possible to defer and hence to control the interference of bias and assumption in recognizing what an object is. Speculation leads from the object as a closed system of signs into the world of intertextual relationships concerned not just with *what* but with *how* the object signifies. Speculation, moreover, reaches beyond unitary readings to lay stress instead on recognizing the object as a site of contested meanings.

Without pleasure taken in the work of the imagination, nothing of the sort is possible. Indeed, little defeats the purpose of this exercise so well as rigor without reverie. Meaning lies hidden in thematic figurations, in structural and functional metaphors, in polarities such as those schematized by Prown, cited above—hidden, but easily discernible, if only we go to the trouble of making them out.[10]

Think creatively about what research would be necessary to test your interpretive hypotheses, detailing whatever speculations you find yourself entertaining, anticipating the argument you can imagine yourself eventually making, and prepare a plan of action (or research prospectus) accompanied by an annotated bibliography. Try to avoid foreclosing interpretive

possibilities by narrowing your focus too far. For now, simply explain the direction (or directions) in which you find yourself headed, the sort of research you anticipate undertaking, and the research problems the endeavor poses.

A research prospectus should be detailed enough to give a clear sense of what *in your object* has given rise to interpretation. From what that you see or know or feel has your sense of your object's thematic content emerged? Be aware that different questions lead to different areas of the library (or to places other than the library, including collections of comparative objects) in which to do original research. Although your annotated bibliography need list no more than a handful of references at this point, these should represent the *range* of your inquiry. You may very reasonably be interested in learning what previous historians have made of your object or others like it, but your study will have now brought you to the point of *original interpretation*. Your proposed report on your findings should go beyond synopsis of others' ideas to offer a persuasive *argument* featuring the strongest claim you feel able to make regarding your object, supported by evidence discovered through research.

Finally, compose a polished interpretive analysis.

Interpretive analysis should not be mistaken for the sum of all the analytic exercises that precede it: description and deduction followed by speculation and then, in turn, by research findings. The method is a means to an end, not an end in itself. Analysis should digest, develop, and present perceptions generated from these exercises, but differ from them in being structured by an *argument,* a clearly-worded *claim* defended though detailed references to both the object (entailing passages of description and deduction) and its context (entailing some citation of sources, primary and secondary, as well as figures and notes). But while you should feel free to choose the extent to which description and deduction are present *as such* in your final essay at all, that these stages of analysis have been thoroughly performed ought to be discernible in both the kind and quality of internal evidence you marshal in substantiating claims regarding what and how your object signifies. The fruits of one's research are not to be presented as somehow self-explanatory, but rather as evidence introduced in support of claims. The object, in other words, must not be seen as a good illustration of something outside of itself—an historical milieu, for instance, or maker's intent—but rather such contextual phenomena be introduced into evidence as illuminating some aspect of the object's own intrinsic interest or meaning. It is the object, more specifically the object as *described*, that represents

the primary evidence, everything else being secondary to it. Through careful looking, one comes to see an object as significant—as *signifying*; one comes to possess, to a greater or a lesser degree, a privileged historical knowledge and understanding.

The entire process may be represented schematically in the following fashion:

PROWNIAN ANALYSIS

Description—>
 Deduction—>
 Speculation—>
 Research—>
 Interpretive Analysis

Projects equivalent to or less than a semester's work might be organized around this program, loosely modeled on Prown's "Art and Artifacts" seminars at Yale, but modified as necessary for use by undergraduates, with the details of written assignments determined locally, as follows:

choice of object, subject to approval
first description
meeting with instructor
rewrite of description
deductions
speculations
prospectus and annotated bibliography
second meeting with instructor
research and writing
oral presentation
submission of final paper

Despite its non-arbitrary rigidity,[11] this sequencing of the stages of interpretive analysis ought not to be resisted as a straightjacket but instead exploited as the logical result of a decades-long pedagogic experiment carried out in numerous academic settings where it has been subject to adjustment and modification. The method as thus configured works because it works. Neither its constitutive stages nor the sequence itself are ends in themselves, but rather means to the end of helping students "become aware of the historical evidence around them."[12] The method works because of the deceptively straightforward simplicity of freely choosing an object and describing it. It works because this process reliably yields awareness of complexity and polyvalent meaning. Students learn to

read history, and to dream history, embedded in—inscribed in—objects, richly and dynamically. As pedagogy this, perhaps, constitutes the method's fundamental achievement, described by Amy Werbel in the following terms:

> The Prown method is the perfect analytic tool for what is now called "student centered" learning. Because the method places value on the interpreter's own input, it requires "active learning"—the system absolutely cannot work without it. Students engaged in this process also confront their own point-of-view as discrete, distinguishable, and constructed. This lesson is very hard for students to grasp using more abstract means. Prownian analysis . . . puts students into a direct relationship with historical materials.[13]

The twelve essays collected in the present volume, all products of Prownian analysis themselves, instantiate that process. They have been organized alphabetically (by author's last name) and not by medium, chronology, function, or theme to underscore their primary value as *essays*—models, or case studies. Each makes its own serious local contribution to scholarship, and will be read by specialists substantively. Indeed, their range—together they cover over 150 years of American history, interpreting a rich variety of objects and materials—renders these essays of unusual value for teachers of material culture surveys who wish to introduce their students both to the history of material culture per se and to a non-naïvely positivist interpretive methodology at one and the same time. But the principal focus of this collection is on applied methodology.

We begin with the premise that in objects there can be read essential evidence of unconscious as well as conscious attitudes and beliefs, some specific to those objects' original makers and users as individuals, others latent in the larger cultural milieus in which those objects circulated. Less concerned than some historians of material culture with the making or makers of such objects, our focus tends to be more on user interface, on the ways embedded meanings are actualized through use—matters subject always (and invitations always) to controlled speculation. Material culture, in this view of it, is consequently less an *explanatory* than an *exploratory* practice. Readers are invited to pay close attention to the role played in these essays by description, deduction, and by what creative speculation can become as tempered by, controlled by, and informed by close research: analytic interpretation, historicized. Most importantly, the reader is invited to enjoy the pleasures in close looking!

NOTES

1. Thanks are owed to the many individuals who took the time to share their recollections and reflections, including three of the contributors to this volume—Robyn Asleson, Jennifer Roberts, and Amy Werbel—and seven others: Barbara Bloemink, Fintan Cullen, Leah Dilworth, Barbara Lacey, David Steinberg, Rebecca Stone-Miller, and Rebecca Zurier, comments by some of whom are cited directly below. I want to register a special appreciation to Paul Manoguerra and Harper Whinery at Michigan State for research and editorial assistance with this project. The class assignment which follows distills and reworks insights derived from Jules Prown's "Mind in Matter: An Introduction to Material Culture Theory and Method," *Winterthur Portfolio* 17 (1982): 1–19; an inspiration refracted through more than a decade of pedagogic experimentation by myself and many others.

2. See Preface, this volume, xiin. 4.

3. Jules Prown, Preface draft, c.1989.

4. Michael Baxandall, *Patterns of Intention: On the Historical Explanation of Pictures* (New Haven and London: Yale University Press, 1985), 1.

5. Joseph Leo Koerner, *The Moment of Self-Portraiture in German Renaissance Art* (Chicago and London: The University of Chicago Press, 1993), 277.

6. See Prown, "Mind in Matter," passim.

7. Asleson notes in this regard that, in the mid-1980s when she took Prown's "Art and Artifacts" seminar, introduction to the method was furthered by coordinated work with writing tutors (personal communication, 22 July 1998).

8. The key control is to return ever and again to the object itself, through this process "amending and developing our ideas"; see Asleson, as above.

9. The order in which these deductive steps are to be deployed—intellectual and sensory followed by emotional deduction in the present formulation—has varied from practitioner to practitioner over the years. A certain ever-lucid flexibility, however, remains absolutely key.

10. Prown, in his Preface to this volume, notes: the goal of speculative analysis "is to discover the patterns of mind underlying fabrication of the artifact. These patterns are often, indeed are usually, metaphorical in character. Artifacts can be or can embody metaphors for aspects of the human condition—states of being, activities, relationships, needs, fears, hopes" (iii). Certain of these figurations take the form of psychosexual body references thematically recurrent in made objects.

11. Prown, Preface, this volume, p. xii.

12. Barbara E. Lacey, personal communication, 2 September 1998. Useful assignments, many in this spirit, can be found scattered throughout the *1997 Material Culture Syllabus Exchange,* Winterthur Museum, 1997, a number of contributors to which were former Prown students.

13. Amy Werbel, personal communication, 4 August 1998.

Jules David Prown

The Truth of Material Culture: History or Fiction?

MATERIAL CULTURE IS just what it says it is, namely the manifestation of culture through material productions. And the study of material culture is the study of material to understand culture, to discover the beliefs—the values, ideas, attitudes, and assumptions—of a particular community or society at a given time. The underlying premise is that human-made objects reflect, consciously or unconsciously, directly or indirectly, the beliefs of the individuals who commissioned, fabricated, purchased, or used them, and, by extension, the beliefs of the larger society to which these individuals belonged. Material culture is thus an object-based branch of cultural anthropology or cultural history.

What material do we study in material culture? Obviously we study things made by human beings—a hammer, a card table, a plow, a teapot, a microscope, a house, a painting, a city. But we also study natural objects that have been modified by human beings—stones arranged into a wall, a garden, a prepared meal, a tattooed body. We may even study unmodified natural objects, as Cyril Stanley Smith has done, to understand better the relationship between the structure of human-made things and the structure of natural things in the physical universe in which we live.

Objects made or modified by humans are clumped together under the term "artifact." That word connects two words—*art* and *fact*—reflecting its double Latin root. The word *art* derives from *ars, artis* (skill in joining), and *fact* derives through *factum* (deed or act), from *facere* (to make or to

do), emphasizing the utilitarian meaning already implicit in the word art; thus, skill or knowledge is applied to the making of a thing. This verbal conjunction introduces an issue that often derails material culture discussions, namely the relationship between artifacts and art. The term art refers to objects whose primary initial purpose has been to represent, to memorialize, to induce veneration, elevation or contemplation, to provide access to or influence supernatural forces, to delight the eye, or otherwise to affect human thought or behavior through visual means. Many cultures do not have a special category of objects identified as art. In our culture, art is what we say is art, including ethnographic and technological objects not created as art, but which have been aestheticized by being placed in museums or other special collections.

There are two ways to view the relationship between art and artifact—inclusive and exclusive. The inclusive approach asserts that just as the word art is incorporated in the word artifact, so too are all works of art, as fabricated objects, by definition, artifacts. Some even hold that the terms are interchangeable. Several years ago, the art historian Irving Lavin of the Institute for Advanced Study set forth a series of what he termed "assumptions" about art, leading to a definition of art history.[1] "The first assumption," he wrote, "is that anything man made is a work of art, even the lowliest and most purely functional object." For Lavin, and for an increasing number of art historians, art is equatable with artifacts, the material of material culture.

Several scholars have observed that any artifact—and the inclusive view would mean any work of art as well—is an historical event. This brings me to the first part of this paper's subtitle: history. An artifact is something that happened in the past, but, unlike other historical events, it continues to exist in our own time. Artifacts constitute the only class of historical events that occurred in the past but survive into the present. They can be re-experienced; they are authentic, primary historical material available for first-hand study. Artifacts are historical evidence.

Artifacts, like other historical events, do not just happen; they are the results of causes. There are reasons why an object comes into existence in a particular configuration, is decorated with particular motifs, is made of particular materials, and has a particular color and texture. Peter Gay, in the introduction to his book *Art and Act*, identified three types of historical causation which apply to artifacts just as they do to other historical events. These he calls craft, society, and personality. The first, craft, refers to tradition. Things are done or made in the way they were done or made previously. This is obviously true in relation to artifacts where artists and craftsmen are trained in art schools or apprenticeships, learn from design books, and learn

from other objects. The second type of causation, society (I would prefer the word "culture"), refers to the mind of contemporary society—prevailing attitudes, customs, or beliefs that condition the ways in which things are said, done, or made. It refers to the world in which both maker and consumer lived, and which affected their values. People are a product of their time and place. The third causal factor, personality, refers to the individual psychological makeup of the person who made the object; it might be entirely conformist and therefore reflective of contemporary society, or it might be quirky or eccentric, producing an original, novel, or idiosyncratic result.

The objective of a cultural investigation is mind—belief—the belief of individuals and the belief of groups of individuals, of societies. There are surface beliefs, beliefs of which people are aware and which they express in what they say, do and make, and there are beliefs that are hidden, submerged. If we may return to etymology for a moment, beliefs that are on the surface are sur-face or super-ficial (on the face). The cultural analyst wants to get at hidden beliefs, at what lies behind surface appearance, behind the mask of the face. What lurks behind the face is our quarry—mind. A culture's most fundamental beliefs are often so widely understood, so generally shared and accepted, that they never need to be stated. They are therefore invisible to outsiders. Indeed, they may be beliefs of which the culture itself is not aware, and some of them so hard to face that they are repressed.

Mind, whether individual or cultural, does not reveal itself fully in overt expression; it hides things from others and it hides things from itself; it can express itself in complex or elliptical ways. Just as some of the secrets of the physical world cannot be observed directly, but only through representations—quarks, black holes—so secrets of the mental world—the world of belief—are manifest only in representations. Dreams are one example of the representation of hidden mind, of the expression of meaning in masked form. The capacity of human beings to process the unnoticed material of daily life into fictions that surface in dreams suggests to me that human beings constantly create fictions unconsciously, using the language of fiction—simile, metonymy, synecdoche, metaphor. I wish to suggest that artifacts are, in addition to their intended function, unconscious representations of hidden mind, of belief, like dreams. If so, then artifacts may reveal deeper cultural truth if interpreted as fictions rather than as history. I realize that an analogy between dreams and artifacts as expressions of subconscious mind is not self-evident; indeed, it seems unlikely. Let me develop the case further.

Because underlying cultural assumptions and beliefs are taken for granted or repressed, they are not visible in what a society says, or does, or

makes—its self-conscious expressions. They are, however, detectable in the way things are said, or done, or made—that is, in their style. The analysis of style, I believe, is one key to cultural understanding.[2] What do I mean by style? The configuration of a single object is its form. When groups of objects share formal characteristics, those resemblances or resonances constitute style. In the practice of art history, the study of those characteristics is called formal or stylistic analysis. When it is used in practice to discriminate between objects, it is often called connoisseurship. That term is unfortunately maligned because it seems to smack of preciousness and elitism. But in fact, connoisseurship is a powerful scholarly tool, permitting rapid distinctions between what is true and what is false. I know of no other field of historical inquiry in which it is possible to achieve such rapid and precise analytical results as connoisseurship which enables an analyst to say immediately and with assurance such things as—this chair is Philadelphia, 1760–70, made by X; or this chest is Essex County, Massachusetts, probably Ipswich, about 1670, from the workshop of Y; or this table is a forgery, a cultural lie.

Whereas iconography, the analysis of subject matter, serves an art historian well in discerning and tracking linkages of objects across time and space, the analysis of style facilitates the identification of difference, of elements that are specific to a place, a time, a maker. Why is this so? It is because form is the great summarizer, the concretion of belief in abstract form. A chair is Philadelphia of the 1760s because it embodies elements of what was believed in Philadelphia in the 1760s, and that formal pattern is what enables an analyst to determine the truth of the chair. It follows logically from this that formal patterns should also allow an analyst to reverse the process: to consider the beliefs, the patterns of mind, materialized in the chair. Instead of analyzing the concrete formal expressions of belief to determine the authenticity of the chair, the concrete formal expressions of an authentic chair are analyzed to get at belief. When style is shared by clusters of objects in a time and place, it is akin to a cultural daydream expressing unspoken beliefs. Human minds are inhabited by a matrix of feelings, sensations, intuitions and understandings that are non-verbal or pre-verbal, and in any given culture many of these are shared, held in common. Perhaps if we had access to a culture's dream world, we could discover and analyze some of these hidden beliefs. In the absence of that, I suggest that some of these beliefs are encapsulated in the form of things, and there they can be discerned and analyzed.

Style is most informative about underlying beliefs where their expression is least self-conscious; and a society is less self-conscious in what it makes, especially such utilitarian objects as houses, furniture, or pots, than

in what it says or does, which is necessarily conscious and intentional. Purposive expressions—for example a diplomatic communiqué or an advertisement—may as well be intended to deceive as to inform. It is just here that the "inclusive" approach accepting a close linkage or even identification between art and artifact causes problems. The function of art is to communicate—whether to instruct, record, moralize, influence or please. In this abstract mode of operation it resembles literature more than it does other physical artifacts. It is self-conscious, intentional expression. An icon of St. Francis of Assisi or a representation of a Madonna and Child may be intended to arouse religious sentiments, to persuade or even convert; a portrait may be intended to flatter. Art may be true or deceptive; in either case it is intentional. Works of art are conscious expressions of belief, fictions composed of a vocabulary of line and color, light and texture, enriched by tropes and metaphors. As cultural evidence, works of art have many of the same liabilities as verbal fictions with their attendant problems of intentionality. The distinction between art and artifact is that artifacts do not lie. That is an exaggerated way to put it, but it makes the point. Card tables or teapots, hammers or telephones, have specific functional programs which are constants, and the variables of style through which the program is realized are unmediated, unconscious expressions of cultural value and beliefs.

It is, however, in what we call art—whether painting, sculpture, literature, theater, dance, music, or other modes of esthetic expression—that societies have expressly articulated their beliefs. Since material culturalists are interested in objects as expressions of belief, and art is, specifically, material that is expressive of belief, it would be absurd to exclude art from material culture. Although we may attach special importance to uncovering deep structures of belief that may underlay the conscious, articulated top layer of belief, we cannot simply exclude the most obvious expressions of belief— art, literature, and so forth—from cultural analysis because they are self-conscious. So if an inclusive approach that identifies art and artifact closely is unsatisfactory, so too is an exclusive approach that would pry art completely away from artifacts as unsuitable for material culture analysis.

For those of us who think that as material culturists we are "doing history" with objects, it is a sobering corrective to realize that in one sense history consistently uses small truths to build large untruths. History can never completely retrieve the past with all of its rich complexity, not only of events but of emotions and sensations and spirit. We retrieve only the facts of what transpired; we do not retrieve the feel, the affective totality, of what it was like to be alive in the past. History is necessarily false; it has to be. On the other hand, literature can weave small fictions into profound

and true insights regarding the human condition. It can recreate the experience of deeply felt moments, and move us profoundly. It can trace inexorable patterns of cause and effect in fiction, and concentrate the largest universal truths into myth.[3]

I suggest, then, that deep structural meanings of artifacts can be sprung loose by going beyond cataloguing them as historical facts to analyze them as fictions, specifically as artistic fictions. While hierarchically art is a sub-category of artifact, analytically it is useful to treat artifacts as if they were works of art. Viewing all objects as fictions reduces the distinction between art and artifacts.

By way of example, I want to analyze a single artifact (Fig. 1.1). This object is 6³/₈ inches high, 4³/₄ inches wide at the widest part of the body, and 7⁷/₈ inches wide overall from spout tip to handle. It is wider than it is high, and could be inscribed within a rectangle. The primary material is pewter, with the handle and lower ring of the finial of wood. There is a small hole in the top of the lid, and inside the vessel there is a circular arrangement of small holes where the spout joins the body.

The vessel is divided by a horizontal line three-fifths of the way up where the lid rests on the body. The lid and the body are also each subdivided by horizontal moldings, the lower one exactly midway between the base and the top of the handle, and at a height exactly equal to the total height of the lid. Viewed from the side the object presents a series of S-curves, including the handle; the spout; and the outlines of the body, the lid and the finial. The spout and the handle rise above the rim. The vessel stands on a ³/₈ inch raised base.

Seen from the top (Fig. 1.2), the object presents a series of concentric circles surrounding the finial. The spout, finial, hole, hinge, and handle are aligned to form an axis through the vessel at its largest dimension.

The object consists of five separate parts—lid, body, handle, spout, and finial. The lower section of the body is a flattened ball; the upper part a reel. The lid is bell-shaped and surmounted by a finial that echoes in simplified form the shape of the vessel—a flattened ball surmounted by a reel, with a hemisphere above.

Setting aside previous knowledge, it could nonetheless be deduced that this hollow-bodied object is a vessel or container, that the larger opening at the top when the lid is opened is used to put some substance into the vessel, and the spout to redirect that substance into a smaller container. The small holes in the body at the base of the spout suggest that the contained substance is strained in the act of pouring to retain in the vessel particles larger than the holes. The fact that the spout rises above the rim suggests that the substance contained is liquid, since if the spout were below the

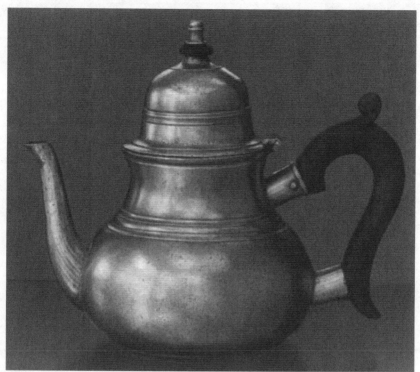

Fig. 1.1. Teapot, pewter, Thomas Danforth III (American, c. 1777–c. 1818) Yale University Art Gallery, Mabel Brady Garvan Collection.

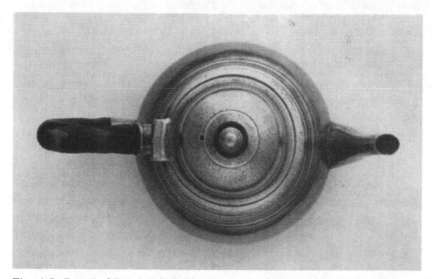

Fig. 1.2. Detail of Fig. 1.1. Yale University Art Gallery, Mabel Brady Garvan Collection.

rim, liquid would overflow when the vessel were full. The use of wood in the handle and in the finial which is grasped to open the lid suggests that the liquid may be hot, since wood is not as good at conducting heat as metal. The fact that an attached rim raises the bottom of the pot off of the surface on which it stands also suggests that the contents may be hot.

Manipulating the object suggests the use of the handle and the finial. Opening the lid indicates that the finial makes contact with the handle, and the absence of wear suggests that the handle, and perhaps the finial disk as well, is a replacement. The bell shape of the lid suggests sound, and actual sound results from opening and closing the lid.

When respondents have been asked to express their feelings about this object following extended analysis, they have used such words as "solid," "substantial," "cheerful," "comfortable," "grandmotherly," and "reliable." The object evokes recollections, and the identification of the links between the object and the memories of experience for which it stands as a sign is the key to unlocking the cultural belief embedded in it. If you ask what in the object triggered such words as "solid," "substantial," and "reliable," respondents will note that the object is wider than it is high, and the flattened ball of the lower part gives it a squarish and bottom-weighted appearance, suggesting stability. The responses are based on experience of the phenomenal world. The words "cheerful," "comfortable," and "grandmotherly" reflect more subjective life experiences that also can be located with some precision by asking questions based on the previously deduced evidence. Under what circumstances do we drink warm liquids? When we are cold, warm liquid warms us inside; when we are hot it causes perspiration which evaporates, cooling the body surface. We drink hot liquids when we are ill—soup or tea—again because it makes us feel better, perhaps by promoting perspiration and helping to break a fever. When we are ill and incapacitated, warm liquids are often brought to us, and the care of another person is comforting. Hot liquids are also drunk on social occasions. Coffee and tea drinking are marked by a sense of well being that derives from the stimulation of the drink itself, by the physical act of giving or pouring and receiving, and frequently by conversation. Drinking hot liquids and talking seem to go together.

James Fernandez has written of the importance of metaphor to anthropologists in decoding culture, a process he referred to punningly as antrope-ology.[4] Although he was discussing verbal metaphors, several of his discriminations are applicable as well to the understanding of how artifacts function as metaphorical expressions of culture. He distinguishes between two kinds of metaphor—structural metaphors which conform to the shape of experience, which resemble actual objects in the physical world, and tex-

tual metaphors which are similar to the feelings of experience. Structural metaphors are based on physical experience of the phenomenal world; textual metaphors are based on the emotive experience of living in that world.

The object, which we can now refer to as a teapot since our analysis of it is complete, invokes multiple textual metaphors—cheerful, comfortable, reliable, grandmotherly, and so forth—metaphors based on the feelings of experience. It also embodies structural metaphors based on the shape of experience. For example, the lid and finial can be read as a bell metaphor. And the bell shape suggests calling—whether a dinner bell or ringing from a sick bed—calling for and receiving help or comfort or sustenance. Another structural metaphor, equally obvious, is less easily retrieved, however, perhaps because repressed. If you ask the respondent (or the analyst asks her- or himself), what is the "ur-experience," the earliest human experience of ingesting warm liquids, the immediate response is that it is as a baby feeding from a mother's breast. Now structural analogies become immediately evident between the shape of the lower section of the body of the vessel and the female breast. And when the object is viewed from above, with the finial at the center like a nipple, the object is even more breast-like (see Fig. 1.2). The teapot is revealed, unexpectedly, as a structural metaphor for the female breast.

Fernandez defines a metaphor as a sign, a combination of image and idea located between a signal and a symbol, between perception and conception. A signal invokes a simple perception that orients some kind of action or interaction. For example, a picture of a teapot could function literally as a signal hanging outside of a tea room beckoning the tourist to enter, or at a tea party the teapot itself serves as a signal for pouring and serving. At the other end of the scale, a symbol triggers a conception whose meaning is fully realized. For example, a common denominator linking the various circumstances we cited in which warm liquids are ingested is that all involve an act of giving and receiving, which is, in its largest social sense, the act of charity.[5] A teapot, fully conceptualized in meaning, could become a symbol of the act of giving, of charity. One could envision a page in an emblem book with an image of a teapot, a symbol of charity, and an accompanying moralizing text.

Located between signal, a simple perception, and symbol, a fully realized conception, the teapot by itself stands as a sign, a metaphor both structural and textual. It embodies deeply felt but unconceptualized meanings relating to giving and receiving; to such things as maternal love and care, oral gratification, satisfaction of hunger and thirst, comforting internal warmth when cold or ill, and conviviality. And it is thus as a sign or metaphor that the teapot works as evidence of cultural belief.

The Truth of Material Culture: History or Fiction? 19

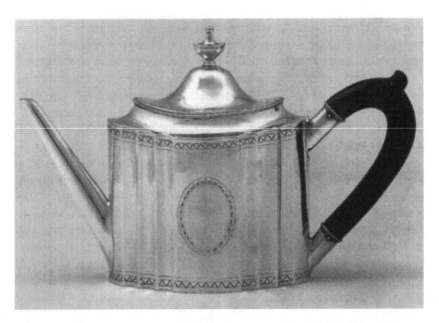

Fig. 1.3. Teapot, silver, Loring Bailey (American, 1740–1814). Hood Museum of Art, Dartmouth College, Hanover, N.H.; Gift of Louise C. and Frank L. Harrington, Class of 1924.

If artifacts express culture metaphorically, what kinds of insight can they afford us? What, for example, does the teapot tell us about belief? The object has given us a clue that the drinking of tea, and perhaps the entire ceremony of tea drinking, may be related metaphorically to the fundamental human act of giving and receiving, and has the potential of being a symbol of generosity or charity, of caritas. The humanness as well as the humaneness of the act is suggested in this teapot by the fact that the liquid is encased in an organic, breast-like form. But as we well know, a teapot can be precisely the opposite in form (Fig. 1.3); it can deny the humanly anatomical or personal aspect of giving or charity, and by using purely inorganic, intellectual, geometric forms deny personal involvement and emphasize the cerebral character of the act. In so doing it conveys something about the different character of a different culture.[6]

The fundamental structural linkage of warm liquids, breast feeding and charity—the human metaphor—suggested to us by our study of a single teapot, is now understood to be a formal potential for all vessels used to pour out hot liquids. The extent to which it is generated, tolerated, or rejected by a culture is an index of one aspect of that culture's belief. Objects are evidence, and material culture enables us to interpret the culture that produced them in subjective, affective ways that are unachievable

through written records alone. They did not write much about breasts in the late eighteenth century, let alone any linkage between breasts and charity, but the metaphorical language of teapots conveys a livelier and perhaps truer picture. What we have made out in the teapot are indicators of beliefs about giving and receiving, generosity, charity, and definitions of the self in relation to others. Can one go on to describe with greater precision the terrain of cultural belief expressed by artifacts? The most persistent metaphors in objects of which I have become aware relate to such fundamental human experiences as mortality and death; love, sexuality and gender roles; privacy (seeing and being seen) and communication; power or control and acceptance; fear and danger; and, as here, giving and receiving.

Metaphors, Fernandez says, locate beliefs in what he calls the "quality space" of a culture.[7] Among the several formulations he noted as to how metaphors locate belief is one which accords closely with the polarities of belief I have encountered in my analysis of American artifacts, W. T. Jones's seven "axes of bias."[8] These "axes" are lines of predisposition, along the calibration of which beliefs are situated. They are: static-dynamic, order-disorder, discreteness-continuity, process-spontaneity, sharp-soft, outer-inner, and other world-this world. (The first term in each opposition cited applies more to the neoclassical Bailey teapot, the second to the Danforth teapot, but in varying degrees.) I wonder whether it would not be possible to graph these points, an admittedly subjective exercise, to arrive at abstractions of artifacts that would constitute a type of cultural fingerprint.

It should be understood that the analysis of artifacts as fictions to discover otherwise unexpressed cultural beliefs does not so much answer questions as raise them. Artifacts make us aware affectively of attitudes and values; however, they provide only limited amounts of data. In the language of semiotics, they are artistic signs articulating a climate of belief; but they are often poor informational signs. Yet the questions they pose are authentic ones, arising from the primary evidence of the artifact rather than being imposed by the investigator.

If artifacts materialize belief, then it follows logically that when a society undergoes a traumatic change, that change should manifest itself artifactually. Perhaps the most clearly defined moment of social change in our country occurred at the time of transition from colony to nation; that is the change signaled in the configuration of these two teapots.[9] We can corroborate the connection by looking at two stylistically similar expressions in a different type of object. A post-Revolutionary Federal or classical revival card table (Fig. 1.4) is regular, geometrical, self-contained, light in weight and structure, and decorated on its smooth veneered surfaces with

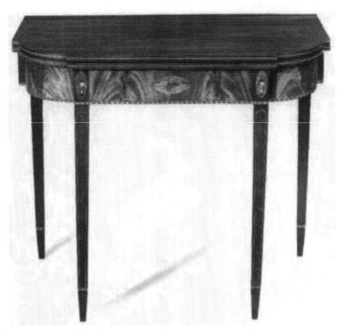

Fig. 1.4. Card Table (American, Mass., 1785–1815), closed. Yale University Art Gallery, Mabel Brady Garvan Collection.

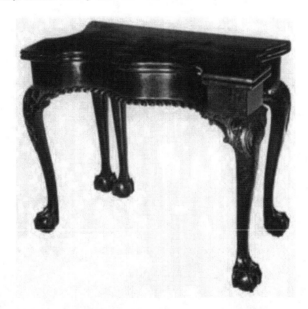

Fig. 1.5. Card Table (American, New York, 1760–70), closed. Yale University Art Gallery, Mabel Brady Garvan Collection.

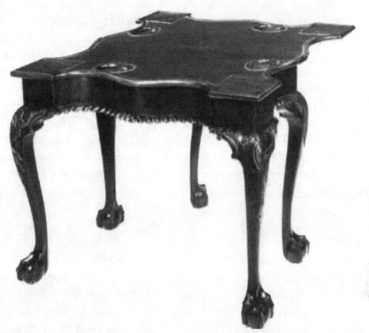

Fig. 1.6. Fig. 1.5, open. Yale University Art Gallery, Mabel Brady Garvan Collection.

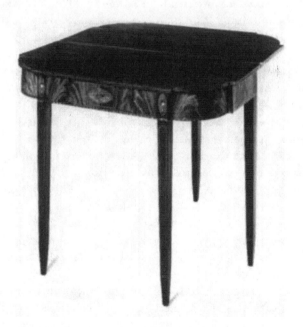

Fig. 1.7. Fig. 1.4, open. Yale University Art Gallery, Mabel Brady Garvan Collection.

inlaid images of flowers and eagles. A pre-Revolutionary New York Chippendale or rococo card table (Fig. 1.5) is irregular, organic, curvilinear, jutting into and penetrated by ambient space, heavy, and decorated with carved leafage, shells, claw and ball feet, and rope gadrooning. It has wells for counters, recesses at the corners for candlesticks, a drawer to hold cards and counters, a baize cover to protect the surface and to make it easier to pick up cards and to keep them from sliding (Fig. 1.6). A Federal card table with three fixed and one fly leg, when open (Fig. 1.7), has two sides with legs in the center and two open sides. Questions arise. Did ladies in dresses tend to sit at the open sides and men in trousers take the sides with the center legs which they could straddle? If so, if two males and two females played, the player across the table was always of the opposite sex. In the games played, was the opposing player a partner, an adversary, or was each player out for him- or herself? A player at a Chippendale table is drawn into closer physical proximity to the other players, in part because the sides, although bowed in the center, are recessed from the corners. The sensation of closeness is especially pervasive if one is forced to circle one's legs around the solid protruding cabriole leg in the center of three of the four sides, becoming literally wrapped up with the table. The other players are near, their faces loom large, their voices are close, their aromas are pervasive, as is the warmth and smell of the candles at either elbow. There is a sense of intimacy, of coziness, reinforced by the warmth of the nearby candles, the soft baize covering, and a sheltered trove of private wealth in a well—a kind of security like food in a bowl or money in one's pocket.

We are aware of the reality of physical substances—the sturdiness and weight of the table, the solidity of elements carved of mahogany that replicate organic elements in the natural world—rope carvings, leafage, shells, claws clutching balls. We are comforted by the real, natural environment of substantial, tangible things. The functionalism of the table is reassuring. Places are carved out for candlesticks, counters, even for the players. The sinuous curves of solid organic forms that surround the player not only suggest the natural world, but the complexity of human relations within that world. Deviousness might be a natural, and not unfriendly, part of the game—it is a fact of life like sinuous curves in nature. The table suggests a culture in which value is placed on and pleasure derived from substantial things, from the realities of the world and of life, from warm, complex, intimate human relations.

The Federal card table seems to substitute the mental for the physical, fragility for substantiality, intellectual geometry for organic complexity, aloofness for intimacy. Forms are slender and orderly, surfaces are sheer

and planar, clarity and regularity replace complexity and sinuousness. The decorative elements on Federal card tables tend not to be real things but pictures of things—inlay—abstract images rather than the things themselves. Projecting sides often serve to keep each player at a slight distance from the table. The players are thus further away from each other. Objects on the table surface are less secure, less rooted, set on a flat, all-purpose surface rather than nestled into designed concavities. The entire enterprise is cooler, more distant, more abstract, and in a sense more tentative, less friendly. It is almost as if at the Chippendale table one tries to win real property from intimates, to put their goods in your pocket, while at the Federal table one attempts to win intellectual supremacy over adversaries, and perhaps money in a more abstract form.

An investigation now could go in many directions; a particularly promising one would be a study to see if the actual games played during the pre-Revolutionary and post-Revolutionary periods changed, and how these changes—if any—related to male-female relations, to ideas about independence and authority, to private and corporate entrepreneurship, to generosity and greed, to hostility and friendship, and a host of other attitudes, values, and beliefs imbedded in the artifacts and acted out in the games people played.

Obviously not all belief can be retrieved. An artifact is embedded in its culture and embodies some of that culture's beliefs. We are deeply embedded in another culture and our understandings are colored by its beliefs. One of the great advantages of the study of material culture is the extent to which it provides a way to overcome the problem of cultural perspective by establishing the broadest possible base of commonality. A society we would study had its set of beliefs, its culture, while we who would seek to understand that culture are not only the products of a different cultural environment, but of a complex of cultural environments. Each of us is pervaded by the beliefs of our own particular groups—nationality, place of residence, class, religion, politics, occupation, gender, age, race, ethnicity, and so forth. We all have biases of which we are not aware, convictions that we accept as unquestioningly as the air we breathe. The issue that haunts all cultural studies is whether it is possible for us to step outside of our own cultural givens, our own time and place, and interpret the evidence of another culture objectively—that is, in terms of the individuals and society who produced it rather than in our own terms. If not—if we are irredeemably biased by our own unconscious beliefs, if we are hopelessly culture-bound to our own time and place—then all efforts to interpret other cultures should be avoided since our interpretations will inevitably be distorted.

The problem is a problem of mind. We are trying to understand another culture whose patterns of belief, whose mind, is different from our own. Our own beliefs, our mindset, biases our view. It would be ideal, and this is not as silly as it sounds, if we could approach that other culture mindlessly, at least while we gather our data. And this is the great promise of material culture. By undertaking cultural interpretation through artifacts, we engage the other culture in the first instance not with our minds, the seat of our cultural biases, but with our senses. Figuratively speaking, we put ourselves inside the bodies of the individuals who made or used these objects; we see with their eyes and touch with their hands. To identify with people from the past or from other places empathetically through the senses is clearly a different way of engaging them than abstractly through the reading of written words. Instead of our minds making intellectual contact with their minds, our senses make affective contact with their sensory experience.

Certainly it is true that sense perceptions which are filtered through the brain may also be culturally conditioned. But while commonality of sense perception cannot be proven either empirically or philosophically, certain conclusions can be drawn on the basis of the shared neuro-physiological apparatus of all human beings which is not culturally specific and has evolved only slowly over time, and also from the inescapable commonalties of life as lived. All humans undergo a passage from birth, through nurturing and aging, to death. En route they experience the realities of the physical world: gravity, a sense of up and down, awareness of night and day, of straight, curved and crooked, of enclosure and exclusion. Through the channels of the senses they taste sweet, sour and bitter, smell the acrid and the fragrant, hear sounds loud and quiet, perceive through touch the difference between rough and smooth, hot and cold, wet and dry; and see colors and shapes. They know hunger and thirst, illness and health, pain, sexual passion, bodily functions, loss and discovery, laughter and real tears. The human body constantly provides a sense of scale. It all adds up to a tremendous body of experience that is common and transcultural. That experience is transformed into belief that finds material expression in artifacts, the analysis of which—material culture—provides privileged paths of access for us to an understanding of other peoples and other cultures, of other times and other places.

NOTES

Part of this essay is derived from a paper given at a conference on North American material culture research, sponsored by the Institute of Social and Economic Research,

the Memorial University of Newfoundland, and the Winterthur Museum, St. John's, Newfoundland, June 1986, and published in *Living in a Material World: Canadian and American Approaches to Material*, ed. Gerald L. Pocius (St. John's: Institute of Social and Economic Research, Memorial University of Newfoundland, 1991).

1. I. Lavin, "The Art of Art History," *Art News* 82 (October 1983).

2. For more on this, see my "Style as Evidence," *Winterthur Portfolio* 15 (autumn 1980): 197–210.

3. Henry Glassie resolved this paradox by viewing history as myth, as art, in his article "Meaningful Things and Appropriate Myths: The Artifact's Place in American Studies," *Prospects* 3 (1977): 1–49; reprinted in Robert Blair St. George, *Material Life in America, 1600–1860* (Boston: Northeastern University Press, 1988).

4. James Fernandez, "The Mission of Metaphor in Expressive Culture," *Current Anthropology* 15 (June 1974): 119–45.

5. The Roman legend of Cimon and Pero, known as the legend of Roman Charity, tells of the daughter who visits her elderly father who is starving in prison. She nourishes him by feeding him from her own breast.

6. Although the Danforth teapot is in the Queen Anne style, it may well be as late in date as the Bailey teapot. One would expect that contemporaneous teapots would be similar in form, and the formal opposition of these two pots would seem to undercut the claim that difference in form conveys difference in cultural character. Apparent anomalies that arise in material culture study pose questions—what is the explanation here for the formal difference of contemporary objects?—and it is precisely this that stimulates further investigation, new thinking, and enlarged understandings. Pursuit of the question is beyond the scope of the present paper, but what is involved here is a difference in technologies required by the different materials (the Danforth pot is pewter; the Bailey pot is silver), which relates to significant differences in stylistic persistence between rural Connecticut (Danforth) and the urban Boston region (Bailey). Retention of a colonial style half a century out of date might well suggest an hypothesis about post-Revolutionary Connecticut, or a particular part of Connecticut, or a particular clientele that would need to be tested more widely.

7. I am not comfortable with the spatial or topographical model for imaging cultural belief, but neither is Fernandez.

8. William Thomas Jones, *The Romantic Syndrome* (The Hague: Martinus Nijhoff, 1961).

9. This section develops ideas introduced in "Style as Evidence," 200 ff.

Fig. 2.1. Lucite lighter, c. 1985, purchased in Los Angeles, California. Collection of the author.

Robyn Asleson

Seduced by an Old Flame: Paradox and Illusion in a Late-Twentieth-Century Lucite Lighter

THE FOLLOWING STUDY examines a lighter manufactured around 1985 and sold in that year by a Los Angeles boutique (Fig. 2.1). The lighter was presented to me as an amusing bauble, the gift of one East Coast non-smoker to another. Like the miniature Eiffel Towers and Statues of Liberty that tourists bring back as souvenirs of Paris or New York, the lighter provided a diminutive memento of an imagined city—in this case Los Angeles-as-"Tinseltown." Brash, glitzy, superficial, and ephemeral, the lighter was not built to last and broke down after less than a year of minimal use. Yet although its functional life proved brief, the lighter continued to fascinate me as an object. Over time, its physical construction and stylistic references yielded witty surprises that were entertaining to rediscover or to watch others detect for the first time. Masked by a precious and witty facade, the actual complexity of the object seemed worthy of study.

The lighter is pocket-size, a little less than the height of a pack of cigarettes and half its girth. Its appearance of geometric austerity results from the repetition of rectangular and conic shapes within a simple two-tier structure. The lower tier comprises a short cubic base and a tall cubic shaft, both fabricated of transparent plastic. Embedded within the transparent shaft are extremely thin squares of red plastic which intersect the shaft horizontally and a pointed cylinder of unknown opaque material sunk into the center of the shaft. From the embedded cylinder rises its near-mirror image, a freestanding cone of glistening red metal.

Clever use of materials brings visual ambiguities and illusionism to the lighter's otherwise simple structure. The slightest change in the viewer's perspective causes the embedded red plastic slivers to shrink or expand, so that from some angles they appear as floating squares, while from others they color the entire shaft or dwindle to invisibility. These changes in

Fig. 2.2. (left) Lighter shaft seen as red solid.

Fig. 2.3. (right) Lighter shaft seen as transparent.

appearance alter the dynamics of the entire object; when the shaft appears as a red solid, the structure seems to be a pedestal supporting a pointed cylinder (Fig. 2.2); when transparent, a pedestal pierced by a cylinder (Fig. 2.3). The visual effect most difficult to achieve is that which reveals the actual physical structure of the object. In order to determine this structure, one must disregard the myriad false appearances that the object presents, testing hypotheses intellectually as well as visually. Meanwhile, the lighter's continuously metamorphosing appearance exercises an irresistible fascination. One feels compelled to toy with the object long after the secret of its magic trick has emerged, suspending the disbelief of the mind in order to entertain the alternative realities presented by the eyes. The lighter thus exemplifies the power of seduction which Jean Baudrillard has attributed to the "flickering of a presence" created by the "rhythm of emergence and secrecy" as an object or person alternately conceals and reveals itself. As Baudrillard puts it, "Seduction does not consist of a simple appearance, nor a pure absence, but the eclipse of a presence. Its sole strategy is to be there/not-there, and thereby produce a sort of flickering, a hypnotic mechanism that crystallizes attention outside all concern with meaning."[1]

Fig. 2.4. Lighter with cap removed to show ignition mechanism and fuel compartment.

The deceptive element that is literally embedded in the lighter's illusionistic shaft also characterizes the object as a whole, for it is not immediately apparent that this amusing bauble also serves a useful purpose. The ornamental cone physically hides the object's functioning parts, while its tall, sleek, candy-apple red appearance creates misleading expectations about what these underlying parts may look like. Only through physical interaction—twisting, turning, and pulling—does one discover the tiny ignition mechanism (consisting of metallic wheel, flint, and wick) and the hollow fuel compartment beneath it (Fig. 2.4). In comparison with the streamlined red cone and the monumental, crystalline shaft that supports it, the ignition mechanism appears puny, crude, and dull, its revelation disillusioning in both senses of the word.

The resulting sense of deflation proves brief, however, as a further discovery soon overturns it. On rubbing the wheel against the flint, the ignited wick creates a flame that recalls the shape and color of the red cylindrical cap. Suddenly, one realizes that this seemingly deceptive ornament actually provided an accurate hint of the object's function as well as the appearance of the thing it concealed. There is an element of ironic wit in the lighter's gradual revelation of its underlying structure and function. Indeed, this revelation unfolds as a joke packing a one-two punch: the outer form represents the set-up, and the concealed wheel and wick, followed by the flame, have the impact of successive punch lines, the first ironic and the second parodic. An association with humor is not unique to this particular lighter. More than any other instrument of daily utility, lighters have traditionally served humorous ends, manufactured to resemble something they are not for the purpose of comic effect. During the 1920–60 period, manufacturers produced a mind-boggling array of novelty lighters whose shapes and formal references played wittily off the lighter's incendiary function.[2] As we shall see, the humor of the Los Angeles lighter is a great deal more subtle and sophisticated than these obvious "gag" objects, but they are all alike in predicating the sparked flame on a sudden flash of amusement.

Further ambiguities and reversals of expectation emerge through use of the lighter. The translucent shaft resembles cut crystal or a faceted jewel, betokening an object of substantial heft. Its red color suggests that it may be hot, while the crystalline cube promises icy coolness. The cone glistens as if wet, and its curves imply softness, seemingly licked or sucked to a smooth point which, like a moist popsicle or lollypop, arouses an oral response. In size and shape, the lighter corresponds closely to the natural pocket formed by a partially closed hand, and the fingers instinctively wrap around it. Contact with the actual materials disappoints each of these sensual anticipations, however. The lighter proves to be lightweight, dry, and of room temperature. Painted metal proves a poor substitute for sugary candy and frustrates oral desires. The lighter's sharp edges and jagged corners dig painfully into the skin when held tightly, so the object must be handled with care.

Moreover, although lighters were developed as tools of convenience—alternatives to matches which saved "the smoker's time and temper"[3]—this particular lighter is extremely difficult to use. One hand must grip the sharp-edged cubic shaft, while the other tugs off the red cone, sets it aside, and repeatedly scrapes a thumb uncomfortably across the roughly striated wheel until the wick finally ignites. This accomplished, one must replace the loose cap, risking burnt fingers if the flame is not blown out prudently

beforehand. Refilling the fuel compartment requires still more effort: gripping the shaft securely in one hand, the other must remove the cap, grasp the striated wheel between two fingers, and pull firmly yet gingerly until the construction eases out of the hollow compartment. The difficulty of this task is compounded by constant fear of snapping off the delicate wheel. Precisely because of these inconveniences, the refillable wheel-and-wick model was superseded in the 1960s by disposable butane lighters, which are ignited in one step with the depression of a button, and entirely replaced rather than refueled.[4]

The streamlined design of butane lighters represents another innovation of the last several decades which the lighter under discussion fails to emulate. The aim of most pocket-size lighters is to fit smoothly against the body or to tuck unobtrusively into a carrying case. The jutting angles and wide base of the Los Angeles lighter make it uncomfortable in a pocket and ungainly in a handbag. These factors, together with the object's low center of gravity, indicate that it was designed not as a portable lighter but as a table lighter—a stationary, upright fixture of a room, rather than a mobile accessory of the body. Lighters of this kind were produced in great number and variety in the 1950s, when the standard accoutrements of a well-appointed home or office included lighters as well as cigarettes, ash trays, and other tobacco accessories as a courtesy to guests.[5] Thus in addition to recalling outmoded technology, the Los Angeles lighter recalls the discontinued rituals and social patterns of a past era. It privileges nostalgia over convenience and modernity—qualities that we typically value as self-evident virtues, especially in the design of tools. Ranking form over function, the lighter presupposes the user's willingness to be subjected to unnecessary feelings of difficulty, physical discomfort, frustration, and risk for the sake of enjoying the alternative delights of illusionism and historical nuance.

As we have seen, few of the lighter's components serve its incendiary function, nor do their shapes and materials arise from practical requirements. Most aspects of the lighter contribute exclusively to the purpose of beguiling the eyes while amusing the mind. This unabashed impracticality is a bit of a pose, betraying the object's pretensions to the status of art. Almost by definition, art subordinates practicality to visual and intellectual interests. Art also often engages in pleasurable play between reality and illusion. In a specifically American context, the lighter recalls the witty trompe-l'oeil paintings of artists such as Charles Willson Peale, William Harnett, and John Peto, who introduced ambiguities into the relationship of physical reality and artistic illusion as a vehicle for visual wit.[6] Like the lighter, these paintings delight the mind by deceiving the eye, positing deception as entertainment.

Stylistically, however, the lighter owes a greater debt to architecture than to painting. Its streamlined geometric underpinnings recall the sleek elegance of Art Deco, as well as the ideal monumentality of classicism. Indeed, the three-tiered structure of base, elongated cube, and pointed cap mimic the tripartite form of a classical temple composed of podium, colonnade, and pediment. A closer look at the lighter suggests that it invokes classical allusions only to turn classicism on its head, subverting many of the qualities that we have come to associate with this ideal. Whereas classical structures intimate eternity through static form and solid materials, the lighter expresses modern ephemerality and instability through its cheap materials and constantly oscillating appearance. In place of marble, the lighter employs synthetic plastic—and specifically, lucite—a devalued, inexpensive, and manmade material which provides an ironically appropriate equivalent to marble in terms of ubiquity. In place of the pure, austere whiteness commonly, if misguidedly, associated with classicism, the lighter uses a brash shade of red—also prevalent in the modern world, and highly charged with meaning. Finally, the lighter reduces the grandeur of classical monuments to pocket-size, physically and qualitatively belittling the very prototypes it emulates. The lighter conjures a style equated with quality, simplicity, stability, and monumentality, only to undercut those attributes through ironic imposition of modernity's artificiality, garishness, ephemerality, and triviality. The object playfully inverts the established order of things, using the "high" form of a sacred temple for the "low" function of a practical tool, and the "cool" medium of classicism for the "hot" message of fire.

Even more than a classical building, the lighter resembles classical sculpture, and particularly Greek and Roman herms supporting bright red phallic sculptures (Fig. 2.5). During antiquity, these phallic herms symbolized fertility and prosperity and protected against the evil eye. In the modern era, the iconic phallus has lost its positive and fruitful connotations and become merely pornographic. Indeed, until recently museums had relegated phallic herms and related objects to restricted areas, off-limits to women and children.[7] Although such restrictions have relaxed within the last few decades, sight of the phallus remains taboo in American society, art, and film. In sublimated form, the phallus is virtually ubiquitous, however, invoked routinely in verbal and visual discourse as an emblem of masculine power and domination. For example, phallic forms recur in the packaging of men's colognes and other products which risk characterization as effeminate. Like those objects, the glistening red "erection" that surmounts the pedestal of the Los Angeles lighter is undoubtedly meant to recall the male sexual organs. Even the construction of the lighter mimics this biological model, with the phallus

Fig. 2.5. Phallic Herms, Avenue of Priapus on the Island of Delos, c. 400 B.C. (photo: Catherine Johns).

rising above a protective case in which the "fuel" is stored. Erect, hard, and aggressively vertical, the lighter seems impertinent and obscene and its use requires overcoming the taboo against touching such things.

Although artistic and biological analogies associate the lighter's red cone with a phallus, it more literally resembles the shape of a bullet. Since the 1940s, references to bullets and guns have recurred in the design and ornamentation of lighters, testimony to their close links with firearms.[8] One such model in particular—consisting of a silver bullet embedded in an unadorned lucite shaft—appears to have provided the prototype for the lighter under discussion.[9] Post-modern mischief perverts this nostalgic

revisitation, however. By coloring the "bullet" red and adding a base to the lucite shaft (thereby enhancing its architectonic quality), the designer projected phallic and classical references onto the erect cylinder, so that the monumental pedestal ennobles a symbol of male sexuality as an instrument of violence and death. In addition, by making the bullet double-headed, with a pointed tip at each end, the designer also doubled the function of the lucite shaft, which serves simultaneously as the pedestal which aggrandizes the bullet and the receptacle which is violated by it.

The stereotypical notions of male penetrator and female receptacle bear obvious relevance to this construction. These stereotypes of sexuality are reinforced by the coloration of the lighter, for the transparency of the lucite "receptacle" suggests passivity and purity, while the startling red of the "bullet" connotes aggression and passion. The materials lend themselves to similar gender stereotypes: hard metal piercing malleable plastic. In this violent, sexual context, the horizontal red squares embedded within the pedestal may be interpreted as blood seeping from the "wound" created by the penetrating bullet. They also recall the successive frames of time-lapse photography, well-known examples of which document bullets entering oranges and other targets.[10] The suggestion of motion intensifies the object's energy and, together with its stylistic references to sexuality and violence, enhances the previously noted contrast between the lighter's cool, classical form and its literally hot function.

The aggressive aura emanating from the lighter derives in large part from its brazen red color, which emits contradictory invitations and warnings to the viewer. The particular shade of red carries strong amorous connotations, suggestive of roses and cherries, valentine hearts, and rouged cheeks and lips. But it also signifies danger, and conjures associations with stop signs, traffic lights, and fire trucks. Most of all, red means fire, and fire is itself highly charged with positive and negative associations. Control of fire enables myriad benefits to human society, but loss of control leads to destruction.

This double-edged character is essential to the earliest myths of human existence. According to the ancient Greeks, man's distinction from all other animals resulted from Prometheus's gift of fire, which he stole from the gods. This impious theft brought immediate retribution in the form of Pandora—the first woman—whom the gods fashioned as an irresistible temptation. Like Eve, Pandora craved forbidden knowledge and her curiosity unleashed a casket full of evils into the world. The lighter tidily consolidates this mythology of fire. Pandora-like, we lift the lid of the mysterious casket only to discover the gift of Prometheus—fire—with its double-edged capacity for good and ill. The warning issued by the lighter's stop

sign-red hue and the pain inflicted by its sharp edges can now be interpreted as intimations of the potential dangers posed by the object's flammability. At the same time, the object's mesmerizing quality mimics Pandora's irresistible allure and the fascination of the flame conveys a sense of fire's mythic alliance with the gods. Initially spellbound by the magic trick of the lighter's oscillating shaft, we next become transfixed by the mirage-like appearance of the flickering flame, and disregard the warnings issued by the object in order to indulge in its dangerous pleasures. But fire is only half the story of the lighter, for the transparent cubic shaft suggests fire's elemental opposite: ice. Uniting cold crystal and hot flame—fire and ice—the lighter is indeed a mass of contradictions.

The crowning contradiction is this: despite the masculine character implicit in the phallic-bullet ornament, its closest resemblance in color, shape, and apparent moisture and softness is to lipstick. Indeed, use of the lighter actually mimics that of a lipstick, requiring preliminary removal of a protective cap. Even the lighter's monumental base seems inspired by the packaging of lipsticks, which inevitably appear in advertisements as glistening, red, phallic projections rising from pedestal-like cases (Fig. 2.6). Whereas most pedestals display art, both the lipstick and the lighter place artifice on a pedestal.

Here again, the lighter's specific shade of red seems significant. Bright red lipstick drifts in and out of fashion, but retains an iconic status as the quintessential lipstick color. This is largely the result of its association with an ideal of glamorous femininity reified by Hollywood films of the pre-1960s era and embodied in stars such as Jean Harlow, Rita Hayworth, and Marilyn Monroe.[11] Other attributes of this celluloid ideal—for example, her scarlet fingernails and torpedo breasts—are suggested by the color and shape of the lighter's conical cap. These alluring feminine associations add a further humorous dimension to the discovery of the object's actual function, for the flames sparked by the lipstick-lighter metaphorically embody the blaze of passionate desire ignited by the "hot-lipped" temptresses of Hollywood film.

The lighter seems to revel in the artificiality of the Hollywood starlet—her redder-than-red lips and nails, exaggerated curves, flashy dress sense, and propensity for ocular titillation. Precious in size and construction, the lighter itself seems feminine, and recalls such accessories of the toilette as lipstick, jewelry, perfume bottles, and nail polish vials.[12] At the same time, the lighter's hard surfaces, sharp edges, and brash color undercut the stereotypical notion of pliant feminine passivity. As noted earlier, the object's superficial attractions merely serve as snares concealing physical pain and perilous flammability. Rather than the stereotype of benign female weak-

Stay-on color. Stay-on shine. All yours now
in sixteen splendid Estée Lauder shades.
Some of the most beautiful women in the world
are already wearing it.

Here are just four from the collection:
All-Day Wine Punch, All-Day Ripe Raspberry,
All-Day Red Pepper, All-Day Pink.

Fig. 2.6. Lipstick advertisement, *Vogue,* ca. 1985.

ness, the lighter thus invokes another time-honored cliché—that of malig-
nant female power—a type much favored by Hollywood screenwriters,
whose films throughout the century have spun fantasies of enticing but
deadly *femmes fatales.* These drop-dead gorgeous bombshells literally
dressed to kill and were all the more sexy for being dangerous, all the more
tempting for being forbidden fruit. Unnatural creatures capable of smolder-
ing without melting, deadly screen sirens resembled the lipstick-lighter in
employing alluring facades to hide their destructive power, which also rested

on a combination of fire and ice. Like the user of the lipstick-lighter, the duped males of celluloid romance made the belated discovery that instead of toying with a pretty bauble, they were actually playing with fire. Despite the danger of "getting burned," few could resist the pyromaniacal compulsions induced by their alluring "flames."

A lipstick which is also a bullet, the lighter succinctly encapsulates this B-movie world of gun-toting toughs undone by lethal, red-lipped seductresses. The sexiness of the moll and the deadliness of the gangster merge in this miniature monument to a glamorous and distinctly American fantasy world of sex and death. In Hollywood's mythologized battle of the sexes, lipstick is a crucial weapon in the arsenal of the *femme fatale*. The lethal power inherent in this instrument of sexuality explains the phallic connotations of the lipstick-bullet. In fact, the lighter provides a graphic emblem of the notional masculinity of powerful women, who are often characterized as hermaphroditic monsters, chimeric cousins of their treacherous ancient precursors—sirens, mermaids, and Gorgons.[13] Not only that, but the emasculation anxieties ostensibly aroused by powerful women find symbolic representation in the phallic lipstick rampant above a plunging phallus. The latter appears to be sliced by the red squares of the crystalline base—castrated in the very act of penetration—a sleek rendering of the mythic vagina dentata.

The lighter's misogynistic fusion of glamour and gore reflects the perverse underside of the cult of Hollywood. As evinced by the insatiable public appetite for tales of macabre deaths and gruesome lifestyles experienced by glamorous stars, Hollywood's glittering illusions have spawned prurient curiosity about the ugly realities that lie hidden. Myriad tell-all publications also speak to a perverse animus against the very stars the public has chosen to place on the pedestal of fame.[14] The ambivalent feelings of attraction and repulsion elicited by Hollywood's female icons translate directly into Gay and Camp culture, and particularly the performances of drag queens, which isolate and exaggerate feminine traits in order to create monstrous female caricatures. Like the lipstick-lighter, drag is a triumph of hermaphroditic illusionism and sharp-edged irony. The same may be said of Pop artists' double-edged imagery of movie stars such as Marilyn Monroe, whose suicide in 1962 established her as the quintessential embodiment of Hollywood's illusory pleasure and real pain.[15] Monroe imagery recurs in drawings, sculptures, and constructions by Claes Oldenburg, such as his *Lipstick with Stroke Attached (for M[arilyn]. M[onroe].)* of 1967–71 and *Lipstick (Ascending) on Caterpillar Tracks* of 1970 (Fig. 2.7). Intending the latter as a symbol simultaneously erotic and warlike, Oldenburg observed that "the lipstick did a strong flirt with a bullet," and others have noted that

Fig. 2.7. Claes Oldenburg, *Lipstick (Ascending) on Caterpillar Tracks*, 1970; from Ellen H. Johnson, *Claes Oldenburg* (New York: Penguin, 1971), 46.

"this amusing conceit cloaks a sober truth—the interchangeability of life (Eros) and death."[16] The history of Oldenburg's sculpture bears out the notion of interchangeability. Having conceived the lipstick as a replacement for the statue of Eros in Piccadilly Circus, Oldenburg ultimately developed it for a war memorial at Yale University. The final design signals its morbid associations through a structure reminiscent of classical funerary monuments consisting of a horizontal base and vertical plinth. The same references are implicit in the lipstick lighter and in table lighters as a class, many of which were manufactured by mortuary firms.[17]

Reducing Marilyn Monroe to a limited number of distinguishing features, Oldenburg generated a symbolic iconography that he could manipulate with great freedom and irreverence. At its most basic level, this iconography consisted of a single feature—the red-lipsticked mouth—which he dehumanized still further so that the tube of lipstick itself symbolized Monroe. Other Pop artists followed suit.[18] The painter Tom Wesselman

deconstructed Hollywood's feminine ideal in series such as the *Great American Nudes* of the 1960s and *Smokers* of the 1970s.[19] Wesselman's paintings document a depersonalized lexicon of erotic feminine attributes: glistening red mouths, erect nipples, glossy nail polish, red lipstick, and cigarettes.

That seemingly incongruous final ingredient in Wesselman's erotic formula—cigarettes—attests to the close connections between smoking and sex that were forged by Hollywood films during the first half of the twentieth century.[20] Under the constraints of strict censorship, the amorous atmosphere of many a B-movie owed much of its steam to smoke. With an air of heady decadence befitting an opium den, Hollywood actors and actresses smoked together as communicants in an intimate, highly sensual ritual. Romantic smoke signals filled the air in *To Have and Have Not* (1944), in which Humphrey Bogart and Lauren Bacall played out an elaborate sexual courtship through smoking. The erotic insinuation palpable in Bacall's inquiry, "Anybody got a match?" arose from Hollywood's well-worn conceit that to ignite a woman's cigarette was tantamount to lighting her fire. Scenes of jostling male rivals thrusting flaming matches and lighters toward the virgin white cigarette of a beautiful woman recur as sublimated battles for sexual hegemony in films and advertisements.[21] Appropriately, films equate the sharing of cigarettes with sexual alliance, employed as a metaphor not only for post-coital harmony, but for all the preliminary steps along the road to sexual consummation.[22]

The frequent appearance of actors and actresses in cigarette advertisements of the 1940s and '50s reinforced the linkage of smoking with sex, emphasizing the seductive allure of women smokers and the suave virility of men.[23] However, since the late nineteenth century, advertisers have relied most heavily on female sex appeal in selling cigarettes to men and women alike.[24] In movies, too, it is the female smoker who has held the greatest erotic appeal. One has only to watch Louise Brooks in *Pandora's Box* (1929), Marlene Dietrich in *Blonde Venus* (1932), or Rita Hayworth in *Gilda* (1946) to observe the camera's fixation on the moist, mobile, glistening red mouth which becomes the unattainable object of the viewer's erotic desire.[25] Repeatedly entering the fetishized mouth, the cigarette becomes a surrogate for these thwarted desires. It is no wonder that male commentators have attributed the perceived eroticism of women smoking to the resemblance to fellatio.[26]

At the same time, there is a distinct onanistic element in the autonomous self-pleasuring of the female smoker. Richard Klein has characterized it as "both a source of visible sensual pleasure and an emblem of woman's erotic life, . . . a sight both threatening and intensely, voyeuristically exciting."[27]

During the late nineteenth and early twentieth centuries, photographers explored this erotic terrain in numerous pornographic images of partially draped women smoking in the "privacy" of bedrooms and bathrooms.[28] More recently, internet sites dedicated to images of smoking women have tapped the same sexual vein, dancing around the pornographic threshold that Tom Wesselman toed in his paintings and sculptures.

The erotic connection between women and smoking has had a direct impact on the ornamentation of smoking paraphernalia. The "artistic" nudes that frequently adorned lighters during the first two decades of the twentieth century were superseded in the 1930s, '40s, and '50s by pin-ups and Varga girls, and from the 1960s by bathing beauties whose skimpy drapery disappeared with a tilt of the lighter.[29] The waxing and waning red squares of the Los Angeles lighter recall the kitsch gimmickry of the latter type, its witty appeal reliant upon a "rhythm of emergence and secrecy" that is analogous to the seductive mechanism of "golden-era" Hollywood films. These concealed as much as they revealed, allowing audiences a tantalizing glimpse of erotic pleasure through a combination of smokescreens and smoke signals. The nostalgic design and technology of the Los Angeles lighter invites us to express our yearnings for this beguiling illusion of America's mythic past in the sublimated experience we now most closely associate with it: smoking.

In late-twentieth-century America, smoking itself seems tinged with nostalgia. Assaulted on a variety of fronts—medical, legal, and social—the practice persists in stubborn opposition to the spirit of the times. The marginal status of the smoker in contemporary society glosses the element of escapism in the design of the Los Angeles lighter, which references not only the past, but a fictitious version of it. Moreover, the cognitive dissonance experienced by contemporary smokers—who endure physical pain, social ostracism, disease, and death in their pursuit of pleasure—sheds light on the lighter's embrace of paradoxical ambiguities. Emitting conflicting signals of desire and danger, the lighter simultaneously constitutes totem and taboo. It beckons us to touch what it tells us we should not, inviting us to eschew the "rational" values of safety, practicality, and comfort in order to experience the censured delights of risk, fantasy, and pain. Warnings of danger enhance the object's attractions, as they do the attractions of Hollywood's mythical *femme fatale*. By the same perverse streak in human nature, warnings of danger have also mystified smoking, converting a once acceptable habit into an outlaw addiction.[30] Each of these forbidden objects of desire posits an alluring image as a foil to the instinct for self-preservation. Allying danger with pleasure, they add an enticing *frisson* of adventure to otherwise commonplace acts.

The Los Angeles lighter consolidates America's two greatest contributions to modern culture—tobacco and Hollywood—and celebrates the deceptive illusions that entrenched their position in national life.[31] Tarting up vulgar materials with a sophisticated design, this functionally ephemeral object accommodates itself to immediate gratification at the expense of long-term viability, evincing a value system that we now associate equally with the culture of Hollywood and that of tobacco. Evanescent as smoke and illusionistic as mirrors, the lighter provides an appropriate miniature monument to America's two most seductive old flames.

NOTES

1. Jean Baudrillard, *Seduction*, trans. Brian Singer (New York: St. Martin's Press, 1990), 85 and passim, and "What are you doing after the orgy?" *Artforum* 22 (October 1983): 42–3.

2. For lighters mimicking alcoholic drinks, weaponry, and human and animal figures, see James Flanagan, *Collectors' Guide to Cigarette Lighters* (Paducah, Ky.: Collectors Books, 1995); Neil S. Wood, *Collecting Cigarette Lighters: A Price Guide* (Gas City, Ind.: L.-W. Book Sales and Publishing, 1994).

3. Roseann Ettinger, *Compacts and Smoking Accessories* (West Chester, Pennsylvania: Schiffer Publishing Ltd., 1991), 113.

4. Gene J. Gavorsky, *The Lighter King: Cigarette Lighter Collecting* (Lawrenceville, Ga.: T. L. K. Direct, Inc., 1995), 8–9; Urban K. Cummings, *Ronson, The World's Greatest Lighter* (Palo Alto: Bird Dog Books, 1992). An important exception to this rule is the Zippo lighter, which provided a more elaborate and reliable version of the wheel and wick design from the 1950s (Stuart Schneider and George Fischler, *Cigarette Lighters* [Atglen, Pennsylvania: Schiffer Publishing, Ltd., 1996], 7).

5. Schneider and Fischler, *Cigarette Lighters*, 7.

6. For illusionism and wit in the works of these artists, see: Doreen Bolger, Marc Simpson, and John Wilmerding, eds., *William M. Harnett* (Fort Worth and New York: Amon Carter Museum and Metropolitan Museum of Art, 1992), 20–6; John Wilmerding, *The Art of John F. Peto and the Idea of Still-Life Painting in Nineteenth-Century America* (Washington, D.C.: National Gallery of Art, 1983), 91, 164, 183; Alfred Frankenstein, *The Reality of Appearance: The Trompe l'Oeil Tradition in American Painting* (Berkeley: University Art Museum, 1970).

7. Michael Grant, *Eros in Pompeii: The Secret Rooms of the National Museum of Naples* (New York: William Morrow & Co., Inc., 1975), 108–12; Catherine John, *Sex or Symbol: Erotic Images of Greece and Rome* (London: British Museum Publications, 1987).

8. Lighters owe their existence to the wheel-and-wick technology employed in rifles. Cultural links between firearms and lighters were cemented during wars of the 1939–69 period, when lighters gained cult status among soldiers (Gavorsky, *The Lighter King*, 8–9). For the links between cigarette culture and warfare, see

Richard Klein, *Cigarettes are Sublime* (Durham and London: Duke University Press, 1993), 135–56; *Acts of War: The Behavior of Men in Battle* (New York: The Free Press, 1985), 129–30; and Paul Fussell, *Wartime: Understanding and Behavior in the Second World War* (New York and Oxford: Oxford University Press, 1989), 144–5.

9. Wood, *Collecting Cigarette Lighters*, 152. The lighter's nostalgic design reflects the burgeoning interest in historic lighters during the 1980s (Gavorsky, 4–5).

10. *Edweard Muybridge: The Stanford Years, 1872–1880* (Stanford: Department of Art, Stanford University, 1972).

11. Meg Cohen Ragas and Karen Kozowski, *Read My Lips: The Cultural History of Lipstick* (San Francisco: Chronicle Books, 1998).

12. In the first half of the twentieth century, manufacturers styled lighters for women's use, coordinating them with items characteristic of the vanity table (Ettinger, *Compacts and Smoking Accessories*, 126–60).

13. Nina Auerbach, *Woman and the Demon: The Life of a Victorian Myth* (Cambridge and London: Harvard University Press, 1982), passim; Klaus Theweleit, *Male Fantasies* (Cambridge: Polity Press, 1987), 72–9, 181–204 passim.

14. Some notable examples are Kenneth Anger, *Hollywood Babylon* (San Francisco: Straight Arrow Books, 1975) and *Hollywood Babylon II* (New York: Dutton, 1984); John Austin, *Tales of Hollywood the Bizarre* (New York: SPI Books, 1992); Mark Drop, *Dateline Hollywood: Sins and Scandals of Yesterday and Today* (New York: Friedman/Fairfax, 1994); Marianne Ruuth, *Cruel City: The Dark Side of Hollywood's Rich and Famous* (Malibu: Roundtable Pub., 1991).

15. For a recent discussion of the links between Pop and Camp, see Cécile Whiting, *A Taste for Pop: Art, Gender, and Consumer Culture* (Cambridge: Cambridge University Press, 1997), 177–86.

16. Claes Oldenburg, "America: War & Sex, Etc.," *Arts Magazine* 41 (summer 1967): 38; Ellen H. Johnson, *Claes Oldenburg* (Harmondsworth, Middlesex: Penguin Books, 1971), 47; Barbara Haskell, *Claes Oldenburg: Object into Monument* (Los Angeles: The Ward Ritchie Press, 1971).

17. David Poore, *Zippo: The Great American Lighter* (Atglen, Penn.: Schiffer Publications, 1997), 173–4.

18. For a discussion of Hollywood-inspired imagery in the works of Claes Oldenburg, Tom Wesselman, Andy Warhol, and other Pop artists, see Christin J. Maniya, *Pop Art and Consumer Culture: American Supermarket* (Austin: University of Texas Press, 1992), 98–111, and Whiting, *A Taste for Pop*, 147–58.

19. Thomas Buchsteiner and Otto Letze, *Tom Wesselmann* (Ostfildern: Cantz Verlag, 1994), passim.

20. See chapter "L'Amour en Fumée" in Philippe Reynaert and Philippe Elhem, *Le Cinéma en Fumée* (Paris: Contrejour, 1990). Significantly, the authors divide imagery of smoking in the films into two categories—power and love—and highlight the manner in which films often transform a pleasurable smoke into an instrument of torture, used to burn, menace, and tantalize.

21. For stills from *Angel* (1937) and *Scarface* (1932), see Reynaert and Elham, *Le Cinéma en Fumée*, 194, 196. For a Zippo advertisement of 1950, see Flanagan, *Collectors' Guide to Cigarette Lighters*, 115.

22. The erotic significance of smoking became more pronounced over time. The intimacy conveyed when Paul Henreid lit twin cigarettes for himself and Bette Davis in *Now, Voyager* (1942) became overtly sexual when Gregory Peck sparked a light directly from Ava Gardner's cigarette in *The Snows of Kilimanjaro* (1952), as William Holden did with Jennifer Jones in *Love is a Many-Splendored Thing* (1955).

23. For Camels and Lucky Strike ad campaigns of the 1950s, see Flanagan, *Collectors' Guide to Cigarette Lighters*, 121, 126. For endorsements of Ronson and A.S.R. lighters, see Cummings, *Ronson, The World's Greatest Lighter*, 51–54, and Ettinger, *Compacts and Smoking Accessories*, 147. For Ronson product placement in *The Maltese Falcon* (1941), *Strangers on a Train* (1951), and other films, see Cummings, *Ronson*, 115.

24. Advertisers, too, have relied most heavily on female sex appeal to sell cigarettes to both men and women; see Jordan Goodman, *Tobacco in History: The Cultures of Dependence* (London and New York: Routledge, 1995), 102–9.

25. A 1950s advertising campaign commercialized this erogenous zone as the "T- [or taste] zone," focusing attention on the enticing lips, teeth, and tongue of attractive female models (illustrated in Flanagan, *Collectors' Guide to Cigarette Lighters*, 120). For a discussion of the cinema's eroticization of the cosmetized female face, see Laura Mulvey, *Fetishism and Curiosity* (Bloomington and Indianapolis: Indiana University Press), 40–50.

26. David Krogh, *Smoking: The Artificial Passion* (New York: W. H. Freeman & Co., 1941), 14.

27. Klein, *Cigarettes are Sublime*, 160.

28. Michael Koetzle and Uwe Scheid, *Feu d'Amour: Seductive Smoke* (Berlin: Benedikt Taschen, 1994).

29. For examples, see Flanagan, *Collectors' Guide to Cigarette Lighters*, 28–31, 48, 67.

30. Several recent studies have examined the capacity of danger warnings to glamorize smoking as a pseudo-erotic thralldom to a lethal but irresistible seducer. Smokers see themselves as lovers "driven by illicit urges beyond their control . . . [;] people who, in consuming their exotic, dangerous objects, are themselves consumed" (Krogh, *Smoking: The Artificial Passion*, 14).

31. Like the glamorous Hollywood star, smoke and smoking is most alluring as a visual phenomenon that masks unpleasant realities. In the latter case, these include the irritation of eyes, nose, and throat, the burning of fingers and clothing, the discoloration of eyes, teeth, and fingers, and the deterioration of the lungs.

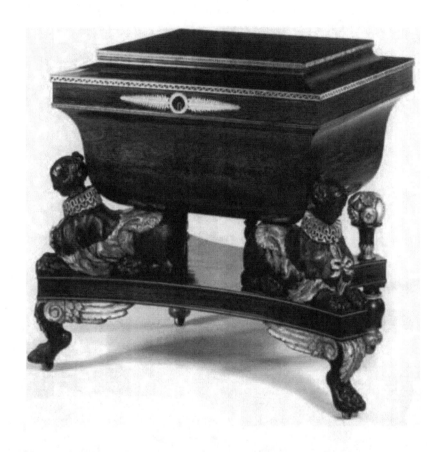

Fig. 3.1. *Cellarette,* New York City, ca. 1810–20. Eastern white pine, maple, alder, rosewood and mahogany veneer, ebony, brass. 76.6 by 87.5 by 54.5 cm. Yale University Art Gallery, Mabel Brady Garvan Collection.

Jeffrey Collins

In Vino Vanitas? Death and the Cellarette in Empire New York

The art of conjecture certainly belongs to the historian, but as an art that operates on hypotheses and "residues." The "historical project" is such only if it does not renounce procedural rigor and continuous autoverification.
— Manfredo Tafuri and Antonio Foscari[1]

A CHALLENGE AND A METHOD

Few objects reveal as much about their makers as those connected with eating, drinking, and mourning. When we eat, we strengthen both our bodies and the bonds of hospitality; when we drink, we loosen social constraints and show our truer selves. And when we mourn, we not only commemorate the dead but reveal our hopes and fears about life itself. In many societies these functions and their attendant material culture are distinct. In early-nineteenth-century New York these lines were blurred, as revealed in a remarkable cellarette or "wine cooler" (Fig. 3.1) whose macabre funerary imagery challenges traditional notions of early national taste. How can we reconcile this cellarette's morbid theme with its known domestic function? What accounts for its unusual iconography and articulation? More importantly, how do we as historians approach a familiar but potentially puzzling artifact? Do we look inward, for telltale marks, joints, and scars—what Manfredo Tafuri has called the physical "residues" of history-making collisions between values and agendas? Or do we look outward, for links to broader attitudes, sources and trends? Perhaps we must do both. As Jules Prown has argued, in the pursuit of culture "there is no single *right* methodology; it is the variety of approaches that makes and enriches our field."[2] The task, then, is to connect the cellarette's internal clues to broader data about its patron, setting, and cultural context in order to untangle its apparent contradictions.

47

What is a cellarette? As the name implies, "cellar-ettes" are small pieces of household furniture used to store wine bottles near the dining table. The form first appeared in Europe in the late eighteenth century in conjunction with the sideboard, another recent innovation. Those lined with zinc or lead in order to hold ice are properly called "wine coolers" (compare Fig. 3.3); many had casters and could be wheeled about as needed. Like related

Fig. 3.2. Henry Sargent, *Dinner Party*, ca. 1821. Oil on canvas. Museum of Fine Arts, Boston, gift of Mrs. Horatio A. Lamb in memory of Mr. and Mrs. Winthrop Sargent. Courtesy, Museum of Fine Arts, Boston.

furniture forms such as dumb waiters, cellarettes kept the food and bottles within arm's reach, and allowed the host to dismiss the servants without interrupting the flow of libations.[3] Although never common in America, cellarettes did figure in some especially luxurious households. We can observe such a setting in Boston painter Henry Sargent's *Dinner Party* of about 1821 (Fig. 3.2), in which eighteen gentlemen enjoy a final course of fruit around a gleaming dinner table as two servants look on. The multipurpose dining furniture of the colonial era has been replaced by the expanding paraphernalia of elegant entertainment, including a cellarette to the left of the table and a sideboard to the right. Together with its companion picture, *Tea Party*, Sargent's picture suggests the important role that the latest furniture forms and styles played in cementing hospitality among the highest strata of early-nineteenth-century American society.[4]

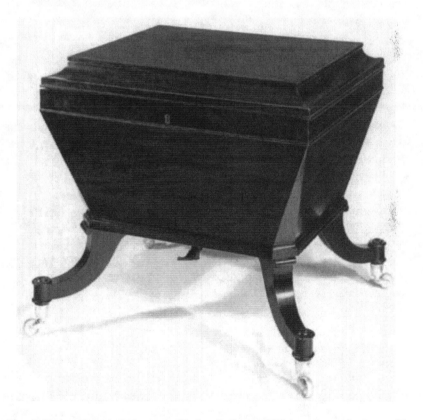

Fig. 3.3. Attributed to Duncan Phyfe. *Cellarette.* Mahogany and pine, with zinc lining and brass spigot. 22 ³/₁₆ inches by 26 ³/₁₆ inches by 23¹/₂ inches. Boscobel Restoration, Inc. Garrison, NY.

Our cellarette conforms to this general type, standing about 2½ feet high on castors and holding six bottles in unlined mahogany compartments. But although its profile recalls contemporary New York examples attributed to craftsmen like Duncan Phyfe (Fig. 3.3), its specific form is unprecedented. Whereas most cellarettes were simple boxes or barrels raised on legs (compare Fig. 3.2), this one has boldly S-curved sides, a cove-molded lid, and elaborate sculptural supports. Its hollow case rests on two coquettish sphinxes that recline on a scalloped plinth that also supports two flowering urns. The two rear feet are turned, while the front feet are carved in the shape of winged animal paws. The materials, too, are unusually opulent. Both plinth and case are wrapped in veneers of dark rosewood punctuated by gilt-bronze escutcheons and brass stringing bands, whereas the carved elements, now painted black, originally simulated verdigris-patinated bronze and are partly gilded.[5] These brighter elements relieve the cellarette's general impression of darkness, massiveness, and weight, creating an ensemble of great visual power.

That power reflects the object's distinguished provenance. Together with a related card table also at Yale, the cellarette was probably bought about 1814 by New York's wealthy financier Stephen Ball Munn (1766–1855) to furnish his lavish new house on lower Broadway. After beginning as an itinerant tin peddler, Munn quickly became one of the city's wealthiest men. Although he was nearly ruined in the War of 1812, Munn was a shrewd businessman who made huge profits through speculation in western land grants. As a self-made man, he was not known for fine manners. According to one chronicler Munn was vulgar, ruthless in collecting debts, and "in early life was excessively dissipated." At the funeral of a friend's mother he is said to have asked loudly, "Well, Jack, what is the news in Wall street?"[6] Munn's modish furniture may have suited his grasping taste, offering him the latest in elite household fashion.

But if social ambitions illuminate Munn's desire for a cellarette they do not explain its form. What accounts for its unusual decoration, and what was such imagery doing in a New York townhouse? The answers lie partly in contemporary fashion. Like the finest New York furniture, our cellarette's sculptural neoclassicism departs from the abstract linearity of earlier Federal furniture and is indebted to progressive London designers such as George Smith or Thomas Hope who interpreted the latest Continental trends. Munn's cellarette documents the arrival of French Empire style from Napoleonic Paris: antique-inspired swans, eagles, griffons, and even sphinxes all featured in Charles Percier and Pierre-François-Léonard Fontaine's innovative furnishings for the palace at Malmaison and quickly became an international vogue. Even the material—rosewood veneer with

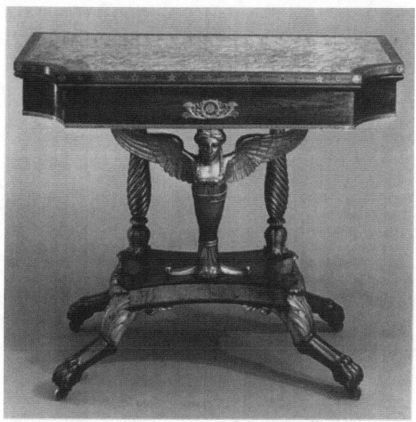

Fig. 3.4. Charles-Honoré Lannuier, *Card Table, New York City, 1810–1815.*
Bird's eye maple, rosewood, satinwood, and mahogany veneers, gilt gesso
and verd antique, brass inlay, gilt bronze mount, mahogany, white pine.
Height 78.7 cm. (31 inches). The Metropolitan Museum of Art, New York,
Funds from Various Donors, 1966 [66.170].

brass and ebony inlays—reflects the Continental preference for exotic
woods over the more familiar mahogany.[7]

The cellarette's overt Frenchness has led many scholars to attribute it to
New York's recently-arrived ébéniste Charles-Honoré Lannuier (see Fig.
3.4), whose expensive veneers, imported mounts, Greco-Roman motifs, and
daring statics link his sophisticated provincial products to those at
Malmaison. The sphinxes, paw feet, and brass stringing bands of Munn's
cellarette all correspond to Lannuier's Empire vocabulary. However, David
Barquist has suggested convincingly that the Yale cellarette and card table
were not made by Lannuier, but by an unidentified shop working in a simi-
lar idiom. On closer inspection neither the manufacture nor the composition

reaches Lannuier's high standard.[8] Nevertheless, the French tone of Munn's furniture reflects France's expanding influence on American design at the expense of traditional British models. One wonders if Munn's Francophilia was colored by his personal setbacks in 1812.[9] Although we cannot be sure, Munn's "French" cellarette may represent a rejection of New York's recent British past in search of new cultural exemplars.

RIDDLE I: SPHINXES

If the cellarette's style is roughly intelligible, its iconography is puzzling and enigmatic. The sphinxes are a particular rarity in American furniture. Sphinxes, or human-headed lions, had originated in ancient Egypt as temple and tomb guardians and maintained this apotropaic function in later cultures. Although sphinxes had been employed in Western art for centuries (usually in their feminine Greek form, with wings), their appearance in our cellarette seems to be an echo of the "Egyptomania" spawned by Napoleon's 1798 African campaign, which greatly increased knowledge of Egyptian antiquities. Our sphinxes' untraditional appearance, however— one writer has called them "Egyptoid"—complicates such a reading.[10] By 1814 nearly all sphinxes had reverted to their ancestral guise with proper pharaonic headdresses and a stoic, masculine demeanor. A pylon clock of 1806 by London maker Benjamin Vulliamy (Fig. 3.5) suggests how far our sphinxes are from their "correct" European contemporaries. Despite their Egyptian-revival colors, Munn's girlish creatures are refugees from rococo France, their delicate profiles and old-fashioned ruffs recalling the courtly creations of Daniel Marot or the soft-focus fantasies of Jean-Honoré Fragonard.[11] Is this merely an accident, a provincial stylistic blunder, or was there some logic behind the choice?

As Richard Randall first proposed in "Sources of the Empire Style," the cellarette's direct inspiration seems to have been rococo garden ornaments. Our sphinxes' knotted hairstyle, ruff, and fringed shawl all derive from a plate in Jacques-François Blondel's *De la distribution des maisons de plaisance et de la décoration des édéfices en générale* (Paris 1738), captioned "design for a sphinx on a socle for the decoration of terraces." Blondel himself was following a fad begun under Louis XIV in the late seventeenth century for using pairs of marble and terracotta sphinxes on garden balustrades, where their apotropaic function gave way to contemporary fashion. As Hugh Honour writes, "these creatures, usually female and coyly smiling, were treated with such rococo elegance that it is sometimes difficult to remember that they derive ultimately from solemn Egyptian ancestors." Updated with wigs and wraps to fend off the northern cold, they bore the

Fig. 3.5. Benjamin Lewis Vulliamy, *Pylon Clock Resting on Four Sphinxes*, London, 1806. Black marble with gilt and patinated bronze, 22.8 by 30.2 by 12.5 cm. Victoria and Albert Museum, London. Art Resource, NY.

faces of court beauties with attenuated necks, a fashion that may explain the unnaturally small heads of Munn's examples.[12] Whether our maker copied Blondel directly or some intermediate source, he reinforced their garden pedigree by including two stylized, flowering urns that recall French topiary forms (Fig. 3.1). This is not to claim that Munn's unorthodox sphinxes no longer served as guardians in Munn's "guard de vin," as cellarettes were sometimes known. The real issue is why these feminized, garden forms were preferred over more authentic versions for which models were clearly available.

RIDDLE II: SARCOPHAGI

Despite its rococo sphinxes, the cellarette includes other components with antique, mortuary overtones. Its animal-paw feet, for instance, recall furniture excavated at the dead cities of Pompeii and Herculaneum, whereas the purplish veneers and simple masses imitate basalt or red porphyry,

dense, African stones that had long connoted ancient Egypt. The bottle case's flaring lip recalls Egyptian cove moldings, whereas its prominent central escutcheon (formed from a wreath and opposed fronds) suggests a winged solar disk. Most importantly, nearly all commentators (including Wendy Cooper in her recent *Classical Taste in America*) have identified the cellarette's shape as that of "an ancient Roman sarcophagus." This helps explain the guardian sphinxes, although the reference to antiquity is again indirect. Ancient sarcophagi included straight-sided, round-bottomed, bathtub- or temple-shaped types, and might be plain, strigillated, or carved with narratives, but they rarely sported flaring sides, a flat lid, or paired animal supports.[13] These features derive instead from Renaissance recreations of classical form, beginning with the humanist tombs of Quattrocento Italy. The monument to Cardinal Pietro Riario of about 1475 in Rome by Andrea Bregno and Mino da Fiesole, for instance, includes a round-bottomed sarcophagus supported by a row of female sphinxes. Perhaps the earliest example of the genre, the monument to Carlo Marsuppini in Florence of 1453 by Desiderio da Settignano (Fig. 3.6), even shares the cellarette's paw feet, paired wings, ogee-shaped sarcophagus, angled sphinxes or harpies, and prominent flowering urns.[14]

Fig. 3.6. Desiderio da Settignano, *Monument to Carlo Marsuppini*, S. Croce, Florence, 1453 (detail). Marble with traces of polychromy (total height approx. 6 m). Alinari/Art Resource, N.Y.

Fig. 3.7. *Tomb of Diane de Poitiers*, 1576. Black and white marble. Originally at the Château d'Anet, reconstructed at Versailles. Giraudon/Art Resource, N.Y.

In Vino Vanitas? *Death and the Cellarette in Empire New York* *55*

Distant as it may seem, Desiderio's eclectic, antiquarian composition on a funerary theme seems to be the source of many of the forms and motifs that ended up in Stephen Munn's New York dining room.

Certain later variations on Desiderio's model approach the Munn cellarette quite closely, and may account for its distinctive conjunction of animal supports and a curving sarcophagus. The sixteenth-century tomb of Diane de Poitiers in France's Loire valley (Fig. 3.7), for instance, includes two buxom female sphinxes that carry an ogee-shaped, black-marble coffin with a flat, cove-molded lid—all elements that reappear (minus the crowning effigy) in our cellarette.[15] Generations of Baroque artists invoked similar arrangements, which became a virtual cipher for antique tombs.[16] One wonders how the designer of Munn's cellarette knew this European funerary tradition, and what suggested its domestic adaptation. Had he seen Italian or Italianate tombs, perhaps through paintings, drawings, engravings, or pattern books? One possible intermediary is the tradition of echoing sarcophagus forms in Italian wedding chests or *cassoni*. Antonio Maffei sculpted a pair of such chests in about 1559 (Fig. 3.8) with ogee-shaped cases, flat lids, and twin supports in the form of crouching lions set at a slight angle. Despite their greater length, the Getty chests are almost exactly the same height and depth as the Munn cellarette, and their dark walnut wood with original parcel gilding would have created a roughly analogous visual effect. Did a Renaissance *cassone* make its way to Empire New York, or had the maker seen one before coming to the New World?

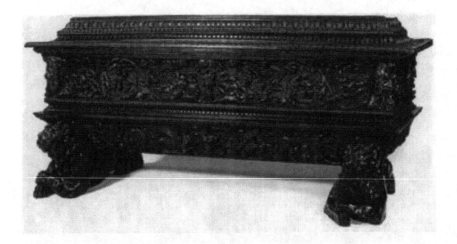

Fig. 3.8. Attribute to Antonio Maffei, *One of a Pair of Cassoni*, 155(9). Carved walnut, originally gilded. 75 by 181^1/$_2$ by 59 cm. The J. Paul Getty Museum, Los Angeles.

What were his design sources, and how much of their context survived? Munn's matching card table poses a similar problem, since Barquist has shown that its antique-looking eagles and swags descend from Louis XIV's short-lived silver furniture for the Hall of Mirrors at Versailles.[17] Munn's neo-Baroque furniture certainly reveals sophisticated antiquarian ambitions. Even if we cannot specify the mechanism, it seems clear that its designer drew on a rich tradition of European funerary art in crafting his tomb-shaped wine holder.

DEATH: TRAGEDY OR TRIUMPH?

Eclectic as it seems, the cellarette's repetition of funerary themes suggests that cultural as well as aesthetic concerns factored in its design. This idea has intrigued previous commentators, who have noted the maker's irony in linking drink to death, and inferred that some deeper message was intended.[18] To be fair, this connection was hardly new by Munn's day. In late-eighteenth-century Europe the association of wine coolers and coffins had become so pervasive that "cellarette" and "sarcophagus" were almost interchangeable. This worried Thomas Sheraton, who warned in his 1803 *Cabinet Dictionary* that although cellarettes might be "in some faint degree, an imitation of the figure of these ancient stone coffins," this visual resemblance was the *only* reason that "the term can with any colour of propriety, be applied to such wine systems."[19] Although Sheraton surely protests too much, he reminds us that some funerary imagery was a natural by-product of neoclassicism. Not just wine coolers but tea caddies and knife boxes could be conceived as coffins or cinerary urns, since these well-known antique forms offered convenient shapes for household storage. Still, there seems to have been a particular connection between tombs and cellarettes, as even more modest examples attest (compare Fig. 3.3). What accounts for the tomb's popularity as a design inspiration in Empire New York?

One general explanation is the increasing importance of death in nineteenth-century American thought. Although health and sanitation were gradually being improved, high infant mortality, war, and disease made Munn's contemporaries far more intimate with death than we are today. Moreover, the abiding Puritan concept of *vanitas*—of the futility and transience of earthly success—still induced antebellum Americans to understand death as a call for moral behavior. Sunday sermons emphasized life's fragility, while diarists admonished themselves to "let your reflection be of death and future state."[20] As cultural historians have pointed out, an obsession with transience and morality/mortality often corresponds with

periods of rapidly increasing prosperity. Just as seventeenth-century Dutch burghers had purchased sumptuous still lives as a caution against earthly pride, Stephen Munn might have desired a functional *memento mori*. In this reading, his sarcophagus-cellarette would remind him not to take his sensory pleasures too seriously.

For the period's cultural elite, such funereal meditations were further promoted through the aesthetic rubric of the Sublime. Edmund Burke had identified as Sublime "whatsoever is fitted in any sort to excite the ideas of pain and danger"—principally reminders of human smallness, fragility, and death. Burke's followers took this even further by validating feelings of "delicious" fear. Thomas Aiken, for instance, entitled one 1773 treatise *On the Pleasures Derived from Objects of Terror and an Enquiry into the kinds of Distress which Excite Agreeable Sensations*.[21] Since nothing was more Sublime than a tomb, tombs became a leitmotif of Romantic art. For cultured New Yorkers interested in confronting death head-on, what better vehicle than a simulacrum of a sarcophagus in the dining room? Although history does not record Munn's perspective on the subject, we do know that he had his wife's body "laid out in the house" before her funeral. Did this take place in the dining room beside the cellarette?[22]

The *vanitas* thesis sketched out above does not account, however, for the cellarette's rococo sphinxes or flowering urns, which are certainly not Sublime. Perhaps, rather than constituting a traditional *vanitas*, Munn's domestic "sarcophagus" documents a gradual shift in his generation's understanding of death. As the eighteenth century waned, life's end came to be seen less as a fearsome fate than as a welcome respite from travail. Social historian Lewis Saum has noted that the rhetoric of consolation in antebellum America increasingly figured death as a release, defining the hereafter as escape from trouble, and end to difficulty.[23] Death-the-Grim-Reaper became Death-the-Comfort-of-the-Just. In a rather similar way, the cellarette's medley of rococo France and ancient Egypt surrounds the threatening "sarcophagus" with the trappings of topiary and terrace, providing Munn's buried booze the pleasantest of settings. To the extent that broader intellectual shifts affected household aesthetics, this important shift in the conception and figuration of death may explain the cellarette's novel fusion of the fearsome visual qualities of the Sublime (darkness, heaviness, infinity) with the comforting ones of the Beautiful (variety, softness, grace).

Americans' changing views of death might also explain the cellarette's juxtaposition of mortuary and garden elements—the garden sphinxes, the flowering urns. Indeed, Munn's "beautiful" sarcophagus seems to anticipate the rural cemetery movement that would soon radically transform the

Fig. 3.9. *Reverend Dr. Channing's Monument,* Mt. Auburn Cemetery, designed by Washington Allston, as drawn by James Smillie. From *Mount Auburn Illustrated* (New York, 1851), opposite p. 85.

American way of death. Pioneered at Père Lachaise in Paris, by the 1830s the movement had taken root outside Boston, New York, and Philadelphia in necropolises with bucolic, reassuring names like Mt. Auburn, Greenwood, and Laurel Hill (Fig. 3.9). Crowded colonial churchyards were replaced with salubrious suburban Arcadias meant to draw nature lovers and to cheer the bereaved with historicizing tombs and meandering, picturesque paths. In her praise of Mt. Auburn's "Consecration Dell," for instance, an apologist quoted William Cullen Bryant:

> Thou, God, art here . . .
> Here is continual worship; nature here,
> In the tranquillity that Thou dost love,
> Enjoys thy presence.[24]

Whether an outing to these "gardens of graves" provided the opportunity to lose oneself in thought or to instruct the young on the merits of a virtuous life (Fig. 3.9), the tomb became a fitting subject for edifying (and pleasant) contemplation. Like the European elegiac gardens on which they were based, America's rural cemeteries were at once pastoral paradises and sites

of profound loss. The new sentimental cult of mourning embraced them both.[25]

How does this apply to our wine cooler? By setting a foreboding, Egyptian tomb alongside comforting garden elements, Munn's cellarette, too, pairs cheerful and solemn elements to create an elegiac view of death. Death's harshness is softened by the pretty sphinxes and urns, much like the actual tombs at Mt. Auburn. The cellarette's stylistic alchemy both suggests the pleasures that are lost in death and implies they have been regained for eternity. Like the rural cemeteries, Munn's cellarette documents the transformation of the tomb from a locus of horror to an object of bittersweet contemplation.

ALCOHOL: MEMORY AND METAPHOR

In linking the cellarette to notions of vanity and commemoration we have overlooked its practical function. Alcohol, by all accounts, played an important role in early-nineteenth-century society and may have influenced the cellarette's novel form. Although historians Mark Lender and John Martin have characterized these years as "probably the heaviest drinking era in the nation's history" (presumably coinciding with Munn's period of dissipation), they note that wine was not most Americans' drink of choice. Even in wealthy homes it tended to be reserved for guests, with rare vintages commanding fantastic prices—a fact that may explain both the cellarette's prominent lock and its potentially menacing form. At the same time, the cellarette's visual qualities echo its probable contents. According to Richard Hooker, wealthy Easterners like Munn preferred not light French or German wines that might be served chilled, but the heavier, blood-colored elixirs of Spain, Portugal, the Canaries, and Madeira.[26] Fortified liquids that fortified the flesh may have suggested the bodily analogies implicit in the sarcophagus form.

Given its antiquarian style, the cellarette's mortuary allusions may also have been influenced by literary testimony regarding ancient dining practice. Significantly, the connection of death and feasting originated in Egypt, as the Greek historian Herodotus describes:

> And at the banquets of the rich, when the meal is over, a man carrieth around a corpse fashioned of wood in a coffin, one or two cubits long and counterfeited perfectly with painting and with graving; and he sheweth it unto each of the company and saith: Look upon this, and drink and be merry; for when thou diest, thou shalt be even such. Thus they do at their banquets of wine.[27]

Plutarch invokes this custom twice in his *Moralia*, recasting it as a call to brotherly love:

> Now the skeleton which in Egypt they are wont, with fair reason, to bring in and expose at their parties . . . although it is an ungracious and unseasonable companion to be introduced at a merry-making, yet has a certain timeliness, even if it does not incline the guests to drinking and enjoyment, but rather to a mutual friendliness and affection, and if it urges upon them that life, which is short in point of time, should not be made long by evil conduct.[28]

The most colorful reference to this practice is provided by the Roman satirist Petronius, whose *Satyricon* mocks the vulgar banquet of the parvenu freedman Trimalchio, a would-be philosopher whose dinner-table conversation focuses on his tomb. As Trimalchio serves his guests rare, "hundred-year old" wine, he bemoans that "wine lives longer than miserable man. So let us be merry. Wine is life. . . ." When a slave, on cue, places a jointed silver skeleton upon the table Trimalchio sagely opines, "Alas for us poor mortals, all that poor man is nothing. So we shall all be, after the world below takes us away. Let us live then while it can go well with us."[29] Munn's cellarette, wheeled out ceremoniously at the end of a meal, was thus but one in a long line of classically-inspired (and potentially vulgar) *mementi mori*.

By Munn's day this literary evidence was amply supplemented by archeological evidence of the ancient tendency to remember death at the moments of greatest physical enjoyment. Because the Romans understood dining and drinking as a time of communion between the living and the dead, they decorated lamps, pavements, cutlery, and tableware with skulls, skeletons, and other mortuary themes. A mosaic table top from Pompeii, for instance, features a skull with the motto "Death Levels All Things," whereas a silver cup from Boscoreale features the skeletons of famous philosophers. Although these examples might seem strangely close to the Christian *vanitas*, their message was less moralistic than hedonistic. *Carpe diem*, they announce: pleasure is to be enjoyed while we are able.[30] This Epicurean attitude was so widespread in antiquity that even the Jews declared, "let us eat and drink, for tomorrow we shall die" (Isaiah 22:13). Similar hedonism seems to resonate in Munn's cellarette. Like those ancient reminders of death it contrasts pleasure and oblivion while claiming the (temporary) superiority of the living over the dead. In fact, Munn outdoes his classical predecessors. While their miniature skeletons and sarcophagi merely reminded diners to enjoy life, his wine-filled "sarcophagus" contained the actual means with which to do so.

Thomas Sheraton aside, both etymology and ancient funerary practice further link wine and death. "Sarcophagus" (literally "flesh eater") originally referred to a caustic limestone that consumed bodies placed within it, and was only later extended, rather ironically, to coffins where preservation was the desired goal. It was thus only natural to expand the term further to containers of alcohol, a substance which—depending on its use—either preserves the body or destroys it.[31] Munn's classically-educated guests might have known that ancient cinerary urns themselves contained alcohol, since wine was often mixed with the ashes before they were interred.[32] Since alcohol was also used in embalming, the cellarette's wine bottles correspond to the sets of canopic jars that preserved the hearts and lungs of Egyptian pharaohs. Retrieved from their dark chambers, they were uncorked to "breathe" again. Even the English word "cellar-ette" invokes a part of the home often associated with darkness, danger, and death. One thinks of Edgar Allan Poe's macabre 1846 story "The Cask of Amontillado," in which a drunken man is walled up in a wine cellar.[33] As Bernardin de Saint-Pierre explained in 1784, tombs occupy "the frontiers of two worlds."[34] The sarcophagus was thus a fitting form for an object that divided (or united) darkness and light, past and present, life and death, and—considering the contents—sobriety and drunkenness.

TREMORS AND TRANSITIONS: A HIDDEN CLUE

In exploring this cellarette we have moved far beyond Tafuri's physical "residues"—the tangible, material features of the object itself. We have also overlooked its most unusual formal feature. We saw how the heavy bottle case rests on the two sphinxes and—one assumes—on the flowering urns (Fig. 3.1). Yet this is not so. In fact the "sarcophagus" just misses the urns and sits instead on a small post hidden at the center of the platform (Fig. 3.10). This unexpected arrangement, together with the top-heavy massing and suggestion of wings, gives the cellarette a strange anti-gravity, as if the leaden case is somehow afloat. Although some play of solid and void occurs in the Renaissance and Mannerist tombs, which also contain wings (Fig. 3.6), the cellarette takes this further, as if its wine-filled sarcophagus is actually headed for the beyond. Its unorthodox design seems to encode the weightlessness of inebriation, the disorientation of drink. Is the cellarette floating, or are we? From its iconography to its structure the cellarette embodies the experiences and associations generated by alcohol.

Perhaps alcohol is the cellarette's real inspiration. Its form seems to suggest that if we drink the lethe contained within, we will float to a peaceful

Fig. 3.10. *Cellarette,* detail of hidden support. Yale University Art Gallery, Mabel Brady Garvan Collection.

garden to enjoy the sleep of the dead. If we are not too tipsy perhaps we will admire the pretty sphinxes, enjoying not the big death but the little one. Whatever individual fantasies it evokes, this cellarette exploits the natural associations between drunkenness and sleep, and between sleep and death. Ages old, this habit survives in modern slang. How many of us have "put a pet to sleep" or say that we are "dead tired?" More ominously, we joke about getting "embalmed" at a party, or of being "dead drunk." All these associations lie buried in this cellarette.

IN VINO VANITAS: THE LIMITS OF HISTORICAL FICTION

As the old adage claims, "in vino veritas"—in wine there is truth. This essay has asked, "in vino vanitas?"—in wine is there only vanity? Perhaps what is vanity is to expect truth from art historians. Tafuri reminds us that all history is provisional, as one generation wrestles with formulations and structures in which it, too, is implicated. "'True history,'" he writes, "does not cloak itself in 'philological proofs,' but recognizes its own arbitrariness,

recognizes itself as an 'unsafe building.'" Or, as Jules Prown has put it, "History is untrue; it has to be."[35]

This cellarette's structure, condition, and style provide compelling "residues" of past events that I have sought to link with patterns of patronage, beliefs, and personal psychology. But one can never recapture the maker's or the patron's intentions, and what Munn's cellarette "means" depends on what evidence is privileged. Was it a reminder of worldly vanity? Or does it prefigure the garden cemeteries' sentimental cult of death? Or was it just an alcoholic joke—a reminder to drink deep before sleep (and death) engulfs us all? We may never know. Carlo Ginzburg discussed the historical process in this way:

> There comes a moment (though not always) in research when all the pieces begin to fall into place, as in a jig-saw puzzle. But unlike the jig-saw puzzle, where all the pieces are near at hand and only one figure can be assembled (and thus the correctness of each move be determined immediately) in research only some of the pieces are available, and theoretically more than one figure can be made from them. In fact, there is always the risk of using, more or less consciously, the pieces of the jig-saw puzzle as blocks in a construction game. For this reason, the fact that everything falls into place is an ambiguous sign: either one is completely right or completely wrong.[36]

Ultimately, the cultural historian must test all hypotheses (and all completed puzzles) against both the physical evidence and the constants of human experience. Material objects are particularly useful in this regard, since—as historical events that can still be experienced—they open a tantalizing window to the past. As we have seen in examining its history, its function, and its form, this cellarette may record its maker's and perhaps its users' unspoken beliefs about the abiding passages from waking to sleep, from sobriety to intoxication, and from life to death. As such this cellarette reveals a fundamental purpose of both alcohol and its associated material culture: to ritualize the difficult but inevitable transitions in human life.

NOTES

An earlier version of this essay was presented at the 1996 College Art Association conference in a panel entitled "Answering Questions the (American) Object Cannot Answer." I would like to thank Jules Prown, Margaretta Lovell, George Hersey, and Kenneth Haltman for their astute suggestions, and David Barquist of the Yale University Art Gallery for facilitating my access to the cellarette.

1. Manfredo Tafuri and Antonio Foscari, *L'Armonia e i conflitti: la chiesa di San Francesco della Vigna nella Venezia del '500* (Turin: Einaudi, 1983), 9 (my translation). Nick Napoli kindly brought this passage to my attention.

2. Jules David Prown, "In Pursuit of Culture: The Formal Language of Objects," *American Art* 9 (summer 1995): 2. See also Prown's fundamental studies, "Style as Evidence," *Winterthur Portfolio* 15 (fall 1980): 197–210, and "Mind in Matter: An Introduction to Material Culture Theory and Method," *Winterthur Portfolio* 17 (spring 1982): 1–19.

3. On cellarettes in general, see John Fleming and Hugh Honour, *Dictionary of the Decorative Arts* (New York: Harper and Row, 1977), 863; for their use in America, see Charles F. Montgomery, *American Furniture: The Federal Period* (New York: The Viking Press, 1966), 358, 431–2, and Elizabeth Bates and Jonathan Fairbanks, *American Furniture 1620 to the Present* (London: Orbis Publishing Co., 1981), 233–4, 276. On related forms like liquor chests, see Nina Fletcher Little, *Neat and Tidy: Boxes and their Contents used in Early American Households* (New York: E. P. Dutton, 1980), 161–5.

4. See Jane C. Nylander, "Henry Sargent's *Dinner Party* and *Tea Party*," *Antiques* 124 (May 1982): 1172–83. Nylander suggests (1172) that the painting depicts the Wednesday Evening Club, composed of four clergymen, four doctors, four lawyers, and four "merchants, manufacturers of gentlemen of literature and leisure." The barrel-form cellarette was probably made in New England between 1810–20, descended in the Sargent family and is now in the Museum of Fine Arts, Boston. The French Empire-style chairs in *Tea Party* follow a plate in Percier and Fontaine's *Receuil de décorations intérieures* (Paris, 1812 edition; see below).

5. The cellarette (1966.126) is catalogued by Gerald W. R. Ward, *American Case Furniture in the Mabel Brady Garvan and Other Collections at Yale University* (New Haven: Yale University Press, 1988), # 229, 442–44. The brass inlay bands and painted areas have been restored, while nail holes in the corners of the plinth indicate missing mounts. The cellarette's mahogany interior suggests that the wine was served at room temperature.

6. Joseph A. Scoville (alias Walter Barrett), *The Old Merchants of New York City* (New York: Worthington Co., 1885, based on an earlier edition) II: 20–32, 37. The Munn provenance is discussed by Ward, 443, and David L. Barquist, *American Tables and Looking Glasses in the Mabel Brady Garvan and Other Collections at Yale University* (New Haven: Yale University Art Galley, 1992), #120, 227–30. Both pieces descended in the family until 1962. Munn moved to New York from Connecticut in 1794, first living over his dry goods shops on Maiden Lane and Pearl Street. The cellarette and table may have formed part of a larger suite purchased for the new house he constructed in 1814 on Broadway between Broome and Spring Streets, where he lived until his death. See William Frederick Cornell, *The Munn Family* (Freeport, N.Y., 1941).

7. On the American Empire style, see Wendy Cooper, *Classical Taste in America 1800–1840* (New York: Abbeville Press, 1993), and Richard Randall, "Sources of the Empire Style," *Antiques* 83 (April 1963): 452–3. Designs by Percier and Fontaine, Pierre de la Mésangère, Hope, Smith, and others, were widely diffused through pattern books. See Kenneth Ames, "Designed in France: Notes on the Transmission of French Style to America," *Winterthur Portfolio* 12 (1977): 103–14.

8. Both Ward and Barquist questioned the attribution to Lannuier (see nn. 5–6 above) and no cellarettes are accepted in Peter M. Kenny et al., *Honoré Lannuier, Cabinet Maker from Paris: The Life and Work of a French Ébéniste in Federal New York* (New York: Metropolitan Museum of Art, 1998). See also Lorraine W. Pearce, "The Distinctive Character of the Work of Lannuier," *Antiques 86* (1964): 712–17, and "The Work of Charles Honoré Lannuier, French Cabinetmaker in New York," *Maryland Historical Magazine 55* (1960): 14–29. The same unidentified shop seems to have made a card table in the Henry Ford Museum in Dearborn, Michigan (# 64.26) and a very similar table (attributed to Lannuier) offered at Skinner's on November 16, 1985 (lot 650).

9. Ames, as in n. 7. Scoville, 23–24, notes that at war's end Munn was forced to exchange his stockpiled goods for "worthless" western land, which he finally sold for $200,000 during the great land speculation of 1835–36.

10. Bates and Fairbanks, 276; see also Cooper, 132.

11. Egypt's influence on western design is analyzed in *Egyptomania: Egypt in Western Art 1730–1930* (Ottawa: National Gallery of Canada, 1994); for Vulliamy's clock see #145. See also James Stevens Curl, *The Egyptian Revival: An Introductory Study of a Recurring Theme in the History of Taste* (Boston: Allen & Unwin, 1982); Hugh Honour, "Furnishings in the Egyptian Taste," in *The Concise Encyclopedia of Antiques* (New York: Hawthorn Books, 1961), 5: 45–50; and Nikolaus Pevsner, "The Egyptian Revival," reprinted in *Studies in Art, Architecture and Design* (London: Thames and Hudson, 1968) 1: 213–55. For American Egyptomania, see Donald Fennimore, "Egyptian Influence in Early Nineteenth-Century American Furniture," *Antiques 137* (May 1990): 1190–1201. On modern sphinxes, see Heinz Demisch, *Die Sphinx. Geschichte ihrer Darstellung von den Anfängen bis zur Gegenwart* (Stuttgart, 1977); Henry Havard, *Dictionnaire de l'ameublement et de la décoration* (Paris: Maison Quantin, 1897), 1066–7; and Philippa Lewis and Gillian Darley, *Dictionary of Ornament* (London: Macmillan London, Ltd., 1986), 283. The dress and hairstyle of the cellarette's sphinxes recalls Fragonard's "Spanish"—costume portraits of the 1770s.

12. Randall, 452–3, and Honour, 46. The full reference to Blondel (2:24, pl. 23) was provided by Thomas Michie in a 1984 letter in Yale's curatorial files. "Portrait" sphinxes were also manufactured by eighteenth-century potters; the Kadison collection preserves two Wedgwood examples in black basalt with the faces of actresses Peg Woffington and Kitty Clive.

13. Cooper, 136. For ancient sarcophagus forms, see Guntram Koch and Hellmut Sichtermann, *Römische Sarkophage* (Munich: C.H. Beck, 1982) and Koch, *Sarkophage der Römischen Kaiserzeit* (Darmstadt: Wissenschaftliche Buchgesellschaft, 1993). The cellarette's formal features (round bottom, twin supports, pyramidal lid) seem to be closer to ancient fountain basins, such as the porphyry example conserved since the eighteenth century at the Villa Borghese in Rome, or the larger porphyry basin (which might be a sarcophagus) that Pope Clement XII moved in the 1730s from outside the Pantheon to his tomb in S. Giovanni in Laterano. This famous example had already been copied by Antonio Rosselino for the tomb of the Cardinal of Portugal in S. Miniato al Monte in Florence in ca. 1460.

14. On Italian Renaissance tombs, see Gerald S. Davies, *Renascence: The Sculptured Tombs of the Fifteenth Century in Rome* (London: John Murray, 1910); Margaret H. Longhurst, *Notes on Italian Monuments of the 12 to 16th Centuries* (typescript prepared posthumously by the Victoria and Albert Museum, n.d.); John Pope Hennessy, *Italian Renaissance Sculpture* (London: Phaidon, 1958); and Joachim Poeschke, *Die Skulptur der Renaissance in Italien*, 2 vols. (Munich: Hirmer, 1990). Similar layered compositions and animal standards reappear in Mannerist furniture like the "Sea Dog Table" of ca. 1580 at Hardwick Hall; see Gervase Jackson-Stops, ed., *The Treasure Houses of Britain* (Washington, D.C.: National Gallery of Art, 1985), 108–9.

15. Pevsner, 224–25, relates the Anet tomb to those of Angelo Cesi in S. Maria della Pace in Rome (attr. to Vincenzo de Rossi, ca. 1550) and Guillaume du Bellay in LeMans cathedral of 1557, both with paired sphinx supports and a curving sarcophagus. He traces the form to an actual Roman monument (incorporating a sarcophagus of conventional shape) recorded by Marten van Heemskerck. Iconographic connections between Diane de Poitiers and the Egyptian goddess Isis are explored in P. D. Roussel, *Histoire et Déscription du Château d'Anet* (Paris, 1875).

16. Similar sarcophagi appear in seventeenth-century Dutch Italian landscapes, such as J. B. Weenix's *Ruin Scene with Sarcophagus* (reproduced in Christine Schloss, *Travel, Trade and Temptation: The Dutch Italianate Harbor Scene, 1640–1680* [Ann Arbor: UMI Research Press, 1982], fig. 17), or Karel Dujardin's *Soldier's Tale* (see Philadelphia Museum of Art, *Masters of Seventeenth-Century Dutch Genre Painting* [1984], #39, 194–95; and *Selected Paintings and Sculpture from the Yale University Art Gallery* [New Haven: Yale University Press, 1972], #22). Eighteenth-century Italian architect Filippo Juvarra included dozens of analogous designs in his capricci of ancient ruins; see Rudolf Wittkower, "A Sketchbook of Filippo Juvarra at Chatsworth," in *Studies in the Italian Baroque* (Boulder: Westview Press, 1975), 187–210, especially ff. 2, 4, 10, 17, 21, and 28.

17. This furniture was melted in Louis' own lifetime, and Barquist (230) illustrates the original designs now in Stockholm. He also notes (227) the influence of English neo-Palladian furniture on other New York "baroque" designs.

18. Ward, 444, citing curatorial notes by Thomas Michie. Bates and Fairbanks, 276, suggest that the cellarette's suggestion of "death and immortality" is typical of the "complex meanings and symbolism . . . of nineteenth-century life."

19. Thomas Sheraton, *The Cabinet Dictionary* (London, 1803), quoted in Lewis and Darley, 269. The usage survives in some modern dictionaries.

20. Diary of Hiram Peck of New York, quoted in Lewis Saum, "Death in the Popular Mind of Pre-Civil War America" in David E. Stannard, ed., *Death in America* (Philadelphia: University of Pennsylvania Press, 1975), 32. See also Stannard, "Death and Dying in Puritan New England," *The American Historical Review* 78 (December 1973): 1305–30. On the vanitas theme in art, see, for instance, David Oliver Merrill, "The 'Vanitas' of Jacques de Gheyn," *Yale University Art Gallery Bulletin* 25 (March 1960): 7–30.

21. Kenneth Clark, *The Romantic Rebellion* (New York: Harper & Row, 1973), 45.

22. Scoville, 32.

23. Saum, 30–48.

24. Quoted by Cornelia Walter in *Mount Auburn Illustrated, in Highly Finished Line Engraving, from Drawings Taken on the Spot*, by James Smillie (New York, 1851), 101. Walter describes the spot as "picturesque and beautiful in the highest degree," and cites Judge Story's 1831 consecration address:

> the rivalries of the world will here drop from the heart. . . vanity will let fall its plumes. . . But that which will ever be present, pervading these shades like the noonday sun, and shedding cheerfulness around, is the consciousness. . . that this is but the threshold and starting-point of an existence, compared with whose duration the ocean is but as a drop, nay, the whole creation an evanescent quantity.

 One participant called Mt. Auburn a "garden of graves."

25. See also Richard Etlin, *The Architecture of Death: The Transformation of the Cemetery in Eighteenth-Century Paris* (Cambridge, Mass.: MIT Press, 1984). American funerary art is surveyed by Peggy McDowell, *The Revival Styles in American Memorial Art* (Bowling Green, Ohio: Bowling Green State University Popular Press, 1994).

26. Mark E. Lender and John Martin, *Drinking in America: A History* (New York: The Free Press, 1982), 46; Richard J. Hooker, *Food and Drink in America: A History* (Indianapolis: The Bobbs-Merrill Co., Inc., 1981).

27. *Herodotus* 2.78, trans. J. Enoch Powell (Oxford: Clarendon Press, 1949), 1: 144–45. Lucian later claimed (*De Luctu* 21) that Egyptians dried their dead and displayed them at meals and symposia. Cristiano Grottanelli analyzes these texts in "Wine and Death-East and West," in Oswyn Murray and Manuela Tecuan, eds., *In Vino Veritas* (Rome: The British School at Rome, 1995), 62–89.

28. Plutarch *Moralia* 148, trans. Frank Cole Babbitt (London: William Heinemann, 1928), 2:359. Plutarch mentions this again at 357, about Isis and Osiris.

29. Petronius, *Satyricon* 34, trans. Michael Heseltine, rev. E. H. Warmington (Cambridge, Mass.: Harvard University Press, 1987), 61–3.

30. The use of skeletons at banquets is investigated by Katherine Dunbabin, "Sic Erimus Cuncti. . . The Skeleton in Graeco-Roman Art," *Jahrbuch des Deutschen Archäologischen Instituts* 101 (1986): 185–255. Although the Boscoreale cup (Inv. Louvre AGR, Bj 1923) was not discovered until later in the century it is typical of related objects; see Soprintendenza Archeologica di Pompei, *Il Tesoro di Boscoreale* (Milan: Franco Maria Ricci, 1988), #14. It bears the inscription: "Enjoy life while you are alive, for tomorrow is uncertain."

31. This point was first made by Michie (see n. 17) and refined by Ward, 444.

32. James Stevens Curl, *A Celebration of Death* (New York: Scribner, 1980), 41–43. Ausonius describes a related practice in Epitaph 31, "On the Tomb of a Happy Man." Ancient sarcophagi imitating wine vats with spigots were popular among the Dionysiac cults, based on Bacchus' connection with resurrection; see Koch and Sichterman, 80–82.

33. Edgar Allan Poe, *Poetry and Tales* (New York: Library of Classics, 1984), 848–54. Poe's wine cellar lies within the family vaults: "We had passed through walls of piled bones, with casks and puncheons intermingling, into the inmost recesses of the catacombs" (851).

34. *etudes de la nature. . .* , quoted in Curl, 214.

35. Manfredo Tafuri, *The Sphere and the Labyrinth: Avant-Gardes and Architecture from Piranesi to the 1970's* (Cambridge: MIT Press, 1987; originally published in Turin by Einaudi, 1980), 12; Prown, "Pursuit," 2.

36. Carlo Ginzburg and Adriano Prosperi, quoted in Tafuri, 1.

Kenneth Haltman

Reaching Out to Touch Someone? Reflections on a 1923 Candlestick Telephone

In no other country would it have been possible for the telephone to be invented, which allows one to enter another's house without the ceremonies of entrance or introduction, and moreover without actually going there.
—Hugh Kenner, *A Homemade World* (New York: Knopf, 1975), 84.

Some years ago, I spent a few months with a non-functioning candlestick telephone on my desk. Those who asked were told that I had brought the phone set there for the purposes of analysis—that, in fact, I was waiting for it to speak to me. While this is hardly uncharacteristic of human-telephone relations it did seem curious in my case, for I am notorious for having never liked "the telephone" (meaning telephones in general) at all. But I did like this one. I liked the dull black enamel of its finish, liked the resistance of its dial against my finger and the reassuring *click click click* of its return; I liked the phone set's overall stature and dignity, its heft and weight, its stability and calm; and I even liked that it was disconnected, not only because this guaranteed my control over the instrument (for no one could call me), but because it seemed an appropriate reminder of the decontextualization to which the object had been subject at the hands of time. Disconnection served to remind me of the phone set's challenge as well, for only an imaginative reconstruction would suffice to reconnect it to the hidden network of affective responses by which its original, contextual meaning had been generated.[1]

Reprinted from *Technology in Society*, vol. 12, 1990, pp. 333–54, with permission from Elsevier Science.

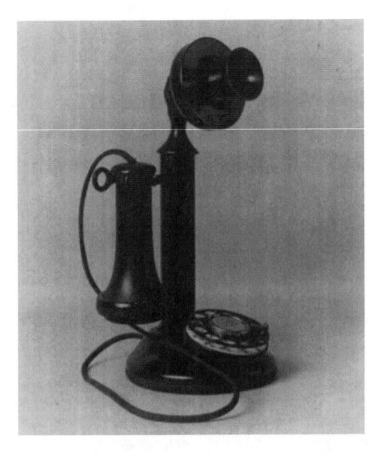

Fig. 4.1. 1923 Candlestick Telephone with dial. Property of AT&T Archives. Reprinted with permission of AT&T.

The black-enamel phone set, viewed frontally (Fig. 4.1), is composed of a transmitter (for speaking) and receiver (for listening), each separately joined to a vertical shaft, the transmitter to its top by an adjustable yoke and the receiver to its left side by the two prongs of the switchhook on which it rests and by a 27-inch cord. The shaft itself sets flush into a rounded base, bearing a circular dial. Exclusive of the subscriber set or bellbox which attaches to the wall at the end of a second 48-inch cord (Fig. 4.2), the ensemble measures almost a full foot in height and weighs well over five pounds. The substantial presence which results is owed in part to the generous use of brass in the phone set's construction but, as well, to the unassuming grandeur of its asymmetric silhouette.

Although mechanical and undeniably metallic, the instrument appeals immediately to the senses with the smooth contours of its modified

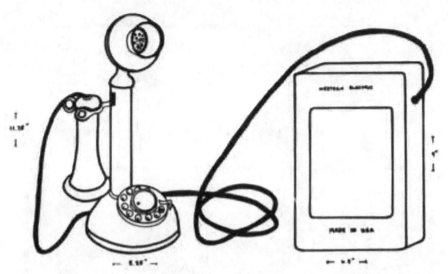

Fig. 4.2. 1923 Candlestick Telephone with dial and bellbox. Drawing by Cynthia Ott.

cylinders and spheres. There is in fact so unmistakable a visual communication among these forms that it seems proper to speak of a leitmotif of the curvilinear. The transmitter or mouthpiece, which is round, has at its center three concentric rings of circular perforations; the receiver is in its entirety a gracefully expanding cylinder; the switchhook culminates in two opposing circles; the shaft, which has a regular diameter, slips beneath the encompassing cap of the yoke above, and fits snugly into the enveloping swell of the base below; and the dial, formed of one rotating circular plate held fast above another, both round and turning round, is radially lined with ten numbered and lettered fingerholes, and inset with a phone number holder, also round.[2]

In the face of such apparent harmony of form, one discovers with astonishment that the phone set actually is composed of over two hundred independently tooled components manufactured out of dozens of raw materials. In addition to the brass, which is itself an alloy of zinc and copper, this elemental wealth includes rubber in the receiver, aluminum and shellac in the mouthpiece, cotton in the cord coverings, and wool in the felt pad underneath the base; silver, gold, and platinum in the contact points of springs, which are themselves composed of nickel; flax or muslin as linen paper in the transmitter; mica in the diaphragm, which contains granules of coal; both tin and lead as solder, asphalt in the finish, iron in the terminal and baseplate clamps and screws, and silk in the receiver cover and extension cord. If one adds the chemicals which would have run the battery, this amounts to a virtual inventory of the world commodity market at

Fig. 4.3. "What's in Your Telephone"—*AT&T Telephone Almanac* (1925).

the time the telephone was manufactured, including textiles, metals both precious and common, synthetics, minerals, and alloys (Fig. 4.3).[3]

Despite this variety of elements, the instrument manifests a remarkable stability and calm. Visual harmony is maintained, for one thing, by a seamlessness in the telephone's design. Contact points between components not manipulated in ordinary use are either understated, through the use of recessed screws (basepad to base) and soldering pins (yoke to shaft, shaft to base), or kept hidden altogether (dial to base, switchhook to shaft). Surface screws, where used, as in the dialstop, mouthpiece, yoke, and bellbox, have been placed unobtrusively. Minimizing the evidence of articulation has the effect of deflecting attention away from the telephone's mechanical complexity and towards its user interface, involving simpler and larger parts whose function is easily understood, such as the lift of the receiver, the turn of the dial, or, somewhat more subtly, the tilt of the transmitter on its yoke.

The telephone's interiority is a second factor in its external calm. The scientific apparatus or mechanism has been hidden inside. It is possible, however, to peer into the shaft between the transmitter and yoke; the aperture is tiny, but there, descending through the narrow metal tubing, snakes another cord. The receiver unscrews, affording one a glimpse of still more cords, narrower this time and attached to copper clamps. These depths

exert a fascination, surrender to which is heightened by suggestions of an almost corporeal violation. Of importance here is not so much the detail of what can be seen as the fact that one is simultaneously discouraged from looking and tempted to look; not the content to be analyzed, but the fact of content. The telephone is hollow—to its public presence, there corresponds an inner world.

This hint at physiology is an interpretive clue of importance leading one to recognize the human form in the phone set's containment of complex and fragile inner works within a shell suggestively organic in both contour and configuration. This bodily presence of the instrument, though underplayed, works out in anatomical detail, with the transmitter as mouth or eye (both synecdoches for head), the yoke as neck, the switchhook as uplifted arm, the shaft as torso, the receiver as both hand and ear, the dial as genitals and phonecord aperture as anus, set into the belly of the base. The base performs the role of belly in literal as well as formal terms. While the transmitter, receiver, yoke, and shaft all contain their share of electronics, it is the base which contains the phone set's metaphoric guts, its bellyload of rubber-insulated wires, dialing mechanism, copper plate mounts, and screws.

Not only in their placement but also in their range of mobility, certain of the phone set's elements explicitly support this personification. The articulation of the yoke, for instance, has been circumscribed so as to limit the transmitter's movement to two fixed positions, both of which face the mouthpiece forward. The switchhook also has been limited to two positions, either held down horizontally or inclined upward 20 degrees when released. These limitations echo, or rather caricature, the articulation of the human neck and shoulder.

These examples, involving the dynamics of human encounter as well as static form, raise the question of where and how the phone would have been used. In this essay, I choose to discuss the phone set as it was typically found—in the middle-class home.[4] The felt pad underneath the base, allowing for easy sliding back and forth without damage to a surface, seems to argue for a tabletop or desk location. The deployment of the bellbox, to be screwed into a wall, supports this reconstruction: I deduce from its relative inelegance and the restriction of its 4-foot tether that the wall of preference would most likely have been both behind the phone set and beneath it, out of sight. A user's principal interaction, then, was with the phone set itself, although the cord, a brown textile umbilical reminder of the hidden bellbox, would have reached out connecting the two. The likelihood of one's sitting as opposed to standing when making a call depended in part on the nature of the room in which the telephone was placed. The yoke in any case affords a certain flexibility, adjusting up for standing and

down for sitting, although the former would almost certainly involve lifting the entire set for effective use.

The dynamics of encounter in this way both determine and are generated by one's physical relation to the phone. One engages the instrument with hands, eyes, and ears. No sooner is the phone set encountered than a hand goes out to fondle the receiver or spin the dial. The instrument's exterior is hard and smooth. Its swelling, rounded contours lure and gratify the hand. Though not quite yielding, every surface is responsive; if not quite warm, every surface warms to the touch. This touch need not be hesitant or fumbling. Unambiguous design directs both hands into position, and provides them necessary business to accomplish there. The weight of brass is critically important to this sense of clarity and ritual. The telephone's every feature is substantial; heft commands respect.

When the phone set is at rest, its horizontal and vertical axes come into alignment, receiver and shaft parallel and switchhook at right angles to both, a configuration suggestive of stasis and stability. When the receiver is lifted, however, visual symmetry is disrupted. The switchhook springs upwards, empty-handed, in a mock salute—animation signifying use.[5]

Dialing would require that one insert a finger of the right hand into labeled circular holes sequentially, first moving the finger and the mechanism through a clockwise arc, and then releasing to allow the dialface to return.[6] One's pleasure at this touch is multiple, deriving from the game of playing with a wheel but also from the firm vibration of resistance offered and the inevitability of the dial's return—a tension and release caused by the winding of a spring which relaxes when one's finger is withdrawn.[7] Like the up-down opening and closing of the switchhook, also activated by a spring, this movement, in responding to one's gestures directly and predictably, provides a satisfying reassurance that the phone set is in one's control. It is one's touch which lends the phone set its mobility. It visits for one—a point made clear in later advertising and cliché: the fingers do the walking, accessing the phone.

Such visits at a distance are the magic that a telephone performs, a magic both made plausible and dramatized to the user through a process of surrogacy or displacement. One is not alone or speaking to oneself; the instrument, "like" a human figure, stands before one's eyes, responding to one's gestures, listening with its own ear. The phone set stands in symbolically for those to whom one speaks. Its gaze naturalizes (and rationalizes) the apparent solipsism of conversation with an absent other. The essence of this surrogacy is that it is symbolic rather than literal, and largely unconscious. The phone set's form serves to compensate for what telephony itself cannot provide, or can provide only in metaphor.

Absence becomes presence. The transmitter one stands before and into which one speaks is both a functional metaphor, an ear, and a symbolic one, an eye—which like the switchboard never closes. Through transmitted speech, periscopic vision is obtained: vision around. One is seen as well as heard, seen by *being* heard. This conflation of symbolic sight and actual sound, a condensation of the experience of telephone use, anchors one in physical reality while freeing the imagination. The ear trumpet design of the receiver similarly bridges a gap of unfamiliarity through metaphor, amplifying transmission by association.[8] To use the phone is to embrace one's circumstantial blindness—synesthetically to hear with the aid of the phone set rather than to see, to make contact with a person at a distance through symbolic contact with the telephone itself.

To dial is to engage in a form of ritual foreplay, a preliminary touch with the fingertips reminiscent of the social rituals of handshake or caress.[9] The sensuality in this full or thick engagement of the phone set's body with one's own—the insertion of a finger and the spinning of its dial, the face to face contact with the transmitter, the answer of its hand (or switchhook) to one's hand at the receiver—provides a needed reassurance that this form of human contact is not entirely dissimilar to more traditional encounters. When one is at the telephone, only the dial requires one's attention. One sees not what confronts one in the here and now, but rather one's anticipation of an interlocutor's response, conjured up in its form (and our gesture) by the telephone itself. Anticipation harnesses imagination. The process is subliminal, its efficacy guaranteed by telephony's own magic: the reembodiment of the disembodied voice.

The telephone's inner and outer surfaces are covered with inscriptions, several dozen in all. In some cases these are cast into the metal, in others mechanically engraved. According to these inscriptions, almost the entire instrument under consideration was produced by Western Electric, the Bell System's official manufacturing unit and principal supplier. From the registration or patent years marked on individual components (which run from August 1912 through October 1921) in combination with the presence of a dial, an indication of automatic switching,[10] the phone set can be dated to 1923 or thereabouts.

Instances of the inroads of science into ordinary life in the form of appliances in 1923 could be counted on the fingers of one hand; and while the telephone as an idea may well have been common, as a device it was by no means ordinary.[11] The phone set in fact came to serve as a popular symbol of advances in American technology—a symbolism which, if not exactly invented by the telephone's promoters, was certainly made much of

in company advertising. As a result, the intellectual and emotional response to telephones involved ambivalent feelings about progress and modernity in general. Signs of this ambivalence are present in the phone's design itself, as I will show below.

For the industry, the early twenties was a period of explosive growth.[12] The Bell System by 1925 operated 71 percent of all the telephones in the United States. The number of phone sets that the company owned or controlled rose from one million in 1900 to five million in 1910, seven million in 1920, and nearly seventeen million by the end of the decade.[13] The East and West coasts had been linked since 1915, the same year wireless transmission brought Europe within reach. By 1925, fifty million domestic calls were being made daily, which came to over twenty-two billion calls annually, and nearly two hundred calls per capita.[14]

The nation's twenty-five hundred local directories, which listed name, business designation, address, and phone number, served increasingly as commercial guides.[15] In many places "Time" and "Information" service was available. A study by the Acoustical Society of America found that people were friendlier and more immediate on the telephone than they were in writing. "Telephone English," the report concluded, "is simple, direct, unselfconscious, and unqualified."[16] Some claimed the telephone had freed social relations at last from the limitations of the neighborhood—a veritable "victory over space and time."[17]

The dial, however, was not yet a common feature of telephones in the early twenties. There were dials on only one out of eight phone sets in the United States in 1925, and as late as the Depression this standing had only improved to one phone out of four.[18] The novelty of a first encounter with the new technology is easy to recognize in the tone of articles written throughout the decade. "To those who are not familiar with the dial," one account began, "the simplicity of its use may be surprising."[19] Diagrams and advice were provided by the U.S. Department of Commerce in a Bureau of Standards circular published in 1921.[20] Subscribers were reassured they would receive complete instructions in the mail, and that personal demonstrations could be arranged.[21]

The dial meant automation. With its introduction an important human element was eliminated from telephone communication. The *New York Times* described the new technology suggestively, noting in an editorial in 1922 that soon "connections [would be made] by machinery instead of girls."[22] This use of the term "connections," though a technical one here, seems in hindsight freighted with ironic weight. Actual human contact, already mechanized by manual switching, was now abstracted further still through the elimination of even a disembodied human interface.

All operators had been male until the 1880s, but women were preferred thereafter on the grounds of their supposedly superior "dexterity, patience, and forbearance." In reality, women could be made to work for wages as much as 50 percent lower than those paid to men.[23] In 1917, on the eve of nationalization, women represented fully two thirds of the company's wartime workforce; and in 1923, following broad commercial introduction of the dial, 40 percent of Bell's employees and nearly 100 percent of its remaining operators were women. These operators, their average age nineteen, were the "girls" soon to be replaced with machinery—one dial switchboard operator could do the work that it had taken six to do before.

The *New York Times* editorial went on to predict that within a decade no calls made within the metropolitan area would involve any human contact whatsoever. Operators themselves would all be "made of brass or steel." Attempts were made to naturalize this somewhat troubling, even cybernetic juxtaposition. One early model automatic telephone, for instance, was christened the Machine Girl.[24] This literal association of women with the telephone based on the operator's voice may be one explanation for the phone set's rounded figure and feminine lines. Consonance between phone set design and the gender of the voice inhabiting it, however, functioned as well to obscure the actual subservience of women in the workforce by means of a symbolic display of femininity.[25] Harmonious, organic lines and an anonymous female voice played their part in softening a technological transition, suggesting that intimacy in telephone communication might reside in a familiarity with the machine itself.

In actuality, telephone technology in general and automatic telephones in particular alienated intimacy as thoroughly as they ensured it. The elimination of face to face contact and the arrival of phone bills every month, demanding payment in cash for conversations sold as commodities, defined a new detachment in relations not only between subscribers and the phone company, but among subscribers themselves. This was only intensified by the elimination of most operator contact. Progressive depersonalization of telephone service may be said to have begun as early as the winter of 1879, when subscribers were first designated by number instead of by name.[26] Phone numbers were first introduced on a wide scale in the late teens and early twenties, a process described in a newspaper article with the revealing title "This Machine-Made World Conquers One More Rebel."[27]

Sociologists in the 1920s discerned already the effect the telephone was having on the patterns and the quality of social intercourse. The impersonality and fragmentation of contemporary life was linked to the telephone, which was seen as an accessory to large-scale industrialization and

urbanization.[28] The telephone was here understood not primarily as a machine but rather as a system or network of social and commercial relations. Its main contribution to modernity in this view had less to do with production per se than with the organization of bureaucracy.[29]

Nowhere was this depersonalization suggested so clearly as in popular cultural depictions of unhappy love involving the telephone, much in contrast to the industry's own rhetoric of interpersonal connectedness and satisfaction. A message of loneliness—epitomized in Dorothy Parker's 1930 monologue "A Telephone Call"[30]—countered the optimism of executives and engineers: a woman waiting for a phone call from her lover pleads with God. The irony in Parker's title (for the phone call never comes) is evidence of the telephone's new role in the production of anxiety. An absent lover's silence is transmogrified into a telephone's blank stare and refusal to ring; a woman's pleas, ostensibly to God, are to her telephone instead.

Although some have argued that the telephone greatly added to privacy—one historian notes that it was no longer acceptable to drop in on people without warning them[31]—the opposite case, that one could suddenly no longer be alone, seems better supported by the evidence. If one could call anyone, one could be called by anyone as well. After considering the side effects of dialing, which ranged from prank phone calls to busy signals and wrong numbers, a journalist in 1925 concluded that the only adequate defense against intrusion would be psychological.[32]

In this respect the telephone's cold, shrill, insistent ringing seems its most characteristic feature. The instrument, seen to serve as the agent or animate of anyone seeking one's attention, was in this sense not a passive technology at all. Intrusiveness was made the subject of an unhappy *Chicago Tribune* editorial in 1925. "The telephone rings," the text began. "It is preemptory in its demand for attention. Perhaps no call or sound in the world is more impersonally preemptory."[33] At least one, perhaps unusually maladjusted Wall Street broker of the day would have agreed, but hardly sympathized. "The telephone," he told a *New York Times* reporter that same year, "breaks in on the work of a busy office, interrupts thought, and so is really a time destroyer instead of a time saver."[34]

In light of the globally positive impact of the telephone on business, such complaints in an office setting may have seemed beside the point, and could in any case be dealt with through a rearrangement of secretarial responsibilities to shield "important" persons from disruption. In the home, on the other hand, the phone set's presence within a family space exclusionary and private by definition heralded a shift in orientation outward. The ringing of the telephone announced the arrival of a human presence at the purlieus of the home, and, like the ringing of the doorbell,

offered one a choice: to answer or not to answer; to open up the home or to maintain its insularity. Despite these similarities, answering a door and answering a telephone differed fundamentally in their symbolic import. The phone, "a quasi-human presence" as one writer put it in 1924,[35] already stood across the threshold. This might be termed its Trojan Horse effect. Home had previously been defined by who was not allowed to enter as much as by who belonged; but now the enemy, potentially, had been invited within the gates.

This "irreverence for privacy" was dramatized in 1920 in "Telephone Terror," an anonymous essay whose author confessed that, while some had the courage to deal with "such a furtive tyrant" as the telephone, he for one had not. "I let it bully me," he wrote, exaggerating for effect. "I am its slave, and so I hate and fear it."[36] On his seventy-fifth birthday in 1922 (the day before he died), Alexander Graham Bell revealed a scandalously similar prejudice, making headline news: for reasons of privacy he would never consent to have a telephone near his study.[37]

When a conversation *was* desired, privacy could be an unreliable commodity. Before the advent of dialing, operators had been a regular and acknowledged presence on the line; and, as late as 1929, party lines were still the rule.[38] Symptomatic of the problem were laws passed after World War I making it illegal for company employees to divulge information that they overheard.[39] Nor was cooperation with the Justice Department long in coming—in 1925, and every year thereafter, wiretapping was to have its own subject heading in the *New York Times* Index.[40]

Not only was the telephone a doorway through which anyone might enter, it was one neither owned nor fully controlled by the people who used it and which represented obligation (the word chosen by phone company and Commerce Department officials alike in describing the relationship) as well as expense. Subscribers were to "properly care for the company's property." It was to be "safeguarded against mechanical injury" and "kept clean." Company officials were to be allowed reasonable access.[41] Articles in newspapers and magazines stressed the way a phone set should and should not be used. It worked best on a level surface. Wet umbrellas against the phonecords caused shorts. Animals caused other trouble, as did teething infants. In giving one's name, one was to speak in a low and well-modulated voice. One was not to tap one's pencil against the transmitter.[42] The *New York Times* in 1923 reported with dismay how few companies provided their employees written instructions concerning the telephone's "proper" use, and suggested nineteen rules.[43]

The design of the candlestick phone set served to soften the effects of and to humanize this new and disruptive, "preemptory" technology. The

need for two hands sensualized use; rounded edges and a vaguely human form restored to mediated discourse an immediacy which had otherwise been lost. The *New York Times* made this stylistic metaphor explicit in 1922 when it noted that the instrument was "almost human."[44] The correspondence of its parts to human body parts, though stylized, was crucial; sympathy (and perhaps complicity) was won through the illusion that one spoke *to* the machine instead of *through* it. Eye, ear, and hand associations metaphorically connected an alienated ritual with traditional ones, and language appropriately played its part. The receiver, for instance, was

Fig. 4.4. 1900 Wall Telephone. Courtesy of John Dommers.

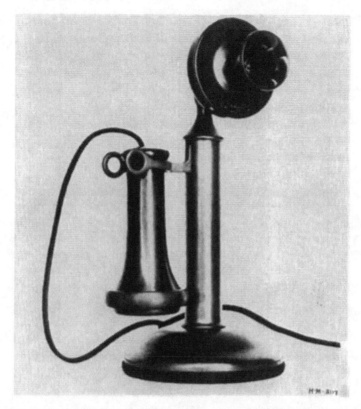

Fig. 4.5. 1919 Candlestick Telephone. Courtesy of John Dommers.

known popularly as the butterstamp, due to its form of course but with undeniable connotations of the pastoral and the familiar.[45] The term candlestick, with its reassuring suggestions of warmth and ceremonial light, lent the telephone an aura of sanctity.

The electric apparatus which constituted the telephone's functional core came to be housed in the candlestick form only over a period of time.[46] First came the wall telephone (Fig. 4.4), a rectangular box with transmitter and receiver mounted on the outside, containing most other elements within. An extraordinary although somewhat crude human resemblance was to be noted. Where the wallphone was purely functional, the creation of inventors and engineers faced with a scientific problem, the form of its successor, the deskstand or candlestick phone, was dictated by commercial rather than by strictly technical concerns. It was therefore the first self-conscious telephone design, one based in large part on its makers' psychological and emotional intuitions (Fig. 4.5).[47] More convenient than the wallphone, which was fixed in place and difficult for people of different heights to use, the

new improved experimental model was first fitted with an angular trans-
mitter adjustment (or yoke) in 1891, a tubular support (or shaft) in 1892, a
felt-covered base in 1894, and a pronged switchhook in 1897. In order to
keep the device small enough for practical use, its speech circuit and ringer
were housed separately in a subscriber set or bellbox; and, with the advent
of automatic switching, a dial was mounted in its base.

In its day, the candlestick's humanlike appearance and omniscient eye
lent presence to a room. It signified progress; science itself spoke through
the apparatus, mysterious and powerful. As networks spread and tele-

Fig. 4.6. Telephone Cabinet—"Concealing the Unsightly Telephone,"
Courtesy *House and Garden* 44 (December 1923): 64.

phones grew more common, this initial glamour gradually wore off. There is evidence, in fact, that the same features which made the style adaptive initially gradually grew counterproductive over time.

It became fashionable to hide the phone set away. "There is only one thing to do with the telephone," wrote *House and Garden* as early as 1923: "conceal it."[48] Among the devices used to this end were specially built cabinets (Fig. 4.6) and hollow boudoir dolls (Fig. 4.7). Use of the latter in particular served to underscore the foetal nature of the phone set, its status as a small person, and the umbilical nature of its cord. Such behavior seems to suggest desire to deny the phone set's birth, the wish that Ma Bell's problematic progeny be swallowed back into its corporate invisibility, significantly an expression of distrust as well as distaste. At the same time, to conceal the instrument in any of the commercial "hide-a-phones" available was to become oneself the midwife to one's conversations, in a sense to reassert oneself against the mediation of technology through fairy-tale flourishes of decor.

The model which replaced the candlestick, introduced in 1927 as the French Phone (Fig. 4.8), was something else again—more compact, less visible, and very differently elegant. Its innovation was to combine the trans-

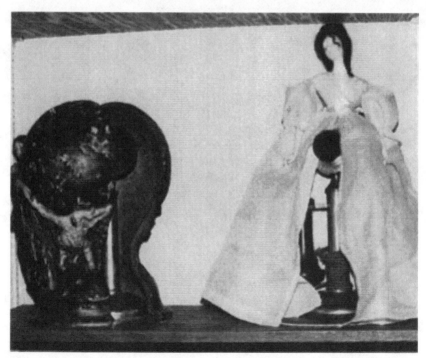

Fig. 4.7. Globe and Doll Hide-a-Phones. Courtesy of John Dommers.

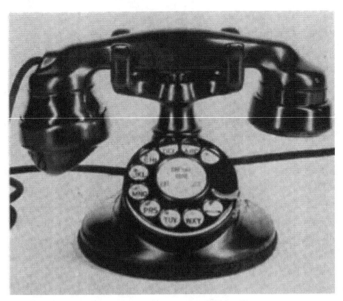

Fig. 4.8. 1928 French Telephone. Courtesy of John Dommers.

mitter and receiver together, eliminating all suggestion of verticality or human form.[49] Whereas the two-part receiver and transmitter of the candlestick obliged one to confront the phone set's body face to face, the handset of the new French phone was held invisibly beside the head, depriving the imagination of all figural grounding.[50]

In its day, the candlestick was multifunctional. Its transmitter served to convert speech waves into electrical analogs and its receiver to convert them back again; its dial initiated signals to direct routing and switching, and its bellbox alerted one to the fact of a call. Because these elements constituted the network's sole user interface, they were of necessity designed to be compatible with human requirements—some functional, others emotional and psychological. This makes the model more susceptible to psychocultural than to purely functional analysis.

The phone set's meaning resides in its style, and its style played an active role in modulating popular response to how the world had changed as a result of its existence, to other changes that this one change symbolized. Predictably, reactions were not uniform but mixed. The phone meant contact with a wider universe, yet at the cost of privacy. Its dial in particular gave one autonomy, but at the price of becoming a number, no longer a name. Evidence of this ambiguity is discernible in the candlestick's design. Its human form lays claims to personhood, and yet its dial serves

to remind one of its function based on coded abstraction. The substantial weight of its crafted brass serves to ground the phone set in the very "here" it functioned to transcend.[51]

The formal division in the candlestick's design between phone set and bellbox suggests a deeper significance, one involving tension between what the telephone was imagined to do and what it actually did. As I have tried to demonstrate, one's relation to the phone set is primarily figural. Its calming contours and surrogate presence represent telecommunication to one magically as warm, unmediated, sensualized contact. The stylistic austerity of the bellbox, on the other hand, accords well with its more literal function, which also involves contact but this time electrical and physical, not metaphysical in nature.

That the phone set was left visible, at least at first, and the bellbox kept out of sight, speaks to a tension which existed between reality and dream. A phone call, in actuality dependent on a subterranean (for phone lines disappeared into the walls and floor), hence metaphorically mysterious and dangerous connection, was experienced in large part as unmediated and as not contingent through the work of the imagination, a process facilitated by the telephone's design. Similar tension can be read into the pairing of the telephone's two cords, one (the receiver line) visible, serving to link the voice one hears back into the phone set's reassuring form; the other, an "outside" connection to the bellbox, remaining hidden behind and below, a link to and reminder of the actual facts of absence, of mediation, and of disconnection.

As architectural historian David Handlin has pointed out, telephone lines, like water pipes, electrical cables, sewage systems, hot-air ducts, and gas mains, though they destroyed a household's isolation, were yet objects of suspicion. They "disrupted age-old relationships and brought people into contact with one another in ways that they were not accustomed to or did not understand." The very nature of these lines, invisible and indeterminate, intensified ambivalence. "Every utility that entered or was part of the home," Handlin notes, "at some time was thought to be a source of danger."[52] In the case of the candlestick phone set, anxiety was held at bay by means of style and design. Form provided reassurance, through organic contour and suggestions of familiar ritual, that touch was possible, even at a distance.

NOTES

1. I want to acknowledge the assistance of Ethel Burke and George Anastasion of Southern New England Telephone; David Fletcher of New Haven's Long Wharf Theatre; and most especially John J. Dommers, author of *The Telephone Connection: A Guide to the Identification of Old Telephones* (Madison, Conn.:

Sachem Press, 1983), who entrusted me with one of his prized phone sets for longer than either of us could have expected. My thanks to Joseph Lebensfeld for his thoughtful reading of the manuscript.

2. The bellbox in comparison to the phone set proper is visually silent. Here lyric circularity has yielded to the anonymity of quadrilateral expanse, attenuated only by rounded corners which are to the eye only a partial and inconclusive transformation of rectangular cube to sphere.

3. The telephone was in its very composition both the symbol and the product of a new world order in which hierarchies of industrial power had been globalized. The telephone's raw materials were the spoils of an international exchange with economic and political ramifications exactly as far reaching as the phone lines themselves. Zinc and silver were shipped from Canada, Mexico, Australia, and the western United States; cotton from Egypt and the South; gold from Alaska; platinum from Colombia; aluminum from Canada; flax from Ireland; nickel from Ontario, Oregon, and North Carolina; mica and shellac from India; tin from the Dutch East Indies; asphalt from Trinidad; iron from Norway and Sweden; silk and muslin from China and Japan; rubber from Brazil, Bolivia, Africa, the Dutch East Indies, Java, and Borneo (see Fig. 4.3). In the industry's own words, "all the world" contributed to every manufacture (*Bell Telephone Almanac*, 1925).

4. In 1925, a year for which national statistics are available, as many as 60 percent of all telephones in the United States were residential, and some 39 percent of households owned at least one phone (although only 13 percent of these were equipped with dials). Bell Telephone Laboratories, *The Early Years (1875–1925)*, volume II of *A History of Engineering and Science in the Bell System*, ed. M. D. Fagen (1975), 1004. A wide variety of articles and ads appeared in magazines and newspapers throughout the decade, aimed mostly at the well-to-do, concerning the phone set's best use and optimal location. See for instance "Talking Points in the Home," a 1923 series in *House and Garden*, with its focus on candlestick phone sets equipped with dials.

5. In old candlestick models, flicking the now liberated switchhook up and down several times would have served to bring an operator onto the line.

6. One may deduce from the disposition of the phone set's elements with the receiver to the left that this model, as virtually all others, was designed with right-handed persons in mind.

7. "The return rotation was limited to a moderate speed by an escapement mechanism and, during the return, the required number of circuit interruptions took place to control the central-office switches" (*The Early Years*, 124).

8. This is not coincidental; Alexander Graham Bell (1847–1922), who invented the telephone in 1876, had originally been a teacher of the deaf.

9. See Erving Goffman, "On Face Work: An Analysis of Ritual Elements in Social Interaction" in his *Interaction Ritual: Essays in Face to Face Behavior* (New York: Pantheon, 1982), 5–45.

10. Automatic switching came to Southern New England, where this phone set originated, only late in 1922. Reuel A. Benson, Jr., "The First Century of the Telephone in Connecticut" (Southern New England Telephone Company, 1978), 15.

11. For an early account of the enormous cultural and social impact of the telephone, see J. Ellis Barker, "The American Telephone and Its Lesson," *Quarterly Review* [London] 236 (October 1921): 308–21. For more recent discussion, see any of the essays in *The Social Impact of the Telephone*, ed. Ithiel de Sola Pool (Cambridge: MIT Press, 1977), or Joshua Meyrowitz, *No Sense of Place: The Impact of Electronic Media On Social Behavior* (New York: Oxford University Press, 1985).

12. See William Chauncey Langdon, "The Early Corporate Development of the Telephone," *Bell Telephone Quarterly* 2 (July 1923); John Brooks, *Telephones: The First Hundred Years* (New York: Harper and Row, 1975); and Claude S. Fischer, "'Touch Someone': The Telephone Industry Discovers Sociability," *Technology and Culture* 29 (1988): 32–61.

13. *The Early Years*, 1004 (Fig. P-1), 1007 (Fig. P-4).

14. Ibid., 1004–5 (Figs. P-1 and P-2).

15. "The Telephone Directory," *Bell Telephone Quarterly* 2 (July 1923).

16. In a survey commissioned by the Bell System, five hundred conversations yielded a total of eighty thousand recorded words. There were no nouns among the twenty-five most frequently recorded, and only three among the top fifty: "day," "thing," and "morning." More significantly, or so those who ran the survey thought, the two most common words spoken were "I" and "you" (as opposed to "the" and "of" in similar studies done of written English). "Telephone Talkers Use A Limited Vocabulary," *New York Times* (7 July 1929): Section IX, 10.

17. Gelett Burgess, *The Romance of the Commonplace* (Indianapolis: Bobbs-Merrill, 1916), 153–58. "A telephone exchange is a radical rearrangement of social space. It brings any two speakers together on demand, regardless of where they are located. By thus collapsing social space, it also vastly expands its scale, making millions of people who would otherwise be inaccessible to each other capable of instant, real-time conversation." Milton Mueller, "The Switchboard Problem: Scale, Signaling, and Organization in Manual Telephone Switching, 1877–1897," *Technology and Culture* 30 (July 1989): 534.

18. The first dial telephones with fingerwheels had been installed in Milwaukee's City Hall and at Albion, New York in 1896. Bell initiated its own automatic dialing development only after many independents had grown successful at it, and early competition was tremendous despite consolidations during the First World War. The Automatic Electric Company of Chicago, for instance, advertised in the trade journal *Telephony* as late as 1921 that "the extremely heavy demand [for its] dials ha[d] made it possible for the Company to more than double its facilities for manufacturing them." *Telephony* 81 (31 December 1921): 20. By the early to mid-twenties, despite the late start, the number of Bell dials in service came to exceed that of all the independents together. (Bell Telephone Laboratories, *Switching Technology, 1925–1979*, volume 3 of *A History of Engineering and Science in the Bell System* [1982], ed. M. D. Fagen, 8.) "Already, from the standpoint of numbers alone," declared the *Southern Telephone News* in October 1928, "the dial is one of the most important means for furnishing telephone service in this country." Cited in C. E. Dean, "The Back of A Telephone Dial," *Literary Digest* 99 (3 November 1928): 25. Manufacturing output by the fall of 1928 was over 750 thousand dials per year.

19. Dean, "The Back of A Telephone Dial," 25.

20. *Telephone Service, U.S. Bureau of Standards Circular* No. 112 (24 June 1921): 97.

21. "Dial Phones Nearly Ready," *New York Times* (3 August 1922): 14.

22. "Automatic Phones Start Saturday," *New York Times* (8 October 1922): Editorial Section, 1.

23. In 1915 a field investigator from the U.S. Commission on Industrial Relations attributed the unusually high incidence of nervous breakdowns among these operators to rigid discipline and strain. See Brenda Maddox, "Women and the Switchboard," in de Sola Pool, ed., 262–80.

24. Emory Lundquist, "The Invention and Development of the Dial Telephone: The Contribution of Three Lindsborg Inventors," *Kansas Historical Quarterly* 23 (spring 1957): reprint edition, 7.

25. The persona of Ma Bell comes to mind. For a discussion of corporate and other institutional use of such pseudo-maternal imagery, see Marshall McLuhan, *The Mechanical Bride: Folklore of Industrial Man* (New York: Vanguard Press, 1951). The linguist Edward Sapir, in his 1924 essay "Culture, Genuine and Spurious" (reprinted in *Culture, Language, and Personality*, ed. David Goodman Mandelbaum [Berkeley: University of California Press, 1961], 92), noted that "[t]he telephone girl who lends her capacities, during the greater part of the living day, to the manipulation of a technical routine that has an eventually high efficiency value but that answers to no spiritual needs of her own is an appalling sacrifice to civilization."

26. AT&T, *Events in Telecommunications History* (1978). The move was made in Lowell, Massachusetts, during a measles epidemic which threatened to paralyze the phone service. Every subscriber was assigned a number "to make it easier if substitute operators had to be called in." *SNET* [*Southern New England Telephone*] *News* (July 1988): 4. Managers feared the public might take the practice as an indignity, and there is no reason to believe that some did not. A recent historian argues that the company's decision to go automatic was opposed internally, as well, because it violated the principle of "user transparency," that in order to popularize telephone technology making a call should require as little knowledge and intelligence as possible. Mueller, "The Switchboard Problem," 544, 558.

27. "A square envelope comes in the mail . . . Inside is a card, and on the card is printed: My telephone number is ———." *New York Times* (13 July 1924): Section VII, 3.

28. Aronson, 161; see also Ithiel de Sola Pool, "The Social Effects of the Telephone" in his *The Telephone's First Century—and Beyond* (New York: Thomas Y. Crowell, 1977), 12.

29. Colin Cherry, "The Telephone System: Creator of Mobility and Social Change," in de Sola Pool, ed., 112–26.

30. Dorothy Parker, "A Telephone Call," first published in *Laments For the Living* (New York: The Viking Press, 1930), 101–12.

31. de Sola Pool, "The Social Effects of the Telephone," 18.

32. "Ourselves Alone," *New York Times* (13 June 1925): 14.

33. "Telephone Discourtesy," *Chicago Tribune* (17 June 1925): 312. Sociological studies of this phenomenon have concluded that most individuals will almost compulsively answer a ringing telephone. See Henry M. Boettinger, "Our Sixth-and-A-Half Sense," in de Sola Pool, ed., 202. Avital Ronell, *The Telephone Book: Technology, Schizophrenia, Electric Speech* (Lincoln: University of Nebraska Press, 1990), opens suggestively: "And yet, you're saying yes, almost automatically, suddenly, sometimes irreversibly." More recently, see Christina Duff, "Pick Up On This: Just Don't Answer, Let Freedom Ring," *Wall Street Journal* (14 January 1998): A1.

34. "Dealer in Wall Street 41 Years Has No Phone: Among First Users Here, But It Annoyed Him," *New York Times* (20 December 1925): 7.

35. Brooks, *Telephones The First Hundred Years*, 174.

36. "Telephone Terror," *Atlantic Monthly* 25 (February 1920): 279.

37. "No Phone in Bell's Study," *New York Times* (4 March 1922): 14. Another Bell System survey found that for older people the sound of a ringing telephone was most frequently experienced as unpleasant. "For those born before 1920, the telephone is still and always will be an intrusion" (cited in Martin Mayer, "The Telephone and the Uses of Time," in de Sola Pool, ed., 232).

38. Sixty-four percent in 1929. *The Early Years*, 1004.

39. "Information . . . passed over telephone lines," subscribers were informed in 1921 under the rubric SECRECY, "is unquestionably the private property of the users of the telephone and is so regarded." *Bureau of Standards Circular* no. 112, 178.

40. The immediate rationale for this explosion of legal wiretapping was difficulty in enforcing Prohibition.

41. *Bureau of Standards Circular* no. 112, 185.

42. "Chase Troubles Away From Your Telephone," *Illustrated World* 31 (April 1919): 271–3.

43. "Finds Telephone Instructions Needed," *New York Times* (2 December 1923): XI, 13.

44. "Automatic Phones Start Saturday," 3.

45. Butterstamps themselves were wooden devices with an incised design on top, used to mold butter sold in bulk into round pats. The term butterstamp receiver technically applies only to the earliest model of handheld electro-acoustic converter cased in wood, discontinued after 1877. The name, however, stuck, and was informally retained with reference to smaller hard rubber receivers in later years. *The Early Years*, 89 n. 19.

46. *The Early Years*, 44. In the 1890s, Bell Laboratories instituted what was for its day a highly innovative approach to product development. Competing teams of design engineers devoted themselves strictly to research. An Apparatus Design Division was formed in 1911.

47. This development was discussed in 1915 by Frank B. Jewett, Assistant Chief Engineer at Western Electric, before the Second Pan American Scientific Congress. See "Some Recent Developments in Telephony and Telegraphy," Smithsonian Institution *Annual Report* (1915), 489.

48. "Concealing the Unsightly Telephone," *House and Garden* 44 (December 1923): 65.

49. The basic idea of the one piece handset, with its obvious advantage of convenience, was not a new one, however. The earliest patents had been filed in 1877, and between 1890 and 1902 Western Electric produced three handset designs in limited quantities for the domestic market. After 1900, the handset became a staple of European sales, and a great many "French" phones were in fact manufactured in the United States for shipment abroad. *The Early Years*, 127–40.

50. Telephones today are more ubiquitous by far, come in all shapes and sizes, and play a commensurately greater and more invasive role in private life. The era of the candlestick appears in hindsight a privileged moment of connection, replaced since by the relatively greater anonymity of today's vaster, tremendously more complex telecommunications networks. That privacy remains the dominant concern in public response to telephones can be measured by continuing controversy over caller identification, call blocking, and call retrieval functions. Gary T. Marx, a professor of sociology at MIT engaged in research on technology and privacy, has argued: "Appropriately applied, new communications technology can serve the legitimate privacy and related interests of callers and receivers of calls." *New York Times* (31 August 1989): Letters to the Editor, "Dial 'P' for Privacy in New Phone Technology." The need to express such reassurance is suggestive of the volatility of public feeling. For personal accounts of the effects of changes in telephone technology on peoples' lives, see "Readers Write About the Telephone," *The Sun* 70 (January 1990): 24–9.

51. The phone set seems to survey the space of a room through one all-seeing eye, an impression reinforced by its probable location very near to or against a wall. Oracular in function as well, the telephone both gives and takes life by pronouncement, simplifying and complicating human relations enormously.

52. David Handlin, *The American Home: Architecture and Society, 1815–1915* (Boston: Little, Brown, 1979), 452–55.

Sara Laurel Holstein

Sewing and Sowing: Cultural Continuity in an Amish Quilt

MANY SCHOLARS HAVE noted that the richness of Amish quilts seems to be, if not in contradiction, at least in tension with the culture's non-worldly outlook. A "plain people," the Amish forbid fancy or individual dress, makeup, high art (anything not functional), and most forms of interior decoration. They emphasize frugality, simplicity, and restraint in all aspects of their life and material culture—except, one might argue, their quilts. The high quality fabric, the vibrancy of color and its bold combinations, and the fine stitching emphasize the materiality of these objects. These physical details do not enhance the usefulness of the quilts and thus cannot be justified under the rubric of utility, making these quilts difficult for observers to place comfortably within Amish society. This tension is also perceived by some Amish, the most conservative among whom produce single color or dark-colored quilts, viewing other patterns as too worldly. Writers have posited various explanations, from the artistic—quilts are "the struggle to achieve aesthetic perfection within predetermined boundaries"[1]—to the psychological—"the quilts constitute a bold statement of independence from the tedium of earthly existence"[2]—to the practical—the Amish make their undergarments out of these same fabrics.[3] I will not attempt to find an explanation for this seeming contradiction; rather, I suggest that, given the time and effort Amish women devote to their quilting and the importance of these objects as indicated by this effort and the fine fabrics employed, these quilts present sites rich in cultural meaning and investment. Where other scholars have tried to understand Amish society through field work, historical studies, and quantitative analysis, I attempt to discover and evaluate elements of the Amish culture through a close reading of one of its quilts. This process offers insight into basic social beliefs that shaped both the maker and the object. In this essay I will

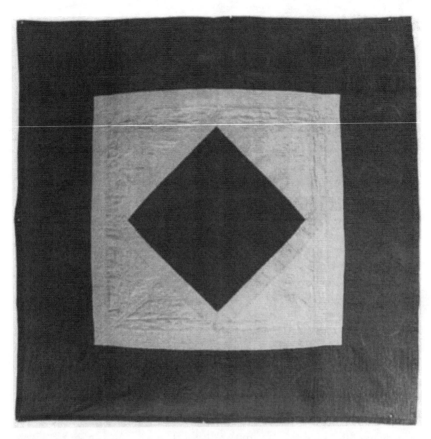

Fig. 5.1. Amish quilt (central diamond style). Private collection.

propose various metaphorical interpretations of the quilt design. These multiple readings reinforce one another, building a stronger statement of Amish values with every layer. While the initial postulations may conform to previous scholarship, ultimately the interpretive apparatus employed here allows an understanding of Amish culture not previously reached by more conventional forms of study.

The quilt under investigation, a Lancaster County, Pennsylvania, example made between approximately 1910 and 1915, consists of a large square within which rests a diamond, the whole centered in the larger square of the quilt itself (Fig. 5.1). This design is known as a central-diamond style. A 1-inch border of dark blue encircles the perimeter of the quilt, while 3-inch light purple borders enclose both the inner square and the diamond. Red fabric composes the diamond as well as the outermost square; bright turquoise makes up the inner square, which actually consists

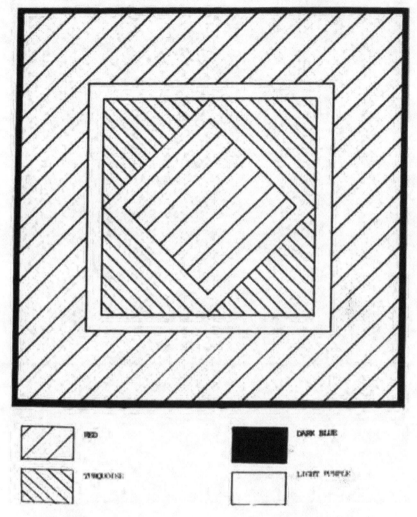

Fig. 5.2. Schematic drawing of Fig. 5.1, indicating colors.

of four equal right triangles whose hypotenuses form the boundary of the inner diamond (Fig. 5.2).

The quilting—stitching that connects the front and back sides and secures the thin batting between them—forms long garland vines, daisies, roses, and tulips, six and eight pointed stars and geometric designs (Figs. 5.3 and 5.4). The garlands curl in symmetrical patterns throughout the outer red area and form a wreath within the central diamond. A single rose flanked by a tulip on either side fills the turquoise area. Repeating geometric patterns of crossing lines and "pinwheel" shapes cover the purple borders, and six-pointed stars mark their corners. Daisies grace the corners

Sewing and Sowing: Cultural Continuity in an Amish Quilt 95

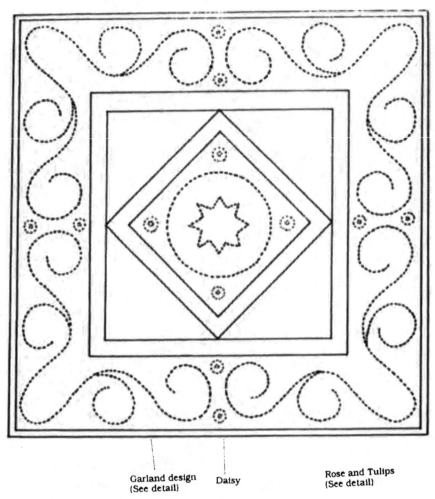

Garland design Daisy Rose and Tulips
(See detail) (See detail)

Fig. 5.3. Schematic drawing of Fig. 5.1, indicating pattern.

of the diamond and lie in pairs between the garlands in the center of each side on the outer portion of the quilt. Finally, a large eight-pointed star surrounded by six-pointed stars and encircled by the wreath dominates the center of the quilt.

Fine wool fabrics of various types—twill-woven batiste, diagonal weave, standard weave—make up this front side, while the back consists of a single piece of maroon and white patterned cotton flannel. While the quilting was done by hand, the seams are machine stitched. The quilting—approximately ten stitches to the inch—displays skill and care on the part of the maker.

The materials, the overall design, and the quilting motifs represent the traditional work of the Amish community in Lancaster County.[4] This quilt

Fig. 5.4. Details of Fig. 5.3: "Garland" and "Rose and Tulip" designs.

demonstrates that, although individual quilters made certain choices—color, whether or not to include corner squares, and the combination and placement of quilting motifs—tradition dictated the overall design and range of permissible elements. No aspect of this quilt breaks with accepted practice in Lancaster County. As such, this quilt must be viewed as both the vision of an individual woman who planned the design and as the product of an entire society.

That the quilt follows traditional patterns says much about the Amish. This design probably derives from late-eighteenth- or early-nineteenth-century English and American quilt patterns, though by the mid-nineteenth century other Americans had abandoned the central medallion-style quilt in favor of the repeated rows of the block-style quilt.[5] This quilt denotes a purposeful retention of an old design, one that remained consistent from the mid-eighteenth century, when the Amish first started quilting, to the mid-nineteenth century and continues as a primary model for personal quilts among the Amish today.

In a larger sense, the quilt represents a resistance to change in general. Indeed, one of the primary concerns guiding Amish communities in America has been the maintenance of their lifestyle and the rejection of most technical and social changes embraced by the rest of the country. As Joseph Downs proposed: "No other foreign nationality in America remained so homogenous or so faithful to its old-world customs and manners."[6] In their dress, religious services, and community and family structures, the Amish have altered their practices only slightly in their centuries in America.[7] According to Donald Kraybill, "[a]lthough the Amish carried the banner of reform at their origin, their accents on congregational discipline and church-world separation have fostered a traditional and conservative culture over the centuries."[8]

The American Amish emerged from the Anabaptist movement, the radical wing of the sixteenth-century Reformation in Europe. Anabaptist groups preached a literal reading of the Bible, rejected child baptism, demanded a separation of church and state, and sought reforms of the ethical and ceremonial practices of the Catholic and new Protestant churches. In 1693, members of a Swiss Anabaptist sect, led by Jakob Ammann, split with the movement in protest of a perceived relaxing of standards. Thus formed the Ammann-ish, later the Amish community.

Attempting to live a strict Christian life following Biblical teaching and the example of Jesus, the Amish reject "worldly" goods in favor of a simple and "plain" life. Their understanding of the Bible leads them to live separately from the world and to avoid contact with those who reject Jesus' teachings, as interpreted by the Amish.

Persecuted in Europe and drawn by economic opportunity, Amish families began emigrating to America in the eighteenth century, settling primarily in Pennsylvania, where many other German-speaking settlers also congregated.[9] Although not dissimilar from their neighbors in the colonial period, the non-worldly Amish quickly became a visibly separate community that consciously retained its traditional way of life and worship in a growing and changing America. Therefore, although the Amish exist within the larger American society, they have maintained an essentially separate and distinct culture. They do not refuse all change; rather, they are slow to change and make adaptations in their society only after careful consideration of the ultimate consequences. As Jonathan Holstein writes: "[i]t was not that the Amish were unaware of fashion, but that they chose in their quilts, as in all things, to consciously keep apart from the world, and to bear witness in this manner."[10]

Observing its basis in tradition reveals only the most obvious manner in which cultural values shaped this quilt design. An examination of the

formal elements of the design and the way they are structured yields richer insights into Amish societal beliefs.

The juxtaposition of organic motifs and geometric shapes presents one of the most striking aspects of the quilt. The geometric color blocks serve as frames for the stitched organic elements. The garlands and floral designs do not cross the borders of the individual geometric shapes; rather they respect the boundaries and remain enclosed within them. Thus, the outer red square contains daisies and an elaborate garland chain, the turquoise square contains the tulip and rose designs, and the inner diamond holds another garland and daisies. This configuration of geometric shapes containing organic forms suggests agricultural cultivation—that is, the division of land into parcels, usually geometric in shape, for farming or gardening. The crossing-line design on the purple borders which articulate the geometric areas reinforce this analogy, creating fence-like boundaries between the various planted areas. Although, as J. B. Jackson notes, the geometric nature of land division in the United States may not have been visually obvious until the advent of airplanes, the practice was well established by the eighteenth century.[11] I do not suggest a conscious adaptation of an agricultural model in the making of the quilt. That such similarities exist, however, underscores the importance of farming to the quiltmaker and her community.

The Amish have historically considered farming essential to the continuation of their way of life, and they practice intensive farming on small family farms, achieving consistently greater yields than non-Amish farmers through their energetic working of the soil. Although rising land costs have forced some contemporary Amish families to find other means of employment, between 1830 and 1950 the Amish farmed almost exclusively. Not only does farming necessitate hard work, a primary component of a virtuous life, it also allows a high degree of self-sufficiency and isolation from the greater society. Walter Kollmorgen, who studied the Lancaster County Amish as part of a federal government examination of rural life in the 1940s, concluded that not only is the Amish farmer:

> wedded to the land . . . by a deep and long tradition of good agricultural practices, but farming has also become one of the tenets of the Amish religion. A rural way of life is essential to these people so that their nonconformist practices may be perpetuated. Their desire to live on the land, and to live . . . separate from the world, has been an ever-present stimulus to good farming practices.[12]

On a basic level, farming provides a means of feeding oneself. In the cultivation of the land, one hopes to ensure the continued survival of the

family or community. As a cyclical activity, farming is a means by which humans participate in the processes of natural regeneration. It encompasses both the renewal of the land and the continuation of society. In the practice of farming, then, lies the concept of fertility, most obviously of the land but also of the humans who work it. Fertile ground provides sustenance for the people cultivating it, so that they may reproduce and achieve their full fertility potential. The quilt suggests such ideas.

The notion of fertility asserts itself in other aspects of the quilt as well. The bed is the site of human procreation, just as a flowerbed is the site of plant generation. Although quilts such as the one I am studying did not provide the primary bedding layer, they formed the top, decorative layer on Amish beds. This association with the location where reproduction takes place reinforces the implied fertility concerns presented by the planting metaphor. Indeed, the association of planting seeds and impregnation is a common metaphor. Following this reading, fertility, of both the land and the people, forms a central concern for the Amish woman who made this particular quilt and the culture that canonized the motifs.

Since the eighteenth century, Amish women in America have maintained a mean fertility rate of slightly over seven children, a rate consistently higher than that of the general population.[13] This higher birthrate indicates that childbearing was a priority within Amish society. Moreover, Hostetler observes that the Amish view reproduction as the primary function of the family.[14]

Practicing separation from the world and isolating themselves as much as possible, the Amish have never sought converts or preached outside their community. Children, therefore, signify the only means of preserving the Amish way of life. Amish communities welcome children, seeing them as God's creations, Adamic beings who, though impure by association with fallen man, begin life sinless. If properly raised they will maintain the Christian way of life, taking over from their parents the role of God's stewards of the earth and perpetuating the Amish faith.

Farming and fertility may have a more complex and deep-rooted connection than the incidental, metaphorical relationship I have explored thus far. Eugene Ericksen et al. argue that labor-intensive farming practices require high fertility.[15] Since the Amish eschew most labor-saving devices in their land cultivation and farm more intensively than most other groups, they need a large amount of manpower to produce the high yields on which their system depends. The farming techniques and high fertility rates mutually reinforce one another. Intensive farming encourages families to produce many children to work the farm; conversely, the large number of children requires increased agricultural production to remain self sufficient.

Furthermore, since farming represents the most promising means of maintaining a community separate from the world, grown children must have access to land if they are to continue the Amish way of life. Ericksen et al. found an increased rate of departure from the community among young people who were unable to acquire farms.[16] Therefore, profits reaped from agriculture, which in other communities might allow the more luxurious lifestyle avoided by the Amish, must be used instead to obtain land to accommodate the increasing population. The relationship between fertility rates and land cultivation, predicated on the Amish desire for separation and self sufficiency, represents a highly successful but unspoken and informal community strategy of self preservation.

In light of the procreative reading of the quilt I have suggested, the range of cultural dynamics implied by the relationship between the pieced and quilted designs expands. As noted earlier, the geometric controls the organic. The abstract controls the natural. If the organic elements signify human fertility, then the abstract forms that contain them could be said to represent the social structure into which children are born. Children, the fruits, or in this case, flowers, of reproduction, enter a world of laws that influence their development.[17]

Rather than a simple controlling relationship, however, one can also interpret the organic elements as accepting the bounds created by the geometric. Compliance, the acceptance of rules, then, becomes the paradigm put forth in the quilt. These readings find ample support within Amish practices. On the most immediate level, obedience to parents forms a cornerstone of Amish preaching, and the family is considered the primary socializing institution, responsible for moral, religious, and social development. "[R]estrictions and extracting disciplines are continuously imposed upon the child. . . . He must be taught to respect the authority of his parents and to respond properly to their exactness."[18]

Although parents take responsibility for instilling values in their children and view themselves accountable to God for the children's spiritual growth, the community regulates and defines what those beliefs will be, and it does so more consciously and aggressively than in the greater American society.[19] These rules take the form of the *Ordnung*, an unwritten but communally accepted and practiced set of behavioral laws. The *Ordnung* prescribes proper actions for public and private life, covering all aspects of Amish society, from appropriate dress to what technologies may be adopted. Although various aspects of the *Ordnung* may have changed over time, the basic beliefs implied by it have remained consistent; the Amish do not consider these laws debatable and expect strict obedience to them by all members of the culture.[20]

The abstract control embodied by the geometric shapes may also be related to God's laws, which define all living things. The quilt becomes a symbolic landscape in which God's creations, the plants specifically, but metaphorically all living beings, may flourish if they respect His will. The themes of control and acceptance already discussed work in the same way but reference the individual's ultimate loyalty to God above all else. A strictly religious community, Amish society bases its worldview on biblical teachings. *Gelassenheit*, a governing principle, means "submission—yielding to a higher authority . . . self-surrender, [and] resignation to God's will."[21] Children are taught that "joy" means *Jesus* first, *Yourself* last, and *Others* in between.[22] Furthermore, the Amish do not believe in predestination; only by leading a virtuous, simple life based on God's word may they gain divine favor and be saved. Thus, a symbolic mapping of God's plan for the world in which his people conform to his laws holds particular relevance for Amish culture. Embodied in the quilt's design, therefore, is the idea of control—social and divine—and an acceptance of and obedience to community and God-given laws.

Various aspects of the above-mentioned readings take on further significance when one considers the intimate connection of quilts to marriage in Amish society. Since the family forms the primary social unit and promises the preservation of Amish tradition, marriage holds special significance for the community. Amish women must enter married life with a supply of quilts already made. Miriam Stoltzfus, an elderly Amish woman, recalling her childhood says, "[q]uilts said a lot to the community. If you were busy quilting this said you were going to get married."[23] More importantly, mothers have traditionally made quilts for each of their children to be given as marriage gifts. Although I do not know whether this particular quilt was a wedding gift, it may well have been. In that case, the quilt becomes metaphorically a wish for fertility for the young couple, a reminder of how children should be raised, and a road map of social and religious codes of conduct. It symbolizes the function of marriage—reproduction and the ensuing regeneration of the community—as well as the value system to which the couple must conform.

As I mentioned earlier, grown children need farms on which to establish their families. The Amish understand that the successful continuation of the process begun by the marriage ceremony and culminating in the production of a new generation rests on the ability of these young adults to install themselves on farms. Traditionally, parents provided or at least helped their married children acquire this land. Indeed, historically parents have considered it their duty to provide farms for their children, and Amish culture sets great store in this practice.[24] Returning to my earlier reading

of the quilt as land, the giving of the quilt at marriage may function symbolically as a manifestation of this social contract. It becomes, in other words, a promise of its eventual fulfillment.

Up to this point, the notions discussed, while never explored through a close analysis of a quilt, would not surprise a scholar of Amish society. I hope my examination enriches the previous dialogue, adding subtleties and a recognition of an unconscious life that is often missing from discussions of the Amish, who because they live a "simple" life are assumed to be psychologically uncomplicated people. Other elements of the quilt design suggest metaphorical readings that illuminate less studied facets of Amish society.

The centralized, symmetrical design and regular geometric shapes, as well as the saturated colors, create a composition of great visual strength. The dominant motif of the design, the square, is an inherently stable element, as are horizontal, vertical, and 45-degree lines, which are the only ones used. Large areas of uninterrupted color and the dark outside border, which contains the object, further enhance the sturdiness of the motif. Given the previous discussion of Amish society, such steadiness is not surprising. However, by turning a square onto its corner to create a diamond, the maker has undermined the stability of the form and produced an inherently unstable image. Delicately balanced on a point, a diamond could easily topple to either side. Inscribing the diamond in a square so that its corners rest against the sides of the larger shape steadies it, rescuing it from its imminent fall. Despite this effort, however, the fundamental precariousness remains. I propose that this element reflects a societal uncertainty and further, that as the diamond forms the center of the quilt, that this insecurity lies at the heart of the culture.

The turquoise elements on which the diamond lies form a square. However, they also form four individual triangles. The large border around them reinforces the square reading, but the vibrancy of the turquoise pieces, especially in comparison to the light purple that surrounds them, emphasizes the individual shape of each rather than their interconnection. These elements remain ambiguous, shifting between their two identities. This refusal to remain a single form suggests possibilities, alternatives.

The primary alternative with which the Amish contend is the alternative lifestyle of the non-Amish. In other words, when this quilt was made (indeed, even today), Amish tradition dictated the large aspects of life—livelihood, lifestyle, etc.—so while individual choice and expression exist, the only major alternative open to the society's members is to become not Amish, since to practice an unconventional lifestyle is not possible within Amish culture. Although today the shortage of farming land affords more

opportunity for Amish people to choose different livelihoods, at the beginning of the century when this quilt was made, this prospect was almost inconceivable. This occupational restriction remained a defining and cherished element of Amish culture.

Within this Amish/non-Amish dichotomy lies the key to the uncertainty I detected in the quilt, for every Amish person must choose consciously to become Amish. As Anabaptists, the Amish practice adult rather than child baptism. They believe individuals must embrace God and His teachings for themselves. Children, who are ignorant of all things, cannot do this. Child baptism is meaningless because the infant enters the world sinless, without need of spiritual cleansing and because the baptism is not chosen or sought by the child. Only after learning the Biblical teachings and Amish beliefs may a person deliberately accept the faith and undergo baptism. So, although Amish families must produce children in order to perpetuate their community, the presence of these offspring alone does not ensure the future of the society; these children must choose to follow the Amish way.

Built into the structure of the society, then, is the potential for each person to accept or reject its tenets, and although the community may pressure its young members to choose the "right" path, it cannot force them to do so. The community does not ultimately control its destiny. I believe that therein lies a fundamental precariousness at the base of Amish society.

Although they would not speak of it in such terms, the Amish recognize the importance of this choice. All aspects of children's upbringing centers on instilling Amish values. Moreover, they view the mid- to late teen years as a particularly delicate time since it culminates in the decision to be baptized or not. Exemplifying this concern for childhood and teen years is the reaction of Amish communities to public schooling in the early twentieth century. At the beginning of the century when this quilt was made, most Amish children attended rural public schools through the eighth grade, at which time they left school to work family farms. Given the isolated nature and small size of the schools at that time, the Amish were able to exert control over the teaching of their children. However, when the federal government began consolidating rural schools and raising the number of required school years in the 1930s, Amish communities protested vehemently. While they viewed basic education as important, they considered higher learning—anything beyond the eighth grade—inappropriate to their simple Christian life. More important, they realized that if their children were to attend high school, they would be exposed to non-Amish ideas and worldly temptations during the essential years of personal decision making. Fearful that this sustained contact with outsiders would seduce the

youngsters and needing the teenagers to work on the farm, Amish communities refused to comply with the new federal laws. Some parents accepted arrest rather than send their children to high school.

Strong borders contain the two unstable elements within the quilt design. A dark outline surrounds the entire composition, dividing it from its surroundings. Nothing remains free of or outside these demarcations. It is this framework that keeps the diamond balanced. Not only are these elements manifestations of the separateness for which the Amish strive, these borders mirror the strong community structure which seeks to support the individual and encourage him or her to remain a member.

These substantial outlines reflect the clearly defined boundaries of Amish society. One cannot be an occasional or partial member. One must accept the way of life and belief system fully or not participate at all. Indeed, if a person who has embraced the faith and undergone baptism transgresses from the prescribed path, he or she risks being put under the *Meidung*, a practice of excommunication and communal shunning. Being shunned not only bars a member from attending religious ceremonies, but also prohibits participation in all community activities. Even families avoid shunned members because, by forsaking Amish beliefs, a person joins the ranks of those who reject God, and contact with such sinners is clearly forbidden by the Bible: "Be not unequally yoked together with unbelievers; for what fellowship hath righteousness with unrighteousness?"[25]

Taking these readings a step further, the central diamond suggests the place of the individual in Amish society. This individual must choose whether to accept or reject the Amish way of life and thus, like the diamond, balances precariously. The thick borders both support and insulate the diamond. Likewise, the closed Amish community offers positive inducements—a safe haven from the world and, ultimately, salvation—to its deciding members and attempts to isolate those members from the outside world. Furthermore, if the quilt as a whole represents Amish society, then the red wool material of the diamond, the individual, mirrors that of the large outer portion, the full community. This color relationship suggests the homogeny of personal and communal beliefs and standards which is so essential to the Amish. Therefore, within the boundaries of the quilt/culture strong borders/laws both support and restrain the diamond/individual, which is nonetheless "cut from the same cloth," both literally and figuratively, as the larger composition or community.

The woman who made this quilt drew upon established motifs. Her combination of the elements—the respect for the geometric structure she exhibited in her quilting, for instance—created meaning, which I have attempted to understand through a creative reading of the formal

composition. The quilt becomes a symbolic landscape of God's order in the universe and human order on earth. It expresses both hopes for and uncertainty regarding the future of the Amish faith. It speaks of farming and regeneration—primary and interconnected concerns. And, ultimately, it maps out the individual's relationship to the community, recognizing the essential personal choice all members must make and alluding to the social structure which defines it. More than a personal aesthetic vision, this Amish quilt, invested with cultural significance, encompasses and reflects the fundamental belief system of the community within which and for which it was made.

NOTES

1. Jonathan Holstein, "Amish Quilts," in *Quilts des Amish* (L'Ausanne, Switzerland: Musée des Arts Décoratifs de la Ville de l'Ausanne, 1988), 13.

2. Phyllis Haders, *Sunshine and Shadows: The Amish and Their Quilts* (Pittstown: Main Street Press, 1984), 19.

3. Ibid., 18.

4. For examples of Amish quilt styles, see Haders; Holstein; and Robert Hughes, *Amish: The Art of the Quilt* (New York: Alfred A. Knopf , 1993).

5. Haders, *Sunshine and Shadows*, passim.

6. Cited in Haders, *Sunshine and Shadows*, 15.

7. The Amish do adopt some innovations. The use of a sewing machine in fabricating this quilt represents one such instance. Many observers have reported on how the Amish have responded to modernity, finding that they adopt some innovations while rejecting others. Most view this process as a conscious evaluation of the potential benefits and dangers of the new ideas or technologies. They reject those which threaten the Amish way of life or could lead to an abandonment of Amish ideals and accept those that do not. The rate and amount of acceptance varies between communities depending on the level of conservatism within the group.

8. Donald B. Kraybill, "The Quiltwork of Amish Culture," in Donald B. Kraybill, Patricia T. Herr, and Jonathan Holstein, *A Quiet Spirit: Amish Quilts from the Collection of Cindy Tietze & Stuart Hodosh* (Hong Kong: South Sea International Press, for the UCLA Fowler Museum of Cultural History, 1996), 15.

9. By the beginning of the nineteenth century, Amish families had migrated west. They established settlements in Ohio and Indiana, and today these areas, along with Lancaster and Mifflin Counties, Pennsylvania, contain most of the Amish communities in the United States.

10. Holstein, "Amish Quilts," 20.

11. John Brinckerhoff Jackson, "The Order of a Landscape: Reason and Religion in Newtonian America," in Donald William Meinig, ed., *The Interpretation of Ordinary Landscapes: Geographical Essays* (New York: Oxford University Press, 1979).

12. Walter M. Kollmorgen, "Culture of a Contemporary Community: The Old Order Amish of Lancaster County, Pennsylvania," *Rural Life Studies* no. 4 (Washington, D.C., 1942); cited in John A. Hostetler, *Amish Roots: A Treasury of History, Wisdom and Lore* (Baltimore: Johns Hopkins University Press, 1989), 58.

13. Julia Ericksen and Gary Klein, "Women's Roles and Family Production Among the Old Order Amish," *Rural Sociology* 46 (1981): 286.

14. Hostetler, *Amish Society*, 145.

15. Eugene P. Ericksen, Julia A. Ericksen, and John Hostetler, "The Cultivation of the Soil as a Moral Directive: Population Growth, Family Ties, and the Maintenance of Community Among the Old Order Amish," *Rural Sociology* 45 (1980): 52.

16. Ericksen, Ericksen, and Hostetler, "The Cultivation of the Soil as a Moral Directive," passim.

17. It is tempting to read these geometric and organic elements as gendered masculine and feminine, respectively, as graphic reiterations of a patriarchal social structure. Indeed, it has become conventional to read quilts as social artifacts produced by disempowered women. While technically descriptive of Amish culture, this paradigm of gender inequality obscures major differences between an isolated subculture and the larger community and illustrates the danger of applying generalized notions uncritically. While Amish society is ideologically patriarchal, in practice it reflects a high degree of gender parity. For instance, although women may not speak in church or perform religious services—central community activities—they have historically enjoyed equal votes on church and community issues. While women in America could not yet vote in national elections when this quilt was made, Amish women enjoyed that privilege within their own communities. Publicly women may have deferred to their husbands, but in the household they acted independently. Julia Ericksen and Gary Klein have noted that, while men may appear more powerful in societies in which women's lives revolve around the home, wherever the domestic sphere forms the central social structure in a society, actual power is more equally distributed. Ericksen and Klein label this phenomenon "powerless authority" and suggest that "[t]he predominance of men in the public sphere is not as important as [it] might at first appear, due to the emphasis on the private sphere in Amish culture." ("Women's Roles and Family Production Among the Old Order Amish," 293). I do not wish to idealize Amish culture or give the impression that women enjoy full equality with men, but only to suggest that, while gender issues remain relevant to discussions of Amish society, the gender model as applied in past quilt studies may not be appropriate to the Amish.

18. Hostetler, *Amish Society*, 156.

19. Ericksen, Ericksen, and Hostetler, "The Cultivation of the Soil as a Moral Directive," 52.

20. Hostetler, *Amish Society*, 82–7.

21. Kraybill, "The Quiltwork of Amish Culture," 20.

22. Ibid.

23. Cited in Patricia Herr, "Quilts within the Amish Culture," in Kraybill, Herr, and Holstein, *A Quiet Spirit*, 55. The Amish do not practice long public engagements. Weddings are announced one to four weeks before they take place.

24. Rising land prices and growing populations have made this task arduous and often impossible in recent years, a development that many Amish and non-Amish see as threatening to the future of the culture. At the beginning of the century and well into the mid and late part of it, however, parents performed this custom consistently.

25. II Corinthians 6:14.

Daisann McLane

Unwrapping the *bwat sekre:* The Secrets of a Haitian Money Box

IN 1994, I WENT to visit a friend who had recently returned to New York from several months of anthropological field work in Haiti. She had not yet unpacked, and her apartment was a confusion of half-open duffel bags, books, clothes, papers and assorted items that she had picked up in Haiti to carry home as gifts. One of these objects immediately caught my attention: a shiny squarish metal box, about 6 inches high by 4 inches deep, covered with a bright red, white, and blue pattern of what appeared to be, from where I stood on the other side of the room, wheels in motion (Fig. 6.1).[1]

I walked over to the box in order to see it better, and it all but jumped into my hands. Delighted by the box's lively, kinetic contrasting colors, its pleasing size and shape, I examined it as a child would a toy (indeed, it seemed to be some shiny plaything), turning it around and around, admiring the way the light caught and reflected off its metal sides. It was not until later that I noticed that while handling the box, I had scratched my hands on the sharp points of its metal corners.

Although I have been to Haiti several times, I had never seen anything quite like this box, and I had no idea what it was "for"—if indeed it was "for" anything besides tourists. Haiti's extraordinary art—especially painting, iron sculpture, and cloth and bead work—is famous throughout the Caribbean and the world; few are the first-world travelers who do not bring some remarkable Haitian object home from their trip to Port au Prince. On the walls of my living room, in fact, hang several intricately-sequined Haitian vodou flags, replicas of flags that are used to salute and call the *lwa*, or spirits, in Haitian religious ceremonies. As a knowing and experienced participant, then, in the exchange and consumption of these "decontextualized" objects, I naturally assumed that my friend's box fell

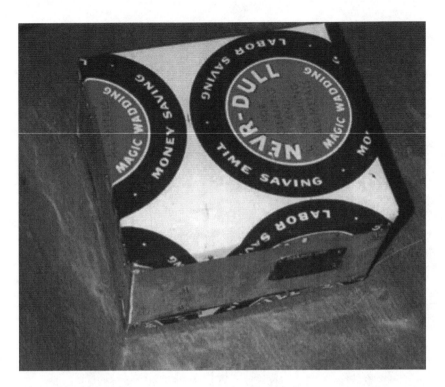

Fig. 6.1. *Bwat sekre.* Hammered metal, 6 inches (height) by 8 inches (length) by 4 inches (width).

into this category—that the box was a commodity meant for exchange between the Haitians who produced it, and the foreigner wishing to carry something of the island home.

But this was not the case. According to my friend, this box was neither a folkloric nor a tourist item, it was a *bwat sekre*—a "secret box" of the kind in which Haitians, particularly market women, keep their money. In other words, the object was a Haitian piggy bank. I then examined it more carefully, and noticed a small slit, slightly more than an inch long, at one end of the narrow side: the money slot, of course (Fig. 6.2). I peppered my friend with questions, but she did not have much more to tell me; only that she had bought this box, and several others, for the equivalent of about five U.S. dollars each from a man who made and sold them in the Iron Market of Port Au Prince. (The Iron Market is the main trading center of the city, so called because it is an open space covered by an iron roof.) There were several box vendors in the market; she had bargained for the best price, and believed that she had paid perhaps twice what a Haitian would have paid for the item.[2]

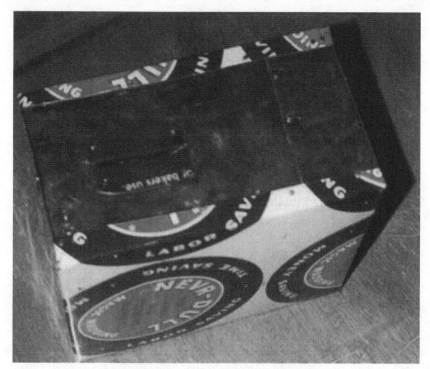

Fig. 6.2. *Bwat sekre* from above, slot positioned for use.

The knowledge that this box was a vernacular object, not a tourist object, and that it had a specific, particular function and utility in Haiti did not satisfy my curiosity. Indeed, the longer I regarded this secret box (it soon was to occupy a central position in my living room, on the bookshelf), the more I wondered whether the "secret" it represented really had to do with money-keeping at all, because there seemed to be something more to this object than its stated use-function indicated. While I was not certain yet what this "something more" might be, I could locate the point of my fixation in the box's material and design; it was from here that the secret box, indeed, almost seemed to be speaking.

The most arresting visual feature of the secret box, as I have mentioned, was the red, white, and blue circular pattern wheeling around its metal sides. The pattern, when you look at it up close, also carries a punch line, at least for an American observer. On closer inspection, one realizes that the tri-colored spinning wheels are not wheels at all, but molds for jar or can lids, printed onto a piece of sheet metal in order to be stamped out (eventually) into three-dimensional form by some sort of mechanical press (there are thin X shaped crop marks placed around the circles, possibly the

guide for the stamping/cutting machine). The patterns, as well as the sheet metal they are printed on, are American in origin, not Haitian, as evidenced by the iconography that decorates the borders and fills in the centers of the concentric circles—"Nevr-Dull Magic Wadding/For Cleaning and Polishing All Metals/Time Saving/Money Saving/Labor Saving." Made for the purpose of capping a jar or can of an American brand of metal polish (Nevr-Dull), this first-world industrial scrap instead found its way somehow—and I wanted to know how—to Haiti, where its upbeat slogans about economy, thrift and shine now danced around the sides of a piggy-bank.

The first impulse is to read this juxtaposition as ironic or clever, which is what I did, before I realized that there is an enormous problem presented by such a reading. The problem is language. The box's iconography is in English, a language spoken by few Haitians, and read by even fewer. Most Haitians—around 80 percent—speak a version of French known as Kreyol (the rest are bilingual in standard French and Kreyol), and cannot read or write in this or any other language.[3] It was unlikely, therefore, that the secret box's maker had any idea that the English language messages printed on this scrap metal echoed the box's function as a money-keeper. Yet, somehow, the Haitian boxmaker had "heard" and "understood" the words "time," "money," "labor," and "saving" on the sheet of metal, and incorporated them into this portable metal bank. Though this seemed improbable, the alternative deduction—that the selection of this particular piece of sheet metal was coincidental—seemed even more so, given the aesthetic integrity and unity of the box's design with its function.

Time and money, if not labor, prevented me from flying immediately to Port au Prince, seeking out the maker of this box in the Iron Market, and querying him on his choice of materials, his aesthetic and practical reasons for fabricating the box the way he did. How, then, could I begin to penetrate the secrets of this box? The methodology of material culture studies seemed to offer a unique way "in." In the course of subsequent research, it became evident that the box reflected a certain number of beliefs, values, attitudes and assumptions—and not only those of Haitian culture. I found that the *bwat sekre* is a container for streams of knowledge running between several cultures: Haiti, the United States, and the BaKongo of Central Africa. The anthropologist Arjun Appadurai, writing on what he calls the "social life of things," observes that all commodities represent "complex social forms and distributions of knowledge."[4] What I will suggest in this essay is that the *bwat sekre*, a commodity poised at the intersection of several cultures, dynamically transmits and translates knowledge in several languages simultaneously across all the strands of its

sources. To read the box carefully is to trace several stories about Haiti and its economies, about Haiti's connections, both historical and cultural, to Africa and the United States, and about the transfer and exchange of commodities, culture and cosmology from first to third worlds and back.

My reading of the *bwat sekre* begins with an evaluation of the object from a sensory and emotional perspective. This initial reading proceeds from, and reflects my position as a person of Western cultural background. With the second reading of the box, I begin to integrate evidence culled from Haitian informants and secondary sources in order to show how the box is, at once, an expression of economic and political relations between Haiti and the United States, and a site in which Haitians struggle to express and to control the contradictions of two conflicting systems—those of the urban industrial first world on the one hand, and rural agricultural third world on the other. The third reading of the box proceeds, as much as possible, from an Afro-Haitian perspective; it explores the ways in which the box, although a secular object, resonates within the cosmology of Haiti's African-based religion, vodou. The final reading attempts an integration of the box's several cultural sign systems by examining the sign system common to all the box's cultures: money.

I begin by picking up the box, squeezing it at the frame, and then at the middle of its two large rectangular metal faces. When I push them in, the large sides give slightly, and make a low and gentle *thunk!* sound. But the outer edges cannot be manipulated; they are rigid, which suggests that the object contains another, unseen material. Since the box's surface is covered with small nails, nails that sink into something, it's reasonable to deduce that there exists, hidden from view, an interior frame around which the metal strips are lapped and overlapped, and that this frame is made of wood. Short of dismantling the box, or x-raying it, there is only one way to probe this interior mystery: through the small narrow slit that breaks the top surface. So I drop a nickel into the slit—it fits without problem—and shake. When the coin hits the big metal sides, it clinks; but when it hits the long narrow sides, a muffled thud ensues. The wood frame hypothesis, then, seems plausible.

After shaking the box for a while, I run my fingertips over its exterior, and note that the flat metal surfaces of the box are cool and smooth, while the edges, seams and corners are sharp enough to cut flesh if not negotiated carefully. The strips of metal that comprise the box's exterior look as if they have been sliced out of a larger sheet, or sheets, with a linoleum (or similar) knife by hand. The other details of the box's construction also point to human, rather than industrial, manufacture. The metal cuts do not form geometrically straight lines, but instead waver, as a human hand

The Secrets of a Haitian Money Box 113

would do in trying to draw a line without a straightedge. The box itself forms an imperfect rectangle, and not a single one of the eight corners describes an exact 90-degree angle. The metal strips lap unevenly around all sides, giving the object the appearance of a gift package that has been wrapped in a hurry and somewhat clumsily.

The unevenness and inexactness of articulation stamp this box as a homemade, handmade product. Yet the materials themselves resonate of industry and the factory: the metal strips, commercial flat-headed nails, and, as I have mentioned, the iconography of the metal polish jar tops. This is not the only contrast presented by the box; indeed, the longer I observe it, the longer grows the list of tensions and contradictions embodied in the box. Smooth, even metal planes are offset by sharp corners and jagged hand-cut metal edges. The comforting "boxiness" of the box's shape is subverted by the inexactitude of its measurements—its "right angles" are ever-so-annoyingly "off." The slit, also, is off-center. And not a single one of the prominent red, white, and blue wheel patterns is visually intact as a circle. The round circles either are broken off by the cuts of the linoleum knife, or interrupted when they fold around the side of the box. Indeed, the incomplete circles are the very reason why the box appears to be wheeling in motion; the eye, attracted to the bright round shapes, "follows" them as they fold around the sides, and continues to fill them in even where their shape is cut off abruptly by the artisan's knife.

The list of tensions and contradictions continues to grow as I move from a physical and sensory inventory of the box to a consideration of my emotional responses to it. The secret box embodies a tease that is at once tantalizing and upsetting. On one level, it is hardly "secret" but rather glittery and eye-catching, an object that lures you in (as it did me) from across the room. Yet for all its flash and attention-getting, the box hides; it is, like all closed boxes, a mystery. The slit allows no glimpse of the interior, and it is only by shaking, dropping objects in, and probing that one can explore beyond the shiny surface. I could, and did, insert money into the box of different kinds: a dime, a folded Haitian banknote, a dollar. But upon doing so, I would not feel any sense of satisfaction (for having "saved" money) or security (for having "safeguarded" money), but rather an uneasy fear that these items had slipped out of sight, far from my reach and control into a dark netherworld. The money still existed—I could shake the box and hear it clunk—but it had passed from the world of shiny surfaces and primary colors represented by the bold exterior of the box, and now occupied another dark and hidden dimension, a realm I could only imagine.

The *bwat sekre* belongs to that family of "subversive" Caribbean and African objects that includes the steel drums, plastic soda bottle trees,

pipe-fitting grave sites of Trinidad and Tobago, and the toolbox suitcases of Mali, just to mention a few examples of this genre. In each of these examples, imported first-world commodities and/or materials have been modified and reshaped into a local object, whose use-function bears little or no relation to that of the original commodity, yet whose appeal is enhanced by its incorporation of the foreign commodity. "Foreign" in this case may mean that the original materials or objects have been imported from outside the country; but it often means that the objects have been assembled on local soil in a foreign-owned factory, under foreign supervision and with imported equipment and material. The process of creating a "subversive" object involves the de-contextualization of the foreign object or material—for example, when a Trinidad petroleum worker steals and takes home a few oil drums from the field—and subsequently, its modification and re-contextualization. The oil drum that is cut, heated, pounded, mounted and repainted by a Trinidadian becomes a sophisticated musical instrument that is the backbone of the island's important Carnival ritual—yet its origins as oil drum are not disguised, and indeed, the steel drum's "marvellousness" as an object is intrinsically tied to the process of its transformation, from the way in which it has been ingeniously "kidnapped" from one world, and reestablished in another.

Subversive, recontextualized objects like the Trinidad steel drum and the Haitian *bwat sekre* could be seen, on one level, as examples of modern bricolage, to use Levi-Strauss' term for the metaphor—making activities of the "natural" (i.e., non-Westernized) mind. But these objects, emerging as they do from cultures that have access to both Western and non-Western knowledge, also carry on a dialogue that crosses cultures; a dialogue between producers and consumers at (seemingly) opposite "poles" of the world economic system. Appadurai, speaking of the way in which knowledge moves through complicated, intercultural flows of commodities, notes that "knowledge at both poles has technical, mythological and evaluative components, and the two poles are susceptible to mutual and dialectical interaction."[5] A recontextualized object like the *bwat sekre* is a paradigm, as we shall see, of such interaction. There is indeed an exchange of knowledge taking place in this object, and it is a dialogue taking place on several "levels" or channels at once, the economic/political, the social, and the mythic.

The first dialogue one encounters in the *bwat sekre* is an economic/political one. To trace the materials and manufacture of this box is to encounter the story of U.S. economic relations with the Caribbean, Haiti's economic and ecological crisis, as well as physical evidence of recent political events in Haiti. One advantage of a material culture approach is

that it amplifies and details histories that are only partially available to us from sources such as economic and political statistics. For example, we can learn, from the economic data, that Haiti's average annual income is $300, that the official minimum wage, $3 a day, was earned by only 20 percent of the population in 1989, and thus Haiti is considered the "poorest" nation in the Western Hemisphere.[6] We can learn, from a review of recent news clippings, that thuggery, terrorism, and repression by an economic elite continued in Haiti despite the 1986 overthrow of dictator "Baby Doc" Duvalier and the subsequent election and exile of President Jean-Bertrand Aristide. However, since the box represents a material product that emerges from the context of these statistical abstractions, its examination provides a way of understanding how these economic and political facts play out in Haitian daily life.

The box, as we have seen, is made from scrap metal wrapped around a frame of light packing-frame wood—materials that are left over or discarded products of manufacturing and import/export. The use of metal for a *bwat sekre* is an innovation; I queried several Haitian informants who told me they remembered seeing *bwat sekre* in use as far back as the forties, but the older versions were made entirely of wood, with wooden sides.[7] (The Kreyol word "bwat," or box, contains within it the word "bwa," or "wood.") Why the switch to metal, then? Perhaps it is a matter of style that today's Haitian boxmakers prefer the look of brightly colored metal (along with the "modernity" that signifies) to dull wood. But there is a single important economic factor that may explain the change in materials. The metal and scrap-balsa construction of contemporary *bwat sekre* reflects the scarcity of wood in Haiti today. Over the last three decades, large tracts of the Haitian forest have been stripped by impoverished and desperate peasants, who use the wood to make charcoal fuel to sell in the market. The ecological devastation that this forest-stripping has caused is well-documented, and immediately obvious to anyone flying over the barren, brown mountains of the Western side of the island of Hispaniola.[8]

Besides hinting at Haiti's ecological deterioration, the scrap metal used in the box also tells us about Haiti's position in the international marketplace, and of recent antagonistic political developments between Haiti and its neighbor, the Dominican Republic. Although I was unable at first to trace the manufacturer of the "Nevr-Dull" metal polish (the metal sheets that make up most of the box's surface material), I was able to find the origins of another of the bits of metal on the box. Around the money slot, two pieces of blue metal bear the words, in white letters, "for baker's use." The size, color and typography of this iconography matches the lettering used on the commercial-sized canister of baking powder manufactured by the

Red Star Baking Powder Company in Milwaukee, Wisconsin. Red Star Baking Powder does not have any plant or manufacturing facility in Haiti; however, they maintain, in partnership with a Dominican company, a packing and distribution center in the "Free Zone" industrial belt two hundred miles away, just outside Santo Domingo.

A "free zone," in the language of international economic development, is a third world industrial park or belt where foreign investors are encouraged by local governments to relocate, by the offer of tax advantages and other incentives, the most obvious being that of the availability of low-wage labor. The "free" refers to the advantages enjoyed by the producers (and to the local elites who control the government, and thus, the national cash flow), and not to the benefits obtained by the workers, whose labor is purchased at a rate well below first-world market levels, and whose workplace conditions are often hazardous by first-world standards. I have visited several of the free zones near Santo Domingo; there is, as well, a "free zone" of light manufacturing and assembly plants just outside of Port au Prince, Haiti. In countries with large populations of rural poor, such as Haiti and the Dominican Republic, the "opportunity" of gaining salaried employment in the free zone sectors is a magnet that draws peasants to the urban areas.

My hypothesis is that the remainder of the box's metal (the sheets of jar lid molds for "Nevr-Dull" metal polish) also comes from the industrial free zones of Port au Prince or Santo Domingo. But even the tiny bit of Red Star Baking Powder metal that is traceable tells us much about trade and commerce in Haiti today. For one thing, the presence of metal from Santo Domingo in a Port au Prince-purchased object is material testimony to the fact that goods flow freely between the two nations, despite the fact that the borders between the historically antagonistic nations are often closed. Additionally, both the Red Star and Nevr-Dull metals are physical reminders of the "free zone" system of industrial production that links Americans and Haitians in a circle of exploitation.

Finally, and perhaps most importantly, the scrap metals, as used in the box, conduct a dialogue between the industrial first world of the U.S., and the rural third world of Haiti. To understand this link, one must first know that the *bwat sekre* is considered by city-bred Haitians to be something rustic, "from the country"—possession of one is a sure indication that the owner is new to the city, an unsophisticated peasant.[9] As I have mentioned, the free-zone factories are a magnet for these same migrating Haitian peasants. In these factories, the rural Haitian accustomed to the rhythms of agriculture and the culture of the village encounters for the first time the time clock and the imposed rhythms of industrial production. As a "rural"

object constructed from the industrial waste of these factories, the *bwat sekre* materializes the clash between these two radically different systems of time, labor, and economics. Imagine the culture shock of a Haitian peasant, new to the city, confronted with the alien systems of the factory, wage-labor, money. It is a shock that takes material form in the tensions and contradictions between the *bwat sekre*'s industrially-manufactured materials and its handmade, one-of-a-kind craftsmanship, between its smooth planes and knife-sharp edges, between the rural traditionalism of its intended use and the modernity of its "look." The box expresses the need to make sense of this collision of systems. With the appropriation of the Red Star and Nevr-Dull metals, the Haitian maker of the *bwat sekre* (like the Trinidadian steel drum maker) not only transforms the foreign into the familiar, but takes symbolic control, with his very hands, of an exploitative and doubly-alienated economic exchange.

To attempt to deconstruct the meanings of a Haitian object without utilizing the cosmology of vodou is like trying to deconstruct a contemporary Western object without utilizing psychoanalysis. Vodou, the Haitian religion that combines elements of Kongo, Dahomey, and French colonial Catholic traditions, is Haiti's unique and ubiquitous system of signs, one that operates not only in religious ritual, but also in contexts that, in Western culture, would be considered secular. Vodou, like the African religions from which it evolved (and unlike Western religions), does not dichotomize the religious and the secular, but rather, insists on the infiltration of those categories. The spirits of the vodou pantheon, the *lwa*, may appear during vodou ceremonies, but they are also as likely to turn up unexpectedly in the home, or marketplace.

"Vodou spirits are larger than life, but not other than life," observes anthropologist Karen Brown in her recent ethnography of a vodou priestess, Mama Lola.[10] Haitian art powerfully expresses this fluidity and continuity between sacred and secular realms. In a critique of the Tap Taps, Haiti's famous baroquely-decorated taxi vans, art critic Donald Cosentino suggests that the gloriously painted and appliqued vehicles are, simultaneously, mobile vodou altars. "Within vodoun, heaven and earth are permeable; the world, the flesh, the devil—and the divine—are one. That great unity is the single vision that informs the Haitian aesthetic in all its disparate iconography. . . ."[11] If Tap Taps are altars, and Haitian painting a visible manifestation of the *lwa*'s power, what then is a *bwat sekre*? The pun in the Kreyol word for secret is sacred (sekre/sakre), a strong suggestion that the box, indeed, does represent "something more" than a mere money-holder for a Haitian. But there is no ethnographic evidence that a *bwat sekre* is used in conjunction with vodou ceremony; in this respect, it

must be classified a secular object; closed containers do play an important role in vodou practice, and I will explore the implications of this shortly. There are, however, several striking continuities between the box's iconography and vodou iconography that suggest that the box, while not used in or for vodou ritual, nevertheless falls within the vodou system of signifiers for Haitians. The box may not be a vodou object, but vodou is present in it because the box is dressed (like Cosentino's Tap Taps) in vodou symbology. Positioned at the juncture of sacred and secular, the *bwat sekre* is like a radio transmitter/receiver that allows for the flow of language, symbol, and meaning between worlds.

The use of color-coding is the first element that links the box to vodou (and, significantly, to Haitian politics). In vodou, each *lwa* has its own colors, colors that at once represent the spirit and embody its energy. When a *serviteur*, or devotee, becomes possessed with the spirit Gede, for example, s/he will be dressed in clothing of black and purple, Gede's colors. Altars and flags for Gede, and candles burned for him, will echo this color-coding. The *bwat sekre* is emblazoned with circles of dazzling red and blue; in the vodou pantheon, these colors belong to Ogun, the warrior *lwa*. Ogun, also represented in Haitian iconography by the Catholic St. Jacques, is fighter, protector, and swordsman; iron and metal are his elements (he is the patron of ironsmiths), the battlefield his ground. As St. Jacques in the Catholic lithograph that appears on Ogun's altars, he rides astride a bucking white horse, brandishing a sharp, shiny sword, a red and blue battle flag sailing behind him.[12] A Haitian, seeing the red and blue blazons on the *bwat sekre*, understands them as coded symbols of Ogun, colors that imprint the *bwat sekre* (and thus protect its valuable contents) with fighting strength, protective vigilance, and a sharp metallic edge (that is "Nevr-Dull").

Ogun, as Maya Deren reminds us in her classic study of vodou, *Divine Horsemen*, is first and foremost a figure of authority and might, and in some manifestations he represents the might of the state, for "[t]oday power is political, and Ogun is, in fact, often a political figure."[13] This aspect of Ogun as symbol of political power reverberates not only in the box's function as moneykeeper (money being perhaps the most important everyday symbol of state power), but in the political symbolism for Haitians of the colors red and blue. The French Revolutionary tricolor of red, white, and blue was adopted by Haiti's revolutionary slaves during the nation's war for independence in the early nineteenth century. When the Haitians won their independence, the tricolor was incorporated into the new national flag. Red, white, and blue remained the colors of the Haitian flag until the 1940s, when "Papa Doc" Duvalier, Haitian President-for-life,

decided to change the blue to black, symbolizing the rise of blacks to power over the mulatto elite. The Haitian flag remained red, black, and white until 1986, when Duvalier's son and heir, President-for-life Jean-Claude "Baby Doc" Duvalier, abdicated the presidency and left Haiti for exile. In the ensuing popular celebration, Haitians everywhere tore off, or painted over, the black (now associated with Duvalier and his tyranny), and replaced it with blue. In 1987, there was a joyous explosion of red and blue everywhere in Haiti, painted along the curbs of streets in Port au Prince, on wall murals, even painted on tin cups for sale in the market. By 1991, red and blue had become the colors associated not only with the Haitian state, but also with Father Aristide's popular campaign for president, and they continue to decorate public areas in Haiti.[14]

On one level, the red and blue color-coding is a simple expression of political change; but because the colors also have meaning in vodou, Haiti's prevailing sign-system, the colors reverberate with other, deeper meanings. The blue vanquishes Duvalier's corrupted black with the political strength and integrity of Ogun. The red and blue together, painted upon every imaginable public surface, express the triumph of Ogun's fighting justice, and a wish to protect the new government from harm or corruption by emblazoning Ogun's colors over homes, streets, public buildings, and private objects. The *bwat sekre*, I believe, expresses both the political and religious aspects of these color-coded meanings. From the lack of rust or wear on the metal we can assume the box was made after Duvalier's fall in February, 1986, and that it is an artifact that belongs to the "red/blue" post-dictatorship period. The bright shield-like red and blue circles on white background become a protective wrapping of the money inside, articulating at once the vigilance of Ogun, and the integrity of the new Haitian state. The colors that symbolize Haiti's moment of national self-definition, the revolution, express a (communal, public) hope for the future that is transferred, in the object, into a (personal, private) hope for the successful accumulation of money—a resource as scarce in Haiti as honorable political leaders. The selection of the Red Star and Nevr-Dull scrap metals reveals itself to be not only an aesthetic choice, but also a conscious application of the language, power and symbolism of vodou. The American commercial iconography— itself a symbol of political and economic power—becomes even more powerful when layered with the red/blue symbology of Ogun and the Haitian nation-state.

The *bwat sekre* does not just express a desire (to protect and increase money); it is a machine designed to make these desires come true. The form of the box—wrapped and nailed shiny metal outside, money inside, echoes the form of what is perhaps the most ubiquitous material object in vodou

practice, the paquet congo. The paquet is a container-like vodou charm that consists of dirt, usually graveyard dirt, leaves, animal bones and sometimes money wrapped or tied with ribbon and cloth, adorned with sequins and studded with pins.[15] Scholars of vodou believe that the paquet, and related containers like Haitian spirit bottles, are reformulated Afro-Atlantic versions of Kongo *minkisi* charms, Kongo being one of the most important cultural influences in vodou. Kongo *minkisi* (singular *nkisi*) contain spirit; the wrapping and tying of these packets and containers represents the entrapment and enclosure of spirit into a place from which it may work for the benefit of the owner of the charm.[16] The spirit within the *nkisi* is held in objects such as animal and human bones and grave dirt, materials that mediate between the worlds of light and darkness, living and dead. In Kongo cosmology, these twin worlds are represented by the symbol of a cross within a circle, a cosmogram that art historians Robert Farris Thompson and Joseph Cornet call "The Four Moments of the Sun."[17] The circle traces the path of the human soul as it wheels through the four cardinal points of birth, maturity, death, and rebirth.

The *bwat sekre* is not a *paquet/nkisi*, of course; it is a piggy bank. But it metaphorically "quotes" these Kongo/vodou spiritual objects and cosmograms, and in so doing assimilates their symbolic power. This is the other "secret" of the secret box—that it is not only there to store your money, but to make it work for you. Compare the *bwat sekre* to the ritual objects, and the analogies to the minkisi and paquets congo begin to unfold one by one. The box encloses money—which is not exactly a vodou spirit, but certainly a symbol of powerful and invisible forces—and ties and encloses it in a coffin-like dark place, wrapped in metal fastened down with nails (pinned, as in the paquet congo). The "uneasiness" I felt during my sensory experimentation with the box now begins to make sense—when I was slipping money into the box, I was metaphorically passing it from the world of living to the world of the dead. The circles wheeling across the exterior surface of the box can be seen as a metaphor of the "wheel" of the Kongo cosmogram of the four moments of the sun, the cardinal points of the life cycle, wheels that set the money in motion between two worlds—not only the worlds of light and dark, but of country and city, farm and factory, Haiti and the United States. The shiny, mirror-like sides of the box surface echo the mirrors often attached to or embedded upon minkisi, objects of "flash" that at once activate good spirits, and repel bad ones.

The *bwat sekre* riffs and plays upon the symbology of Kongo and vodou religions in a manner not unlike the African-American material culture display that has come to be known as the yard show. In the yard shows

(examples of which have been documented throughout the U.S. and the Caribbean), African American collagists such the late stonemason Henry Dorsey transform their houses and property with what Thompson describes as "interlocking material puns on meditation and transcendence . . . recombining objects taken from their original industrial functions, thus giving them new meanings."[18] Yard shows, like the *bwat sekre*, draw on the symbols of BaKongo cosmology to "speak" in new ways, combining spiritual metaphor with secular meaning. In the yard shows, for example, a rotary windmill or an electric fan mounted on a rooftop may represent a pun on the Kongo idea of wheeling from heaven to earth, or it may be a material metaphor intended to protect the home from harm by "blowing away" evil intentions, or an assertion of mastery over technology and industry, or all of the above.

In the African American yard shows, I believe, is a clue to most puzzling "secret" of the Haitian box: the meaning, for Haitians, of the English-language iconography. By now it should be evident that the Haitian maker of the secret money box intentionally utilized the "Nevr-Dull" scrap metal in the box design because of the way the metal's colors and form draw visual parallels to vodou and Haitian national political symbology. But what about the words "Time Saving/Money Saving/Labor Saving" dancing around the circles? Were they read by the boxmaker, and did he realize that he was putting a pun on the piggybank? To answer that question, let us turn for a moment to one of the most striking characteristics of the yard shows—their use of language and words to decorate, assert, and protect. The house of Henry Dorsey, as described by Thompson, is embellished everywhere with iconography—Dorsey's name, the initials and birthdates of his children, and several cryptic messages. In other instances of yard show display, pages of text from newspapers and magazines are plastered up to cover all the available walls of a house. Such examples of decorative "word intoxication" reflect Afro-Atlantic belief in the intrinsic power of words, belief manifested in non-visual contexts by spiritual practices like speaking in tongues. The visual glossolalia of a Rastafarian Jamaican house that is completely wallpapered with pages from the Old Testament represents a confidence in the power of words that extends well beyond those words' mere meanings. The words, in these decorative displays, are meant to be "read," but not as literal text.

It is in this sense, I believe, that the "Nevr-Dull" iconography on the secret box must be understood. Did the Haitian boxmaker have a literal understanding of the English-language "money saving, time saving . . ." etc.? Perhaps not. But I would argue that in a culture such as Haiti's where words are understood to have intrinsic power, and where the ability to

think in symbol and metaphor are so highly developed, the "coincidences" between the boxmaker's reading of the "Nevr-Dull" iconography and its English-language meanings are not coincidences at all, but rather an extraordinarily perceptive cross-cultural reading of their semiotics.

What is money to an American? A Haitian peasant? Does its meaning remain constant, or change according to context? As I worked with the *bwat sekre*, it became impossible to avoid these questions; indeed, the longer I explored the box's meanings with respect to vodou symbology, the more I became aware of the "strangeness" of money as a material object in my own culture; the defamatory phrase "vodou economics," popularized during the Reagan Administration, gradually began to take on a new, and positive meaning. For what is money, after all, but a means to an end, a "spirit" waiting to be put to "work" by a master?

Drawing on George Simmel's *The Philosophy of Money*, anthropologist Daniel Miller makes the observation that money has a "pure directed purpose . . . the purest example of a tool . . . since there is no other reason for its existence except as a medium through which ends may be accomplished."[19] Money is "pure symbol," a fact that tends to get obscured in modern cultures where it is the medium in which everything swims. But in cultures that retain economic structures that hark back to a non-monetarized era, "the nature of money and its role in the transformation of social relations is made explicit."[20] In other words, in cultures where cash exchange is not the single dominant form of commerce, people pay more attention to money, and attribute more of a range of non-economic meanings to it. This certainly seems to be true in a country like Haiti, where cash and traditional peasant/barter economies co-exist. Since money is not the only means of economic exchange, its distinct qualities (as abstraction, symbol of power and the state) are noticed more, and it tends to become fetishized, as evident from Karen Brown's description of the saving practices of Haitian market women:

> By the time the women returned [to the village from town], some would have spent every penny they had earned for a long, hot day's work. Others would carry away a few coins in grimy double-knotted kerchiefs tucked into their bosoms or in small sacks pinned to petticoats beneath their ragged skirts. Food, tools, and labor were shared freely among the family members, but money was different. The woman who managed to earn a little beyond what she had to spend protected it by silence and magic. . . . Even the husbands of these women rarely knew how much money they had.[21]

The market women of Haiti dominate the cash-economy of the small business—this is a tradition whose origins extend back to West Africa. The market women have an intimate, physical relationship to money; it is their hands that give and receive coins all day, their bosoms that hold the well-worn bills. They are, of course, the main "consumer market" for the *bwat sekre* that are sold in the Port au Prince Iron Market. Protecting their money with "silence and magic," the women slip it into the secret box with a hope that it will not only be protected, but that it will "work" for them. By slipping their money into a secular *nkisi,* they purify the grimy public bill of the marketplace, transforming it into a personalized instrument of good.

It is easy, perhaps, to dismiss the behavior of Haitian market women and their *bwat sekre* as examples of the juju of an underdeveloped culture. But what is money, if not juju, and how different are the aims of vodou and economics? The poster in the lobby of my bank assures me that I "have a friend at Chase Manhattan" and encourages me to let this unknown friend help me make my money work for me. My money in the bank is largely invisible to me; I deposit it into the mouth of a machine that eats it, and it disappears, transformed into an abstraction in which I "believe." My daily transactions with money, too, are largely hidden, symbolized by signatures, notes, exchanges of electronic impulses and plastic. "Listening" to the *bwat sekre* has enabled me to see these daily transactions in a different light, and reminded me of the juju behind all money (a mysticism expressed in the very iconography of a U.S. dollar bill imprinted with a pyramid topped by an all-seeing eye). I sign my paycheck and feed it into the ATM, then later I drop a couple of quarters into the secret box on my bookshelf. In both cases my money vanishes from sight, but I am very sure now that it is working for me, if not in one world, then in another.

EPILOGUE

Several months after I completed this paper in 1994, I finally received an answer to a letter of inquiry I wrote to the George Basch Company in Freeport, New York, the manufacturers of Nevr-Dull metal polish. The letter provided some interesting new information that filled in some of the blank spaces in my story of the Secret Box. In particular, the letter provided an answer to the question of how a piece of industrial metal made for an American company found its way to Port au Prince.[22]

According to Mark Ax, vice president of the firm, the sheet metal for the company's product packaging is imprinted and impressed by an independent contractor. If the ink color is not quite right, or if the metal printing is irregular, the piece of sheet metal is pulled out of production and sold

Fig. 6.3. Advertisement for the new Nevr-Dull.

as scrap. Ax surmises that the material for my secret box was part of a lot of irregularly printed scrap metal sold to such a scrap dealer. Apparently, these batches of scrap metal regularly find their way to the third world, a process of global recycling from first to third worlds similar to the circulation of used clothing described by Karen Hansen with regard to used clothing markets in the Zambia.[23]

Ax also mentioned that the product logo and package design for Nevr-Dull metal polish had been completely changed in 1983. Therefore, the raw materials for my Secret Box had been sitting around in warehouses or in container ships for more than ten years. The designers of the new Nevr-Dull package (Fig. 6.3) have done away with the lively concentric circles and product slogans—today's tin is a rather drab and functional dark blue cylinder

with white lettering. Four small icons around the product name display an automobile, a lamp, a boat and three pieces of silverware. The icons resemble the pictographs commonly used in international airports. Each icon is enclosed in a red rectangular field, and contains lettering to indicate the various uses of Nevr-Dull polish that the icon represents (automotive trim, brassware, marine, cookware). The no-nonsense packaging with its emphasis on the material and functional, rather than the "magical" and transformative aspects of the product ("time saving"—"money saving"—"labor saving"), serves to make Nevr Dull seem, well, rather dull. Perhaps the designers and marketers have come to believe (unlike the Haitian box-crafters) that, in the latter part of the twentieth century, it is overly ambitious to suggest that something as mundane as metal polish could have a magical quality.

And so I was not surprised not to see any secret boxes made from the new Nevr-Dull design when I paid my first visit to Port au Prince's Iron Market in the summer of 1995. What did surprise me was not seeing any secret boxes made from patterned metal at all. Arriving at the section of the market reserved for box vendors—only two stands were in operation—I inquired after the boxes and was shown several, some around the size of the box I already owned, and some much larger, nearly the size of a packing crate. The vendors explained they were meant to be used as suitcases. All had the same fish crate/newspaper/scrap metal construction of my *bwat sekre*, however, all the metal had a plain silver or gold finish.

Behind the vendors was a workshop, open to the street, where I could see boxes—all plain metal—in various stages of completion. I asked one of the workers to show me a box in patterned metal, and he told me that they were no longer being made. He explained that the embargo placed upon Haiti by the United States and the United Nations during Aristide's exile had decimated Haiti's trade. No scrap metal from the United States had shown up for sale in quite some time. The box-makers creativity was thus limited to whatever they could find or recycle.

I purchased one of the plain metal boxes from the vendor for about $5, and he wrapped it up carefully in old newspaper from the Dominican Republic. In truth, I bought it mostly to thank him for his time, since I found the box itself rather bland and industrial compared to the Nevr-Dull box. The shiny surface of the box reflected the bright tropical sun so powerfully that, if you looked at it a certain way, the glare was blinding. In that sense, it was a powerful and aggressive object, perhaps suitable for protecting money in Port au Prince's current climate of political and social unrest. When I passed through the security inspection at the airport in Port au Prince, the guard unwrapped my new box, examined it, and shook his head. "You cannot take this on board," he said. "Too dangerous."

NOTES

1. I am indebted to Elizabeth McAlister for her generous gift of the *bwat sekre* as well as for the invaluable insights she has given me about vodou and Haitian culture during my work on the box.

2. Personal communication, Elizabeth McAlister, December 1993.

3. Exact figures for Haitian literacy are difficult to obtain. However, these are the figures generally used by researchers—see, for instance, the introduction to Albert W. Valdman's Kreyol teaching text, *Ann Pale Kreyol* (Bloomington: University of Indiana Press, 1989).

4. Arjun Appadurai, "Commodities and the Politics of Value," in *The Social Life of Things: Commodities in Cultural Perspective*, ed. Arjun Appadurai (New York: Cambridge University Press, 1986), 41.

5. Appadurai, "Commodities and the Politics of Value," 41.

6. Cited in Alan W. Barnett, "Revolution of the Walls: Public Murals in Port au Prince, Haiti," *Art In America* 77 (July 1989): 67.

7. Professor Carolle M. Charles, personal communication, December 1993; Holly Nicolas, personal communication, January 1994.

8. For a description of the ecological devastation of Haiti, see Amy Wilentz, *The Rainy Season* (New York: Knopf, 1990), chap. 2.

9. Holly Nicolas, personal communication, January 1994.

10. Karen Brown, *Mama Lola: A Voudou Priestess in Brooklyn* (Berkeley: University of California, Press, 1992), 8.

11. Donald Cosentino, "Divine Horsepower: Transit Vans in Haiti," *African Arts* 22 (May 1988): 39.

12. For a discussion of the Haitian use of Catholic iconography, see Michel Leiris, "On the use of Catholic Religious Prints by the Practitioners of Voudoun in Haiti," *Evergreen Review* 4 (1960): 84–94.

13. Maya Deren, *Divine Horsemen: The Living Gods of Haiti* (New Paltz, N.Y.: McPherson and Co., 1953), 131.

14. The observations are from my field trip to Haiti in 1987. For further discussion of the post-Duvalier use of red and blue in public places and in popular art, see Barnett, "Revolution of the Walls," 65–69.

15. Karen Ellen Richman, *They Will Remember Me In The House: The Pwen of Haitian Transnational Migration* (unpublished Ph.D. dissertation, Department of Anthropology, University of Virginia, August 1992), 263.

16. For an account of Kongo cosmology and its relation to the paquet congo, see Robert Farris Thompson, *Flash of the Spirit* (New York: Vintage, 1983), 125–28. Elizabeth McAlister explores these connections in some detail, from a material culture perspective, in "A Sorcerer's Bottle: The Art of a Haitian-Kongo Wanga," in *The Sacred Arts of Voudou*, ed. Donald Cosentino (Los Angeles: University of California Press, with the Fowler Museum of Cultural History, 1995).

17. Robert Farris Thompson and Joseph Cornet, *The Four Moments of the Sun: Kongo Art in Two Worlds* (Washington, D.C.: National Gallery of Art, 1981).

18. Thompson, *Flash of the Spirit*, 147.

19. Daniel Miller, *Material Culture and Mass Consumption* (Oxford: Basil, Blackwell, 1989), 72; see Georg Simmel, *The Philosophy of Money* [*Philosophie des Geldes*], trans. Tom Bottomore and David Frisby (London and Boston: Routledge & Kegan Paul, 1978).

20. Miller, *Material Culture and Mass Consumption*, 72.

21. Brown, *Mama Lola: A Voudou Priestess in Brooklyn*, 27.

22. Personal communication, 24 August 1994, from Mark Ax, Vice President, George Basch Company, Freeport, NY.

23. Karen Tranberg Hansen, "Dealing with Used Clothing: Salaula and the Construction of Identity," *Public Culture* 6 (spring 1994): 503.

Leslie Shannon Miller

The Many Figures of Eve: Styles of Womanhood Embodied in a Late-Nineteenth-Century Corset

OF ALL THE FASHION practices of the nineteenth century, the phenomenon of corset-wearing is perhaps the least understood today. The corset, a clinical-looking arrangement of laces and stays, appears to modern eyes little more than a stylish torture device, endured in the past only by the most fashionable or perhaps the most bizarre of women. These, however, were not the reputations enjoyed by corsets or by the people who wore them in the late nineteenth century. Since small waists were the primary measure of corporeal beauty, corset use was nearly universal among Western females from the middle class upwards (and, to a lesser extent, downwards).[1] The corset was as indispensable to the nineteenth-century mode of dress as the bra is today; most women wore one, and those who did not risked being thought indecently dressed.[2] De rigueur from the age of puberty in places as far-flung as the Dakota Territory, corsets were often kept on at night for the most beneficial results.[3] The 20-inch to 24-inch waists that were the resulting norm appear barbarously small by today's standards, but after a lifetime of corsetry, they did not seem so to the women who sported them.[4] The use of the corset was, in a word, normal.

Nonetheless, its use was also a source of well-documented discomfort. Medical practitioners of the era filled their professional literature with anti-corset diatribes, citing case after case of illnesses brought on by the patient's dress.[5] Even regular wearers who acknowledged the corset as a fashion necessity complained of its unrelenting grip,[6] and advertisements of the day touted special fasteners that allowed a wearer to loosen her stays secretly if she could not bear them any longer.[7] Wearing a corset required something of a sacrifice before its benefits could be reaped, yet most women chose to make that sacrifice and wore corsets from puberty to death. Even as women themselves aged and changed, the corset remained

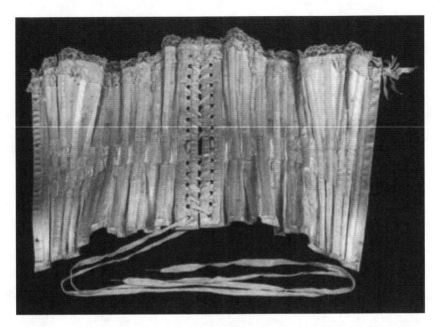

Fig. 7.1. *"608 Pongee" Corset,* ca. 1895, Royal Worcester Corset Company; Connecticut Historical Society, Hartford, CT, 1964 [76.3]. Corset exterior, laid flat.

the same, although many other aspects of dress did not. The sartorial transformations that heralded the process of growing older included the pinning up of long hair, the lengthening of skirts, the acquisition of a wedding ring, the donning of black with the advent of widowhood. Despite these and other outward changes, the corset was an underlying constant in the equation of a woman's dress, no matter what her age or position in life. That women chose to wear corsets despite their considerable inconveniences and that they chose to wear them for a lifetime suggests that the social message proclaimed by the owner of a small waist must have been both highly desirable and highly flexible, able to adapt as women moved from one phase of life into another.

Having understood that women did wear corsets, yet not fully understanding why they did so, we now directly approach the object in question (Fig.7.1). This corset was purchased for the wedding of Lucy Griffith to Charles Johnson Clark on 30 November, 1895, in Oswego, NY, and is currently in the collections of the Connecticut Historical Society.[8] Off the body, the garment is ungainly and awkward despite the elegance of its nuptially-traditional white silk.[9] The corset consists of two mirror-image squarish halves, laced together in the center by a long woven string that

runs briskly in and out of sixteen metal grommets that line each inner vertical edge. The body of the corset is made of pongee, a plain-weave silk fabric that is both light and strong. The two pongee halves of the corset are not laced together directly from top to bottom as a shoe is, but with a slight vertical gap at the waist of the garment. The laces themselves are about 18 inches longer than they need to be to simply hold the corset together. Each half of the corset has vertical edges to the left and right, but the top and bottom edges flow in a rumpled manner, giving the corset a disheveled appearance. The outer edge of each half measures roughly 12 inches, although the top and bottom are capable of being expanded to 17 inches by virtue of gathers in the silk that forms the base of the garment. Twenty-eight fabric-covered stiffeners covered in silk satin, fourteen per half, lie vertically atop this material and lead the eye to the terminating ruff of lace that crowns the corset's top edge. Tiny machine-made stitches (four every 3 inches) hold a horizontal "Y" shape in place between the stiffeners and the main squarish base. These same stitches recur throughout the corset's construction and indicate that is not a handmade object.

The corset is less finished on the reverse (Fig. 7.2). The stays that were covered in satin-weave silk on the exterior are here encased in plain-weave pongee, and a wide, sturdy cotton or linen tape runs horizontally across

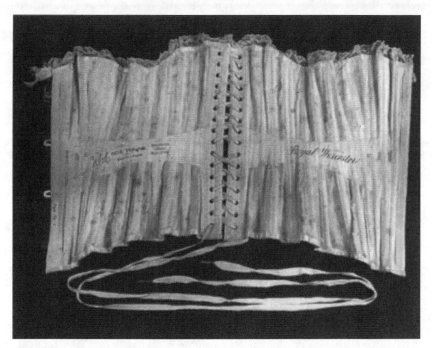

Fig. 7.2. Corset interior, laid flat. Connecticut Historical Society, Hartford, CT.

Styles of Womanhood Embodied in a Late-Nineteenth-Century Corset 131

each half. This horizontal tape bears the trademark of the Royal Worcester Corset Company on one side, with the style ("608 Pongee"), the size ("medium length") and an attestation to the company's use of "warranted genuine whalebone" (i.e. warranted not to break) on the other.[10] An advertisement for the 608 Pongee in an 1891 Royal Worcester catalogue indicates that this was a lightweight corset, a popular model whose delicacy was suitable for a wedding, and shows the range of sizes and colors in which this model was available.[11] Despite some discoloration, the corset looks unused and new, unstretched by its owner and unsullied by the passages of time.

And yet, when analyzed formally, the tidy, efficient corset reveals ambiguous aspects. Thirty-six inches wide at its widest point and only 13 inches tall at its tallest, the horizontal shape initially appears to dominate the overall form. However, the twenty-eight whalebone stays set up a chorus of verticality that de-emphasizes the width of the object; the two orientations conflict with each other beneath the overarching ridge of irregularly wavering lace that undermines them both. The stays themselves are off the true vertical, so the entire vertical/horizontal dialogue seems to take place in a world where nothing is steady or certain. Short, sharp diagonals in the laces, confined by extremely heavy vertical strips of satin where they pierce the fabric of the two halves, are too self-contained to play a dominant role in the pattern of the whole. Vertical contradicts horizontal, straight line undermines curve: this is a fluid object, capable of one visual transformation after another.

The formal ambiguity and uncertainty of the corset when laid out indicates that it was not meant to be appreciated in that position. Indeed, putting the garment on the human body transforms its appearance. The four small metal posts on one outside vertical edge fit neatly into the four correspondingly placed metal loops on the other edge, holding the corset in place (Fig. 7.3). The laces of the corset run down the spine of the wearer and the post/loop connection goes in the front, so that, when worn, the heavier vertical supports on the outside edges of the corset create a smooth line from breast to hips. This arrangement is visually attractive, as the flattened corset's linear discord becomes, in cylindrical form, a harmonious play of lines that swirlingly and gracefully delineate the figure they encompass.

Every part of the corset except the frill of decorative lace at the top has a binding function, forcing the body it contains in at the waist and out at the chest and hips. The cylindrical corset measures 23 inches around the waist and 34 inches around both the bust and the hips, a transition that is accomplished by the grip of the evenly-coursing whalebone. The resulting

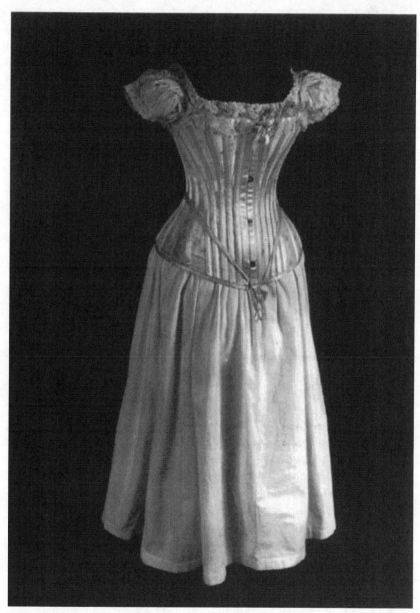

Fig. 7.3. The corset on the female form. Connecticut Historical Society, Hartford, CT.

visual effect is one of "effortless" beauty, but reflection reveals that this effortlessness is the result of considerable strain. Twenty-three inches is small for the waist of a grown woman. The average uncorseted waist of women in the 1890s was between 26 inches and 30 inches, but that does

not make this corset abnormally small; in London in 1886, for example, the average corset measured 23 inches.[12] This differential between the average natural waist and the average corseted waist means that the corset literally reshaped the body that chose to wear it. The corset would thus have to bear the wearer's exertions while squeezing into a garment four inches too small for her, explaining the function of the powerful reinforcing strips visible on the inside of the garment. They not only held the wearer's body in but they also held the corset together when it was subjected to force. This force would ordinarily come from one of two sources, either from the efforts of the wearer herself to tighten the garment, or from the efforts of a second person standing behind the wearer and pulling the corset together in the middle by its long laces. The lacing pattern visible in Figure 1 allows the laces to be tied firmly at the bottom and pulled tight at the waist (Fig. 7.4), wrapping around the wearer and hooking at the bottom of the front of the garment (see Fig. 7.3). That the middle section is the last to be tightened indicates that most of the force exerted in tightening the corset is directed at making the waist smaller. It was possible for the wearer to do this herself, using her forearms for leverage, but the best leverage and greatest effect came with the assistance of a second person. Assistance was also required from another party to adjust the tension of the laces at the top and the bottom of the corset, which are less affected by pulling on the laces in the middle and which the wearer could not easily reach herself without taking the corset off.

While lacing the corset took time, physical effort, and, for greatest leverage at the waist, the cooperation of another person, exiting the corset was significantly easier because of the post and loop connection in front that was within comfortable reach of the wearer who thus had access to an "emergency exit" of sorts through the posts and loops and could escape from the corset's confines by herself if the necessity arose. She could also use the posts and loops to put on the corset unaided, provided that someone else had previously tied the laces at the back with the proper tension while the corset was being worn. In this case, the wearer would not need to retighten the laces every time she put the corset on, but she would still need periodic assistance from another to tighten the strings as they loosened or stretched over time.

This corset, lightweight though it may have been, was anything but "the great HEALTH garment of the age," as the 608 Pongee was touted by the Royal Worcester catalogue to be; the excessive advertised promise of ease and the quick escape mechanism of the post and loops suggests to modern sensibilities that corsets were indeed expected to be uncomfortable and confining. The creation—and maintenance—of a small waist was the

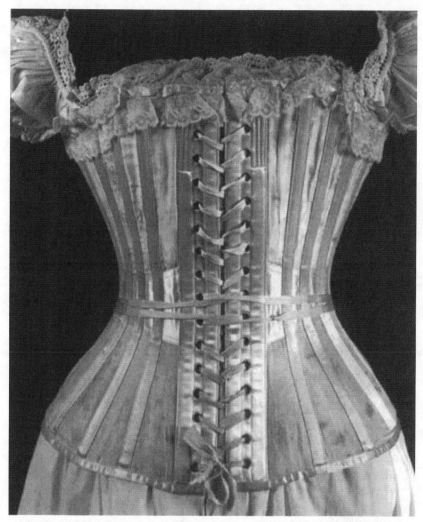

Fig. 7.4. Corset, back view. Connecticut Historical Society, Hartford, CT.

primary intention of the garment, the wearer's comfort a dim second. Advertisements of the day proclaimed corsets' abilities to give "perfect freedom to . . . all the movements of the body," but the confinement suggested by the powerful binding abilities of the garment was confirmed by outspoken women of the period who were adamant about the limitations on movement and comfort to which a corset subjected its wearer. "To expect a woman to perform the simplest kind of exercise healthfully, with her vital organs in a turn-screw and her limbs in swaddling-clothes," wrote dress reformer Elizabeth Phelps in 1873, "is like inviting a martyr on the

rack to have a polka with you."[13] The corset prevented all types of bending from the waist, any form of deep breathing, and sitting in any position other than on the edge of a chair. The wearer could not sit fully on the chair because the busk, the widest and strongest element of the corset that ran down the front and had the duty of keeping the stomach in, would be knocked upwards and out of the clothes by the tops of the thighs when one sat back too far.[14] Any movement that could still be made was altered, often with unhappy results: "A woman writhes, wriggles, jerks, struggles, but never walks."[15] If strolling was difficult, climbing stairs was nothing short of harrowing, with each leg lift threatening to push the busk upwards out of position and place the wearer's entire costume in disarray. Discomfort and constant awareness about the state of one's dress were the result.

Returning from the effects of the corset to the object itself, it must be noted that the corset has an aesthetic aspect in addition to the practical function of reshaping the body that wears it. This attractiveness results in part from the decorative fabrics used in its construction, such as the satin weave covering the stays on the exterior of the garment and the lace edging at its top. Plainer, more ordinary corsets cost between $1.00 and $2.50,[16] but the attractive white silk 608 Pongee was near the top of Royal Worcester's line and cost $3.75.[17] Pongee was regarded as a durable, washable fabric, and was therefore a practical choice for the construction of a foundation garment. However, the non-functional lace and satin used on the outside of the garment suggest that the corset was meant to be seen by someone more worth impressing than a servant or female relative who may have helped with the lacing-in, perhaps a lover and, as we know in this case from its provenance, at least eventually a husband. The corset was covered by the exterior dress so that it remained hidden, its luxury held in reserve for those intimate with the wearer. But despite the silken material on the outside of the corset, it is still relatively rough on the interior and was worn over a lighter, thinner chemise instead of pressing directly against the skin. The wearer's tactile experience was thus one of firm whalebone encased in plain-weave pongee; the gentler satin weave was reserved for those who beheld her. Likewise, the shape that the corset bestowed upon her body was meant less for her appreciation than for the gaze of the public.

That both the richness of the materials involved and the body shape created by the corset were intended for the view of others indicates that the corset was ultimately a public garment, functioning and signifying for the beholder rather than serving the wearer's own delight. This is true despite the corset's role as an undergarment. The corset itself was not meant to be seen, except in the most private of situations, but the results of its action

were. This public role of the corset was further reinforced by the need that someone else be present to tighten the laces most effectively, for even the act of putting the corset on involved for the wearer standing or sitting in the presence and view of others. Due to this firm connection of the corset to the public gaze, we may conclude that the corset's role has less to do with the privacy of its wearer and more to do with her public persona, with the way she wished to appear to others.

Because the corset changes the shape of the body, it is not surprising that some of its most powerful messages to others have to do with the physical or biological status of the wearer. One of the first and most obvious messages transmitted by the body wearing a corset is that of physical youthfulness. A corset creates a slender waist, a flat stomach and delicately swelling breasts and hips and betokens the figure of a recently-matured young woman, a virgin not yet claimed by a suitor. Female waists tend to thicken with age, and the impossibly small waist achieved by the wearer promises the viewer, or visual consumer, that the wearer is young, and, by association, innocent and inexperienced. These virginal qualities are reinforced by the tactile experience of actually putting an arm around a corseted waist, should a would-be suitor be so bold. The female body, with its higher percentage of stored fat than the male, is relatively soft and pliable, a softness also suggested by the appearance of the corset itself, with its delicate fringe of lace at the top and glisteningly carressable satin stays. When actually touched, however, the corseted body turns out to be hard as iron around the waist due to the unyielding whalebone and the tightly compressed body beneath.[18] The vertical stays, in fact, resemble nothing so much as the bars of a cage that emphatically repel the very caresses that the appealing appearance of satin and lace encourage. The corset is thus tactilely deceptive, promising soft femininity but delivering firm rigidity and discouraging suggestions of untoward intimacy.

The iron cage of the corset creates a "touch-me-not" aura of high morality and discipline that went hand in hand with the message of physical youth indicated by the wearer's slim waist. In an era when premarital dalliances were socially unacceptable displays of loss of control, a firm body betokened a firm mind that held a tight rein over the body and the self.[19] Slouching in such a tight matrix was simply not possible; the corseted woman was always physically, and by association morally, "upright."[20] The opposite of this morally upstanding, rigidly controlled lady was the "loose" woman, in whom laxness of attire was unquestioningly equated with immorality. The corset physically distanced the wearer from such dissolute associations, providing her with an armor that set her apart from the profane world. The Worcester Corset Company enhanced

the corset's association with virtuous inaccessibility by calling their line of corsets "Royal Worcester." Actually located in Worcester, Massachusetts, the company had nothing to do with Britain or royalty, yet the name evoked images of well-guarded castles and a queenly distance between the wearer and all who might behold her. The corset thus helped to make the woman who wore it feel inviolable, allowing her to gird her loins against the advances of the world quite literally as well as figuratively.[21]

Another effect of drawing in the waist was the creation of the hourglass figure.[22] The term "hourglass" in relation to the corseted female form conjures up the intriguing image of a woman having her corset pulled more and more tightly around the middle, trying to slow or stop the sands of physical time. Formally, this image is not too far off the mark. As mentioned previously, a corset flattens the stomach, slims the waist, prevents sagging, and firms the torso, giving the wearer a body with all of the attributes of youth. But this body is not too young—the apparently larger breasts created by the narrowing of the waist constructs the body of a young girl recently matured. In fact, the corset itself was a sign of maturity, and its assumption signaled the transformation from little girl to young woman.[23] To have a profile like an hourglass was one way to conserve this delectable stage of youth, this hovering on the threshold of a fuller maturity. As expressed by a London corsetière in 1890, "to preserve the measure of one's waist [is] to preserve the measure of one's years."[24] The very fact that the whalebone strips that give a corset its binding power are called "stays" also implies that the role of a corset is to help a woman "stay" as she is, to halt the passage of time and to stay the spread of her body.

The corset was, however, not a true substitute for the Fountain of Youth. An article in an 1888 magazine promoting "rational dress" for women attributed the lack of physical vitality, the propensity for uterine diseases, and the increase of neurasthenia in older women to the use of corsets.[25] Another article in the same publication a year later again mentions the aging properties of the garment: "With the complete attainment of the dressmaker's ideal waist, the gladness which comes in youth from a sense of vigorous health is at an end."[26] Beyond the mere sapping of youthful zeal, however, the corset was guilty of even greater thefts of life force. Horror stories of death by corsetry abounded, none more gruesome than the 1859 account of a girl whose liver was bored through by three of her ribs, and none more unfortunate than the 1860 account of a twenty-one-year-old London prostitute whose cause of death was listed as "syphilis, consumption, and corsets."[27] Granted, not many women were killed by their corsets; the majority of women merely lost the spirit and energy of youth even as they attained its physical shape.

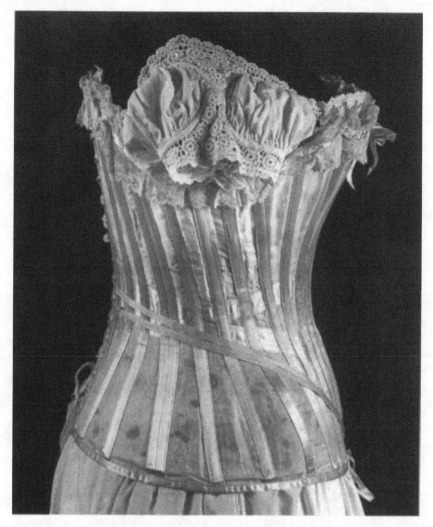

Fig. 7.5. Corset, side view. Connecticut Historical Society, Hartford, CT.

Just as the corset itself contains many formal contradictions—such as the play of vertical against horizontal lines—so too the messages created by the corset's action on the human body are varied and apparently contradictory. The corset may inform its viewers that its wearer is young and untouchable, but it also has formal associations evocative of motherhood and a woman's reproductive role. Seen from the side, the upper half of the garment looks very much like the profile of a coal scuttle or pitcher (Fig. 7.5). Both are containers, but the latter is perhaps more relevant, as pitchers can hold milk just as female breasts do. If the corset/pitcher were to be

tipped as if to pour, any liquid that it contained would flow from the breast region, creating a visual metaphor for the flow of milk from the breasts. This harkening to the role of motherhood is complemented by the apparent enlargement of the hips, created by their juxtaposition with the reduced waist, that suggests the wider lower body that results from successful childbearing.

This image of motherhood combines with that of moral virginity with interesting results. With such a small waist, the fiction of never having actually borne children was formally inescapable, despite the suggestion of motherhood contained in the relatively larger breasts and hips that were also produced by the corset. The two principles, however, are equally supported by the corset, so that neither one overwhelms the other. The dual image of the "Mother/Virgin" is an attractive one, creating a woman for display with all of the allure and none of the faults of each category. The makers of corsets played on the attractive duality of coincident maternal production and virginity in their advertisements. Royal Worcester trade cards, small slips of cardboard printed with appealing pictures on one side and corset price lists on the other, typically featured the image of a little girl holding a baby doll. Such drawings combined the notions of innocence and motherhood in the gentlest of ways. In one less subtle trade card image, an infant wearing a black corset declares, "Papa, see, I have on Mama's Royal Worcester corset," associating the garment with ideals of both chastity (the child) and reproductive ability (the Mama) while reinforcing the corset's appeal to an external male gaze.

There was little doubt that it was the corset's attractiveness to men, its ability to draw this acknowledged male gaze, that kept it so popular for so long.[28] The importance of men in the propagation of corsets was condemned again and again by doctors and dress reformers. "If men would refuse to marry women who wear corsets, how long would it be before corsets are out of fashion?" asked one doctor in 1886.[29] For no matter how attractive the Royal Worcester Corset Company's advertising department may have thought innocence and motherhood to be, the heart of a corset's drawing power for men surely lay in its sexual messages. Even as the corset narrows and tightens the waist, giving the wearer the reassuring feel of possessing moral armor, it pushes the hips down and bust up, causing these to become the largest and most noticeable parts of the body to the eyes of the viewer. In point of fact, the corset actually *discovers* the chest and hips, creating a confusing dynamic between the protection felt by the wearer and the revelation perceived by the viewer. The breasts are especially altered by this treatment, as the corset forced women to breathe with the upper half of their lungs, an action that made the chest swell and

expand with regularity and created the poetic "heaving bosom" of the damsel in distress.[30] The small waist created by the corset thus becomes nothing more than a clever use of negative space to emphasize the large size and attractive quality of the breasts and hips of the wearer—a sexual effect not lost on writers of the time.[31] The sartorial emphasis on the erotic zones of the female body even caused one perceptive woman to liken the female style of dressing to a perpetual and rather indecent marriage proposal.[32] The small waist became a "safe zone" of sorts, a relatively unerotic part of the body that could be mentioned in everyday conversation. Remarking on Miss X's slender waist was a more acceptable way of noting what a comparatively large chest she had. Such emphasis on the female erogenous zones stood in direct opposition to the message of high morality given by the cage-like aspects of the corset. The two diametrically opposed poles did not cancel each other out, but existed simultaneously and created a tension between the moral and immodest qualities of the wearer that remained formally (if not experientially) unresolved.

Consonant with this moral tension in chest and hips, the flat stomach of the corset creates an opposition to the ideal of motherhood that also carries sexual connotations. The emphatically slim torso of the corseted figure not only promises youth, but also contradicts the idea that this same stomach could become a belly swollen by pregnancy. When such a flat stomach is contrasted with the appearance of the artificially enlarged bosom and pelvis above and below, the enticing prospect of liaisons without responsibilities or after-effects is raised. Furthering this idea of impregnability is the fact that corsets were actually known to cause miscarriages. In a society where knowledge of birth control was rudimentary at best, the corset was one of the most widely recognized means for getting rid of unwanted pregnancies.[33] Jokingly referred to as a tool of the prostitute's trade for that very reason, corsets were also responsible for miscarriages and stillbirths among the more respectable classes.[34] As corsets were usually worn during the first two-thirds of pregnancy, albeit increasingly more loosely, accidents could happen—and did.[35] This rather grim aspect of corset wearing only reinforces the idea that a man could "liaise" with a corseted woman and avoid any repercussions, creating the image of the woman as a source of physical pleasure above and beyond her roles as mother and virgin.[36]

Sex appeal, however, differs from the appeal to maternal virtue or virginity in its anticipation of the corset being taken off. The salient image here is that of the "loose" (or simply "loosened") woman who sheds her morals as she sheds the confines of her clothes. The bursting-forth, releasing experience felt by the wearer as she removes the corset and her waist once again expands to its natural 27 inches is an anticipation of the pleasurable release

of sexual tension. In addition to these sexual implications, the dynamic between tension and release has social overtones as well. Women acknowledged as being "loose" had turned from the tight morality demanded by nineteenth-century society and had chosen to follow another path. Being "loose" implied a certain level of freedom from social mores but also meant being excluded from the mainstream of society, being someone who was not "the kind of girl you would take home to Mother." Stepping outside the tight bars of the corset's whalebone implied stepping outside of society itself. The corset, in this light, becomes a symbol of acceptable behavior, of civilization, and a metaphor for the rules that governed those who lived in that society.

Despite the corset's embodiment of social control, it could accomodate a variety of roles and moral stances as we have seen, all formally supported by the shape of a woman's corseted body. That some of the roles seem to contradict each other—nurturing mother, sexy harlot, touch-me-not virgin—tells us that the woman who wore a corset was not simultaneously all three things (though of course the possibility of slippage always existed). Instead, the corset's support of multiple roles allowed it to remain relevant as the woman herself developed over time and her position within society changed. Within the context of being a wife, for example, a woman went from being a pure, virginal girl to being married. Immediately after marriage, she could play the role of "honeymoon harlot," in which she was expected to remove her corsets—now that she was protected by the moral framework provided by marriage—in order to have romantic liaisons with her husband. Without this step, she could never attain the next and final phase, that of motherhood. Throughout this socially sanctioned progression, the shape of the corset remained the same, though its ultimate message to others would be filtered and supplemented by other sartorial cues. For example, a corseted woman with a high-necked dress and unbound hair was visibly in the virgin phase, and a corseted woman with a low-necked dress in a certain range of styles could be supposed to be a harlot. No matter what her actual role, the corset was her constant companion, for with the proper accessories it was able to support and define the woman's role at any stage along the way.

All of the messages held in the shape of the corseted body revealed so far have been mutable, changeable to fit the particular circumstances of the woman who possessed it. She could be young, a mother, with high morals or low—no one interpretation of either her biological role (mother, virgin, and harlot all having directly to do with how a woman uses her body and its reproductive functions) or her level of virtue is supported by the corset over another. However, the corset also carries additional layers of meaning

that remained constant whatever the wearer's biological or moral state, meaning that has more to do with the overall position of women within society than with one woman's current role at a single given point. No matter what else a woman wore, the basic fact remained that the corset's shape was always meant to be seen and interpreted by others. This implies the presence of others, a viewing audience, at every stage in her life. Further, the biological roles suggested by a formal analysis of the corset—virgin, harlot, mother—are all defined by a woman's relationship with others.[37] Even more important than suggesting the presence of others in a very basic biological relationship with the wearer, the corset itself dictates the tone of that relationship. Although the wearer was able to don the corset by herself, the most effective binding function was provided when another person was on hand to arrange and tighten the laces, as much greater leverage could be achieved by a second person than by the wearer herself. By requiring someone else to stand behind the wearer and tighten the laces when the corset is put on, the corset makes its wearer dependent on those others in her life. This dependence comes from both the need for someone else to help the wearer into the garment and from the fact that the corset exhausted its wearer and prevented her from performing any task that required more than a mild amount of physical exertion.

The corset, in fact, rejects the suggestion of physical labor in its shape as well as its function. When seen from certain angles from the side, the inward curve atop a matching outward curve of the corset bears a striking resemblance to a sheaf of wheat (see Fig. 7.5). The vertical stays echo the stalks of wheat, and the lace at the top of the corset suggests the full-bodied heads of grain that surmount the stalks. In the harvest, the sheaf represents the near-final stage of production; the wheat has been grown, cut, and gathered—all the most taxing physical labor has been done. The smooth geometric form and aesthetic beauty of the sheaf becomes a symbol of bounty, masking the amount of rough work necessary to get the wheat to that stage. So, too, does the figure of the corseted woman become a symbol of laborless abundance. Childbearing increases the hips and chest of the mother, but also tends to increase the waist as well. The corset flattens the stomach of the wearer, so she projects the conflicting and enticing message that she has gone through childbearing and proved her reproductive ability without suffering through the grueling and belly-enlarging process of labor in the birth sense. The sheaf and the corset shape, then, both promise abundance while formally denying that grain or children require effort to create. In this way, the corset also downplays the creative and action-initiating possibilities of the woman wearing it, even in the role of motherhood.

The idea of living a "laborless" life has certain social and economic overtones that also accompany the wearer of the corset no matter what her actual station in life. Thorstein Veblen explored these economic meanings in *The Theory of the Leisure Class* (1899), in which he coined the phrase "conspicuous consumption" to describe how the elite of his day used far more material goods than they needed to demonstrate how wealthy they were to those around them. In this view, which also presupposes an audience for the corset-wearing woman, Veblen found women's dress to be as conspicuously consumed as unfinished roast pheasant and country estates purchased for seasonal use. Not only were women's clothing styles sumptuous beyond reason, but they also incapacitated the wearer to the point where she could do no useful labor whatsoever.[38] He singled out the corset for special attack: "The corset is, in economic theory, substantially a mutilation, undergone for the purpose of lowering the subject's vitality and rendering her permanently and obviously unfit for work."[39] According to Veblen, unfitness for work indicated that the woman was wholly supported by the man on whom she depended, since she could do no work of her own. A woman's job was merely to display the wealth of her "master," a role that ultimately reduced her to the status of just another parlor-shelf object. The corseted woman, in short, represented the conspicuous consumption of a life. The irony in this view is that while the corset did prevent women from performing many actions, it also made the things that she was able to do many times more difficult, so that even the lightest of tasks became a laborious ordeal.[40] The corset denied the possibility of labor both formally and functionally, and kept the woman who wore it in a state of dependence on those around her. It is important to note, however, that any woman who wore a corset had made an active choice to do so—she was not the victim of the corset. Rather, its wear represented a certain economic and social situation and implied that, since the wearer was unable to act, she must be surrounded by others who were able to do physical tasks for her. Whether these tasks were performed by a husband or servants, the message for her audience was that the wearer was wealthy enough to be cared for.

No matter what a woman's role or position in life, her corset remained relevant and enabled her to reshape her body in a way that broadcast the most attractive messages possible to her surrounding audience. But more than conveying mere attractiveness to men, the corset placed its wearer into a defined role in society, a role based on both her biological functions and how far she had made those functions available to others. By suggesting that another person be present when putting the corset on to achieve its maximum potential, the corset also located its wearer within a larger

household. The members of the household could be protectors (parent/husband), allies (sister/friend), or the protected (children/servants), but the basic fact is that the corset-wearing woman was rarely a woman alone. A wholly independent life was difficult to sustain if the woman in question wished to remain properly dressed. As few women would refuse to live alone merely because of the difficulty of finding someone to assist with tightening their stays in the morning, the corset reflected the expectations of the day rather than dictated them. To women one hundred years later, these expectations that a woman simply would not be independent and would depend fully on someone else, most likely a husband, are perhaps even more confining than the corset itself.[41] But to the women and men in the 1890s, the corset stood for adherence to social rules, the preservation of youth, a certain level of economic attainment, a specific sexual role for the wearer, and the suggestion of a certain moral standard: in short, the corset represented a level of security within society not unlike the security perceived by the woman actually wearing the object.

Because the corset emphasized roles in which women were not only related to other but also dependent on them in everything from earning a living to lifting heavy objects to getting dressed in the morning, the woman who chose to wear one signaled her acceptance of a position within a defined social framework in which she was not primary actor. It is no coincidence that the corset lost favor as women gained social autonomy and began to act in ways that transcended the story of biology and dependence told by the corset. A corset offered its wearer beauty, attractiveness, the appearance of morality, and the security of a defined, understood place within society. However, these benefits came at a price, and as women discovered that they preferred physical mobility and the ability to live without dependence on others, the price exacted by wearing a corset eventually became too high to pay.

NOTES

1. Valerie Steele, *Fashion and Eroticism* (New York: Oxford Press, 1985), 108.
2. Ibid., 161.
3. Laura Ingalls Wilder, *Little Town on the Prairie* (New York: E.M. Hale and Co., 1941), 86–87. It is not surprising that pioneer women wore corsets, despite the amount of physical labor required of them. The goal of early settlers was to tame the great western wilderness, civilizing it with every means at their disposal. Corsets, like any other type of invention that controls nature to meet human whim, were considered symbols and even tools of civilization.
4. David Kunzle, *Fashion and Fetishism* (Tatowa, N.J.: Rowman and Littlefield, 1982), 309.

5. John and Robin Haller, *The Physician and Sexuality in Victorian America* (Urbana, Ill.: University of Illinois Press, 1974), 170.

6. Wilder, *Little Town*, 87.

7. See "The Magic Corset Clasp," *The Ladies' Home Journal* 9 (April 1892): 22.

8. Connecticut Historical Society, Hartford (#1964–76–3). My thanks go to Pamela Cartledge of the Society for allowing me to analyze the corset in 1988, and to Susan P. Schoelwer and Adrienne Saint-Pierre for their assistance in the preparation of this article ten years later.

9. Kunzle, *Fashion and Fetishism*, 31.

10. Elizabeth Stuart Phelps, *What to Wear?* (Boston: James R. Osgood and Company, 1873), 66.

11. *The Ladies' Companion: A Hand-Book of Royal Worcester Corsets* (Worcester, Mass.: Worcester Corset Company, 1891), 6.

12. Kunzle, *Fashion and Fetishism*, 309–11.

13. Phelps, *What to Wear?*, 68. Phelps was the American founder of the anti-corset dress reform movement, so her comments may be exaggerated in the interest of her cause. The experiences of which she speaks, however, are echoed in other literature. See *A Modern Hygeian* (Boston: George Frost and Co., 1891).

14. Haller and Haller, *Physician and Sexuality*, 164.

15. Phelps, *What to Wear?*, 68.

16. See *The Ladies' Home Journal* 9 (April 1892): 22.

17. *The Ladies' Companion*, 6.

18. Recounted in the contemporary accounts of several men who were surprised to find such unexpected firmness (Kunzle, *Fashion and Fetishism*, 329).

19. Haller and Haller, *Physician and Sexuality*, 148–49.

20. J.C. Flügel, *The Psychology of Clothes* (London: Hogarth Press, 1930), 76.

21. Steele, *Fashion and Eroticism*, 176.

22. The term "hour-glass" was used to describe a woman's figure as early as 1891 (see *A Modern Hygeian*, 33).

23. Wilder, *Little Town*, 87.

24. Quoted in Kunzle, *Fashion and Fetishism*, 322.

25. *Rational Dress Society Gazette* 1 (April 1888): 4–6.

26. Ibid., 5.

27. Kunzle, *Fashion and Fetishism*, 124–25.

28. The erotic qualities of the corset, in fact, have turned out to be the most enduring ones; today, corsets are found in sex shops more often than on the bodies of "respectable" matrons.

29. Dr. M. T. Runnels, cited in Haller and Haller, *Physician and Sexuality*, 148–49.

30. H. T. Finck, "On the Evils of Wearing Stays," *The Rational Dress Society Gazette* 1 (April 1888): 6.

31. These writers were largely physicians, who could discuss the erogenous zones of the female body clinically and get away with it—not many others could (Haller and Haller, *Physician and Sexuality*, 159); see also Steele, *Fashion and Eroticism*, 180.

32. Phelps, *What to Wear?*, 74.

33. Eugene Becklard, *Becklard's Physiology* (Boston, 1859; reprinted in *Sex for the Common Man*, New York: Arno Press, 1974), 66.

34. Kunzle, *Fashion and Fetishism*, 44, 124.

35. Phillis Cunnington and Catherine Lucas, *Costume for Births, Marriages and Deaths* (New York: Barnes and Noble Books, 1972), 15–17; Emma M. Hooper, "Hints on Home Dressmaking," *The Ladies' Home Journal* 9 (1892): 26; and *A Modern Hygeian*, 22–25.

36. The "corseted-woman-as-harlot" image receives further support from the biological sciences. Studies have shown that men prefer women with larger breasts, all other things being equal, describing such women with favorable adjectives such as "provocative" (see Daniel Freedman, *Human Sociobiology* [New York: The Free Press, 1979], 106). Since the size of a breast has little connection with the amount of milk produced, it is possible that breasts have a function not unlike that of the tail of a peacock: in addition to a basic functional role (production of milk, rudder during flight), breasts and peacock tails act as an attractive force for the opposite sex (see Freedman, *Human Sociobiology*, 106). And as far as the opposite sex is concerned, bigger seems to be better. In the world of the peacock, this has led to the evolution of extremely ungainly tails, while in our own society, it has contributed to the development of the corset, the push-up bra, and perhaps even the modern popularity of breast implants.

37. In socio-biological terms, a virgin is a woman who has not yet mated with others, a harlot is a woman who is available for mating with others, and a mother is a woman who has mated and produced offspring.

38. Thorstein Veblen, *The Theory of the Leisure Class* (New York: The Modern Library, 1934), 167.

39. Ibid., 172.

40. Phelps, *What to Wear?*, 5–37; see also *A Modern Hygeian*, 3–6.

41. It is significant that the corset, whose use demanded the aid of another person, evolved in the first half of the twentieth century into the girdle, which also bound the waist and hips of the user, but could be put on and taken off by the wearer on her own. The girdle is also more flexible than the corset and allows a greater range of motion. The slow transformation from corset-wearing to girdle-wearing roughly mirrored the changes in society that allowed women more freedom in their social roles over the same period.

Joel Pfister

A Garden in the Machine: Reading a Mid-Nineteenth-Century, Two-Cylinder Parlor Stove as Cultural Text

SUPERFICIALLY, NATHANIEL HAWTHORNE'S "Fire Worship" (1843) presents a charming sketch about the increasing popularity of parlor stoves. But Hawthorne's imaginative engagement with the stove has a critical edge: the stove has become an object of his cultural concern because its widespread use has produced a "great revolution in social and domestic life." The open hearth is romanticized as a symbol of the orderly, preindustrial community within which beliefs and bonds of allegiance were unambiguous and firm: "While a man was true to the fireside, so long would he be true to country and law, to the God whom his fathers worshiped, to the wife of his youth, and to all things else which instinct or religion has taught us to consider sacred."[1] By contrast, for Hawthorne's narrator the iron stove symbolizes the incursion of a fast-changing industrial world into the home.

At a time when factories began to dot New England's landscape, the industrial associations of the stove evoked an exploited laborer-in-confinement. "Alas! blindly inhospitable, grudging the food that kept him cheery and mercurial, we have thrust him into an iron prison, and compel him to smoulder away his life on a daily pittance which once would have been too scanty for his breakfast." Although fire enabled mankind to construct the industrial world with its "steamboat" and "rail-car," men have now made this productive element an airtight "prisoner of his cage." Rather than offering a metaphorical window on a better world, like the hearth the stove entombs voices of the damned: "Voices talking almost articulately within the hollow chest of iron . . . my firewood must have grown in that infernal

Reprinted from *Technology in Society*, vol. 13, 1991, pp. 327–43, with permission from Elsevier Science.

forest of lamentable trees which breathed their complaints to Dante."
These "sighs, burdened with unutterable grief" are also imagined as threat-
ening the (middle-class) home: "We tremble lest he should break forth
among us."[2]

Hawthorne's stove not only connotes anxieties about industrial trans-
formations of work; it signals a new kind of airtight domestic arrangement.
The narrator links the obsolescence of the hearth to the emergence of a
new domesticity characterized by the emotional isolation of individuals
from one another: "Domestic life, if it may still be termed domestic, will
seek its separate corners, and never gather itself into groups."
Conversation "will contract the air of debate." Family members will be
more airtight, uptight, and unrelated than ever.

With my historical curiosity sparked by Hawthorne's view of the stove
as an agent and symbol of social change, I descended into the labyrinthine
underworld of the New Haven Colony Historical Society's basement in
search of a mid-century parlor stove to find out what it could tell me. The
stove I found took me by surprise, partly buried by a pile of boxes. Not the
conventional pot-bellied type I had expected, it looked, rather, like a large,
iron toy—a black, Gothic castle comprised of twin towers, connected by a
tubular bridge, and crowned with turrets. The twin towers, though metal-
lic and machine-like, sprouted icons of nature—foliage, vegetation—too
plentiful and elaborate to take in at a glance. As I kneeled down to admire
and touch its bucolic ornaments and figures, I was reminded of Leo Marx's
classic, *The Machine in the Garden* (1964). With the stove before me, and
Hawthorne's sketch as well as Marx's book in mind, I found my historical
imagination questioning the cultural meanings of a garden in the machine.

This was the commencement of a decade-long dialogue between the
stove and myself, a dialogue which revealed much about the stove's tech-
nological, cultural, and ideological context. Our exchange required that I
fuse close, formal reading, some "common sense," occasional speculation
(for which Hawthorne set the precedent), and historical research.[3]
Questions opened up by this polyvalent technological "text"—about mid-
nineteenth-century cultural roles, pressures, and anxieties—have enriched
the critical perspective that I bring to my reading of contemporary written
sources, such as Hawthorne's writings, and historical studies based on doc-
uments, such as Leo Marx's work. I share the specifies of our encounters
below.

My first response to the stove, as I noted, was tactile. The stove's jet
black, cast-iron parts invite one's touch, while the smooth, shiny sheet iron
has optic rather than haptic appeal. Its twin cylinders as well as most other
parts are made of sheet metal, unless indicated otherwise. Each cylinder

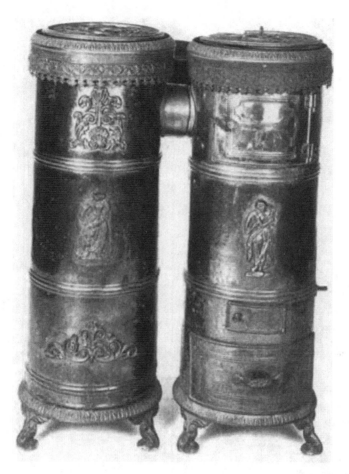

Fig. 8.1. Two-Cylinder Parlor Stove with Crowns (mistakenly placed upside-down), ca. 1845. Courtesy New Haven Colony Historical Society. Photo: Joe Szaszfi.

(ht. 33 ¾ inches, d. 10 ¾ inches) rests on three short, cast-iron, S-shaped legs and is crowned with a crenellated band decorated with what resemble tiny, black bushes, trimmed symmetrically (Fig. 8.1). A pipe, almost 2 feet off the ground, links the two cylinders. At the same height, in the rear, an identical cylindrical pipe extends from each cylinder and joins a rectangular pipe.

Each cylinder is divided vertically into three sections by smooth moldings, which rise slightly from the surface. In the upper section of the left cylinder, a lyre-shaped piece, mostly foliage, points to the crenellated top. Of greater interest is the sheet iron figure in the middle section: a young

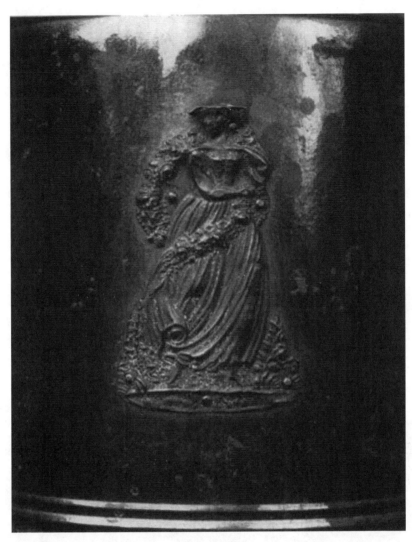

Fig. 8.2. Sheet-Iron Figure, Left Cylinder. Courtesy New Haven Colony Historical Society. Photo: Joe Szaszfi.

woman attired in a nineteenth-century version of Elizabethan-style pastoral dress. Her face and hat are partially broken or melted (Fig. 8.2). The figure is holding in her right hand a large floral wreath, which arches over her right shoulder. She is walking or dancing at a slight angle to the right, and is looking downward. Her left arm rests over her bosom, thus drawing the observer's gaze to the latter. The lower section of the cylinder sprouts a floral decoration of vines, which, like the lyre floral pattern,

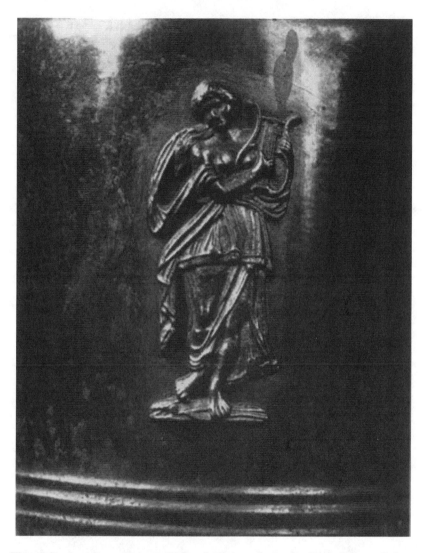

Fig. 8.3. Cast-Iron Figure, Right Cylinder. Courtesy New Haven Colony Historical Society. Photo: Joe Szaszfi.

points up to the crown. The S-shaped legs supporting both cylinders sprout leafy clusters, perhaps wheat or palms.

Looking up from the legs to the lower section of the right cylinder, one sees an oval flower adorning the handle of a removable door. But, again, what attracts the eye is the middle section, in which a young person, made of cast-iron, is suited in classical garb and is playing a lyre (Fig. 8.3). The breasts are small but convex; the legs somewhat thick; the biceps not devel-

oped; the feet not particularly large; neither the thick hair nor its styling indicate gender. No shirt is worn, but a diaphanous material flows behind the body and could suggest a feminine wearer. It could be a muse, or even Sappho singing her love lyrics. The melancholy air of the lyre player, however, also carries orphic associations. The musician's drapery, which hangs over the right shoulder and loops over the right arm, is similar in form to the part of the floral wreath that extends over the pastoral figure's right shoulder to her right thigh. Both drapery and wreath approximate the form of a question mark—which is appropriate, because this pair provokes many questions.

Are they, for instance, rulers of the domestic hearth? The two crowns may be read as symbols of a technological triumph over both fire and the blustery whims of Nature. Perhaps the stove can be taken as celebrating the victory of Yankee ingenuity in the republic, making every man a King, every woman a Queen. Given the luxuriance of pastoral iconography, the stove seems to announce itself as a technological innovation that enables its owners to turn the home into an arcadian castle in the chill of winter.

The stove, however, like Hawthorne's sketch, also invites readings that contest optimism about technological "progress" in the home. The pastoral woman and the classical lyre player do not appear victorious. Their gaze looks downward, as if in subjection, and their spirits seem grim. Bolted into place, they remain banished from one another on their respective cylinders (stove-heated family members, wrote Hawthorne, "will seek separate corners").

The presence of figures on the two cylinders seems to call for a narrative to link them. Inferring the mood of such a narrative from the stove's appearance, it would be elegiac. The exterior blackness contributes to the stove's funereal aspect. Although the figures on the cylinders are expressionless, the tilt of their heads appears melancholic. The lyre player is, perhaps, strumming a lament. It may be this dirge that makes the woman on the adjoining cylinder seem mournful. The bush garden ornamenting the crown could almost be a graveyard. Bits of coal that fall to the ashpit or the crackle of combustion in the firebrick chamber might suggest to the imaginative auditor a crematorium: "Ashes to ashes, dust to dust." Hence the two-cylinder stove, like the Dantesque one described by Hawthorne, seems more like a doleful monument to life past than life present or life future.

Given these funereal associations, perhaps the pastoral woman on the left cylinder is Proserpine, who was abducted by Pluto, and taken to the underworld. The underworld union of Pluto and Proserpine is central to the mythological account of the seasons. Her abduction cast the earth into

a year long winter. Ceres, her mother, goddess of agriculture, bargained for the seasonal return of her daughter by allowing the earth to be warm, green, and fecund again for six months. But the earth stays barren for the rest of the year, while her daughter is lost to Hades. The bucolic stove is like a technological Proserpine who brings summer warmth to the parlor during the cold months.[4]

The demeanor of these figures is also like what one would expect of Orpheus and his newlywed, Eurydice. As Ovid tells it, evil omens marred their marriage. Just after their wedding, Eurydice, while wandering through a meadow, was bitten by a snake and died. Pursuing Eurydice to Hades, Orpheus strummed his lyre and sang to warm the sympathy of the King and Queen of the underworld, until at last they, too, lamented the untimely death of his bride. Orpheus was permitted to escort Eurydice from "the shades" on condition that he not look back but, instead, have faith that she followed. He could not resist viewing his peripatetic bride, however, and, as he glanced at his lost loved one, lost her again to the "dismal regions" forever.[5] According to the myth, the strumming of Orpheus could charm animals and animate objects. Thus it is interesting that the feminized orphic figure is attached to the cylinder in which the fire is built and comes to life. Still, the somber orphic associations of this parlor stove also reference the narrative of a domesticity that never was and a union that never blossomed.

The arcadian stove speaks more of division than unification, for the lyre player is separated from the pastoral female in several ways. This cast-iron musician has well defined features. Its cylinder, as I noted above, is fitted with doors and is visibly functional: it holds the fuel and generates the heat. The pastoral female figure, by contrast, is fragile; her facial features are ill defined, and the function of her decorative cylinder is not apparent. While the right cylinder generates the heat, the hidden function of the other cylinder, as heat exchanger, is to transform this heat into warmth to make the home cozy. The heat exchanger is empty, a cylinder within a cylinder, like a womb. "Dumb stoves" are hollow, usually decorative, metal structures constructed to radiate warmth. They are dependent on the heat supplied by a fuel-burning stove linked to it. The cylinder to which the pastoral woman is confined is such a dumb stove. On close inspection, the two cylinders are bridged by not one but two pipes: a "male" pipe (right cylinder), unseen by the observer, is inserted snugly into the "female" pipe (left cylinder). If the pastoral woman is dancing (through the meadows like Proserpine or Eurydice?), is she stepping to a tune imposed by another? With these comparisons in mind, the form and function of the stove may be said, in part, to express contemporary stereotypes of gender roles.[6]

Bearing in mind Hawthorne's sketch, the two dolorous figures may also be interpreted as lamenting a "world we have lost." In the young American republic, crowns could have represented not victory but pollution, corruption, death, and tyranny. These crowns, in particular, with their abstract resemblance to gardens, might suggest that republican ideology, at first inspired by dreams of an agrarian society, is now endangered by the tyranny of technology. It is the stove's cylinders, not the figures, who wear the crowns. Both classical lyre player and pastoral woman have become reproducible, decorative patterns *bolted* to the stove. In its technological triumphs over nature, the machine may have *replaced* the garden—a garden not of an arcadian republic but of a technological underworld.[7] In this light, the stove is anything but an unambiguous celebration of domestic warmth and fertility. Rather, it simultaneously expresses contemporary anxieties that the home has been invaded.

Along with its funereal characteristics, there is spirited, crackling, impish life in the stove. Its intense heat both threatens (as Hawthorne observed) and appeals to the stove's owners. The sculpted, cast-iron decorations and the intricate, crenellated crown invite touch, but are capable of scorching flesh. This smoldering iron creature, undomesticated by the "civilized" bucolic iconography covering its body, might sate its appetite when least expected. Smoke could choke one if the stove were to let it escape.

Because the placement of the stove can extend into the interior, it is capable of radiating greater warmth to more areas of the room than the stationary hearth, and thus makes its space more habitable during winter months. Its fertile ornamentation is appropriate, for the heat that radiates from the interlocking cylinders also provides fertile possibilities for domestic intimacy. In parlor or bedroom one can dress or undress comfortably in front of the stove, and engage in a range of private activities inspired by its warmth. The grates inside the crowns, which each contain six hearts centering on a looped point (resembling filigreed breasts), may symbolize the affections the stove can arouse.

A good deal of the stove's playful appeal lies in handling it, discovering how it can be dismantled, and deducing how it works, along the lines of a big toy. The stove's filthy and rusty parts confirm that it has hosted many fires. Isinglass windows were meant to be a token concession to the family accustomed to basking in the glow of an open fire. But no real fire can be appreciated through them, and they undoubtedly blacken quickly. One cannot touch its interior and areas of its exterior without getting soiled. But—my students would agree—the pleasure of exploring the machine overwhelms one's reluctance to get dirty.

One can imagine the difficulties its owners must have experienced in keeping their parlors or bedrooms clean during the winter months. The open doors suggest it is a hungry creature that demands to be fed, emptied, and cleaned in exchange for the warmth it radiates. It transforms coal or wood into ashes, which threaten to sully the environment it makes habitable. Like a human being, it grows dirtier when it wallows in its own refuse, and therefore it must be attended.

Ashes can be emptied into the ashpit area at the base of the right cylinder by pulling the handle of the cast-iron grate stick, which supports the middle section of the grate. Since the interlocking cylinders can be detached from one another easily, they can be carried perhaps outdoors and cleaned. The inner cylinder of the left column can be removed and brushed off. Refuse in the bottom of the inside of the left cylinder can be disposed of by removing a small, rear slide door and tilting the column so that the dirt falls out.

Coal or wood can be put into the right cylinder by opening the large upper door—the fire door—or by removing the crenellated band and its inner grate and loading from the top (Fig. 8.4). Once the kindling is in place, it can be ignited through a small door under the fire grate; after the fire is started, coal can be loaded into a space surrounded by firebrick. To

Fig. 8.4. Interior of Right Cylinder, Showing Firebrick and Cast-Iron Grate. Courtesy New Haven Colony Historical Society. Photo: Joe Szaszfi.

achieve maximum combustion, the fire requires adequate air. Thus the small door below the fire grate—the airflow door—can be left open along with two discs—dampers—on the rear pipes. The fire will suck in air from the room. As the fire gets going, both dampers can be shut and the airflow door closed to retard the rate of combustion.

The left cylinder acts as the principal heat exchanger, but heat also radiates from the rear pipes, crowns, and that part of the right cylinder above the firebrick. Hot air and smoke rise from the right fire chamber, flow through the connecting pipe, and circulate in the narrow space between the left outer and inner cylinders. Gradually, the smoke emerges through the flue of the rear pipe on the left. The heat radiated outward by the left cylinder warms the room, while the heat generated inward through the inner cylinder creates an air flow in its middle space with hot air rising through the crown grate. The quantity of coal that can be loaded and the airtightness of the structure would determine how long the stove could generate heat without being refueled.

Two-cylinder parlor stoves seem to have been rare. There are no markings on the stove that indicate either the manufacturer or the date of construction. In the many photos, trade catalogues, advertisements, and drawings of stoves I have examined, only two advertisements depict similar stoves. One advertisement is in the "Annual Advertiser," collected in the *New Haven Directory for 1842–43*. Called a "cylinder stove," it is depicted under the banner, "Olmsted's Patent Stoves." It is black, has two cylinders, two crowns, is divided vertically into three sections, and sprouts abundant floral iconography. However, there is neither lyre player nor pastoral woman in the middle sections, nor are the crowns crenellated. The major structural difference is that the advertised stove was designed so that the "dumb stove" is lined up behind, rather than adjacent to, the heat generating cylinder.[8] The other advertisement, published in Portland, Maine, in 1836, is also for "Olmsted's Patent Stove" and depicts a three-cylinder parlor stove. The central heat-generating cylinder has two doors, floral iconography, and a convex top, while the heat exchanging cylinders on both sides of it are bedecked with floral iconography and are adorned with crowns. This evidence dates the two-cylinder stove, perhaps manufactured by Olmsted, to the late 1830s or early 1840s.[9]

Two-cylinder box stoves, which often sprouted vegetative or floral iconography and were influenced in style by the Greek revival, were popular in the 1840s. Both the lyre player and the cylinders (columns) are signs of the Greek revival. Crowns, lyre ornaments, and figures of arcadian women are common decorative features of American stoves manufactured in the mid-nineteenth century.[10]

The design principle of the two-cylinder stove also supports the probability that it was manufactured in the 1840s. Both Alexander Jackson Downing, in his chapter on heating and ventilation in *The Architecture of Country Houses* (1850), and the anonymous author of "Heat and Ventilation" (1851) endorse Dr. Clark's ventilating stove, used widely in Boston. This stove consists of an inner cylinder that contains the fire and is covered with an outer cylinder that opens at the top. When the inner cylinder is heated, an updraft of warm air is established in the space between it and the outer cylinder. This is the same principle as the inner column of air moving up the center of the left cylinder in the two-cylinder stove. The idea of both stoves is to create a circulation of hot air and eliminate the fire box as the main heat exchanger. Dr. Claries stove, popular in the 1840s, is recommended by the two authors as healthier than most.[11] The removable ashpit, a feature of the two-cylinder stove, was an innovation of the 1830s.[12]

Despite its romantic and domestic associations, the open fireplace often inconvenienced eighteenth- and nineteenth-century families when smoke failed to ascend through the chimney or when cold air rushed down the chimney, scattering dust and ashes over the room. The open fireplace, as architectural historian David R Handlin observes, frequently sacrificed 90 percent of its heat to the chimney.[13] In the *New England Farmer*, 13 November 1825, a letter appears in which the author bemoans "the intolerable evils of a smoky house, a scolding wife and crying children."[14] Although closed stoves were popular in Pennsylvania in the late eighteenth century, New Englanders waited until the 1820s before they brought the stove into the home on a wide scale.[15] By 1848, Boston alone listed forty-nine stove dealers.[16] William C. Baker, who wrote on heating and ventilation, observed in 1860 that stoves "can be cheaply bought."[17] An advertisement in a New Haven paper, the *Daily Herald*, 3 January 1833, indicates that small stoves could be purchased for under $10. Improvements in the technology and manufacturing of cast-iron reduced the prices of stoves throughout the 1830s and 1840s.[18]

Advertisers tried to shape the consumer's perception of the stove as a safe invention and a desirable commodity. There were three forms of advertising: advertisements for the consumer, trade catalogues for the dealer, and promotional pamphlets that recount the development of a particular inventor's stove. Professors, inventors, and ministers were recruited to give testimonials to a stove's efficiency and safety. Littlefield's stove received several endorsements from Dr. Eliphalet Nott, president of Union College and renowned stove inventor, who acknowledged that his own stoves were not as efficient as Littlefield's models.[19]

The advertising pitch often entailed bestowing names on stoves, such as "The Pioneer," "Our Pleasant Home" (Littlefield, 1850s), "Challenge" (Sanford, Truslow, and Co., 1850s), and "The Fire on the Hearth" (Open Stove Ventilating Co., 1876).[20] Some names were domestic, while others suggested adventure or were feminine names. The image of the stove was meant to replace that of the fireplace as a source not only of physical but also emotional warmth. This sales pitch had much to overcome. Littlefield, for example, refers to the stove as a "much abused article" that is "never petted or admired." However, "once perfected" it will contribute to "making the home healthful, cheerful, and agreeable."[21]

The most fascinating and culturally revealing advertisements are those that attempt overtly to construct the consumer's affective relationship to the parlor stove, such as the advertisements run by the J. S. and M. Peckham Co. of Utica, New York.[22] In the "Cherry Parlor" advertisement titled "The Betrothal," a couple cuddling one another is shown sitting beside their Peckham parlor stove. The caption, inscribed on the perimeter, reads: "Mothers take notice! The boys always call where Cherry Parlor Stove is in use and daughters never arrive at an old maidenhood!!!!!!" A similar Peckham advertisement for the "Parlor Palace" depicts a man at the parlor doorway, hat in hand, greeted by a young woman who stands to the left of one empty rocking chair and stove: "Charles calls regular once a week to simply warm himself by the parlor 'palace' stove." Keeping in mind the interlocking towers and the ornamental fecundity of the two-cylinder stove, it is interesting to find that advertisers insinuated that the heat of the stove could spark amorous parlor games.[23]

In the parlor stove's favor was its advantage as a labor saving device. Because efficient stoves burned less wood than hearths, family members did not have to chop and haul quite so much wood as in the days of the hearth. Stoves that could be loaded with coal required even less labor.[24]

Many mid-century writers on heating and ventilation, the consumer watchdogs of their day, viewed the parlor stove neither as an invention that kindles passion nor as a machine that saves labor. They portrayed it as a lethal object waiting to strike. In 1860, one advocate of steam heat cited the "thousands of human lives which statistics show are annually destroyed by exposure to open fire and stoves—children playing within reach of these fiery fiends—are we not led to believe that custom can habituate us to the most appalling and apparent of evils?"[25] Another anonymous author, writing in 1849, charged the owner, rather than the stove, with murder: "Burning anthracite or charcoal, in a close chamber, to heat the air, is either positively criminal, or at best evinces the grossest ignorance."[26] Alexander Jackson Downing maintained that the man who uses

a closed stove with no ventilator should "be looked upon . . . [as] he who should more openly undertake to poison his family and friends with a brazier of charcoal."[27] By the 1830s, anthracite was a popular fuel for stoves in New England.[28] Even Littlefield acknowledged that an "illy constructed" stove could menace an unsuspecting family: "A variety of diseases, particularly among children, have made their appearance since the general introduction of coal as a domestic fuel."[29] While stove advertisers were asking families to invite into their parlors a friend who was a symbol of progress and the future (not to mention a catalyst of romance), heating and ventilating advocates represented the friend as a fiend, a domestic executioner who could burn, suffocate, or poison people. Perhaps this accounts for the strange mix of romantic and funereal iconography on the two-cylinder parlor stove.

The nostalgia for the hearth represented in Hawthorne's sketch also would have made it difficult for advertisers to encode the stove as a desirable commodity. By the 1840s, the hearth was associated with the domestic preservation of sentiment, sincerity, authenticity, and spiritual light in an uncertain capitalist world.[30] The sentimental significance invested in hearth and parlor, starting in the early nineteenth century, betokens the growing "distinction between domestic and productive life."[31] Philippe Ariès has argued that the "industrial revolution" and the urbanization that accompanied it in France and England precipitated, in part, a middle-class "emotional revolution" as a compensatory response. The same can be said of America.[32] The worship of the hearth and the encoding of the parlor as a sentimental space are symptomatic of these economic and cultural transformations.[33]

In the eighteenth and early nineteenth centuries, workers would often live with the masters of shops. By the mid-nineteenth century, the custom was for workers to live on their own. The shop, typically in the front of the house, was replaced by the parlor.[34] This historical transformation explains the context for Henry David Thoreau's censure of the middle-class parlor as a room divested of meaningful or productive activity: "It would seem as if the very language of our parlors would lose all its nerve and degenerate into palaver wholly, our lives pass at such remoteness from its symbols . . . the parlor is so far from the kitchen and workshop."[35] The mid-nineteenth century middle-class home, as historian Clifford Clark observes, was constructed in domestic discourse as a "sheltered retreat, a sanctuary, set apart from the storms of commercial life." Ideally, the home provided a "controlled," bucolic space in which "the family was literally cut off from the dangers of the outside world."[36] Many writers, notwithstanding the efforts of stove inventors and advertisers, felt that the stove

had failed to gratify the sentimental and domestic needs growing out of the "emotional revolution."[37]

Thus Horace Bushnell, in "The Age of Homespun" (1851), reminisces about those "friendly circles [that] gathered so often round the winter's fire—not the stove but the fire, the brightly blazing, hospitable fire." After a while the "circle" round the hearth "begins to spread" and "the fire blazes just as much higher and more brightly, having a new stick added for every guest."[38] Bushnell portrays the hearth as a promoter of community and the stove as an agent of atomization. Although Thoreau wrote of the cooking stove rather than the parlor stove, his orphic lament for a "world we have lost" focuses on the sacrifice of spirituality and a nobler humanity figured in the open fire: the stove "concealed the fire . . . I felt as if I had lost a companion."[39]

In "Fire Worship," Hawthorne's narrator shares these romantic reservations about the technological "iron cage." But he owns up, tongue bulging in cheek: "I, to my shame, have put up stoves in the kitchen and parlor and chamber."[40] Likewise, Thoreau the naturalist confesses, "The next winter I used a small cooking-stove for economy, since I did not own the forest."[41] Nor did Hawthorne "own the forest" when he and his wife, Sophia, leased the "Old Manse" in Concord (not far from Thoreau's cabin) during the early 1840s. Wood was so expensive that efficient airtight stoves proved to be far more economical than the hearth. The "progress" of technology, in the form of the stove, had to compensate for the "progress" of deforestation in New England. "Common sense" prevailed over orphic nostalgia, even for American romantics who evoked a "world we have lost" (writing—or strumming—by their stoves). Dangerous as it sometimes was, and as inadequately "domestic" as it was often perceived to be, the parlor stove triumphed: it won the crown.

NOTES

1. Nathaniel Hawthorne, "Fire Worship," *The Works of Nathaniel Hawthorne* (Boston: Houghton Mifflin, 1882), II, 150, 152.

2. Hawthorne, "Fire Worship," 151, 152, 154, 157, 158.

3. I am grateful to Jules Prown and Kenneth Haltman for their editorial suggestions. This essay was revised while I held an American Council of Learned Societies Fellowship.

4. See Publius Ovidius Naso, *The Metamorphoses of Ovid*, trans. Mary M. Innes (Harmondsworth, Middlesex: Penguin, 1976), 125–30.

5. Ibid., 225–28, 246–48. I am grateful to my colleagues, Carla M. Antonaccio and Elizabeth Bobrick, for discussing the figure of Orpheus with me.

6. The gender division suggested by the stove conforms remarkably well to the picture painted by historians of mid-nineteenth-century gender construction. See Carroll Smith-Rosenberg, "Sex as Symbol in Victorian Purity: An Ethnohistorical Analysis of Jacksonian America," *American Journal of Sociology* 84 (Special Summer Supplement, 1978): 212–47; and G. J. Barker Benfield, "The Spermatic Economy: A Nineteenth Century View of Sexuality," in *The American Family in Social-Historical Perspective*, ed. Michael Gordon (New York: St. Martin's Press, 1973), 336–72.

7. For a study of the iconography of nineteenth-century cast-iron seating furniture that raises similar cultural issues, see Ellen Marie Snyder, "Victory Over Nature: Victorian Cast-Iron Seating Furniture," *Winterthur Portfolio* 20 (winter, 1985): 221–42. On American middle-class anxieties about technological "progress" in the mid-nineteenth century, see Leo Marx, *The Machine in the Garden: Technology and the Pastoral Ideal in America* (New York: Oxford University Press, 1976); John Kasson, *Civilizing the Machine: Technology and Republican Values in America 1776–1900* (New York: Grossman, 1976); Carolyn Porter's chapter on Emerson and industrial capitalism in *Seeing and Being: The Plight of the Participant Observer in Emerson, James, Adams, and Faulkner* (Middletown: Wesleyan University Press, 1981); and Carl Siracusa, *A Mechanical People: Perceptions of the Industrial Order in Massachusetts, 1815–1880* (Middletown: Wesleyan University Press, 1979).

8. See James M. Patten, *New Haven Directory for 1842–43* (New Haven: James M. Patten, 1842), 108. I am indebted to Lucinda Burkepile of the New Haven Colony Historical Society for bringing this advertisement to my attention and for reminding me of the Proserpine myth. I would like to thank the administration and staff, especially Robert Egleston (who introduced me to the stove in 1979) and Amy Trout, for their help in making the stove available to me and my students over the years.

9. See Tammis Kane Groft, *Cast With Style: Nineteenth Century Cast-Iron Stoves from the Albany Area* (Albany: Albany Institute of History and Art, 1984), 15.

10. On two-cylinder box stoves, floral iconography, and the influence of the Greek revival, see Josephine Pierce, *Fire on the Hearth: The Evolution and Romance of the Heating Stove* (Springfield, Mass.: Pond-Ekberg, 1951), 92–93. For photos and drawings of mid-century parlor stoves, as well as descriptions of iconography and structure, also see Groft, *Cast With Style*; Josephine Pierce, "New York State Stove Manufacturers," *New York State History* 32 (1951): 452–60; John G. and Diana Waite, "Stovemakers of Troy," *Antiques* 103 (1973): 136–44; Frank G. White, "Stoves in Nineteenth-Century New England," *Antiques* 116 (1979): 592–9; Edwin Jackson, "New England Stoves," *Olde Time New England* 26 (1935): 55–64; and Laurence Wright, *The History of Domestic Heating and Cooking* (London: Routledge and Kegan Paul, 1964).

11. A. J. Downing, *The Architecture of Country Houses* (New York: Da Capo Press, 1968); Anon., *Heat and Ventilation: General Observations on the Atmosphere and Its Abuses As Connected with the Common or Popular Mode of Heating Public and Private Dwellings* (Rochester: D. M. Dewey, 1851).

12. Pierce, *Fire on the Hearth*, 18, 92.

13. David P. Handlin, *The American Home: Architecture and Society, 1815–1915* (Boston: Little, Brown, 1979), 478.

14. Pierce, *Fire on the Hearth*, 8.

15. White, "Stoves in Nineteenth-Century New England," 592.

16. Pierce, *Fire on the Hearth*, 134. In 1875, Albany and Troy, two stovemaking capitals, "produced 450,000 stoves which cost between $4.00 and $40.00 apiece including all accessories." Groft, *Cast With Style*, 16.

17. W. C. Baker, *Artificial Warmth and Ventilation and the Common Modes by which They Are Produced* (New York: J.F. Trow, 1860), 8.

18. See Jack Larkin, *The Reshaping of Everyday Life, 1790–1840* (New York: Harper & Row, 1988), 51.

19. See D. Littlefield, *A History of the Improvements to the Base Burning or Horizontal Draught Stove* (Albany, New York: C. Van Benthuysen, 1859), and Jordan L. Mott, *Description and Design of Motes Patented Articles Secured by Twenty-seven Patents* (n.p.: printed by Daniel Adee, 1841). See Hislop Codman, *Eliphalet Nott* (Middletown: Wesleyan University Press, 1971).

20. Pierce, "New York State Stove Manufacturers," 456.

21. Littlefield, "A History of Improvements," 3.

22. Pierce, *Fire on the Hearth*, inner covers. Neither dates nor sources are cited for the ads.

23. See Larkin, *The Reshaping of Everyday Life,* 122, 125, 126. Through the early nineteenth century, "parlors" sometimes contained beds. The sexual repression that took hold in the 1830s banished the bed to the "bedroom," hidden from the public.

24. Larkin, 51–2.

25. Baker, "Artificial Warmth and Ventilation," 8–9.

26. Anon., *The Uses and Abuses of Air . . .* (New York: J. S. Redfield, 1849), 227.

27. Downing, *The Architecture of Country Houses*, 484.

28. Jackson, "New England Stoves," 64.

29. Littlefield, "A History of Improvements," 12. Dr. Nott called the first stove that he invented (for his Union College students) the "coffin." See Groft, *Cast with Style*, 90.

30. On the hearth, see Louise Reid Estes, whose "Fireside Joys" was published in the anonymously edited collection, *Echoes from Home: A Collection of Songs, Ballads, and Other Home Poetry* (Boston: Lee and Shepard, 1870), 104–5. Another good source for the meaning invested in the hearth is Rev. A. B. Mazzey, *The Fireside: An Aid to Parents* (Boston: Crosby, Nichols, 1856), 4–19. David P. Handlin observes that "the fireplace was so important to the home that it was often virtually a member of the family." See his *The American Home*, 19. See also Larkin, *The Reshaping of Everyday Life*, 141. The aristocratic associations of the crowned parlor stove are intriguing and, perhaps, enigmatic because the American middle-class sentimentalization of the home-as-retreat came about, initially, as an ideological rejection of European aristocracy. See Stephanie Coontz, *The Social Origins of Private Life: A History of American Families* (New York: Verso, 1988), 161.

31. Joel Kovel, *The Age of Desire: Reflections of a Radical Psychoanalyst* (New York: Pantheon, 1981), 110.

32. Philippe Ariès, *Centuries of Childhood: A Social History of Family Life*, trans. Robert Baldick (New York: Vintage, 1962), 386. On the concentration of emotional life within the nineteenth-century, middle-class family, see Ariès' "The Family and the City in the Old World and the New," in *Changing Images of the Family*, eds. Virginia Tufte and Barbara Myerhoff (New Haven: Yale University Press, 1979), 32, and Eli Zaretsky, *Capitalism, The Family, and Personal Life* (New York: Harper Colophon, 1979), passim.

33. On the ideological significance of the parlor for the American middle class, see Stuart M. Blumin, *The Emergence of the Middle Class: Social Experience in the American City, 1760–1900* (Cambridge: Cambridge University Press, 1989), 238–39. See also Leonore Davidoff and Catherine Hall, *Family Fortunes: Men and Women of the English Middle Class, 1780–1850* (Chicago: University of Chicago Press, 1987), 377.

34. See Paul Johnson, *A Shopkeeper's Millennium: Society and Revivals in Rochester, New York, 1815–1837* (New York: Hill and Wang, 1978), 43: "For until the coming of merchant capitalism . . . [w]ork, leisure, and domestic life were acted out in the same place and by the same people, and relations between masters and men transferred without a break from the workshop to the fireside." By the mid-nineteenth century, one finds a proliferation of middle-class domestic magazines with titles such as *The Family Circle* and *Parlor Annual*.

35. Henry David Thoreau, *Walden and Other Writings*, ed. William Howarth (New York: Modern Library, 1981), 220.

36. Clifford Edward Clark, Jr., *The American Family Home, 1800–1960* (Chapel Hill: University of North Carolina Press, 1986), 38, 43. Also see Mary P. Ryan, "The Empire of the Mother: American Writing About Domesticity, 1830–1860," in *Women and History* 2/3 (summer/fall, 1982): 110. Ryan writes of the 1850s: "Parlors were small, to accommodate family intimacies rather than to cultivate larger social ties."

37. By the 1860s, the coal burning stove was itself rendered obsolete in some circumstances by central steam heat and was transformed into an object of nostalgia. During that decade the Oneida Perfectionists installed steam heat in their Mansion House but, as Dolores Hayden notes, they kept one wood-burning stove: "The warmth of a direct heat source was apprehended as having nurturing qualities which couldn't be improved upon." It provided "a place for telling one's troubles." Dolores Hayden, *The Grand Domestic Revolution: A History of Feminist Designs for American Homes, Neighborhoods, and Cities* (Cambridge, Mass.: MIT Press, 1981), 48.

38. H. Bushnell, "The Age of Homespun," *Work and Play* (New York: Scribner's, 1903), 387.

39. Thoreau, *Walden*, 228.

40. Hawthorne, "Fire Worship," 156. In "The Custom House," introductory to *The Scarlet Letter* (1850), Hawthorne refers to "the captains of the rusty little schooners that bring firewood from the British provinces." By the 1840s, in other words, New England was importing firewood from Canada. See *The Complete Novels and Selected Tales of Nathaniel Hawthorne*, ed. Norman Holmes Pearson

(New York: Modern Library, 1937), 87. When Sophia and Nathaniel Hawthorne moved from Salem to the Berkshires in the early 1850s, they brought their four airtight stoves with them. See Louise Hall Thayer, *The Peabody Sisters of Salem* (Boston: Little, Brown, 1950), 194. By the 1820s, scarcity of wood had fueled the growth of the stove industry. One could purchase a ton of coal for $10 in 1830, $5 cheaper than a ton of wood. By mid-century, one would have found working fireplaces mostly in the homes of the wealthy, who, as the saying doesn't quite go, had wood to burn. See Groft, *Cast with Style,* 18, 19, 34.

41. Thoreau, *Walden,* 228.

Jennifer L. Roberts

Lucubrations on a Lava Lamp: Technocracy, Counterculture, and Containment in the Sixties

IT SEEMS TO BE COMMON knowledge that lava lamps signify the sixties, particularly the psychedelic sixties of "love beads and hippies" and "drug-crazed flower children."[1] Newspaper articles tracking the recent resurgence of lava lamp sales have suggested as much, discussing the new lamps (many redesigned with sleeker casings and brighter colors) as if they failed to reside fully in the present; as if they acted merely as reliquaries for the sixties lava that "was *the* light to get stoned by," that "glowed with psychedelic glob and made you mellow."[2] A lava lamp, whatever contemporary activities it oversees, would seem to remain unavoidably retrospective. An illustration in the *Indianapolis Star* expressed it most succinctly: to be transfixed by a lava lamp is to participate in an inherently archaeological encounter (Fig. 9.1).

Lava World International, the Chicago firm that manufactures lava lamps, has developed its marketing strategy to capitalize on the product's psychedelic associations. In the early nineties, to accompany the renaissance in lava lamp popularity and to help appeal to a new market of adolescents raised in the eighties, the firm introduced its cartoon spokes-mascot, "Lava Larry." An anthropomorphic lamp clad in black turtleneck, peace medallion, and floral headband, with bulging contours and a dazed though earnest expression, Larry is a goofy, non-threatening abstraction of sixties counterculture.[3]

Granted, lava lamps now have "retro" status—a status which restricts the incursion of history here to nostalgia and smirking affection for the "era of psychedelic silliness."[4] But isn't there something more at stake in the retrospectivity of Lava Larry—especially since he functions as a generational liaison, picturing the sixties to an audience that wasn't there to see

167

Fig. 9.1. John Bigelow, illustration for the *Indianapolis Star,* 2 September 1990. Courtesy of the *Indianapolis Star/News.*

them in person?[5] Might the lava lamp—like the sixties themselves—have been more complex than such constructions imply?

This discussion will propose that the lava lamp's original cultural resonances ranged far beyond the psychedelic. The success of the lamp's design, rather, derived from its singular ability to arbitrate *between* the psychedelic counterculture and its nominally antithetical "establishment." The lava lamp, in other words, embodied both IBM and LSD; both housewife and hippie; both Bomb and be-in. And thus this lamp can illuminate for us a different sixties. It shows us a sixties in which the distinctions between culture and counterculture (distinctions we rely upon for our understanding

of the late twentieth century) were far more fluid than we have come to believe.

Although this discussion will focus on its American presence, the lava lamp was actually formulated in England. In the early sixties, an R. A. F. engineer named Craven Walker developed a version which he marketed in Britain as the "Astro Lamp."[6] In 1965, two Americans spotted it at a West German trade show, bought the rights for exclusive manufacturing in the United States, changed the name to "Lava Lite," and set up headquarters in Chicago. Although the company has changed hands twice since then, and despite a near-fatal downtrend in sales in the late seventies and early eighties, Lava Lite lamps have remained in constant production since 1965.[7]

The archetypal Lava Lite design, the first and best-selling, was the *Century* model. Several special-edition designs made brief appearances in the sixties and early seventies, including the *Coach Lantern*, the *Enchantress Planter*, and the *Aladdin's Lamp*, but the *Century* remained the most popular.[8] There were two color combinations available: red lava in yellow liquid and white lava in blue liquid. Red was introduced first and was by far the most popular choice during the sixties. Although the manufacturer has concentrated recently on its newer designs, the firm continues to produce the *Century* to the exact design specifications of the original.[9] The *Century* stands 17 inches high and consists of two main components: a clear, 52-oz. glass tank (called a 'globe' by the manufacturer) and the brushed, gold-toned aluminum base in which it rests (Fig. 9.2). Composed around a central, vertical axis of symmetry, the lamp's slim contours undulate in and out, creating a stack of sleek, truncated cones.

The base is light enough (less than one pound) to be held and manipulated with ease. Its upper portion, or collar, splays upward and outward in order to receive the tank, while its lower portion is perforated by thirty small round holes, each approximately one millimeter in diameter, arranged equidistantly around the cone into five groups of six holes each. A 40-watt frosted white appliance bulb sits vertically within the base (when the lamp is assembled, the top of the bulb rests just below the bottom of the tank).

The tank sweeps outward from its narrowest point at the top (d=2 inches), to a gentle bombé curve at its widest point (d=4.7 inches). It then narrows again to its flat bottom, which remains hidden by the collar when the lamp is assembled. A hard gold-toned plastic cap, 1.25 inches tall, screws onto the top of the tank. A sticker adheres to the top of the cap and reads, "*DO NOT* REMOVE CAP OR ADD FLUIDS TO BOTTLE!" Although the tank weighs nearly seven pounds, there is no mechanism for locking it into the base; gravity alone holds it in place when assembled. The

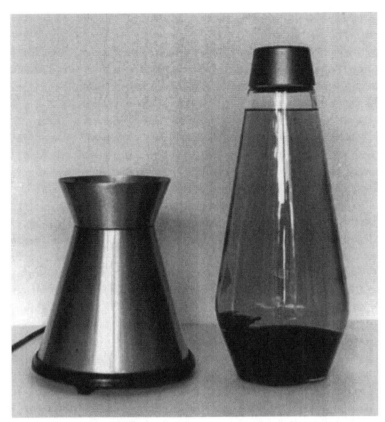

Fig. 9.2. The lamp's two main components: base and tank. Photograph by the author.

tank contains two substances: the yellow liquid, primarily water; and the crimson red, wax-based lava.[10] When the lamp is cool, the lava nestles snugly as a solid in the bottom of the tank, its contours following, but not adhering to, the inner surface of the glass.

A flick of the switch, although it illuminates the light bulb in the base, produces no immediate response from within the tank. The lava first spends anywhere from twenty minutes to three hours in a latency phase, undergoing no spectacular changes, only glowing and heaving slightly. Eventually the heat increases enough to push warmer lava from below toward the surface, opening a vent to the liquid above.[11] In this early phase the liquid remains much cooler than the rising lava, so that as the lava floats out of the vent it is quickly "frozen" into spindly, brittle shoots by the liquid through which it attempts to cleave a path. Eventually, dozens of these petrified forms populate the tank.

After a variable period of time (anything from twenty minutes to two hours), the liquid heats up enough that the lamp can enter its more characteristic globular phase. Lava continues to rise from below, but the liquid no longer solidifies it in its tracks. Instead, the emanations pull away from the vent to form globules of varying sizes which rise slowly to the surface of the liquid. Upon reaching the top of the tank, some globules float slowly back down to the bottom, where they usually rest intact. Others congeal into a larger blob that hangs down from the surface of the liquid and eventually begins to sag and drop globules of its own. Thus globules rise and fall simultaneously; when they collide, they bounce and slip past each other, distorting each other momentarily, but not usually coalescing (Fig. 9.3).

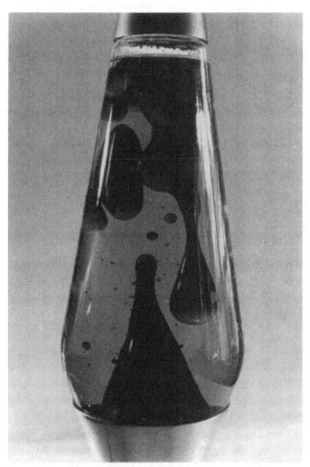

Fig. 9.3. Lava globules in action. The spectacle is usually accompanied by reflections playing across the surface of the glass tank. Photograph by the author.

As the liquid continues to warm, the globules become more and more promiscuous, slipping into each other quickly upon encounter. They become larger and larger, both because they pull away from the lower and upper "mother" forms in larger quantities, and also because they engulf each other more readily. This integration process continues until the lava assumes just two basic forms, one rising and one falling, that pass an occasional glob back and forth between them. Finally, after about four to seven hours from the initial illumination of the lamp, the globs unify into a single egg-shaped form that rests at the bottom of the tank, all gymnastics ceasing until the lamp is extinguished, cooled, and illuminated again.

Given this drowsily paced spectacle of melting integration, it is not surprising to find the lava lamp so strongly associated with psychedelic drug culture and the fluid aesthetics it inspired. In fact, the similarities between the lava process and the published experiments of psychotropic drug users in the sixties are quite striking. Perhaps the most famous of these accounts, Timothy Leary's *Psychedelic Experience*, describes a utopian realm of total integration that closely resembles the oily undulations of the lamp.[12] In Leary's step-by-step descriptions of psychedelic integration, users, experiencing "feelings of [the] body melting or flowing as if wax," (38) become intimately aware of their own organic processes:

[T]he subject is caught up in an endless flow of colored forms, microbiological shapes, cellular acrobatics, capillary whirling . . . the life stream flowing, flowing. (54)

You drift off—soft, rounded, moist, warm. Merged with all life. (58)

The person is allowed to glance back down the flow of time and to perceive how the life energy continually manifests itself in forms, transient, always changing, reforming. Microscopic forms merge with primal creative myths. (55)

All this "merging," of course, makes of the lava lamp a sexual spectacle as well. Although the lava can occasionally adopt a particularly graphic form, its orgiastic suggestiveness arises not so much from specific representational symbols as from its general lubricity and from its constant maintenance of a figure/ground dialogue. The lava may ooze, squeeze, bubble and stir, denying itself any fixed identity, but it never dissolves into the liquid (were it to dissolve, so would its promiscuity; it would resemble instead the abstract color field paintings that art critics like Clement Greenberg, eager to avoid bodily references, were promoting at the time).[13]

So the lava lamp seems, in fact, to merit its reputation as a sign of sixties psychedelia and its associated corporeal permissiveness. Indeed, with its shifting boundaries and fluid integrations, it links into many of the liberalities associated with what was being defined during the sixties as "countercultural."[14] By symbolizing a libidinous, unhurried, organic opposition to the instrumental rationality and cold bureaucracy of "the system," it might seem to have been the ideal artifact for countercultural youth to wield against the parental generation—a generation the members of which were generally perceived either to be active agents of the system, or, as Theodore Roszak memorably observed, "trapped . . . in the frozen posture of befuddled docility."[15]

What, then, are we to make of the original Lava Lite marketing materials? One image shows a well-coifed suburban housewife arranging her *Enchantress Planter* Lava Lite lamp as the centerpiece of her dinner table. Another layout shows three popular Lava Lite designs along with the seven popular television game shows that gave them away on the air. A treatment for a thirty-second television advertisement includes a businessman completing his paperwork next to his *Consort* Lava Lite lamp, which, according to one catalog, had "a masculine flavor . . . perfect for the study or den, so right for the executive suite."[16] If this wasn't the establishment, what was?

The original target audience for Lava Lite advertising was, in fact, emphatically mainstream. Lava Lites were marketed as a home decorating idea; their psychedelic associations were to develop only in the late sixties, and even then never managed to undermine their mainstream appeal.[17] At a twenty-fifth anniversary party for the lamps in 1990, guests remembered them as ubiquitous fixtures in their parents' dens ("Everybody had one over the TV set") as well as their own college dorm rooms.[18] The lava lamp, it would seem, illuminated a swath of shared territory between culture and counterculture. Yet how could a single artifact signify both?

One's definition of the "counterculture," of course, depended on one's definition of the culture that it countered. Most articulations agreed, however, that a runaway technologism and the systems it had spawned were the forces in American society that provoked countercultural opposition. Roszak's term for it—the "technocracy"—was especially influential. American society was not, he believed, ultimately controlled by political, military, or even economic forces; all of these were subordinate to the interests of a "mature and accelerating industrialism," based on an invisible—because ubiquitous—self-justifying faith in technological progress.[19] Noting the disappointments of 1968 and the anemic historical presence of Marxism in the United States, he concluded that the technocracy was immune to traditional revolutionary tactics because capitalism was merely

a subplot of the grander technocratic narrative, which operated through complex megasystems beyond the control of any single individual. Other voices—Ginsberg, Leary, Mills, Carson, Marcuse, Ellul—were also influential, demonstrating various levels of commitment to Marxist orthodoxy, environmental concerns, and the value of scientific endeavor, but all agreed that the country's ills could eventually be traced, in whole or in part, to the use or misuse of science and technology.[20]

Where does the lava lamp stand along the continuum between technocracy and counterculture? Although itself a piece of technology, it does seem to enjoy a certain autonomy from the technological norm. Flipping the switch, the exemplary act of control over technology, has no direct effect on the lava inside. The timing of the various successions of lava-forms is entirely unpredictable. When the switch is turned off, the lava continues to heave for a while and the lamp stays warm for hours afterward. In this sense it seems to allude to the countercultural preference for the "organic"—in the sixties' context a term deriving from Coleridge via Mumford to designate an entity governed by forces from within, instead of "mechanistically" from without.[21] But the lamp is still, after all, a machine. What makes it compelling is its ambivalence; phlegmatic, unpredictable, warm, upright, yet definitely *plugged in*, it resides in the richly unsettling realm of the homunculus and the cyborg.

This ambivalence between the organic and the mechanistic extends, in a different way, to the lava lamp's moist, polymorphous globbings, which on first examination would seem to refer to the organic alone. But suppose one stares into a lava lamp and, as is common, suddenly "sees" an "organic" form, like a blood corpuscle or an embryo. Whence does this recognition derive? In the sixties, such associations often relied upon newly introduced visual technologies that were in the process of refining the image of the "organic" itself. The embryo, for example, might have been showcased in 1968 on an ABC News special showing some of the first *in utero* images of the human fetus.[22] The blood corpuscles could have recalled an electron microscope photograph in a new biology textbook, or, even better, the 1966 film *Fantastic Voyage*, wherein Raquel Welch and other eminent military scientists travel in a miniaturized submarine through the carotid artery, surrounded by red blood cells virtually indistinguishable from lava globs (Fig. 9.4). A panoply of new scopic technologies developed in the sixties, many of them invasive like the miniaturized embryo-cam, made it increasingly difficult to separate the image of the organic from the action of the mechanistic.

But this influence over image-recognition was not the only way that technology could complicate the lamp's organic associations. The lava's

Fig. 9.4. *Fantastic Voyage*, 1966. Twentieth Century Fox. Photograph by the author

very amorphousness, the supposed seat of its countercultural opposition, was gaining new technological resonances during the sixties. It was during precisely this period, for example, that cultural theorist Marshall McLuhan, "Oracle of the Electric Age,"[23] began describing the dehierarchized, free-flowing world of information that sophisticated communications technologies were enabling. An enormously influential thinker (he coined the term "global village" and the phrase "the medium is the message"), McLuhan believed that developments in television and other electric information technologies had provoked the greatest revolution since the invention of movable type. His statements about the new world of "instant information" place another technological valence on the fluid interfaces and boundary dissolutions that occur within the tank of the lamp. Compare Leary, describing the psychedelic escape from technocracy in lava-like terms: "association, opposites merging, images fusing, condensing, shifting, collapsing, expanding, merging, connecting,"[24] with McLuhan, describing the technocracy itself:

Electric circuitry is Orientalizing the West. The contained, the distinct, the separate—our Western legacy—are being replaced by the flowing, the unified, the fused.[25]

We can no longer build serially, block-by-block, step-by-step, because instant communication insures that all factors of the environment and of experience coexist in a state of active interplay. [26]

Television, according to McLuhan, provided a near-universal American experience with this "active interplay." Its rapid juxtaposition of moving images fostered a fusionary mode of vision that placed the viewer in much the same position that the lava lamp does. The common placement of the lamp on top of the TV was perhaps an implicit recognition of the similarities between the two artifacts.

But this discussion should not be limited to the lava lamp's collapsing of a single binary opposition (between the organic and the mechanistic), because the lamp deals at root with more fundamental crises of meaning. The point is that *no* specific meaning can be found in this three-dimensional Rorschach test; the polysemous acrobatics of the lava can encompass too many simultaneous, and often contradictory, associations. Just as organic and inorganic associations have been shown to be coterminous, inner space (blood cells coursing through an artery) is also outer space (nebulae forming in a distant galaxy). The microscopic (amoebae in a drop of pond water) is also the gigantic (an erupting volcano). Positive associations (a fetus developing in utero) oscillate with negative (a mutant fetus floating in a specimen jar). As the viewer stares into the lamp and makes associations (a process often described as a transfixion or a dreamlike state), the lamp becomes a virtual laboratory for Freud's primary processes of condensation and displacement, of metaphor and metonymy.

But not only does the lava lamp undulate between meanings, it also undulates in and out of meaning, playing on the arbitrary distinctions separating a globule with referential value from a globule without it. Sometimes the viewer simply cannot muster a cultural association to match a given form within the lamp. Sometimes, in the lava lamp, a globule is just a globule. Ed Ruscha's "liquid paintings" of the late sixties provide a contemporaneous illustration of this liquefaction of stable semiosis (Fig. 9.5): his abject pools of liquid just barely spell out words, remaining forever in danger of slipping from the realm of reference back into that of formless matter. Here, as in the lava lamp, chaos lurks just below the level of signification.[27]

Fig. 9.5. Edward Ruscha, *Eye*, 1969. Oil on canvas, 60 inches by 54 inches. The Oakland Museum of California. Gift of the Art Guild of the Oakland Museum Association and the National Endowment for the Arts.

This oscillation between meaning and materiality seems to account for much of the transgressive pleasure involved in observing a lava lamp. In the early seventies, Julia Kristeva was coming to similar conclusions in the realm of psycholinguistics, identifying a category of meaningless sounds and sound patterns that lurk below stable systems of language. She linked these purely somatic vocalizations to the interdependent pleasures of transgression and creation (the sounds eluded the order of everyday symbolic language, while also contributing to new patterns within that language).[28] Similarly for Anton Ehrenzweig, an influential theorist of artistic creativity in the sixties, the creative process required transgressive forays into nebulous unconscious territory. Fluidities from the unconscious would then be periodically "re-introjected" into conscious creations. For Ehrenzweig, Kristeva, and Ruscha, as with the lava lamp, the important point is that the oscillation between the amorphous and the symbolic remains unsettled, in

a state of perpetually creative interplay which never calcifies into a fixed form or system.[29]

Thus the transgressive flavor of the lava lamp can be seen as part of its performance of creation itself—its allusion to a semi-sacred, protean process perhaps finally autonomous from technocratic mechanisms. But, alas, this cauldron of infinite semiosis, this shuttling between formless and formed, was also becoming an image of technological production in postwar consumer society. One needs to think only of the proliferation of synthetic materials, whose contribution to the flavor of the decade can hardly be overestimated, to see the connection. Plastic, for example, had been available in some form or another since the early twentieth century; it was only in the postwar period that it began to be conceived not primarily as an inexpensive approximation of luxury materials, but rather as the amorphous material wellspring for an infinity of possible products, many of which were designed to refer back to the fluid, changeable contours of their liquid beginnings.[30] As Roland Barthes wrote in the late fifties, after watching an injection-molding machine in action, "[M]ore than a substance, plastic is the very idea of its infinite transformation; . . . it is ubiquity made visible . . . it is less a thing than a trace of a movement."[31] The lava lamp connotes not only natural or cosmic primordia, but also the seemingly infinite production capacity of the technologically-driven postwar economy. Both could now engender "a perpetual amazement, the reverie of man at the sight of the proliferating forms of matter, and the connections he detects between the singular of the origin and the plural of the effects."[32]

So the sixties found both culture and counterculture laying claim to this plasmic territory of proto-meaning, proto-knowledge, proto-form. The lava lamp conflates the technocratic utopia with the countercultural—its genius is to be able to put Edward Teller and Timothy Leary in the same bottle. But what about this bottle? What does it indicate about the lava lamp's attitude toward its own innards? Here, too, the lamp seems to remain ambivalent. For even as it lasciviously displays its spectacle of boundless integration, its thematic and semiotic infinities, it also assures that they are bottled and stopped.

Indeed, given its rhetoric of expansiveness, fluidity, and unification, it is surprising to discover the insistence with which the lava lamp's design erects both physical and psychological barriers. First of all, its massing and assembly discourage tactile exploration. The only practical way to pick up the lamp is to grip it near the top as one would a soda bottle, then grasp the base with the other hand. But the slippery glass, the tank's considerable heft (7 pounds), and the loose junction between base and tank

make any grip seem uncomfortably tenuous. The lamp is ungainly even when resting on a flat surface: the comparatively greater weight of the tank renders the lamp top-heavy, which, when combined with its considerable height and the fragile juncture of base and tank, allows only an extremely limited range of safe manipulation. The assembly requires careful balance to prevent the tank from falling out of its collar; even dragging it along a flat surface causes the tank to wobble dangerously. And when the lamp is illuminated, it grows hot enough that touching it for more than a few seconds becomes impossible. The lamp invites looking but not touching.

Then there is the carefully guarded secret of the lava's constitution. The printed instructions avoid even the most basic mention of the chemical and physical properties of the lava and liquid, and Haggerty employees may el..borate no further than to identify the two main ingredients as paraffin wax and water.[33] The lamp's innards are, quite literally, a "secret formula," the delicacy of which is further protected by a set of warnings in the instructions which discourage any curious experimentation on the part of the owner. One is never to shake or jostle the lamp, never to leave it on for more than ten hours, never to add or subtract fluids to or from the tank, never to unscrew the cap. Such restrictions communicate little but the extreme complexity of the lamp's function and the viewer's lack of qualification to tamper with it. Most frustrating is the fact that the instructions never say what will happen, or why, if the viewer disregards these warnings.

This hermetic quality, the energy that the lava lamp's design and packaging devote to containment, works on the most literal level to protect the truly delicate processes within the lamp from consumer meddling. But at another level, whether these "delicate processes" are seen to connote the technocracy or the counterculture, the lamp's standoffishness toward its curious viewer engages a far more complex set of cultural relations. To consider these first from the technocratic angle, one finds that the lamp's design replicates the processes which governed the public image of science in the sixties. Since the end of World War II, the increasing cost, complexity, and rapidity of technological development had effectively emasculated the amateur scientist and independent inventor who had guided most scientific activity until the first decades of the twentieth century. Accompanying this change was a decline in the ethos of experimentation—gentleman-scientists and other "tinkerers" were rapidly becoming extinct, replaced by the figure of the scientific "expert."[34] This greatly increased the "black boxing" of technology—until the public no longer expected to understand the machines or chemicals upon which they were increasingly

dependent. Roszak defined this phenomenon as an essential characteristic of the technocratic society, where the cult of the expert instills a broadly based sense of incompetence:

> In the technocracy, nothing is any longer small or simple or readily apparent to the non-technical man. Instead, the scale and intricacy of all human activities . . . transcends the competence of the amateurish citizen and inexorably demands the attention of specially trained experts. . . . Within such a society, the citizen, confronted by bewildering bigness and complexity, finds it necessary to defer on all matters to those who know better.[35]

Just as the lava lamp's instructions warn the unqualified consumer against tampering, so does the entire technocratic structure impose a stance of timid fascination upon the public.

The secrecy and impenetrable bureaucratic complexity surrounding postwar science and technology (especially in its military manifestations) intensified the already established "myth of scientific differentness,"[36] opening a widening rift between what C. P. Snow influentially described as the "Two Cultures" of scientists and non-scientists.[37] A major 1957 study by Margaret Mead surveyed thirty-five thousand high school students about their image of the scientist, and found a mix of repulsion and almost superstitious awe (the girls, by the way, balked at the idea of marrying one).[38] Claude Lévi-Strauss noted that Mead's study gave the scientist a status similar to the mythic position of the blacksmith caste in some "primitive" societies.[39] Indeed, the mythical/religious overtones of science's play of temptation and restriction were not lost on contemporary critics; as Paul Goodman wrote in 1969:

> Men do not do without a system of "meanings" that everybody believes and puts his hope in even if, or especially if, he doesn't know anything about it; what Freud called a 'shared psychosis,' meaningful because shared, and with the power that resides in dream and longing. In fact, in advanced countries it is science and technology themselves that have gradually and finally become the system of mass faith.[40]

Lava Lite designers played along when they released limited edition lamps in the late sixties inscribed with crosses and menorahs. But these overt symbols were ultimately redundant, because the lamp's rocket-shaped contours and other scientific design cues were enough to generate its religious aura.

Those charged with marketing "Space Age" consumer products were quick to adopt and reinforce the quasi-religious longing already inhering in the public's image of science, and this helps explain how science could be at once so alien to the public and so thoroughly imbricated in the economy (how, in other words, Dupont could sell its chemicals to the American housewife). Science—this seething, fascinating, vaguely threatening stuff—had to be domesticated, but not so far as to render it completely familiar and thus to attenuate the very mesmeric qualities that would help stimulate consumption.[41] Science had to be bottled in such a way as to maintain its intellectual distance while inducing consumers to keep it at close quarters. This was certainly happening at the literal level; the household chemicals industry, for example, paraded before consumers a cavalcade of goops of indeterminate origin and mysterious powers. Their bottles and labels provided the consumer with a limited sense of security and control without decreasing their sense of bewitched ignorance at the products' chemical wizardry. Even the consumer names of such chemicals and compounds (e.g., CYCOLAC®; PLIO-TUF®), participated in the play of mystified domestication.[42] Their capital letters and registered trademark symbols remove them from the range of prosaic typography, signaling a garbled realm of specialized scientific discourse, but their homey phonemes (especially their central O's), exude a sense of snug enclosure and a comforting association with quotidian consumerism. So, regardless of whether actual bottles were involved, the domestication of science was occurring through the same strategies of mystification as those managed by the thick glass of the lava lamp. The lava lamp, with its own bottled garble, offered its owners a full-bodied abstraction of their stance toward science itself.

The insistency of the lava lamp's seal, separating an unpredictable chaos from its transfixed observer, also mimics another drama that governed postwar popular scientific discourse, one which dealt more explicitly with the anxieties attending scientific enterprise. This was usually articulated as a containment narrative, often involving a toxic or otherwise overwhelming force which, once captured by absentminded or unethical scientists that could not or would not contain it, might spill out of control. Nuclear fission, of course, provided the most compelling image of the issues at stake, becoming a ready metaphor for any dangerous force or process which required hermetic enclosure as a control measure (and the lava surely inspired associations with nuclear material, especially since the lamp's contour resembles both a cooling tower and a bomb casing).[43]

More generally, this containment drama played itself out in science-fiction laboratory scenes, with colorful and supposedly noxious liquids busily gurgling in some elaborate installation of equipment, tubing, beakers, and

flasks, supervised by a lab-coated, bespectacled, possibly mad scientist. Here, with its illuminated bubblings and clear glass vessel, the lava lamp would find itself right at home—as it would (to cite another typical sci-fi lab setting) among rows of glass specimen jars holding various monstrous anatomies in suspension. Such science-fiction laboratory scenarios inherently implied the threat of the breach of the container, the escape of the creeping matter in question, and the contamination of the environment. This variation on the Pandora's box theme (recall the sticker on the top of the lamp: "*DO NOT REMOVE CAP* . . .") exposes the epidemiological resonances of the lava lamp's trope of containment.

It is intriguing to note how often the "creeping matter" of containment-failure narratives assumed forms similar to the lava glop. In *The Andromeda Strain* (1971), for example, an alien species which forms spasmodic, gelatinous colonies eats through the gaskets in the lab designed to contain it. Its predecessor, *The Blob* (1958), remains the classic example, featuring a glistening red heap of protoplasmic matter that, once freed from its meteorite casing, terrorizes a city by smothering and ingesting its inhabitants, growing larger and more threatening with each victim.

But the Blob, as a fluid, homogeneous mass digesting every individual in its path, was also a blatant allegory of "creeping communism" and an exhortation to its continual containment. Recognizing this allegory allows us to reopen the question of the lava lamp's relation to counterculture by noting that the Pandora's box (or bottle) theme, already compelling in its attitudes toward the mysteries of science, was also a primary vocabulary for contending with the counterculture. Indeed, from an establishment standpoint, both the familiar communist counterculture of the fifties and the newer psychedelic counterculture of the late sixties threatened the dissolution of the individual, the dismantling of all class distinction, and the specter of social and psychological chaos. Leary wrote that "superficial differences of role, cast, status, sex, species, form, power, size, beauty, even the distinctions between inorganic and living energy, disappear before the ecstatic union of all in one."[44] "Your control is surrendered to the total organism."[45] Against this psychedelic utopia, as against the New Left ideology which it superficially resembled, mainstream popular culture could immediately mobilize a well-tuned battery of cold war containment metaphors.

There is another name for the effect produced by these spectacles of containment, in both their epidemiological and their mystificatory roles— the sublime. From Kant to Burke to Lyotard, the "sublime" has designated the operation wherein a viewer confronts a terrifying prospect from a secure position, thus assuring that the prospect "is all the more attractive the more fearful it is."[46] This interpenetration of fear and pleasure dovetails nicely

with the processes of display and containment under discussion. Yet I do not invoke the sublime in order to settle the lava lamp into a timeless aesthetic category; rather, I hope to describe its deviation here from certain traditional conceptions of the term and to suggest that this deviation addresses specific historical conditions of the sixties.

In the system of the sublime, the glass tank of the lava lamp occupies much the same position as the glass sheet covering a painting of a lava-spewing volcano. Yet here the plane of glass has imploded, enfolded, around a pressurized core or chunk of sublimity. In the painted sublime, the threat remains outside. But the contained or imploded sublime deals with a fear that has come inside, threatening from any angle because the viewer's space surrounds it entirely. This is the domestic sublime, managed by vessels instead of shields. It recalls the incursion of science into the home, but also refers to a more widely noted sense of implosion in the sixties, one with specific political overtones that help illuminate the lava lamp's precise relation to its own psychedelic connotations.

McLuhan referred to the sixties as the "Age of Anxiety" because the information revolution, in its ability to shrink or even obliterate *distance*, was dissolving the barriers that had traditionally maintained social divisions:

> Electric speed in bringing all social and political functions together in a sudden implosion has heightened human awareness of responsibility to an intense degree. It is this implosive factor that alters the position of the Negro, the teenager, and some other groups. They can no longer be *contained*, in the political sense of limited association. They are now *involved* in our lives. . . . [McLuhan's italics][47]

"The Negro, the teen-ager, and some other groups" have now come inside, and, like the promiscuous slippings of the lava, they threaten a contaminating intimacy. Their containment now requires more than the old shielding strategies of "limited association." The counterculture is now a domestic problem: it confronts the culture from within.

Fredric Jameson, writing from the standpoint of the eighties, agreed with McLuhan's notion of implosion, but related it—stingingly—to the machinations of global capitalism. Drawing upon the work of Ernest Mandel, Jameson claimed that

> late capitalism in general (and the 60s in particular) constitute a process in which the last surviving internal and external zones of precapitalism—the last vestiges of noncommodified or traditional space within

and outside the advanced world—are now ultimately penetrated and colonized in their turn.[48]

For Jameson, it is global capitalism which has generated this implosion and which now takes advantage of it to gain universal access to its vestigial opponents. His use of the term "colonization" is especially important here, because it replicates the relations of domestication, or of the imploded sublime, discussed above. Colonization does not always occur along far-flung borders, but may also happen within the colonizing system (Jameson refers elsewhere to the "inner colonized of the first world").[49] Indeed, the digestive capacity of the establishment in technocratic late capitalism was being widely theorized in the sixties. Herbert Marcuse claimed that "in this society everything can be co-opted, everything can be digested."[50] From this perspective we can see that the scenario imagined in *The Blob*, with the counterculture devouring the mainstream, gains its horrific power because it is a perfect mirror reversal, an inside-outing, of the engulfment relations of the status quo.

Yet to colonize (to domesticate, to contain) the counterculture most effectively is not quite to digest it, not quite to resolve it seamlessly into the mainstream. It is, rather, to *ingest* it in hermetic yet transparent capsules. This encapsulation process, already well rehearsed in the domestication of scientific progress, allows dyspeptic social phenomena to be swallowed without being absorbed. Because the capsules in question are hermetic, they prevent the counterculture from poisoning the cultural body; because they are transparent, they allow the counterculture to be exhibited. And the two main, somewhat contradictory directives of the capsule—containment and exhibition—are also the two main ingredients of the sublime. The counterculture is not digested, it is *sublim*ated.

Roszak noted that "those who dissent have to be supremely resourceful to avoid getting exhibited in somebody's commercial showcase—rather like bizarre fauna brought back alive from the jungle wilds."[51] In the lava lamp's symbolic reenactment of this commercial encapsulation, the psychedelic counterculture is indeed "brought back alive," its promiscuous and discomfiting motility, its chaotic churnings, miraculously retained. But, of course, to contain the psychedelic is also to contradict it. The aim of the radical psychedelic experience in the sixties (whether attained through drugs, visual environments, music, or all of the above) was that it "not be assimilable by habitual frames of reference" and that it might thus "compel assessment of the experience in radically new ways."[52] If the lava lamp's design accomplishes anything, with its reenactment of so many

technocratic forms and strategies of encapsulation, it is to impose upon its innards an habitual frame of reference.

So the newspaper articles of the nineties are correct in suggesting that the lava lamp contains the sixties psychedelic counterculture. But it also "contains" every other amorphous force that threatened the stability of sixties culture, illustrating and activating the processes of specular containment which, because they are still very much with us today, help explain a new generation's fascination with an older generation's artifact. In fact, from the standpoint of the turn of the century, the lava lamp performs a double miracle. The psychedelic is brought back alive not only across its original cultural gap but also, now, across history. To gaze at the lava now is not only to ponder a scientific or countercultural chaos, but also to confront the nebulous slippings of nostalgia and memory. The lamp orchestrates for us a sublime (and ultimately neutralizing) encounter with the sixties themselves.

NOTES

1. The term "lava lamp" as used throughout this essay shall be understood as a colloquial variant of the brand names "Lava Lite® lamp" (when referring to lava lamps in the sixties) and "Lava® brand motion lamp" (when referring to lava lamps manufactured today). Lava® brand motion lamps are manufactured exclusively in the United States by Lava World International™, a division of Haggerty Enterprises, Inc., Chicago, IL. LAVA®, LAVA LITE®, and the motion lamp configuration are registered trademarks of Haggerty Enterprises. I am indebted to Dick Clarke of Haggerty Enterprises for providing me with marketing and publicity materials and answering (as well as possible given his severe security restrictions) my questions about the history, materials, and construction of the lamps. I also wish to thank Mark Hamin for sharing with me his apparently limitless bibliographic knowledge of the history of science. "For the Love of Lava," *Los Angeles Times* (9 May 1996); Marla Donato, "Lava Lite Sales, Dormant Since '60s, Erupting," *Indianapolis Star* (2 September 1990): section H.

2. Gordon Walek, "Hav' a Lava Lite," clipping from unidentified source in Haggerty Enterprises Files (17 June 1990); Isabel Wilkerson, "Cool Sign of the 1960s Glows Again," *New York Times* (7 May 1990): section B.

3. His black turtleneck is actually something of an anachronism, making him half beatnik and half hippie.

4. R. J. Igneizi, "Lamp Sales Can't Keep Up with Heavy Demand," *San Diego Union-Tribune* (27 December 1996): section E.

5. I should clarify at the outset that I am following Fredric Jameson in including the early seventies—up to 1974—within the cultural and political designation of "the sixties." See Jameson, "Periodizing the Sixties," in *The 60s Without Apology,* ed. Sohnia Syres, et al. (Minneapolis: University of Minnesota Press, 1984), 183.

6. Dick Clarke (of Haggerty Enterprises), telephone conversation with author, 18 November 1993; "Kitschy Cool," *People* (16 September 1996): 194. See also the Lava World International website, www.lavaworld.com.

7. Dick Clarke, telephone conversation, 18 November 1993.

8. For illustrations of these earlier lamp models, see the Lava World International website.

9. Dick Clarke, telephone conversation, 8 December 1993. The Century model lamp with which I have worked was manufactured in 1991, but is, as mentioned above, virtually identical to lamps manufactured in the sixties. The only differences are a slightly tighter seal on the cap and a small change in the liquid chemical balance, instituted to compensate for a change in the pH of Chicago's tap water during the 1980s. I purchased it from a retail outlet in New Haven, Connecticut; since it was the display model, I like to think that it behaves like a well-used lava lamp would have during the sixties.

10. The precise formula for the lava and liquid remains a closely guarded trade secret; see note 33 for more on this.

11. The technical explanation for this process is that the two substances in the tank have slightly different coefficients of thermal expansion. The lava, which is denser than the liquid at room temperature, expands more drastically when heated, thus becoming slightly less dense than the liquid and floating toward the surface. Because the tank is tall and narrow, the liquid remains cooler at the top than at the bottom, and globules, upon reaching the top, eventually contract and sink back to the bottom.

12. Timothy Leary, Ralph Metzner, and Richard Alpert, *The Psychedelic Experience: A Manual Based on the Tibetan Book of the Dead* (Secaucus, N.J.: Citadel Press, 1964). Leary, initially a Harvard psychologist, became the leading advocate of LSD as a vehicle for the expansion of countercultural consciousness. His "manual" for drug users went through several editions. Other influential publications in this vein included Aldous Huxley, *Doors of Perception* (New York: Harper, 1954) and Alan Watts, *The Joyous Cosmology: Adventures in the Chemistry of Consciousness* (New York: Pantheon, 1962).

13. Greenberg, the most influential American art critic in the mid-sixties, advocated with evangelical zeal an abstract painting style that eliminated reference to the body. His aesthetics permitted spatial illusion only if it suggested a purely optical, weightless space, one that viewers could not imagine traversing with their bodies. See his "Modernist Painting," in volume 4 of *Clement Greenberg: The Collected Essays and Criticism*, ed. John O'Brian (Chicago: University of Chicago Press, 1993), 85–94.

14. The term "counterculture" had many definitions, but in the United States it generally referred to a population composed primarily of alienated middle-class youth who were conspicuously attempting—by means either disruptive or escapist—to resist the impositions of the political, industrial, and technological systems governing American society.

15. Theodore Roszak, *The Making of a Counter Culture: Reflections on the Technocratic Society and its Youthful Opposition* (Garden City, New York: Doubleday, 1968), 22.

16. Quoted on the Lava World International website, as in note 6, October 1998.

17. Dick Clarke, telephone conversation, 8 December 1993.

18. Wilkerson, "Cool Sign of the Sixties," B12.

19. Roszak, 19.

20. For a good review of countercultural positions on technology, see Everett Mendelsohn, "The Politics of Pessimism: Science and Technology Circa 1968," in *Technology, Pessimism, and Postmodernism*, ed. Yaron Ezrahi et al. (Dordrecht: Kluwer Academic Publishers, 1994), 151–73.

21. On Mumford's influence on debates about technology, see Thomas Hughes, *American Genesis: A Century of Invention and Technological Enthusiasm, 1870–1970* (New York: Penguin, 1989), 446–50.

22. Richard Maltby, ed., *Dreams for Sale: Popular Culture in the 20th Century* (London: Harrap, 1989), 159.

23. So he was labeled by *Life* magazine; see "Marshall McLuhan, Canada's Talky Social Catalyst," *Life* (25 February 1966).

24. Leary, Metzner, and Alpert, 69.

25. Marshall McLuhan and Quentin Fiore, *The Medium is the Massage* (New York: Random House, 1967), 145.

26. Ibid., 63.

27. For an extensive discussion of anti-formal tendencies among Ruscha's contemporaries in the arts, see Yve-Alain Bois and Rosalind Krauss, *Formless: A User's Guide* (New York: Zone Books, 1997).

28. Julia Kristeva, "The System and the Speaking Subject," in *A Critical and Cultural Theory Reader*, ed. Antony Easthope and Kate Gowan (Toronto: University of Toronto Press, 1992), 77–80.

29. Anton Ehrenzweig, *The Hidden Order of Art* (Berkeley and Los Angeles: University of California Press, 1967), 192. For Ehrenzweig's theories of creativity in relation to formlessness, see especially chapter 11, "The Minimum Content of Art."

30. See Jeffrey L. Meikle, *American Plastic: A Cultural History* (New Brunswick: Rutgers University Press, 1995).

31. Roland Barthes, "Plastic," in *Mythologies*, trans. Annette Lavers (New York: Noonday Press, 1972), 97.

32. Ibid.

33. Haggerty has, in fact, recently initiated several trademark-violation lawsuits against manufacturers and retailers of lamps similar to the Lava Lites. Given the company's usual attempts to project an image of sixties-style mellow insouciance, publicity over the suits has placed company spokespersons in an awkward position. "Baldovin conceded that filing a lawsuit runs counter to the firm's 'mellow' lava philosophy, but he said the company 'just can't let this go on'" (Jim Kirk, "'Knockoffs' Boil Lava Lite Maker," *Chicago Tribune* [12 June 1997]: section 3). A controversy over the company's strict trademark control is also currently brewing on the internet, where posted recipes for homemade lamps flaunt Haggerty Enterprise's claim that it will "SQUISH anyone who infringes our stuff!" (this warning is sprinkled throughout current Lava Lite publicity materials).

34. Robert Friedel, "Perspiration in Perspective: Changing Perceptions of Genius and Expertise in American Invention," in *Inventive Minds: Creativity in Technology*, ed. Robert J. Weber and David N. Perkins (New York: Oxford University Press, 1992), 11–30.

35. Roszak, 6.

36. See Marcel C. LaFollette, "Characteristics of the 'Men of Science,'" chapter four in *Making Science Our Own: Public Images of Science, 1910-1955* (Chicago: University of Chicago Press, 1990), 66–77. LaFollette studied representations of scientists in mass-circulation magazines, identifying several stereotypical characteristics of the male scientist, each of which separated him from mainstream culture. Common stereotypical traits included the scientists' superhuman brainpower and diligence, and subhuman fashion sense and emotional life.

37. C. P. Snow, *The Two Cultures and the Scientific Revolution* (New York: Cambridge University Press, 1959).

38. Margaret Mead and Rhoda Métraux, "The Image of the Scientist Among High School Students: A Pilot Study," in *The Sociology of Science*, ed. Bernard Barber and Walter Hirsch (New York: Free Press of Glencoe, 1962), 230–46.

39. G. Charbonnier, ed., *Conversations with Claude Lévi-Strauss* (London: Jonathan Cape, 1969), 46.

40. Paul Goodman, "Can Technology be Humane?" in *The New Technology and Human Values*, ed. John G. Burke (2nd ed., Belmont, Calif.: Wadsworth Press, 1972), 35.

41. David Nye, in "The Consumer's Sublime," chapter 11 of *The American Technological Sublime* (Cambridge: M.I.T. Press, 1994), 281–96, also discusses the feminization and domestication of technology. But while I emphasize that domestication could occur without demystification, he argues that, through domestication, technologies "disappeared into ordinary experience" (283).

42. The term "CYCOLAC®" comes from a Marbon Chemicals advertisement, *Time* (6 October 1967); "PLIO-TUF®" from a Goodyear Chemicals advertisement, *Time* (3 November 1967).

43. For an excellent survey of the rhetoric of nuclear containment in this period, see Spencer R. Weart, *Nuclear Fear: A History of Images* (Cambridge: Harvard University Press, 1988).

44. Leary, Metzner, and Alpert, 65.

45. Ibid., 24.

46. Immanuel Kant, *Critique of Judgment*, trans. Werner S. Pluhar (Indianapolis: Hackett, 1987), 120.

47. Marshall McLuhan, *Understanding Media* (New York: McGraw Hill, 1964), 5.

48. Jameson, "Periodizing the Sixties," 207.

49. Ibid., 180.

50. Herbert Marcuse, "Varieties of Humanism," *Center Magazine* (published by the Center for the Study of Democratic Institutions) 1 (July 1968): 14.

51. Roszak, 70.

52. John L. Haer, "The Psychedelic Environment," *Journal of Popular Culture* 3 (fall 1969): 263. For a lively and thorough discussion of the history of the psychedelic utopia see Jay Stevens, *Storming Heaven: LSD and the American Dream* (New York: Atlantic Monthly Press, 1987). Thanks to Kenneth Haltman for suggesting this reference.

Carlo Rotella

Industry, Nature, and Identity in an Iron Footbridge

AN IRON FOOTBRIDGE SPANS the Mill River in a stretch of woods and marsh land in New Haven's East Rock Park. Civic leaders, following the lead of park designer Donald Grant Mitchell, built the park in the late nineteenth century as part of a massive effort to use nature to shape the inner lives and recreational habits of an industrial city's inhabitants. The footbridge, an artifact of that high-industrial moment of railroads and reform, has survived into a very different time—the park lies between the inner city and suburban periphery of postindustrial New Haven. The footbridge has made the same steady arc over the Mill River for a century, drawing visitors whose interaction with it inflects their experience of the park and the city. Human meanings have thus accrued around and in the footbridge: the structure has an identity to the extent that it has a place in the overlapping personal geographies of strollers, dog-walkers, runners, birdwatchers, sunset-viewers, readers, photographers, nature-lovers, beer-drinkers, park rangers, loiterers, those who come to fish, and those who end up at the bridge for reasons they cannot reconstruct.

Like any bridge, the footbridge is both a piece of sculpture and a road-way across an obstacle. The sculpture, offering aesthetic transport, encourages the eye and mind to linger above the stream of events in a suspended moment; the roadway, enabling physical transportation, offers a way to get to the other side. The two imperatives condition and complement one another. In the same way, exploration of the footbridge's form and history tends to collapse together ostensibly antithetical terms—park and city, nature and industry, self and environment, past and present. Even as an object of analysis, the bridge serves its traditional function: it allows us to distinguish each term from its opposite, like two banks of a river, but it gives us a way to understand the pair together as a single larger terrain.

Fig. 10.1. Detail of a map of East Rock Park, 1989. The footbridge, located just above the M in "Mill River," links networks of footpaths (broken lines) on either side of the river. Courtesy of New Haven Park Department. Photo by Yale University Audiovisual.

The woods of East Rock Park along the Mill River are overgrown and particularly wild for an urban park, so that one must the approach the footbridge along narrow footpaths (Fig. 10.1). The paths lead through the woods, skirting the muddy, thicketed flats fronting the river. Approaching

Fig. 10.2. Approach to the footbridge, western side. Photo: Michael Marsland.

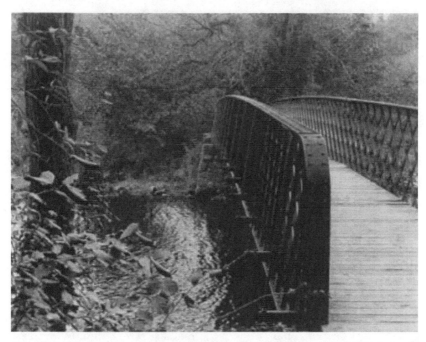

Fig. 10.3. Footbridge and surrounding plant life, seen from the bridge's western end. Photo: Carlo Rotella.

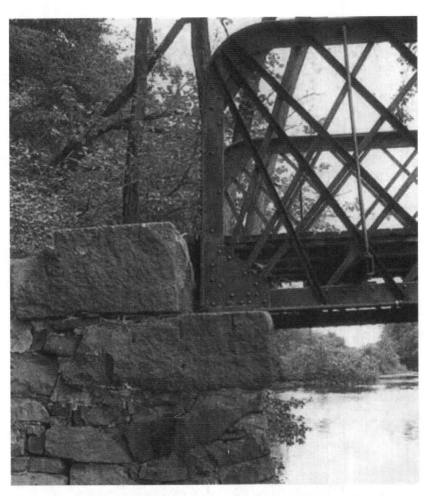

Fig. 10.4. Iron truss bolted to stone footing. Photo: Michael Marsland.

from the west, the path becomes tunnel-like as it curves through thicker growth and under storm-damaged trees. At the end of the last curve, the rounded corner of one of the bridge's black cast-iron trusses appears, framed by plant life (Fig. 10.2). On the eastern bank, the path parallels the river more closely, allowing glimpses through the trees of the bridge's black framework as one approaches it. Arriving from either direction at the bridge, one emerges from the woods into a surprisingly insular space. The river helps to isolate the bridge by making a slight jog just south of it and a right-angle bend just north of it. Trees and other riverside plant life press in on three sides (Fig. 10.3). Only when looking to the south, where one can see downriver past the jog to the arch of a larger bridge at East Rock

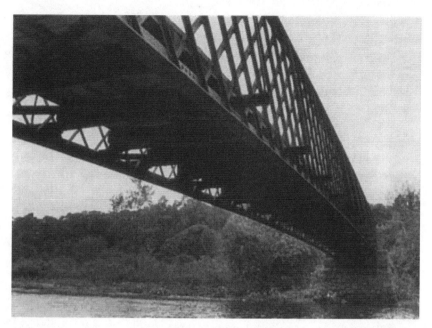

Fig. 10.5. Articulation of supporting framework and bridge floor. Photo: Michael Marsland.

Road, does one sense an opening in this bubble of private-feeling space. Standing on the bridge, then, one feels intimately contained yet able to command a view of expansive vistas: trees against the sky on three sides; the river stretching away south on the fourth; and, dominating the scene, the reddish 365-foot eminence of East Rock rising abruptly out of the woods to the east.

The footbridge is composed of two long cast-iron trusses thrown across the river, bolted to stone footings on either bank, and supporting between them a floor of wooden planks. In round numbers, the span measures 85 feet long—greater than the breadth of the river at this point—by 7 feet wide. The bridge's lower edge hangs a little more than 6 feet above the water surface at each end, a distance increasing to more than 7 feet at mid-span. The footings, rectangular masses of earth contained by basalt blocks (Fig. 10.4), shape the riverbanks into outcrops joining the bridge to its approaches. Each truss is composed of top and bottom girders, about 5 feet apart, connected to one another by a lattice-like grid of diamond shapes formed by intersecting diagonal bars. A network of beams and stays joins the trusses to one another and also supports the floor (Fig. 10.5). In addition, thin pipe-like stabilizers project out from the trusses, keeping the iron girders from leaning inward or outward under their own weight. All

elements of the bridge show signs of weathering; the rusty iron flaking and discolored; the wood worn and splintering; the stones cracked, crumbling, separating from one another.[1] The footbridge, designed by New Haven's City Engineer Robert Hill and built by employees of J. E. Buddington (who submitted the winning bid of $888 to New Haven's Parks Commission), was completed between November, 1897 and April, 1898.[2]

The bridge stands where it does because Donald Grant Mitchell, a guiding creative force behind the New Haven's park system, wanted one there. In his *Hints for the Lay-Out of East Rock Park* (1882), Mitchell indicated that a small bridge across the Mill River would connect footpaths running along either bank of the river, a crucial piece in a system of paths giving visitors access to the park's wildest sections.[3] Mitchell, who cut a national figure as park designer and Yankee *philosophe*, designed the park around the impressive centerpiece of East Rock. He followed the principle that the location's natural beauty, artfully enhanced, should be allowed to speak for itself:

> The bold picturesqueness of the site does not invite the niceties of conventional gardening. Beside those ragged reaches of precipice, and the skirting forest, little fetches of garden craft would be impertinencies. I have therefore sought mainly, in the plan submitted, to make access easy and enjoyable, not only to the more commanding localities, but to the retired nooks and recesses of the range . . .

Mitchell envisioned a park of "fine vistas" and "sheltered nooks" in which "the things best worth seeing there will always be the rocks and woods and views as nature has shaped them."[4] The system of dirt footpaths would channel citizens to these points of interest through terrain that in large stretches of the park remained wild enough to discourage off-trail wandering. Mitchell understood himself to be editing the landscape to make it more intelligible: his park would provide recreation to city dwellers by orchestrating their encounter with the picturesque forms of nature, helping visitors to read a revitalizing content of health and virtue in arranged vistas and little accidents of natural beauty. His vocabulary of desirable human experiences of the park included piquancy, interest, curiosity, surprise, refreshment, inspiration—adding up to recreation in the broadest sense.

Mitchell's conception of East Rock Park derived from a tradition of nineteenth-century park design that, in David Schuyler's words, "recognized the inevitability of the existence and growth of urban areas and advocated creation of more suitable recreational and domestic spaces."[5] The modern park's landscape offered a corrective to the spatial form of the

increasingly industrialized and crowded modern city, which had been hammered into regular gridiron form by the imperatives of real estate, rapid expansion, and the circulation of raw materials and manufactured goods. For reformist park designers like Mitchell and his better-known colleague Frederick Law Olmsted, the urban park offered as well a kind of moral recreation for urbanites, a return to nature that soothed and defused the tensions characteristic of industrial modernity. Urbanites of all classes worn down by the demands of industrial urbanism—the heterogeneous, crowded, volatile working classes as well as the middle and upper classes enervated by the anxieties of commerce—would use the materials of the natural landscape to restore their bodies and their republican souls. For Mitchell and Olmsted's generation of urbanists, who drew upon the long tradition of thought associating natural landscape with the idea of moral and political order, Jeffersonian anti-urbanism had modulated into a reform mentality that accepted the inevitability of a city-centered civilization. The park aspired to temper the effects of city life by allowing the urban self to draw upon woodland or pastoral landscapes ("nature" that had not only been rearranged but also supplemented by the introduction and sometimes toilsome maintenance of species favored by influential European landscape designers) to achieve a sustaining balance.

But the footbridge is not a fallen tree artfully placed across a pristine stream; it is, rather, a railroad truss-style bridge spanning a river named for its provision of power to local mills. As one of the city's machined parts placed in Mitchell's scrupulously "wild" park, the footbridge's cast-iron frame, studded with thousands of bolts, asserts its industrial implications. The general use of the term "railroad truss" to describe even bridges that did not carry rail traffic reminds us that the lines of the truss form itself, so commonly used for railroad bridges, carried associations with the railroad industry.[6] In the latter decades of the nineteenth century, New Haven was a major Eastern rail center; the railroads were essential to the city's economy and to its civic identity. More generally, New Haven was an industrial city. The armory founded by Eli Whitney, a progenitor of modern industry based on labor-saving devices and mass production, still stood a few hundred yards upstream when the footbridge was built (see Fig. 10.1). The Mill River draws its name from supplying water power to industrial concerns of previous eras: Whitney's armory occupied the site of Todd's Mill, New Haven's first grist mill, built in 1641. In his notes for the layout of the park, Mitchell bore in mind the demands of industry, noting that further damming of the Mill River to control fluctuations in water level might "interfere with the mill rights above."[7] The footbridge's cast-iron materials and utilitarian truss design evoke this industrial context.

Why, then, build a railroad truss in East Rock Park? The answer has to do, first, with cost efficiency. The industrialists and other city fathers who made up the East Rock Park Commission and later the Parks Commission considered a railroad truss—employing materials, technology, and expertise readily available in New Haven—to be the least expensive option for a permanent footbridge. Any reading of the commissions' proceedings reveals that cost was at all times an important consideration. Although the commissioners often demonstrated a genuine sensitivity to Mitchell's ideal of a natural and picturesque park, and although they did at times spend more money than they wished to in order to create a park consistent with this vision, the need to limit expenses did come into conflict with Mitchell's imperatives. In 1889, after the initial decision had been made to build a permanent footbridge but before any specific design had been considered, the East Rock Park Commission was absorbed into the Parks Commission, a new city agency. In 1891, this body voted to "respectfully return" Mitchell's suggestions for a bridge at another location—a less railroad-evocative and more conventionally graceful "substantial iron arch-bridge at Lake Whitney"—delegating the Commission's president to inform Mitchell that there were no funds for such a project.[8] The commissioners tried to remain true to the designer's intent, but they also felt obliged to meet their bureaucratic obligations. That might help explain their decision to employ a basic cast-iron railroad truss, rather than a wooden truss (more rustic, but less durable), a stone bridge (picturesque, but more difficult and time-consuming to build), or a less workmanlike but more expensive form of iron bridge (like the one Mitchell proposed, and the commissioners rejected, for the Lake Whitney site north of the footbridge).

Having read the above story of industrialists guided by utility and financial considerations, one might expect the completed footbridge to clash with Mitchell's "natural" park, but it does not. The scale and arc of the bridge begin to modify and even resolve the tensions created by a railroad truss in Mitchell's park. Most obviously, the railroad truss-style footbridge is much smaller and less imposing than an actual rail-bearing truss. The bridge domesticates its industrial charge by shrinking the truss to a human scale. Its exclusively pedestrian traffic makes a strong contrast with rail loads, a contrast reflected in aspects of the bridge's design and their relation to human activity. The lattice pattern of the side panels, for instance, is much more tightly constructed than the characteristically more open lattice truss used on railroad bridges. Considering the minimal strains placed upon the bridge by its human traffic, the tighter lattice seems to exceed its structural function in order to provide assurance that people, especially children, will not fall into the river. People who come to fish off

the footbridge secure their makeshift lines to the bridge's horizontal stabilizers, a serene usage of a structural element that in an actual railroad bridge helps to contain the violent stresses generated by the side-to-side movement of heavy trainloads. A straight beam bridge would normally be used by a rail line to surmount a minor river without commercial boat traffic, but the footbridge describes a gentle arc over the Mill River which softens the industrial lines of the cast-iron frame (Figs. 10.5 and 10.6). The arc might also have been designed to allow more room for pleasure boaters to pass beneath without endangering their skulls, a decidedly human-scale concern. The footbridge employs the materials, technology, and functional lines of an industrial structure but diminution and modification of the railroad truss undercut the tension between this industrial charge and Mitchell's notion of a natural setting.

Mitchell's writing, as well as his park, shows that he regarded nature and industry as antitheses requiring synthesis. At times, he seemed to fear that industrial forms would simply defeat nature, vitiating its potential to uplift and reform. Discussing plans for a larger bridge downstream at East Rock Road, Mitchell suggested various stone arch and timber designs that might "harmonize admirably with the scene." He went on to note that he could not "forbear thinking that a 'railroad truss' at this point, though perhaps the cheapest, will mar very much one of the most rural and park-like scenes which will be subject to [the Commission's] control."[9] This fear of the railroad truss's unharmonious resonances can be traced back to *Rural Studies* (1867), his tract on the virtues and crafting of country landscapes, in which Mitchell warned that railroads, while necessary to bind country people to big-city "civilization," broke up the natural landscape: the railroad "lays its iron fingers upon the lap of a hundred quiet valleys and steals away their tranquillity like a ravisher."[10]

Mitchell felt it was his duty to domesticate the unavoidable signs of industrial development, to imagine how industrial forms might coexist with the agrarian, pastoral, and woodland settings he regarded as natural. In *Rural Studies*, he tried to show how creative landscaping along the right of way, combined with sympathetic railway design, might "harmonize [the railroad's] sweep of level line, its barren slopes, its ugly scars, its deep cuttings, with the order and grace of our own fields and homes."[11] Mitchell, then, was not opposed to the aesthetic implications of a properly "harmonized," or domesticated, industry. Perhaps a miniature railroad truss, endowed with a graceful curve, did not offend as a larger edition at East Rock Road clearly would have. Mitchell almost certainly did not have a railroad truss in mind for the footbridge when he planned the park, but the railroad truss built according to the commissioners' wishes did not neces-

sarily violate his sense of the park's role in harmonizing industrial modernity with natural landscape. For what the negative evidence is worth, the Parks Commission's records do not contain what would have been an influential objection from Mitchell, who was still actively involved in the shaping of the New Haven park system in the 1890s, to the footbridge's design.

Mitchell followed Emerson's lead in undertaking to reconcile industry and nature. In his essays, some written under the pen name Ik. Marvel, Mitchell drew heavily upon Emerson in crafting his own variant of the mystical-imperial Yankee voice. The passages from *Rural Studies* cited above gloss often-quoted lines in Emerson's "The Poet": "Readers of poetry see the factory-village and the railway, and fancy that the poetry of the landscape is broken up by these; for these works of art are not yet consecrated in their reading; but the poet sees them fall within the great Order not less than the beehive or the spider's geometrical web."[12] Emerson's poet, reattaching the results of human creativity to nature, makes evident the beauty in artificial things, even those previously considered antithetical to conventional paragons of natural order like the spider's web. The recognition that nature can love all these works "like her own" carries the poet by degrees to the recognition of a fundamental wholeness incorporating industry, nature, and the observing poetic self. The third term in the triad subsumes and harmonizes the other two: a healthy balance between inspiring nature and productive industry becomes the hallmark of an efficacious modern self. In that the poetics of this wholeness holds out the possibility of what Mitchell calls "harmony," the Emersonian tradition in which Mitchell placed himself encourages a synthetic reading of the bridge—as the medium for precisely the harmonious conjunction of nature, technology, and self that the modern urban park promised to enable.

The footbridge is a grid that frames space: it can be a scaffold, simultaneously containing and generative, in which the encounter between inner self and outer world takes form. Built of iron, wood, and stone, the bridge nevertheless can seem surprisingly insubstantial. The openness of the truss framework emphasizes the space in it. To look at the bridge is also to look through it. One can see the background through the bridge from any angle, and surrounding space seems to flow into the structure from all sides— from above and from the open ends, through the iron lattice of the side panels, through the cracks between floorboards (through which a person standing on the bridge can see the water below). The structure's projections out into space—bracket beams and stabilizers standing out from the truss, thousands of concave bolt heads raised from every iron surface, endlessly repeated L-shapes that cut into space as they incompletely enclose it—fur-

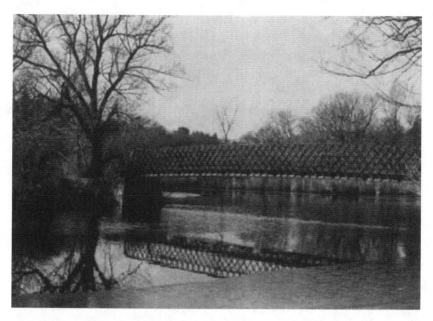

Fig. 10.6. Footbridge and its reflection. Photo: Carlo Rotella.

ther establish this interpenetration between the bridge and surrounding space.

A further set of attributes draws the visitor—first the eye, then the body—*into* the bridge, into the scaffold formed by interpenetration of the structure with the space around it. The fixed, bolted-down footbridge projects a welcoming stillness, but everywhere around it air, water, plants, and animals are in constant motion that flows into the structure of the bridge. People, dogs, and squirrels literally flow across the bridge as they cross and recross it; birds land on it, breezes and rain and snow pass through it. The stone footings that draw the riverbanks up into the bridge are joined to their reflections at the waterline, merging the bridge with its reflection in the moving water so that the river appears to flow through a double-image bridge that is itself half in motion (see Fig. 10.6). The arc of the bridge also creates a sense of lift, emphasized by the mirrored doubling of that arc in its reflection; the material bridge seems to rear away from its counterpart. Tucked away in a "private" space within a public landscape, human-scaled, solitary and still amid the movement of trees and water and sky, the bridge also conveys a sense of intimacy. This combination of interpenetration, flow, lift, and intimacy creates a feeling of suspension when one looks at or walks on the bridge. The stillness of any bridge over any river (or highway) opposes the continuous rush of water (or traffic) passing beneath

Industry, Nature, and Identity in an Iron Footbridge 201

it. Bridges, built ostensibly to transport one over an obstacle, also suspend that movement through the experience of aesthetic transport—the experience of a still moment within or above the flow. That a bridge is a departure predicated upon a return, no matter whether one goes forward or back, contributes to the experience of the time on the bridge as suspension: flight and inevitable descent contained within one another. The simultaneous insubstantiality and weight-bearing, stone-rooted materiality of the footbridge help to make it a scaffolding in which this suspended moment of encounter takes form.

The literature of "bridge epiphanies" articulates a consistent set of observers' responses to the principles participating in this suspension. The Brooklyn Bridge, especially, has inspired a body of writing rich in epiphanic moments to which it owes at least part of its status as a resonant American icon. In his discussion of Hart Crane's "The Bridge," Alan Trachtenberg sets out the organizing principles of the experience: the poet's eye and then the poet's self enters the grid-like scaffolding of the bridge; the poet finds that the bridge "represents not an external 'thing,' but an internal process, an act of consciousness"; the poet ascends to a privileged moment of understanding, unity, and wholeness; "the poet experiences harmony, his troubled self annihilated in a moment of worship." The essential movement in Crane's poem carries the narrating voice from distinctively urban chaos below (exemplified by "the Tunnel," the subway) to the "unfractioned idiom" of the bridge. The poet asks the bridge to "condense eternity," to act as a scaffold that frames and enables an insightful encounter with his world. The bridge, then, becomes an elevated state as well as a place in which an efficacious self defines and identifies itself through engagement with the world around it.[13]

Lewis Mumford and Alfred Kazin give us two classic autobiographical examples of bridge epiphanies consistent with Crane's. They each isolate one specific, paradigmatic experience above all—both occurring at dusk on a winter's day during the narrator's late adolescence. Both epiphanies, that is, occur at high moments of multiple transition, the fall of night and the surging motion of crowds and machines mirroring the narrator's internal sense of change and confusion. Kazin describes a passage up from the noise and ceaseless movement of a rush hour crowd, a dizzying ascent in which the physical bridge drops away—he rises toward a "raw light glittering above the flaky iron rust"—as he enters a state of transport and clarity.[14] Mumford makes explicit the bridge epiphany's erotic subtext (all that intimacy, lift, and flow . . .), likening the exaltation of that moment of ascent and suspension to "the wonder of an orgasm in the body of one's beloved, as if one's whole life had led up to that moment and had swiftly culminated

there." Looking out from the bridge upon the life and movement of his New York, Mumford feels the outer world moving within him: "And there was I, breasting the March wind, drinking in the city and sky, both vast, yet both contained in me . . ."[15]

The bridge epiphany offers a story of recreation in which the bridge makes possible a unique, revitalizing encounter of inner self with outer world. The physical bridge seems to fall away like a scaffold after the completion of the structure of feeling within it. The bridge becomes a matrix in which the suspended self, rendered in absolute clarity over the waters and in flight above the flow of events, rushes outward to encounter the world rushing in.[16] Both Kazin and Mumford couch the encounter in a context of transition and uncertainty; the clarity imparted by the merger of inner self with outer world carries over into a new sense of self in the world: " . . . all the confusions of adolescence dropped from me, and I trod the narrow, resilient boards of the footway with a new confidence that came, not from my isolated self alone, but from the collective energies I had confronted and risen to."[17] (One might continue this discussion with other examples: e.g., Henry Miller's further sexualization of the bridge epiphany in *Tropic of Capricorn*; or the much-repeated story of how Sonny Rollins worked through the confusions of artistic adolescence and found his mature style by practicing among the collective energies and sounds of New York on the Brooklyn Bridge—to which he was "moved," in the first and much repeated version of the story, from the less famously epiphanic Williamsburg Bridge on which he actually played.)[18]

The Brooklyn Bridge is many things the footbridge in East Rock Park is not: a national symbol, a sacred site in the American geography of ethnicity and social class mobility, an enormous structure, a suspension bridge. The principles of interpenetration and suspension, however, apply universally to bridges. In that sense, all bridges become "suspension" bridges. Even the tiny bridges spanning minute streams in Japanese gardens conjure up in miniature the grand-scale bridge epiphany. The footbridge demonstrates this property common to bridges, set in a context of transition between city and park which provides further sources of transport. Mitchell designed the park to inspire and uplift, to provide recreation for modern urbanites. Emerging for a time from the Tunnel of urban life (and from the tunnel-like footpaths leading to the footbridge), these city dwellers would employ the footbridge in harmonizing industry and nature—and thus revitalizing the self. If not itself grand in scale, the footbridge can call upon the Mill River and the natural skyscraper of East Rock for transportive grandeur, much as the Brooklyn Bridge calls upon the harbor and towers of New York City. In 1910, evaluating East Rock Park for the City of New Haven, Cass Gilbert

and Frederick Law Olmsted wrote that "it is in the summation of innumerable little details that are just right or that just fail to be right, which makes the difference between scenery that is a subtle source of inspiration and refreshment, and a 'park' that is only a place to go to take the air."[19] In that the design and placement of the footbridge facilitate its properties of suspension, and thus heighten the recreative potential of the object for parkgoers, the footbridge participates in that inspiration so central to Olmsted's and Mitchell's ideal of the urban park.

The principle of the inspirational park and the literature of bridge epiphanies imagine a flow of meaning between individual and environment. They share the assumption that one's identity does not necessarily stop at the borders of the body but instead extends to landscapes and objects charged with personal and communal meaning.[20] Visitors to a bridge invest it with significance—and, as we shall see in the case of the footbridge in East Rock Park, even alter its physical form—as they enlist the bridge in the project of sustaining and revising identities.

Residents of New Haven and the suburb of Hamden, just north of East Rock Park, call the footbridge "Third Bridge" because it stands upstream from the larger steel arch at East Rock Road and the stone bridge at Orange Street. A loose community of users knows the insular space centered on Third Bridge as a restful and contemplative place, a spatial episode that gives shape to a visit to the park. Word of mouth designates it the best spot to catch fish in the park. Dog-walkers pause for a moment on the span while their dogs sniff around the stone footings. Birdwatchers stop, too, training their binoculars on dead trees to the north and nesting areas in mud flats to the south. Connoisseurs of sunsets, drawn by the play of red tones on the water and the cliff face of East Rock, make a point of stopping by in the evening to appreciate the bridging of day and night. Kids come in groups to hang out and shoot the breeze. Sometimes they—or the occasional adult—drink beer or smoke a joint, but usually they just sit and talk. Runners seem to like the heavy, solid sound of their steps on the wooden planks as they cross over, often exaggerating their footfalls to create satisfying thumps. For the runners, looking ahead and perhaps down, often lost in thought, the footbridge seems substantial and containing; it provides a brief interlude of sure footing and open space before the route plunges once more into the uneven footpaths through the woods. Like railroad trains, the runners run on time. Their experience of the footbridge emphasizes the artifact's solidity, the way in which it enables transportation. Runners predominate in the late afternoon and evening but, most of the time, most of those who come to the footbridge tend to linger. For them, visiting the footbridge has more to do with aesthetic transport than

with transportation: the gaze carries up and out, time passes, the mind wanders.

Written memories of Third Bridge, some of them collected in two guides to East Rock Park published in the 1970s, often associate it with childhood and a return to a moment somehow removed from the continuous processes of urban change. Older locals remember swimming and boating around the bridge; one contributor to the guide, having elegized the lost golden age of his youth in which people behaved well and nature was pure, offers a small consolation in the thought that at least "[b]oys still fish from the Third Bridge."[21] Another contributor, John Harte, departs from his putative subject—birdwatching—to employ Third Bridge in a discussion of decaying values that extends the anxiety underlying Mitchell's reformist urbanism toward the present day:

> Go out there and look for yourself—indeed, you will see more than birds. Standing near the footbridge one achieves a sense of natural isolation which many of us had access to as children but which is unfortunately becoming a rare experience for children growing up in the cities and expanding suburbs of this country.

Harte, like others, characterizes the encounter with the footbridge and with nature (to him, as to the park's designer, the reworked landscape of East Rock Park is still "nature") as inculcating cherished values increasingly under threat from an overly metropolitan society. His brief essay repeats the nineteenth-century urbanists' fear that progressive detachment from nature occasions the decay of civic values. Harte claims that "those of us who grew up in an urban area, but one in which tracts of wild land remained in which man did not tamper with nature" now feel "a sense of urgency that the values we so acquired be accessible to our children and in perpetuity." In his view, his generation could acquire values such as respect for self and environment by enjoying "a sense of natural isolation" in the woods that led to the "experience of discovery." He sees hopeful signs of this transmission of values in the traffic of younger and older regulars around the bridge, but he worries that such encounters with regenerative nature are an increasingly "rare experience" for succeeding generations.[22]

Harte employs a popular formula that contrasts an urban golden age, occurring in the narrator's youth (when things were still done right), with a subsequent decline enacted by later generations who have been improperly trained and socialized. The industrial city may have been new and disturbing in the nineteenth century but it had become nostalgically familiar by the latter part of the twentieth, when the transformation of the industrial city

into the postindustrial metropolis of suburbs and inner city occasioned many stories of decline. During the particularly extensive, wrenching redevelopment of New Haven in the 1950s and 1960s, planners and developers moved the city's high schools from a cluster of buildings in downtown New Haven to more peripheral locations in "the neighborhoods." Many youthful visitors to Third Bridge come from Wilbur Cross High School, the buildings and parking lots of which have since 1956 occupied a site in the southwest corner of East Rock Park—a dramatic instance of concrete and asphalt encroaching upon the park. Like the population of New Haven's inner city, Cross's student body has over the years gone from a "white ethnic" to a large black and Hispanic majority, an ethnic and racial succession that adds to the anxiety pervading some versions of decline. Harte's story is broader and less specific in its fear that city and suburbs are impinging on what is left of "wild land" in the metropolis, but it can be recognized as a local and nature-loving variant of one of the postindustrial era's most potent urban narratives: there goes the neighborhood.[23]

The conventional story of declining civic values leading to the misbehavior of young people posits a failure of succeeding generations to make an investment in the materials of the park, to profit from "the sense of natural isolation" that Harte (following Mitchell) infuses with moralizing potential.[24] Such stories often cite graffiti as a glaring sign of this failure. Like other forms of crime, graffiti was a more significant problem in East Rock Park during the 1970s and 1980s, when gang activity peaked and New Haven's government executed cuts in budget and service that exacerbated the effects of decades of chronic underfunding of the city's parks. All forms of crime, including vandalism, have decreased considerably in the 1990s, not least because the city has in the last decade committed several million additional dollars to renovation and upkeep of the park. Most of the graffiti on Third Bridge has been there a long time. The footbridge is certainly not done up in elaborate taggers' style, but visitors have written and drawn on it. Because the structure makes a difficult canvas—neither the rusty trusses nor the wood planking nor the rough stone footings take paint well, and it is hard to find a broad flat space other than the wooden bridge floor on which to work—kids must go to some trouble to make their mark on it. Graffiti does indeed constitute an inscribed record of the ways in which selfish young people in need of better upbringing ruin the park for others, but that very reasonable reading (favored by the decline formula) should not prevent us from making a second one: kids who hang out at the footbridge provide updated examples of Mitchell's urbanites in search of recreation, and their graffiti suggests that adolescents, as well as birdwatchers like Harte, record in writing an intimate connection with Third Bridge.

We might recall here the importance of transition, especially the uncertainties of youth and adolescence, to the bridge epiphany. Both Mumford and Kazin trace their engagement with the Brooklyn Bridge to a specific moment of transition—between day and night, between boyhood and manhood (a transition emphasized by extended orgasmic imagery). The graffiti adorning the footbridge points almost without doubt to teenagers with time on their hands. They have painted and scratched a wealth of information on the bridge: names, initials (KN's fading initials have been there for a decade at least), relations (pairs of initials joined by a +), culture heroes (Bruce Springsteen's name adorned the wooden planks in the late 1980s), political attitudes ("1#Puerto Rico#1"), and statements of relation to the world ranging from abstract gentleness ("Love") to hostility (a rudimentary swastika painted on the stones of the western footing). The bridge exerts a powerful attraction not only as a formally engaging structure, but also as an out-of-the-way place communicating a sense of belonging to the visitor, a private space removed from the urban gridiron. Kids, like birdwatchers, look for places to stake out, to make private, and their graffiti expresses that impulse taken to a selfish extreme. As a refuge and in its suspension-encouraging capacity, the footbridge offers a place for urbanites, including bored and anxious young people in transition, looking for a means of placing themselves over and outside the continuing stream of events. Mumford and Kazin, as adolescents on the Brooklyn Bridge, balanced fearful uncertainty with the recognition of potential, discovering through the epiphany a sense of purpose. Change, like boredom, can be disorienting and frightening; suspension holds at least the promise of clarity and the sense of efficacy that follows from it.

Regular visitors to the bridge clean up after themselves, and park rangers clean up the area too, but in good weather one still occasionally finds empty beer cans and even used condoms by the footbridge. Both kinds of empties are the residue of time-honored, direct means of achieving a suspended moment. The bridge itself offers a less visceral process of suspension and recreation—and the woods offer cover from prying eyes and the authorities.

Figuring as it does in the lives and identities of individuals, the footbridge accumulates an identity of its own over time for each of its visitors, who invest something of themselves in the structure. In any single encounter with it, the bridge projects a strong synchronic character: a durable artifact, perfectly still against the constant movement of trees and sky and water (much as the Brooklyn Bridge presides over the much more frenetic movement of New York). Over the years, the country has changed around the bridge. A photograph published in the Parks Department's

Fig. 10.7. Photo and caption from Park Department Annual Report, 1901. Courtesy of New Haven Park Department.

annual report for 1901 (Fig. 10.7), taken from high up on East Rock, shows the new footbridge spanning the river in a flat, surprisingly open stretch of ground. A single line of trees approaches from the west. A stone outcrop in the right foreground suggests the vastness of the cliffs just out of the frame. It is a brooding, open panorama, the solitary bridge set in a broad flatland below the mass of East Rock.[25] Photographs of the bridge published in subsequent reports show the wooded country around the Mill River growing in over the years, changing the vista considerably, making it more picturesque by Mitchell's standard of natural-seeming wildness. Throughout the years and the changes in the surrounding park, the bridge describes the same unchanging elongate arc over its reflection in the water.

Of course, forces that make for change in nature have also worked upon the footbridge: the bridge is also a diachronic structure. Its materials have weathered with time. Rust coats every iron surface. Plants grow in and widen the fissures between the stones of the footings. Traffic and weather smooth and pit the mossy wood of the floorboards. Old fishing lines remain tied to the stabilizers. Even the graffiti fades, and occasional new graffiti eclipses the old: someone neatly painted "SPRINGSTEEN '86" over "SPRINGSTEEN '85." Iron, wood, and stone have changed just as the surrounding landscape has changed.

The signifying resonances of iron, wood, and stone have also changed over time. A century of urban development ironizes the railroad truss. In the late nineteenth century the bridge gestured in its materials and form at the rapidly changing world from which Mitchell hoped New Haven's citizens would escape into the park. In the late twentieth century those same materials and form conjure a heroic railroad age, long since receded into industrial atavism, into which an imaginative visitor to the bridge can escape for a brief moment.

Finally, the relation between an individual and the bridge evolves over time. Each successive visit brings a new version of the same person to the bridge, and each time a slightly different bridge greets the returning visitor. Both individual and structure change over time, and the recognition of an intimate bond—a flow of meaning—between subject and object would suggest that the two change one another. Although Donald Grant Mitchell apparently did not have a railroad truss in mind for the footbridge, and although he could not have anticipated how a century of urban history would impart layered meanings to the bridge, his park design orchestrates exactly this process of mutual transformation by subject and object—a process that bridges the materials, and finally the categories themselves, of industry, nature, and identity.

NOTES

1. The pressurized yellow pine floorboards, treated with chemicals to retard weathering, must be replaced every ten to fifteen years. A long overdue regrouting in 1997 shored up the stone footings. All iron and stone elements of the bridge, original parts, have been in place for a century. Two dedicated park rangers, Vin Lavorgna and Dan Barvir, supplied the above information and other assistance, for which the author extends his thanks.

2. New Haven Commission of Public Parks, *Minutes*: 107th Session, 8 October 1897, 165; 108th Session, 12 November 1897, 166; 113th Session, 4 April 1898, 174. The handwritten minutes of the East Rock Park Commission and the Parks Commission are preserved in binders at the offices of New Haven's Parks Department.

3. Donald Grant Mitchell, *Hints for the Lay-Out of East Rock Park* (1882), a map attached to his *Report to the Commissioners on the Lay-out of East Rock Park* (New Haven: L. S. Punderson, 1882).

4. Mitchell, *Report to the Commissioners*, 6, 12.

5. David Schuyler, *The New Urban Landscape: The Redefinition of City Form in Nineteenth-Century America* (Baltimore: Johns Hopkins University Press, 1986), 2.

6. Carl Condit, *American Building: Materials and Techniques from the First Colonial Settlements to the Present* (Chicago: University of Chicago Press, 1968), 93.

7. Mitchell, *Report to the Commissioners*, 13.

8. New Haven Parks Commission, *Minutes: 37th Session*, 16 July 1891, 53.

9. Mitchell, *Report to the Commissioners*, 8.

10. Donald Grant Mitchell, *Rural Studies* (New York: Charles Scribner, 1867), 144.

11. Mitchell, *Rural Studies*, 159. I am indebted to Margaret Ernst, whose undergraduate thesis, "Donald Grant Mitchell and the Birth of the New Haven Parks System" (unpublished paper presented at Yale University, 1980), directed me to these lines.

12. Ralph Waldo Emerson, "The Poet" (orig. pub. 1844), in *Ralph Waldo Emerson: Selected Essays* (New York: Penguin, 1982), 269.

13. Alan Trachtenberg, *Brooklyn Bridge: Fact and Symbol* (New York: Oxford, 1965), 145–46, 153. Trachtenberg ends the book's prologue (3–4) with his own descent from the bridge to the Tunnel, proposing a critic's variant of the cycle in which the poet encounters the bridge, discovers an efficacious self on it, and returns to the city a new man. Writing about bridges in general and the footbridge in East Rock Park in particular has not only carried me back into the history of New Haven, it has obliged me to make a journey back into the history of American Studies. Investigating the resonances—or, if a natural metaphor does not offend, the tree rings of meaning—in this artifact, I found myself passing through *Brooklyn Bridge*, Leo Marx's *The Machine in the Garden*, and other classics of the myth-and-symbol school produced during the postwar romance of American Studies with the problem of industrial modernity.

14. Alfred Kazin, *A Walker in the City* (New York: Harcourt Brace Jovanovich, 1951), 105–7.

15. Lewis Mumford, *Sketches from Life: The Autobiography of Lewis Mumford*, excerpted in *The Lewis Mumford Reader*, ed. Donald L. Miller (New York: Random House, 1986), 37.

16. I use "matrix" here to denote a place or object in which something originates or develops. It is important to recognize the simultaneously enclosing and generative functions of the matrix (a term, after all, also applied to the womb), especially the matrix as grid or frame. The open matrix catches and suspends both the individual and the surrounding space that flows through the framework, serving as a medium that shapes a fresh encounter between the two.

17. Mumford, *Lewis Mumford Reader*, 37.

18. Henry Miller, *Tropic of Capricorn* (New York: Grove, 1961), 48–54; for more on Sonny Rollins, the Williamsburg Bridge, and versions of their encounter, see George Avakian's liner notes for Rollins's album "The Bridge" (RCA, 1962).

19. Cass Gilbert and Frederick Law Olmsted, *Report of the New Haven Civic Improvement Commission to the New Haven Civic Improvement Committee* (New Haven: Tuttle, Morehouse and Taylor, 1910), 84.

20. *In The Meaning of Things: Domestic Symbols and the Self* (New York: Cambridge, 1981), Mihalyi Csiksentmihalyi and Eugene Rochberg-Halton catalogue this investment of objects with personal meaning as one kind of "flow experience," which they define as an activity "in which the psychic energy given to the object is returned to the person as meaningful, enjoyable information, thus creating a kind of free and open 'current' of psychic energy" (187).

21. East Rock Neighborhood Coalition, *East Rock Park* (New Haven: Advocate Press, 1972), 27. For more remembrances of the park, see other entries in this and a companion volume: East Rock Neighborhood Coalition, *Exploring East Rock Park* (New Haven: Advocate Press, 1974).

22. East Rock Neighborhood Coalition, *East Rock Park*, 20–1.

23. For an extended discussion of postindustrial narratives of decline and the historical valences of "there goes the neighborhood," see Carlo Rotella, *October Cities: The Redevelopment of Urban Literature* (Berkeley: University of California, 1998).

24. It bears noting that even in the fondly idealized golden age of industrial New Haven people complained about bad behavior in the park and felt helpless to do anything about it. The Parks Commission's early minutes often mention drunkenness and vandalism, and seven years before the footbridge was built the commissioners were already noting that the park "was the resort of dissolute characters and made use of for improper purposes." That report was duly logged and noted, but "no action taken" (New Haven Parks Commission, *Minutes*: 22nd Session, 15 September 1890, 30).

25. The photograph appeared in *Annual Report of the Commissioners of Public Parks* (New Haven: City of New Haven, 1901).

Lucy Soutter

An Heirloom: Interpreting a Gilded Age Tortoiseshell Locket

MY FATHER GAVE ME the necklace one summer, a sad summer, when he was packing up to vacate his country house. On a dozen previous visits over a dozen consecutive summers, it had never occurred to me to look in the many drawers of the miscellaneous chests and bureaus in the house. Now, from these musty archives, my father brought forth a set of family artifacts that were completely new to me. My great-grandfather's obituary, a photograph of my grandmother circa 1950, showing off her fabulous legs, a passport picture of my father with his only-ever moustache. From one of the drawers, my father produced a bulky tortoiseshell necklace (Fig. 11.1) with a locket containing a photograph of the aforementioned great-grandfather as a baby (Fig. 11.2) and offered it to me. It was from his mother's side of the family, he told me.

It shames me to report that my first reaction was sour disappointment. Of all the family jewelry, much of it beautiful, some of it precious, why did I have to inherit a clunky dark thing that looked like it might be made out of plastic? My second wave of reaction was more akin to gratitude. When I put the piece on, I was pleased by the way it felt and looked around my neck. The fact that the tortoiseshell could be mistaken for plastic suddenly began to seem like an asset; unlike diamonds or pearls, its value was not necessarily apparent. I figured I could wear it on the subway without fear of being mugged. And its chunkiness lent the necklace a kind of hip-hop chic.

In the eclectic late 1980s, urban fashion ran to substantial accessories. Somewhat outmoded punks were still wearing dog collars and bicycle chains around their necks, and the most conspicuous subculture of the moment—hip-hop—was marked by rappers wearing hood ornaments and wall clocks as pendants on gold chains the thickness of rope. My new

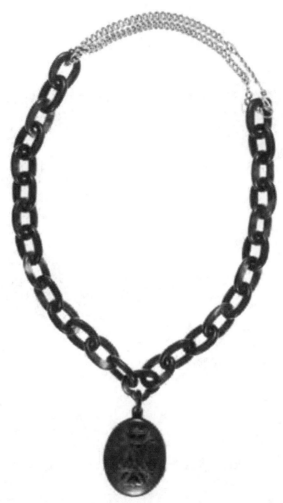

Fig. 11.1. Tortoiseshell necklace. Collection: the author. Photo: Yale Audiovisual.

accessory had morphological similarities to these contemporary fashions, but it clashed laughably with their cultural significance. The plain oval links of the tortoiseshell necklace, each over an inch long, have the simplicity and bulk of a heavy-gauge hardware store chain. Unlike the chain choker that Sex Pistol Sid Vicious wore padlocked around his neck, my heirloom was not a symbol of the oppressive bondage of modern society or of the punk's nihilistic self-consciousness of that bondage. The tortoiseshell locket, an oval measuring 2¹/₆ by 1⁵/₈ inches, and marked with elaborately interwoven initials, is big, bold, and meant to be read, thus bearing

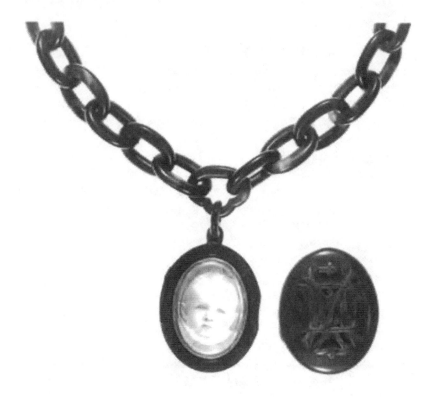

Fig. 11.2. Exterior of locket and photograph of John I. Downey as a baby, ca. 1876. Photo: Yale Audiovisual.

a superficial similarity to the Mercedes and Volkswagen logos worn by members of the band Run DMC, and to the clock worn by Public Enemy rapper Flavor Flav. The hood ornaments, status symbols appropriated from the white hegemony, are an aggressive example of conspicuous consumption, and the clock participates in an iconography of bravado and machismo (your time is running out . . .) designed to threaten the structure of white authority. The original context of my necklace was clearly far removed from these contemporary subcultural fashions.

While I did not take these anachronistic musings very seriously, they raised a number of issues that were to recur in my visual analysis and research: social status, conspicuous consumption, authority, and bondage. The project of reconstructing the historical and cultural significance of the necklace produced a series of insights, some of them disturbing, about my family, the iconography of power and gender relations, and the morality of consumption within the bourgeois culture of late-nineteenth-century New York.

A CONTRARY OBJECT

What seems at first a rather stodgy and predictable object in fact contains a number of internal contradictions. The necklace is simultaneously lavish and somber, ostentatious and private. The tortoiseshell links of the chain are smooth and lustrous, worked to a very fine finish with no sign of molded seams or tool marks. The carved textures which decorate the interwoven initials on the locket; an "M," a "D," and a shape that resembles a backwards "J" evidence skilled handwork. The overall effect is subtle, and the letters cannot be read from a distance much farther than arm's length. The decoration is thus intended for the wearer (to whom the initials are upside down) or for intimate observers in close physical proximity.

From the intricate and polished appearance of the locket, one might expect its opening mechanism to be smooth and reliable. In fact, it is rather temperamental. The locket has no hinges or joints, and the front and back pieces are held together only by friction. Persistent gentle prying, as with a fingernail, is required to separate the two halves. Small rough indentations on the sides of the pendant document the repetition of this action over time. Prying that is not gentle results in the two halves flying apart suddenly. The contents of the locket are also precarious. A beveled glass oval, held in place by a narrow brass ring, holds the baby's photograph inside the locket. The fit of these elements is loose, and they sometimes fall out if the opened locket is turned upside-down. The point of negotiation between the public, external aspect of the locket and its private, internal content is an extremely fragile one.

The piece has been damaged and repaired over time. The tortoiseshell chain is composed of alternating solid links and links with a single straight break in the cross section of one end. The chain in its existing configuration has twelve links on one side but fourteen on the other, each terminating in a solid link, suggesting that one or more have given way. The gap has been bridged by a heavy gold watch chain, doubled over and attached to itself by redundant double clasps. An opulent provisional touch, this repair implies that the locket was important enough to be fixed, but not important enough to be fixed properly, and that the makeshift repair took place in a world where such items as a gold watch chain were easy to come by, easy to spare.

The necklace has inherent value in its materials and aesthetic value in its formal complexity and carefully worked appearance. Perception of these values, however, depends upon close examination. From a distance, the necklace looks dull and brown, the gold chain hidden behind the neck and possibly underneath the hair of the wearer, the contents of the locket hidden from view.

LATE-NINETEENTH-CENTURY PREOCCUPATIONS: DEATH, APPROPRIATE BEHAVIOR FOR LADIES, THE FIRST BORN SON

The dark color and solid design of the tortoiseshell necklace relate to Victorian styles, particularly for mourning jewels. I knew that the necklace did not commemorate the death of the baby in the picture—my great-grandfather's obituary told me he had lived to be eighty-five years old.[1] The history of mourning jewelry nonetheless helps to illuminate certain contradictions manifest in the locket. Originating in England, at the time of the death of Queen Victoria's consort, Prince Albert, in 1861, and soon becoming popular in America, the vogue for women's mourning jewelry epitomized the morbid preoccupations of an era.[2] Fashioned in dark materials, worn against black dresses, mourning jewels were hard to see yet meant to be noticed. Varying in quality, taste, and value, mourning jewels exhibited the wealth and status of a dead husband. Furthermore, in an era preoccupied with the behavior appropriate to the female sex, mourning jewelry enabled a woman to display her refined, dutiful, lady-like grief, sometimes for years after the death of a husband or child.

The demand for mourning dress led jewelers to black or dark-colored materials, especially jet.[3] An organic coal-like material, jet was affordable, light in weight, and therefore lent itself to the bulky designs favored in mourning jewelry. Such pieces were large and often elaborately carved; however, due to their dark color, their detail could only be perceived at close range. In this way, mourning jewels provided a visual analogue for the experience of death in a community: death is announced and commemorated as a public fact, but experienced by family members as an intensely private loss. A locket worn by a bereaved woman might be recognized as a piece of mourning jewelry, but only she, or those on intimate terms with her, would be able to read the carving, let alone to glimpse the image of the deceased secreted inside. As well as sharing the dark color and massive style of mourning jewelry, the tortoiseshell necklace shares this double mode of address. Making a public show of wealth and taste, while keeping certain details private, the necklace points to ways that the cultural logic implicit in mourning jewelry had relevance for Victorian women even outside the realm of the observation of death.

The fashion for dark, heavy-looking accessories for women began with mourning jewels and then spread to jewelry for all occasions.[4] Opera singer Adelina Patti, for example, chose to be photographed circa 1867 in thick double-looped jet chains worn dangling to her waist, despite the fact that she was not bereaved. Queen Victoria fueled the fashion by giving a large silver choker to popular actress Jenny Lind in the late 1870s.[5] These

two examples illustrate other trends that were pioneered in mourning jewelry, notably the use of semiprecious materials rather than gold and gems, and use of nonprecious materials that were exotic without being gaudy. These materials, and the blocky way they were styled, provided a sharp contrast to the sparkling stones and delicate filigree that had characterized luxury jewelry in the earlier part of the century.[6]

The use of tortoiseshell in necklaces fits into this trend. The darker shades of tortoiseshell, which can vary from yellow to dark brown, were considered appropriate for mourning. Much lighter in weight than metal, tortoiseshell was well suited to the fashion for substantial mourning jewels. Its lustrous brown color, which can complement brown eyes and hair, would have contributed to tortoiseshell's appeal in non-mourning jewels as well. Prior to the addition of the watch chain, and completed by the one or two links and a clasp that have been lost, my tortoiseshell locket must have been a loose choker, a style that appeared around 1876 and became widespread by 1878, lasting only a few years until daytime jewelry in general became unfashionable in the early 1880s.[7]

My tortoiseshell locket contains a photograph of John I. Downey, the first born son of a family wealthy from two generations in the construction business in New York City. Given these facts, it seems likely that the locket commemorates the birth of a son and heir, and his baptism at Fifth Avenue Presbyterian Church in 1876. I have not been able to find a firm reference for the iconography of the central symbol on the outside of the locket. I would speculate that the backwards "J" shape, with a cross at the top, and a bulge like the clapper of a bell at the bottom, is a symbol of the Christian faith, and perhaps of the "ringing in" of a new member of the church. The interpretation of this element as a symbol, rather than as a letter of the alphabet, is supported by two English lockets from 1878 (Fig. 11.3) in which two initials are woven around a decorative central element. The two initials on my family locket, "MD," stand for the mother of the baby, Mary Fisher Downey. The "F" of her maiden name is significantly absent, illustrating her assimilation into her new family. Mary Fisher Downey would have worn the necklace to celebrate the perpetuation of her husband's family dynasty, and her role as wife and mother.

Mourning dress and mourning jewelry enabled women to publicize their virtuous response to bereavement. Similarly, restrained fashions in luxurious heavy jewelry allowed women to evoke related values—conformity and duty—at all life's turning points. As deaths were marked with special jewels, so too were engagements, marriages, travels, and occasionally the births of children. If worn in 1876–78, the tortoiseshell necklace would have been fresh and stylish. It would have marked Mary Fisher

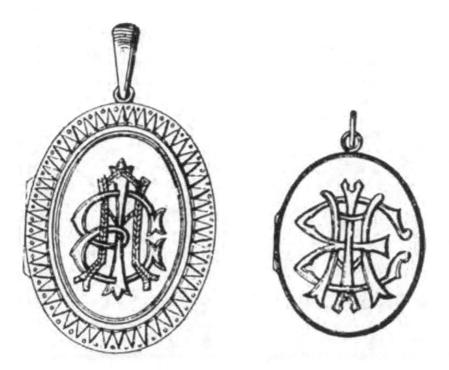

Fig. 11.3. A pair of lockets from *Pringle's Catalogue*, 1878. Photo: Peter Hinks.

Downey as a lady of fashion. The fragile sparkle of early to mid-nineteenth century jewelry drew attention to the carefully cultivated appearance of the women who wore it. Heavy inscribed later pieces like the tortoiseshell locket accented not only the individual beauty, but also the domestic values of their wearers.

PORTRAIT PHOTOGRAPHY

Until the 1880s, locket photographs were either tintypes or albumen prints, usually cut down from studio *carte-de-visite* size, 3½ by 2½ inches.[8] Lockets tended to be large enough to accommodate these standardized images. A fragment of a printed design, an easel with lettering on the back of the Downey photograph, attests that the image originated in a portrait studio. The paper print ranges from dull yellow to medium brown, identifying it as an albumen print, an unstable transitional medium, the tonality of which often faded from its original black and white to a low-contrast yellow-brown.[9]

The technical limitations of the photographic medium have been overcome with a certain ingenuity. The rectangular photograph has been shaped by short irregular cuts consistent with the use of small scissors into a rough oval. The oval shape contains the head, and a very small portion of the chest and shoulders, of a baby. Contained within its dark, airtight container, the print has been partially protected from fading; similarly, the shiny brass ring that holds it in place has been kept from tarnishing.

Shielded and enshrined within the locket, the baby has the air of having been well cared for. His few wisps of hair groomed away from his high forehead, his body bundled in light-colored clothing, the baby looks with unfocused eyes at the camera. While many aspects of the origin and meaning of the necklace can never be known—whether Mary Fisher Downey ever wore it, for example—the photographic index establishes a few points of certain fact. There was a baby. The baby was groomed and dressed carefully. The baby was taken to a professional studio to be photographed. In making their visit to the photographic portrait studio, the Downeys were engaging in a ritual expression of identity less than a quarter of a century old. Photographs provided a new way to mark the passage of time. Placed inside the valuable locket, the photograph of John I. Downey expressed his parents' hopes for his future—that he should always be comfortable, and always be important, the kind of person who would be photographed at all the turning points of his life.

As well as implying a future identity for the baby, the locket preserves a moment from his past—the brief opening of the camera's shutter. This indexical trace of the sitter allows the photograph to function like a relic in a way that a painted portrait could not. In a religious context, relics are ordinarily taken from the bodies of holy men or women after their deaths. Sentimental Victorians brought relics into the secular realm; jewelry made from the hair of loved ones, either living or dead, was worn by ladies of fashion, recalling the locks of hair and chips of bone preserved by devout saint-worshippers.[10] Both a memento and an object of contemplation, the tortoiseshell locket functions as a reliquary, preserving a temporal trace of John I. Downey.

Dead Turtles

The tortoiseshell of the locket and chain, warm and smooth to the touch, glows darkly; its delicate variation of hue attracts the eye. These pleasing characteristics have their root in the bio-organic nature of the material, in the fact that the shell comes from a living creature. Unusual materials, and the associations that they bore, were key to the sentimental effect of

Victorian jewelry. Jewels made of exotic or novel materials invoked a broad range of cultural meanings. Jet, a product of the British seaside town of Whitby, was Queen Victoria's choice to show her grief and support British industry at the same time.[11] Hair jewelry was worn during mourning or simply to show devotion. Even iron and steel jewelry, developed early in the century in Prussia, had a special emotional significance. It displayed the patriotic self-sacrifice of women who had given their gold to the war effort against the French. Other materials evoked far away places. Pieces made from Vesuvian lava were sold as souvenirs of trips to Italy. Certain South American beetles were worn for their shock-value as well as their bright colors.[12]

Tortoiseshell was among the most valuable of these exotic materials. Its initial popularity in the 1830s and 40s was linked to a trend towards naturalism—because it is organic and easily worked, the shell could be molded easily, and its color was ideal for jewelry shaped like twigs or branches.[13] The material itself would have been associated with warm waters and distant lands. While the hawksbill turtle which provides the shell is found in the Atlantic, Pacific, and Indian Oceans, the trade was concentrated in the West Indies and in the ports of Singapore, Bombay, and Zanzibar.[14] Cruelty was inherent to the harvest of tortoiseshell. Turtles were slaughtered for their shells, or suspended alive over hot embers until the individual panels of shell fell off.[15] The dark brown shell used in the locket, mottled with a light amber color, comes from the upper part of the carapace, while less valuable lighter yellow shell comes from the turtle's belly.[16] Because the heated shell is so malleable, finished pieces tend to be smooth and seamless. In looking at a finished piece it is difficult to reconstruct the process that transformed the shell from its original rough state. Typically, several sheets of shell were soaked, pressed, and carved into bulky chains, lockets, bangles, and brooches. Lockets were usually oval, like the one under examination, providing a distant echo of the shape of the turtle's shell. Hard on the outside, hollow on the inside, each carried a treasured image within, protected from unwanted scrutiny. In this way, tortoiseshell represented nurturance as well as cruelty and exoticism.

In the nineteenth century, wealthy New Yorkers would have associated turtles with dinner. Terrapin, cooked alive, was a mainstay of the menus of the rich. Edith Wharton links turtles, luxury, and cruelty in *New Year's Day*, a novella examining the customs, fashions, and morality of New York Society in the 1870s.[17] Her heroine, Lizzie Hazeldean, demands turtle for supper: "And now, some champagne, please—and *hot* terrapin!" The novel is a grim morality tale in which the reptilian dish is twice cited

as a symbol of luxury, a tragic luxury in Lizzie's case as she must maintain a degrading affair with a rich man in order to "keep up" the lifestyle of a beloved husband who is dying of consumption. Wharton's New York fictions evoke the specific culture of consumption in which the tortoiseshell locket was originally purchased and worn, a culture that was torn between luxury and puritanism.

"CLOTHED ALL OVER WITH SENTIMENT"

Upper-middle-class New Yorkers consumed more luxury goods than ever at the end of the nineteenth century, but they maintained ambivalent attitudes towards extravagance. T. J. Jackson Lears has written eloquently of the peculiar psychology of American consumption between 1840 and 1880: "The fears of self-ruination, rooted in a persistent Puritan-republican ethos, pervaded bourgeois culture throughout much of the nineteenth century . . . makers of mainstream culture sought an idiom that would meld aristocratic fashion and republican simplicity. . . . Aesthetic moralists wanted to maintain a tightly controlled equipoise between respectability and extravagance, authenticity and artifice."[18] The conflict was perhaps most acute for the newly rich. Keen to enjoy their wealth, and to make a name for their families, upstarts also had to prove their taste and their moral worthiness to enter Society. These goals were necessarily carried out with a certain amount of hypocrisy, as described vividly by Wharton. The purchase and display of extravagant luxury goods, like the tortoiseshell locket, were tempered with the symbolism of a sober morality. A valuable jewel was not perceived as ostentatious if it conveyed the seriousness of its wearer.

American sculptor Hiram Powers faced a related dilemma in the 1840s. He wanted to sculpt the nude, but needed a respectable device to frame his sculpture's nakedness. A pair of light shackle bracelets joined by two lengths of oval-linked chain provided instant virtue and chastity, transforming a potential harlot into a modest Christian maid (Fig. 11.4). *The Greek Slave* was celebrated on both sides of the Atlantic following its appearance in the Great Exhibition of 1851. The success of the chains as a symbol of redemption was clear to observers such as the Reverend Orville Dewey, who described the nude as "clothed all over with sentiment, sheltered, protected by it from every profane eye."[19]

Similarly, one of the best known emblems of the abolitionist movement featured a kneeling slave, his shackled hands clasped in prayer or supplication, under the caption, "Am I not a Man and a Brother?"[20] Despite his emotionally moving appeal, this slave is a passive figure, suffering his chains with patience and fortitude. Tellingly, these virtues

Fig. 11.4. Hiram Powers, *The Greek Slave*, ca. 1843. Marble, height 65 ¹/₂ inches including integral base, 90 inches including pedestal. Yale University Art Gallery. Olive Louise Dann Fund.

corresponded closely with those expected of late-nineteenth-century women. When she visited England in 1853, Harriet Beecher Stowe was presented with a gold bracelet, "composed of ten links simulating the fetters of a slave."[21] The powerful symbol of the chain moved from the arm of a slave to that of a wealthy white woman, from the realm of propaganda to that of fashion. Later in the century, after the abolition of slavery, sculptors showed male slaves triumphantly holding up their broken chains (Edmonia Lewis, *Forever Free*, 1867) or casting their broken chains to the ground (Francesco Pezzicar, *L'emancipazione dei negri*, 1876, shown in the Philadelphia Centennial Exhibition). Wealthy women of the period, however, continued to wear decorative chains until the end of the decade. Despite the women's emancipation movement, or perhaps in reaction to it, jewelry displayed more than ever the role of woman as chattel.[22]

Certain pieces of jewelry concretized the idea that marriage made a woman her husband's property. Chunky betrothal bracelets, locked on with a padlock, were increasingly common in the 1860s and 70s. These betrothal bracelets may help to explain the evolution of fashion in ladies' chains. Previously delicate showpieces of a jeweler's skill, the new chains were simplified and bulked up to resemble utilitarian forms. Expensive, plain jewelry of this type spoke not only of the moral superiority of its wearers, but also of the power of their husbands. Like most extreme fashions, this fetter-like jewelry went out of style quickly;[23] and, in the early 1880s, as noted above, daytime jewelry went out of favor, awaiting its reconfiguration and rebirth in the Aesthetic movement. But our tortoiseshell necklace, with its visual resonance of lock and chain, was not destroyed. No longer a fashionable accessory, the piece outlived the decade in which it was created.

PROVENANCE: A LETTER FROM MY GRANDMOTHER

November 27, 1995

Dear Lucy,

How well I remember your locket. It was my grandmother Mary Fisher Downey's. I never knew her but the photo is my Dad, John I., when very young. At six months he had grown to be a fat smiley Buddha with a grin, his skin very white & eyes intensely blue. He was her first born of 5 children—3 boys then 2 girls.

I was in my mid teens when the locket came to me [circa. 1925]. I did not wear it often—I was in school uniform or in riding britches

mornings. My shoulders were wide & my hips flat and narrow so I always felt the locket overpowering.

. . . my Suzy and your Dad (like most babies) loved to tweak earrings, beads etc.—so when it broke I don't remember. I'd come by many bits of chain used for pocket watch fobs, Phi Beta Capa's [sic] etc. and having rather long hair I guess I hoped the bit of chain would not show. I don't even remember the occasion or the dress I planned to wear the locket on.

Once in a blue moon I've missed it but never could remember what happened to it when we divided treasures and trash when we finally sold 20 Grace Church Street . . .

1996

The heirloom is a special category of artifact. While the meanings of all artifacts shift over time, an heirloom's meaning accrues and resonates over generations. A family portrait, for example, is painted with posterity in mind. The painting reflects the ego of its subject, but it does not achieve completion until it hangs on the wall of a distinguished descendant, adding patina to the family name. Other heirlooms are unintentional, like the pocket watch that gets passed on after the death of its owner, whether in working condition or not. My heirloom is not particularly precious, or seems not to be perceived as such since it came to me, the third daughter of four daughters and a son. But even as an accidental heirloom, the necklace carries a certain didactic weight. With my great-grandfather hanging around my neck, I move more carefully, with better posture. I dress specially to accommodate the style of the necklace. I do not brag about its origin as overtly as I do about other prized possessions, feeling obscurely that this would be pretentious. In these ways I feel the heirloom has carried the values of its original owner through several generations.[24]

I have not had the necklace appraised, partly from laziness, partly from fear that the object would turn out to be valueless, or perhaps worse, that it would be worth a great deal of money and that I would be tempted to sell it. But of course the deep reason for my lack of curiosity about the object's value is a sentimental morality, passed down through generations of Soutters, based on the idea that money is vulgar and crass. In many ways, this project has underscored my relation to objects, and my participation, through objects, in a culture of privilege. My tortoiseshell locket is a talisman of this culture. It links me to the aspirations and the achievements of my ancestors.

NOTES

1. Obituary notice: "John Irving Downey Dies, Retired Banker, Builder," *New York Herald* (22 April 1961): 8, col. 2.

2. Patricia Warner, "Mourning and Memorial Jewelry of the Victorian Age," *Dress* 12 (1986): 55–60.

3. Ginny Redington Dawes and Corinne Davidov, *Victorian Jewelry: Unexplored Treasures* (New York: Abbeville, 1991), 132.

4. Warner, "Mourning and Memorial Jewelry of the Victorian Age," 56–57.

5. Dawes and Davidov, *Victorian Jewelry*, 37.

6. Peter Hinks, *Nineteenth Century Jewelry* (London: Faber and Faber, 1975), 63.

7. Ibid., 63.

8. Naomi Rosenblum, *A World History of Photography* (New York: Abbeville, 1989), 62.

9. Ibid., 34.

10. Victorians were not the first to bring such relics into the secular realm. Hair from the deceased had been a common feature of miniature cases and the back sides of mourning jewelry in the eighteenth century.

11. Warner, "Mourning and Memorial Jewelry of the Victorian Age," 55–57.

12. Hinks, *Nineteenth Century Jewelry*, 60.

13. Dawes and Davidov, *Victorian Jewelry*, 132.

14. Carl H. Ernst and Roger W. Barbour, *Turtles of the World* (Washington D.C.: Smithsonian, 1989), 124.

15. Ibid., 124.

16. Shirley Bury, *Jewelery, 1789–1910* (Woodbrige, Suffolk: Antique Collector's Club, 1991), 260.

17. Edith Wharton, *New Year's Day: The Seventies* (New York: D. Appleton & Co., 1924). The novella was conceived as the last of a four-part series of stories tracing New York society from the 1840s through the 70s. Later editions drew the four novellas together under the title *Old New York*.

18. T. J. Jackson Lears, "Beyond Veblen: Rethinking Consumer Culture in America," in *Consuming Visions: Accumulation and Display of Goods in America, 1880–1920*, ed. Simon J. Bronner (New York: Norton, 1989), 82.

19. Peter Gay, *Education of the Senses* (New York: Oxford University Press, 1984), 398.

20. This figure, designed anonymously in 1787 for the seal of the Society for Effecting the Abolition of the Slave Trade, was appropriated that very year by Wedgewood for a popular line of medallions; see Hugh Honour, *The Image of the Black in Western Art* (Cambridge: Harvard University Press, 1989), 4: 62.

21. Honour, *The Image of the Black in Western Art*, 4: 202.

22. Hinks, *Nineteenth Century Jewelry*, 63.

23. Ibid.

24. As well as a blood tie, there are institutional links between myself and John I. Downey. I was sent to his preparatory school, and find myself now at the university from which he was graduated roughly a century ago in 1897.

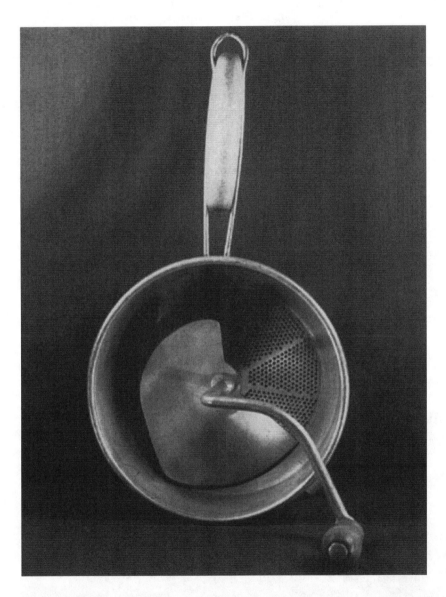

Fig. 12.1. The Foley Food Mill. 6 ¼ inches in height, 14½ inches in diameter. Metal and wood. Collection of the author.

Amy B. Werbel

The Foley Food Mill

THE FOLEY FOOD MILL (Fig. 12.1) stands 6¼ inches in height to the rim, and weighs slightly less than 1½ lbs. The diameter of the bowl is 6⅞ inches. Disassembled, the mill has only three parts: a sieve, a blade-shaft within the sieve, and a wing nut at bottom, attaching the two. The materials of the food mill are similarly simple. Soft, matte aluminum predominates, providing a sturdy surface for long wear and for withstanding heat and cold. Wood is used on the handle of the sieve and knob of the shaft, the places where one would need to grasp the mill to make it work. By shape, texture, color, and lack of conductivity, the food mill beckons the hand.

The particular food mill under observation shows the signs of its age and use. The interior surface of the sieve, with its myriad concentric scratches towards the base, suggests many thousands of rotations of the blade.[1] The handle has been broken off and soldered back on unprofessionally. The wing nut, of a different metal than the body, has replaced a screw with attached needle that once scraped and cleaned the bottom of the sieve as the shaft rotated. The soft, worn metal and wood, the handle bending down from the bowl with the weight of use, and the jutting knob of the mill invite us to pick it up and rotate the shaft, while the arched feet that reach out indicate that we should place something below. At the same time, the mill does not at first glance stimulate curiosity or mystery. Its usefulness presents itself straightforwardly: there seem to be no pretensions or hidden secrets. This is not an object for display, but one that would be at home in a closet with pots and pans, colanders, wooden spoons, and dish

Reprinted from *Technology in Society*, vol. 14, 1991, pp. 345–56, with permission from Elsevier Science.

towels—the objects that in our culture are used daily but rarely thought about.

Most obviously, the mill speaks to us in written language atop the blade, telling us that to clean it we must "remove thumb screw—lift out masher." We know that we will be making something "dirty" by using the mill, and that we are expected to keep it clean. The next lines tell us that we are looking at a Foley Food Mill, produced by the Foley Manufacturing Company in Minneapolis, Minnesota, and that it was granted a patent number, 1921936. No other inscriptions are found, but a language of forms similarly provides us with information about the object.

Every component of the mill is round, rounded, curving or tubular, creating rhythmic circular patterns. The full bowl-form of the sieve is capped by a thick, tubular rim: the surface is pierced only by circular perforations on the floor of the sieve arranged in a radiating pattern like the petals of a flower. Signs of extensive wear have muted the colors and textures of the aluminum sieve and shaft, and softened the warm hues of the wooden handle and knob. The rounded forms suggest cultural associations with femininity, while the patterns of extensive wear signify the passage of time, investments of energy, and long-term productivity.

Just the name "food mill" tells us a lot about what this object does, who used it and when it was made. A mill in the paper, fabric, or flour sense of the word, takes in raw resources and processes them into refined, usually smaller forms more usable for human purposes. A *food* mill thus implies an object into which you put food, and out of which comes the food in a more refined form. No object could suit its title better, for as the shaft is rotated in a clockwise direction, the uplifted edge of the blade traps food underneath it, forcing it through the holes of the sieve as the lower edge comes around. When rotated in the opposite direction, the lower edge scrapes the food off of the bottom and pushes it back up over the top of the blade so that it can be pushed through again if it is still too large. Since the edges of the blade were molded to be round, only food cooked or inherently soft is appropriate. Hot cooked food is comfortably accommodated inside this metal object whose wooden extremities protect the user. As mashed food would only briefly maintain its shape once pressed through the sieve, the mill requires a bowl of similar size beneath it to catch the falling food. Clasping feet encourage this attachment.

So far, we have determined that this curvaceous mill has been used extensively, and that it is good at what it proposes to do as long as you fill it with the right substance—soft food. But why would someone want to mash food? What does mashed food do? The product of the mill is pulp that slides down the throat with ease, requiring no chewing. This has two

obvious benefits, one the textural pleasure, or oral sensation, of eating something of such fine consistency, and the second that the food mill pre-chews your food, an advantage for people with dental deficiencies.

The "dentally-troubled"—elderly, infirm, and babies—constitute a population of care-needers, which suggests that the operator of the mill might be a care-provider. Another reasonable assumption about the potential market for a food mill is that a manufacturing company would want to produce an object that would have wide appeal. Furthermore, we know that the food mill was unique in some sense, at least at the time that its patent was granted.

Knowing who would eat mashed food helps us to determine whose tool this might be. Here, the curvaceous form of the piece suggests a connection of food preparation with women. Women are almost always primary care-givers in their cultures; as nurses, as wives and, especially, as mothers. This is not coincidence. A woman is prepared to nurture not only by the biological ramifications of childbearing and nursing, but also in many cultures by the weighty forces of socialization and cultural expectation.

The food mill has more to do with woman-as-nurturer than is initially obvious, for processing food into more easily digestible forms is one of the central biological functions of women who become mothers. In the womb, the child absorbs nutrients from the mother through the umbilical cord. During pregnancy, the breasts swell as the body captures food from the mother's system, preparing, like the food mill, to process it into a liquid that the infant can easily digest once born. Subsequently the mother's body remains intensively absorbed in the feeding process, as the cry of her baby makes the temperature of her breasts rise, stimulating milk drippage.[2]

A mother's feeding functions go beyond simple structural physiology to include hormonal and behavioral changes that produce nourishing behavior. As the breasts prepare to feed the baby during pregnancy, emotional bonds are likewise created between mother and fetus that inspire caring and nurturing feelings. What we might simply call "maternal love" is partially induced during this period by hormones such as prolastin, which are believed to produce maternal behavior. In rabbits, for example, prolastin induces nest-building.[3]

Impulses to feed, of course, are not only biologically induced; they are greatly determined by processes of female socialization. Girls often watch and emulate their mothers, preparing early on to be mothers themselves. This particular food mill was a favorite toy of my mother and aunt in practicing nurturing behaviors; my grandfather recalls that the two girls fought over who would be the "mommy" and make their younger brother's food with the mill. The mill as a toy, more than a smooth, squeaky object, was

a prop that allowed them to practice one of the roles expected of them in society.[4] Feeding is thus basic to women in this cultural environment; biologically as females, functionally as mothers, and deterministically as girls raised by mothers to *be* mothers. Nor do feeding and nurturing stop with the breast. Human children are not independent even when weaned, and the process of care-giving is long and multi-faceted. Nurturing also extends to groups other than children. Subsequent nurturing is the realm in which the food mill asserts itself, for it is a tool that takes over the role of the breast when the requirements of the care-needers are beyond those of early infancy.

At the specific level of child rearing, the food mill is perfectly designed to prepare foods appropriate after breastmilk. It also is an appropriate expression of the character of this work. Mothers commonly admit that such feeding tasks are tedious, even while continuing to express a sense of self-worth, value, and meaning derived from their activities as mothers.[5] Similarly, there are no supra-functional attributes designed to make use of the mill stimulating or pleasurable. Although the circular rotation of the blade shaft might be considered soothing and rhythmic, on the whole few would use the food mill for purposes of relaxation or seek it out as an object of pleasure. The only decoration on the object is the inscription that provides product information. Thus, like feeding in general, satisfaction lies not in the pleasure that the activity itself provides, but rather in the end that it achieves.

While these contemporary visions of motherhood and care-giving provide a fitting context for the food mill in the present day, we cannot infer the same context to have been true for the society which created the object. As the product of a particular era and culture, the food mill also bears birthmarks which tell us of its original functions and meanings. The most immediately useful birthmark in this regard is the patent mark. Patent number 1921936 is recorded in the 8 August 1933 edition of the *Official Gazette* of the United States Patent office. The designer of the mill was Jean Mantelet of Bagnolet, France. Although it is unclear at what point the design was purchased from Mantelet, soon after this patent was granted the Foley Manufacturing Company, located at 51 Main Street, Northeast Minneapolis, Minnesota began production of the food mill, in 1 quart and 1½ quart sizes.[6] Since the mill has the patent number engraved on it, it must have been produced post-1933. It must also have been produced before 1937, as it was in my family at that time.

The thirties were years of revolution in child-rearing practices and provide a fascinating context for the food mill. Geoffrey Steere points out that prior to the 1930s, child-rearing literature was primarily written by

amateurs with a Mother-knows-best attitude. In the 1930s, however, this literature was "secularized . . . and was offered by accredited experts on the basis of professional experiences and/or scientific research. . . . The manuals translated the machine orientation of modernized society into human relations."[7] This radical shift in approach to child-rearing advice seems to have had a profound effect on the way mothers and society in general felt about feeding and nurturing. Take as a starting point a forward-looking 1926 guide entitled *Elements of Child Training*: "In planning a child's diet the parent had best begin by putting aside his own notions in the matter and following the instructions of some authority on the subject . . ."[8] Advice in contemporary literature—some of it contradictory—abounds regarding the proper atmosphere in which to feed children: the dining area should be pleasant, they should not be coaxed or nagged to eat, the mother should control her anxiety, should cut the food into small pieces, should make sure food is well-prepared and attractively served, should either talk or not talk to children during the meal, should either sit with or sit apart from the child at mealtime, and so forth. All of this advice was intended to quell what was seen as the hysteria of mothers as they tried to get their children to eat. "But," says one young mother, responding to a childcare guide, "How can I act matter-of-fact when I don't feel matter-of-fact? And how can I feel matter-of-fact when he doesn't eat for he *must* eat!"[9] Another adviser writes: "If you feel occasionally like bursting into tears or giving up the gauntlet, curb your impulses and resort to the saner methods of winning the battle. Make a ruling with yourself that you never give vent to anger or despair."[10] This advice was obviously not appearing out of context, as a 1933 study of homes of young children found that one child was "nagged" to eat sixty-four times in the course of one meal, one child eighty-two times, and another 147 times.[11]

To what can we owe this fear-ridden obsession with feeding? It seems unlikely that the thirties spawned a new breed of children. As even contemporary literature pointed out, a child might manipulate the parent's anxiety. A 1931 *Parent's Guide* tells the story of a "grandmother who three times a day danced and sang to Victrola music at the demand of a child before he would eat."[12] The anxiety and tension of feeding children in the 1930s most likely stemmed not from a new era of demanding children, but from the awkward transition from "Mother-knows-best" to reliance on professional advice. A woman's child-rearing role model could no longer be the mother or nanny under whose care she herself had been raised, and in whose procedures of nurturing behavior she had been trained, but now was to be taken from home economics textbooks, scientific guides to child rearing, and articles about nutritional science in women's magazines. The

responsibilities and demands of motherhood done correctly must have seemed daunting indeed.

One 1936 guide described proper meal planning for the family as follows: the woman would first consider whether she had enough of vitamins A through G. She would then analyze her meal content for various mineral salts, proteins, sugars, starches and fats, woody fiber or cellulose, base-forming foods and acid-forming foods, the latter to show that she was truly "in step" with the latest discoveries of nutritional science.[13] And the demands of the nutritionists on the mother were enforced by guilt and terror, conveyed not only in guidebooks but prominently in the pages of women's magazines.

Appealing to an audience of mothers primed by "scientific" child-rearing advice, advertisers for infant foods played on their audiences' worst fears and greatest insecurities in the "scare copy" they used to market their products.[14] If a woman did not use the product, she could only blame herself for the illness or death of her child. Advertisements in magazines like the *Ladies' Home Journal* stressed a child's vulnerability to disease, stunted growth, unattractive features, and death—dire consequences only avoidable through use of the advertised product. Cream of Wheat, which launched several striking campaigns, seems especially to have emphasized the "dangers" involved in infant nutrition.

In a 1933 advertisement, we see a frightened young woman speaking into a telephone. The caption reads: "GORDON, I'M FRIGHTENED! Baby is terribly upset again" (Fig. 12.2). The man in the next frame of the sequence rushes out of his office, ordering his secretary to call a doctor. Soon, the husband and doctor arrive at the home and the infant is saved. The cure proffered, pointed to by a bespectacled man, is of course a box of Cream of Wheat. The reader is warned that she must not "take chances with inferior cereals! . . . Over half the diseases of the first year may be attributed to digestive disturbances." The cause of the illness therefore may be entirely blamed on the mother's choice of a "dangerous" lack of nutrition for her helpless and dependent infant. Furthermore, the message is conveyed that the source of authority on infant nutrition is the family doctor, as usual a male. Indeed, the Cream of Wheat mother is offered no help from other mothers in her moment of crisis. Rather, her advice and comfort must be sought in the men who rush to her aid. In virtually every advertisement and guidebook, it is the masculine world of science which is presented to the woman as guide, thus entirely negating the feminine tradition of nurturing learned through practical experience.

While doctors and scientists are quoted as authorities in virtually every example of 1930s infant foods advertisements, infant foods advertisers went much further than promising merely a medically-condoned food. Many

Fig. 12.2. "Gordon, I'm Frightened!" Advertisement for Cream of Wheat, 1928. *Ladies' Home Journal* 45 (July 1928): 133.

advertisers also emphasized that their product was one which could not be duplicated, even by the most conscientious of mothers. In a striking advertisement for Sunshine Biscuits (Fig. 12.3), we see the clean lines of a "modern" city through the thin, metallic mullions of a modern sealed window, through which peers a "white-frocked baker-man" dressed in a strange combination of laboratory and military clothing. The text reads: "We keep a careful eye, naturally, on every ingredient that goes into Sunshine

Fig. 12.3. "With an Eye out for Babies." Advertisement for Sunshine Biscuits, 1928. *Ladies' Home Journal* 45 (July 1928): 111.

Arrowroot Biscuits. They're for your baby! They must be kept clean . . . We're very, very fussy about that!" In stressing cleanliness and choosing sterile, strictly modern forms with which to associate their product, Sunshine clearly sought to present itself as a purveyor of sterilized foods prepared in a modern production facility. This message serves to suggest to the mother that Sunshine has a production scheme much cleaner than she

can produce herself, along with the fact that the biscuits are "recommended by Doctors as Baby's first solid food." The conscientious reader, made sensitive to the issue of nutrition by a variety of sources, is encouraged to believe that homemade biscuits will not suffice because they can not be produced in a sterile-enough, "scientific"-enough environment.

Ad-writers for Sunshine were not alone in trying to convince women that they were inferior food-preparers, with the evaporated milk association even going so far as to suggest that infant milks were better prepared in the factory. This message is central to a 1928 ad (Fig. 12.4), whose large-type, italicized heading reads: "*Grind Milk?*" The images shown to accompany this intriguing text depict complicated machinery (described in the text as "a series of six pumps") as well as the finished product (a line of six cans below). Grinding milk, we are told, makes it "better food." Indeed, "Evaporated Milk is the one and only form of pure milk that is both *protected and perfected* in purity—that is as safe as if there were not a germ in the universe." Judging from the complexity of the machines, a mother would have no misconceptions as to her inability to reproduce this effect. Here, again, the nourishment a mother can produce is shown to be inferior in cleanliness, nutrition, and safety to commercial products.

In presenting advertisements such as those of Cream of Wheat, Sunshine Biscuits, and Evaporated Milk, women's magazines reinforced the message of child-rearing literature. Through these sources, the conscientious mother would soon learn that her role as nurturer was best that of a thoughtful consumer, or at least a close adherent to the advice offered by doctors and scientists. Although this message must have helped to sell many baby food products, and may even be credited as paving the way for the entrance of women into the workplace, there is no denying that it must also have undercut women's confidence in their maternal capabilities, and as childhood role models.

It did not take long for contemporary critics to realize the exaggerated tone of this literature. Dorothy Dix, writing in 1933, noted the results of the many guidebooks and advertisements of this breed: "No wonder there is a falling off in the baby crop when the air is filled with the propaganda of scientists and psychologists that strikes terror into the hearts of mothers; that makes them tremble at the thought of fixing their baby's bottle lest they may be inadvertently murdering it with a microbe."[15] In light of advertising campaigns like those of Cream of Wheat, Dix's sardonic wit may be seen as containing little exaggeration.

Radically changing ideas about what should be fed to a baby further threatened to confuse and unsettle mothers in the 1930s, with one extremely important consequence for the food mill. Whereas previously

Fig. 12.4. "Grind milk?" Advertisement for Evaporated Milk, 1928. *Ladies' Home Journal* 45 (July 1928): 127.

infants were to be confined to a liquid diet, primarily mother's milk with some orange juice allowed towards the end of the first year,[16] doctors in the late 1920s began advising mothers to feed their babies strained vegetables as early as the eighth month.[17] Strained vegetables and fruits were prescribed for as long as three years in an effort to present vitamins to the child in their most digestible form. The food mill, with its ability to prechew food, managed this task perfectly. With it, the modern mother could produce the perfectly strained vegetables and fruit pulp that would make her child strong and healthy.

Another answer to the new demand for strained vegetables, coming a few years before the food mill, was the baby foods industry, which began producing strained fruits and vegetables in cans around 1928. The Gerber Baby Foods story, presented to the public in an advertising campaign of 1933[18] and fully told in a promotional booklet of 1953, provides two interesting insights into the era. According to the booklet, Mrs. Gerber was told by her physician in 1928 that her daughter, Sally, ought to have strained vegetables every day. Mrs. Gerber, according to the company legend, found this to be a near-Herculean task. She asked her husband, who worked at a canning factory, if he could not produce some canned strained vegetables, but he ignored her request. All this changed when the Gerbers were on their way out one night and Mrs. Gerber was late. To speed things up she asked her husband to strain a pan of cooked peas for the baby by pushing them through a mesh strainer with a spoon. "Dan agreed and the struggle was on! Dan pushed and squashed valiantly but the splatterings on the sink and floor were messy evidence of his defeat. When the job was finished, the meager amount left over for Sally left Dan quite depressed and with a feeling that the whole thing was unfair to fathers."[19] Dan, in response to his failure, began producing the popular line of baby foods that, even today, are consumed by hundreds of thousands of American babies.

This story not only informs us that prepared baby foods were a direct answer to the call for strained vegetables in baby's diets, but also tells us something about the stereotypical roles of husband and father in child-rearing. Dan's stint in the kitchen was both unique and unsuccessful; he was thoroughly incapable of accomplishing the task. This image of a helpless husband, incapable of cooking and cleaning, dominates women's popular literature in the 1930s, including the *Ladies' Home Journal*.

Even men wanted to believe themselves incapable of this type of work, as evidenced in a 1937 guide for bachelors entitled "How to Live Without a Woman," in which the author writes: "I've had my agents working day and night trying to rationalize the process of food preparation." His ultimate suggestion is to invite a woman for dinner and ask her to do the food preparation, or else to rely on the good graces of married women feeling sorry for unmarried men.[20] This image of a woman feeling sorry for a man who must do his own domestic work, along with the image of the helpless husband, shows that the nurturing required by a child was no less expected by adult males.

The woman was to be a nurturer to all the members of her family; she was to be endlessly giving and selfless. Few advertisements in the *Ladies' Home Journal* of this period were directed at some pleasure the woman her-

self might take part in besides that of seeing her family well-fed and well-clothed, and her guests suitably impressed by her wifely skills. In the 1930s a woman's reward, if there was one, was a sense of value and self-worth in a nurturing job well done. "Keeping house" was "a way to communicate deep-seated emotions."[21] However extreme, this expanded role of woman as nurturer is not surprising in light of traditional women's roles: nurse, secretary, garment worker and household manager. In these worlds, men work outside the home while women nourish, clothe, and "nest" in interior spaces. In this sense, the woman's role can be seen as a mill of sorts, processing the world and making it digestible for those around her.

The food mill is an extension of this nurturing woman, enabling her to provide her family with a homemade but scientifically-approved diet. In one respect, the mill looks back to the "Mother-knows-best" attitude predominant in the childhood of the 1930s mother by encouraging home-preparation of food. Ignoring Gerber's advertisements, which insisted that the mother could not possibly prepare vegetables without losing vitamins and minerals, a woman using the food mill could trustfully produce baby food on her own. This attitude suggests a *distrust* of "modernity" in general, and perhaps nostalgia for the era before labor-saving devices such as vacuum cleaners became common in middle class American homes. At the same time, the food mill represented a technological advance over a strainer and spoon, giving the mother an opportunity to do the extra work that showed her love and satisfied her high standards, but using a product that would make that work easier. Thus the maternal instincts could be satisfied, while staying in step with modernity. Finally, the food mill was a material expression, a metaphor, of the industrious mother as processor, as nurturer.

NOTES

1. This food mill was the property of the author's grandmother and mother. The mill has been in the family since ca. 1933–37.

2. Sheila Kitzinger, *Women as Mothers* (Glasgow: William Collins Sons and Co., 1978), 168.

3. Eugene L. Bliss, ed., *Roots of Behavior* (New York: Harper and Brothers, 1962), 196.

4. This behavior is also typical of non-human mammal societies. Young Langur monkey females, for example, follow and attempt to care for infants in their communities. See Meredith F. Small, ed., *Female Primates: Studies by Women Primatologists* (New York: Alan R. Liss, 1984), 53.

5. Mary Georgina Boulton, *On Being a Mother* (London and New York: Tavistock Publications, 1983), 58.

6. Jane H. Celehar, *Kitchens and Kitchenware* (Lombard, Illinois: Wallace-Homestead Book Company, 1985), 72.

7. Geoffrey H. Steere, "Child-Rearing Literature and Modernization Theory," *The Family In Historical Perspective: An International Newsletter* 7 (winter 1974): 9–11.

8. R. J. Gale, *Elements of Child Training* (New York: Henry Holt and Company, 1926), 60.

9. Grace Langdon, *Home Guidance for Young Children* (New York: The John Day Company, 1931), 136.

10. Jean Simpson, "This Business of Eating," *Ladies' Home Journal* 50 (November 1933): 136.

11. John E. Anderson, *Happy Childhood* (New York: D. Appleton-Century Co., 1933), 56.

12. Langdon, *Home Guidance for Young Children*, 135.

13. Florence LaGanke Harris, *Everywoman's Complete Guide to Homemaking* (Boston: Little, Brown and Company, 1931), 135.

14. Roland Marchand, *Advertising the American Dream* (Berkeley: University of California Press, 1985), 14.

15. Dorothy Dix, "And So You Are A Mother!" *Ladies' Home Journal* 50 (October 1933): 139.

16. Mary Swartz Rose, *Feeding the Family* (New York: The Macmillan Company, 1917), 122.

17. Langdon, *Home Guidance for Young Children*, 62.

18. Advertisement for Gerber's Baby Food, *Ladies' Home Journal* (July 1933): n.p.

19. *The Story of An Idea and Its Role in the Baby Foods Industry* (Gerber Products Company, 1953), 9–11.

20. Alexander Wright, *How to Live Without a Woman* (New York: The Bobbs-Merrill Company, 1953), 9–11.

21. Ruth Schwartz Cowan, *More Work for Mother* (New York: Basic Books, 1983), 177.

Weili Ye

The Light of the Home: Dialectics of Gender in an Argand Lamp

LIGHT HAS PLAYED an essential role in human existence since time immemorial. It has also taken on symbolic meanings that have transcended utilitarian value. Light has consistently been associated with ideas and notions cherished by human beings, standing for warmth, hospitality, and security in various cultures, and representing hope, enlightenment, and a brighter future to peoples struggling for liberty and freedom under certain historical conditions.

Lighting devices, material providers of light, have also occupied an important place in human lives. Many of the lighting devices reveal the degree of technological sophistication of their times, and some also manifest a high level of aesthetic elaboration. But what is most relevant to the present study is the way in which lighting devices reflect in some way the ideas, beliefs, and values of the people who produced them and used them; the way in which these "things" contain "messages" of their times, not in written form, of course, but in a more concrete and paradoxically more hidden way.

The late eighteenth century and the first half of the nineteenth century witnessed rapid development in the technology of lighting devices, resulting in the appearance of various kinds of fuel-burning lamps. This was also a period of profound economic and social transformation. One sphere that underwent tremendous changes was domestic life. Did fuel-burning lamps, which were so closely related to home and family life, also reflect this historical process more subtly and less self-consciously? The following account of one particular lamp in this period, an Argand lamp, might shed light on our inquiry.

An item in the collections of the New Haven Historical Society (Fig. 13.l), the lamp is made of brass, bronze, and glass. It consists of two clearly

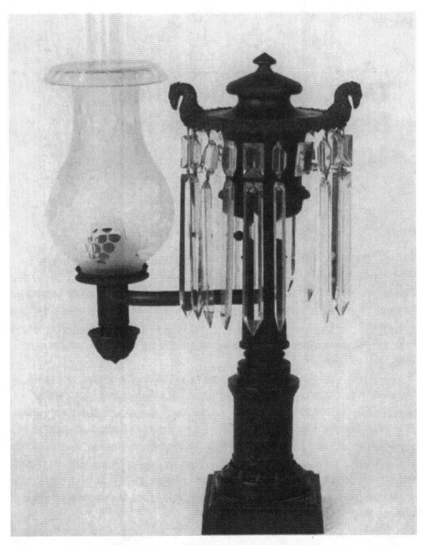

Fig. 13.1. Argand Lamp, ca. 1830. Bronze, manufactured by J. and I. Cox, New York City, 18½ inches in height. Collections of the New Haven Colony Historical Society. Photo: Joe Szaszfi.

distinguished sections: the first contains a reservoir, a short tube, a column, and prisms (hereafter called the reservoir side); the second a burner, a shade, and a chimney (hereafter called the burner side). The two sections are connected by an arm that stretches from the column to hold the burner. The shade, chimney, and prisms are made of glass; the rest is made of metal. The color of the metals is dark, while the glassware is white and transparent.

The lamp is heavy, even without fuel, and the weight is concentrated on the reservoir side. The urn-shaped container has a lid-like top, yet it is not clear how the reservoir can be filled. It seems that the upper part of the reservoir should unscrew, but no joint can be detected.

Below the lid, the upper-edge of the reservoir extends like wide shoulders, carrying a metal ring with eighteen crystal prisms hanging down from it by hooks and wires (a nineteenth prism is missing). The ring is decorated with motifs of leaves and flowers. Two eagle heads rise above the ring, one on each side, their beaks turning downward.

The prisms, each 7 inches long, are shaped like inverted obelisks. They form a crystal skirt around the entire body of the reservoir. The 10-inch tall column is connected to the reservoir by the short tube. A valve emerges from the tube, presumably to control the flow of fuel from the reservoir. Because it ..as not been used for a long time, the valve can no longer move.

The column can be further divided into roughly three parts. A leaf-shaped motif on the upper part has three nested rectangles in front and three in the rear. The longer upright lines of the rectangles convey an impression of verticality. This is somewhat counter-balanced by the middle part of the column where horizontal lines mark the edges of four steps. The lower part of the column, wider in circumference, is engraved with wreath motifs on both front and rear, and is surrounded at the bottom with leaf motifs. The two-stepped square base of the column is decorated with engraved bunches of flowers on the four corners of the upper step.

Altogether, the reservoir side is 18 inches tall. Solid and heavy, it stands firmly. Yet it does not exist for its own sake. A 6-inch long metal arm, smooth and tubular, runs in a straight horizontal line until it curves a little bit toward the end, connecting the reservoir side with the burner side. It functions like a bridge.

Unlike the predominately metallic reservoir side, the only item made of metal on the burner side is the 3-inch cylindrical burner. On its body it bears a rectangular plate with the following in raised letters: "J & I Cox, New York."[1] The bottom of the burner is bowl-shaped with a perforated top.

Inside the burner and projecting below it is the center-draft tube, externally threaded at its lower end. When in use, air enters the tube through the perforations, while the bowl catches any dripping oil. A wick tube fits snugly but freely inside the font. There is a space between the wick tube and the center-draft tube for the wick holder (which is missing). A tubular woven wick, held by small sharp teeth, wraps around the wick holder.

The burner plays a crucial role in the function of the lamp, but when compared with the elegant-looking creamy-white glass shade, it looks

rather obscure. The globe-shaped, short-necked shade, resting over the shade-holder assembly, encloses the narrow, long-necked chimney. The outer edge of the assembly is decorated with motifs of flowers and leaves. The body of the globe is covered with a profusion of leaves, flowers, and grape-shaped fruits on its "belly," and has round spots around its neck. The motifs on the frosted globe are transparent.

This kind of lamp is named after its inventor, Ami Argand, a Swiss chemist and philosopher who lived from 1755–1803. Argand was regarded as the father of scientific lighting in his time. The Argand lamp, his best known invention, included a hollow tube, open at both ends, and extending upward through the center of a burner. A tubular woven wick was fitted tightly around the tube, and an outer cylinder placed around it. Oil from the reservoir was fed into the side of the cylindrical chamber containing the wick. The hollow tube in the center served to admit air to the center of the flame, thus greatly increasing the combustion and the quantity of light.[2]

Argand received his patent in London in 1784, and his lamp became immediately popular in England. A woman who visited a London shop noted in 1786 that the lamps were sold in "every variety, crystal, lacquer, and metallic, silver and brass in every possible shade."[3] When the lamps were lit, the woman wrote, the scene was a "really dazzling spectacle," so bright that her eyes "could hardly stand it for a moment."[4]

Argand lamps were possibly first brought to the New World in 1788 by Thomas Jefferson.[5] George Washington ordered fourteen of them in 1790 and expressed interest in the newly invented lamps which he praised for consuming their own smoke, doing no injury to furniture, giving more light, and being cheaper than candles.[6]

In the first half of the nineteenth century, several modifications were made to Argand lamps. Thereafter, astral, solar reading lamps and mantle arm-lamps such as the one discussed here all found their way into the homes of well-to-do American families.

The mantle arm-lamp was usually placed on a mantelpiece or a piano, in a pair or a set of three with either has a single arm or two arms stretching out from the column to carry the burner or burners. This style was popular roughly from 1820–50.[7]

The lamp is highly ornamental with an elegant glass shade and crystal prisms. Both the shade and prisms also serve practical purposes. The former protects the chimney and enhances the draft, while the latter reflects and amplifies the light coming from the globe, a common device of the time. This duality of ornamentation and utility is a characteristic feature of the lamp, and explains why the mantle lamp remained popular as decoration long after it was no longer used for illumination.

Mantle arm-lamps burned sperm oil or plain whale oil. In America the whaling industry, already well established when the Argand lamp was invented, provided the necessary fuel. The increasing popularity of whale oil lamps after 1800 was one basic reason for the expansion of whaling.[8] In this way, the family that possessed Argand lamps linked itself with the commercial world of both manufacturing and whaling.

A set of elaborate mantle lamps would cost the retailer $54.00 for the metal work alone.[9] Given the high cost, only wealthy families could afford to enjoy them. The heavy lamp was not an object to be moved easily, especially since the fragile shade and chimney required careful handling. It also needed daily maintenance or it would smoke. The author of an instruction book for "house servants" observed: "Lamps are now so much in use for drawing rooms, dining rooms, and entries, that it is a very important part of a servant's work to keep them in perfect order, so as to show a good light. I have been in some houses where the rooms were almost filled with smoke and the stench of oil and the glasses of the lamps clouded with dust and smoke."[10]

We have already noted that the lamp consists of two basic sections. Separated by the arm, the burner side demonstrates strikingly opposite characteristics to the reservoir side. It differs in color, in weight, and in texture. The lines also suggest this opposition, with the glass globe curved and soft, whereas the metal column is vertical and straight. Even the orientation is different, with the prism ends pointing downward whereas the chimney faces upward.

The reservoir side, standing straight on its solid metal base, heavy and dark-colored, appears to embody "masculine" qualities. By contrast, "femininity" characterizes the creamy-white, soft-lined and delicate burner side. Each side brings out opposite elements in the other. Yet the opposition is not absolute. The masculine reservoir side has crystal prisms that lend a feminine touch. And though the globe seems feminine, the metal burner, shaped like a phallus, intrudes into its domain. Overall, the lamp seems to be dominated by masculinity, an observation with spatial but also with functional and symbolic resonance. The lamp produces light through an infusion of whale oil (sperm oil) from a masculine reservoir into a feminine globe in which combustion occurs.

Would this character still have carried the same weight with the lamp lit? The shining globe would have been more prominent and become the focus of attention. Light would have radiated gently and brightly through the globe's frosted body and transparent patterns. Reflecting the light from the globe, the crystal prisms, with colorful rainbows playing on them, would have added a graceful note. More important, an aura of spirituality,

not in evidence when the light is out, would have revealed itself. The balance between the two opposite parts appears to be altered: the bright feminine element now seems to have the upper hand.

But not quite. After all, it is the reservoir that supplies fuel to the burner and makes it possible for the globe to shine. Furthermore, the globe has to rely on the arm, which extends from the column, to hold it up. The arm, while separating the two sections, simultaneously joins them together. A mutual dependence is thus revealed. While the burner side relies on the reservoir for energy and support, the globe, when lit, carries the glory.

Intriguingly, the dialectical relationship between the "male" and "female" sections of the lamp resembles the historical development of Northeastern urban families in the United States that would have been likely to possess Argand lamps in the same period.

The closing decades of the eighteenth century and the early decades of the nineteenth century in the United States were a time of wide and deep-ranging transformation. The growing market economy diminished the importance of household manufacture and increased families' dependence on money to purchase basic commodities. As household production declined, women were increasingly removed from the central process of economic life. Middle-class women in urban areas in particular were largely confined to home, and their essential responsibility became household management and family care. Home became a woman's domain in contrast to the restless and competitive world where her husband struggled. The "domesticity" of women was a significant historical process in antebellum America.[11] Trying to survive in a harsh commercial world, a man was expected to be "the fiercest warrior, or the most unrelenting votary of stern ambition." When he was "toil worn" by "troubled scenes of life," home became a resting place. "It is at home," proclaimed a New Hampshire pastor in 1827, that "man . . . seeks a refuge from the vexations and embarrassments of business, an enchanting repose from exertion, a relaxation from care by the interchange of affection."[12]

It was a woman's role to comfort her man. After four years of marriage, Mary Tucker, for instance, congratulated herself on her husband's happiness at home, "His happy home, I say, and I say it too with pride, and pleasure; it is no small compliment to my own abilities, to my own powers to please . . . to shine as a good wife, is an object of my highest ambition."[13]

In his praises of his wife and his home, a man echoed the same sentiment, tellingly representing a male perspective: "Oh! What a hallowed place home is when lit by the smile of such a being; and enviably happy the man who is the lord of such a paradise . . . When he struggles on in the path of duty, the thought that it is for her in part he toils will sweeten his

labors. . . . Should he meet dark clouds and storms abroad, yet sunshine and peace awaits him at home."[14]

Women were responsible for the comfort and tranquillity of the home, but their "higher" role, for their families and the society, was as spiritual guardians. In this role they were acknowledged to be the moral superiors of men.[15] This period witnessed a "feminization" of religion,[16] and religious piety was considered the core of women's virtue.

Ironically, women's moral superiority paralleled their economic dependence. Since the law of marriage made striving for wealth irrelevant to women, they were generously praised by society for their "disinterestedness" and "selflessness." In giving up economic roles, women achieved the purity of motive that enabled them to establish moral superiority at home.

It is perhaps not coincidental that mantle arm-lamps enjoyed popularity in Northeastern well-to-do families just as American society was undergoing these rapid changes. The Argand lamp, with its sharply contrasting yet interdependent sections, bears an analogy to the relationship that existed between husbands and wives in antebellum America. On the one hand, like the nineteenth-century women who relied on their husbands for a living, the "feminine" section of our lamp is dependent on the "masculine" section for support and fuel. The delicate and fragile quality of the glassware resembles the women who were considered to be vulnerable and therefore unsuitable for the competitive harsh world. Yet on the other hand, when provided with oil and lit, the female-like globe would shine brilliantly, demonstrating a spiritual elegance analogous to the moral and spiritual role assigned to antebellum women.

The symbolic meaning of a lamp might not have seemed totally strange to a nineteenth-century person. One man, discussing the impact of light on his emotions and state of morals, noted that "many a time a sight of a light from a lamp or lantern brought cheer to my heart. . . . When I was coming home late on a dark night, especially in a gale in winter, [the lantern's] tiny wick all aglow warmed me all the way through. There was nothing comparable to lamps and lanterns in our isolated home to raise the morals of its inhabitants."[17]

Who would stay at home and make sure that the light was shining? It was women. In this sense, a brightly-lit house was the symbol of a well-managed home. This idea would not have sounded too farfetched to contemporaries, either. In 1840, a writer on household management equated a good marriage with good light. Forewarning would-be wives, she wrote: "A neat and well-conducted house, with fires and lights always as they should be . . . are comforts that are not lightly prized by many married men."[18] A 1860 paean to women stated even more clearly: "The perfection

of womanhood . . . is the wife and mother, the center of the family, the magnet that draws man to the domestic altar that makes him a civilized being, a social Christian. The wife is truly the light of home."[19]

The Argand lamp in this study has long since lost its practical function and generally attracts little attention from visitors to the New Haven Colony Historical Society. Once upon a time, however, it knew days of glory, being carefully taken care of by a family. Sitting inconspicuously now on a nineteenth-century table, the lamp serves as a silent witness to changing times and to history.

NOTES

1. J. & I. Cox ran a lamp and oil store at #5 Maiden Lane, New York City. According to the New York City Directory of 1848, in that year a man by the name of Cox at that address was chosen as a judge for a test on a new patent lamp at the Twentieth Annual Fair of the American Institution.

2. On Argand lamps, see Malcolm Watkins, *Artificial Lighting in America, 1830–1860* (Washington, D.C.: Government Printing Office, 1952). The light produced by such lamps was so unusually brilliant, apparently, that in 1811 one person even warned that "no decayed beauty ought ever to expose her face to the direct rays of an Argand lamp" (395).

3. *Antiques* 56 (1949): 276.

4. Ibid.

5. *Antiques* 13 (1928): 293.

6. *Antiques* 69 (1956): 102.

7. Herbert Darbee, *A Glossary of Old Lamps and Lighting Devices* (Nashville, Tenn.: American Association for State and Local History, 1976).

8. Watkins, *Artificial Lighting in America,* 393.

9. Larry Freeman, *New Light on Old Lamps* [1944] (rev. ed.; Watkins Glen, N.Y.: Century House, 1955), chapter 4.

10. Elisabeth D. Garrett, "The American Home: Lighting Devices and Practices," *Antiques* 123 (1984): 408.

11. See Nancy Cott, *The Bonds of Womanhood* (New Haven, Conn.: Yale University Press, 1977), 70.

12. Ibid., 64.

13. Ibid., 72.

14. Ibid., 69.

15. Three modern sociologists, after surveying the popular literature published between 1825–50, report that "the moral superiority of women was a pervasive theme during this period." See Carl Degler, *At Odds: Women and Family in America from the Revolution to the Present* (New York: Oxford University Press, 1980), 26.

16. See Mary Ryan, *Womanhood in America: from Colonial Time to the Present* (New York: New Viewpoints, 1975); and Ann Douglas, *The Feminization of American Culture* (New York: Avon Books, 1978).

17. Garrett, *The American Home*, passim.

18. Ibid.

19. Harvey Green, *The Light of the Home: An Intimate View of the Lives of Women in Victorian America* (New York: Pantheon Books, 1983), 181.

Contributor Biographies

Jules David Prown, Paul Mellon Professor Emeritus of the History of Art, Yale University, is the author of *John Singleton Copley* and *American Painting from Its Beginnings to the Armory Show*. A teacher of American art, British art, and material culture at Yale since 1961, he also served as Curator of American Art at the Yale University Art Gallery, 1963–68, and founding Director of the Yale Center for British Art, 1968–76. He received the Distinguished Teaching of Art History Award from the College Art Association of America in 1995. He has written several influential articles on material culture, including "Mind in Matter: An Introduction to Material Culture Theory and Method" in 1982, which won the Robert C. Smith Award "for the best article in the field of the decorative arts published by a North American scholar" that year from the Decorative Arts Society of the Society of Architectural Historians.

Kenneth Haltman, assistant professor of American Art History and American Studies at Michigan State University, received his Ph.D. from Yale in 1992. His research, involving the history of American visual and material culture, has received support from the Smithsonian Institution, Luce and Mellon Foundations, Winterthur Museum, Huntington Library, American Antiquarian Society, American Philosophical Society, NEA, and NEH. Haltman is the author of *Looking Close and Seeing Far: Imagining Nature, Natural History, and Art in Early Nineteenth-Century Philadelphia* (Princeton, forthcoming), critical translations from the French of works by Gaston Bachelard (*Fragments of A Poetics of Fire*, 1989; *Earth and Dreams of Will*, forthcoming), as well as numerous scholarly articles and catalogue essays.

Robyn Asleson, research associate in British Art at the Huntington Library, Art Collections, and Botanical Gardens, is currently writing the catalogue of British paintings at the Huntington. In 1993 she received Yale's Frances Blanshard Prize for her doctoral dissertation on Victorian Classicism. She has curated two exhibitions of eighteenth-century British theatrical portraiture at the Huntington and the J. Paul Getty Museum, and edited and co-authored *A Passion for Performance: Sarah Siddons and Her Portraitists* (1999). She has written articles on English Classicism and Aestheticism, and co-authored *Dialogue with Nature: Landscape and Literature in Nineteenth-Century America* (1985). Her most recent book is *Albert Moore (1841–1893): The Analysis of Beauty* (2000).

Jeffrey Collins is assistant professor of Art History at the University of Washington. He received his M.A. from Clare College, Cambridge and his Ph.D. from Yale in 1994. He is a Fellow of the American Academy in Rome and recently completed a book on the artistic patronage and policies of Pope Pius VI (1775–99). Recent publications include studies of the Quirinal Obelisk-Monument in Rome and the Pio-Clementino sculpture museum at the Vatican. He is currently researching seventeenth-century Venetian mythological painting, disguised self-portraiture in seventeenth- and eighteenth-century art, and the reception of Baroque art in contemporary cinema.

Sara Laurel Holstein earned a Masters of Art from the Department of History of Art at Yale in 1997. Her area of interest is nineteenth- and early-twentieth-century American and Native American art. She currently works as an early childhood teacher and researches private art collections.

Daisann McLane, a former Ph.D. student in Yale's Program in American Studies, currently is a columnist and photographer for the Sunday Travel Section of the *New York Times*. Her essays on global culture, world music and Caribbean affairs have also appeared in a wide array of media including *Rolling Stone*, the *Village Voice*, NPR's "All Things Considered," and in the recently published book *Rolling Stone: The Seventies* (Random House). She is an avid collector of Caribbean cultural objects and American art pottery.

Leslie Shannon Miller received her M.A. in the History of Art from Yale in 1989 and subsequently joined Electronic Data Systems as an editor of corporate publications. In 1992, she was an undefeated five-time winner on the game show *Jeopardy!* and ranks 27th on the show's all-time winnings

list. Now a business analyst and database specialist in cellular telephone billing systems, she lives and works in Sydney, Australia.

Joel Pfister, professor of American Studies and English at Wesleyan University, is the author of *The Production of Personal Life: Class, Gender, and the Psychological in Hawthorne's Fiction* (1991) and *Staging Depth: Eugene O'Neill and the Politics of Psychological Discourse* (1995), and co-editor (with Nancy Schnog) of *Inventing the Psychological: Toward a Cultural History of Emotional Life in America* (1997). He has also published articles on American literature and on the history of cultural studies and American studies.

Jennifer L. Roberts is a Ph.D. candidate in the History of Art at Yale. She is currently finishing her dissertation, *Mirrored Travels: Robert Smithson and History*, and has published essays on Hogarth, Smithson, and contemporary abstract painting.

Carlo Rotella teaches at Boston College. The author of *October Cities: The Redevelopment of Urban Literature* (1998), he is currently at work on a book about blues, boxing, and other forms of urban culture. His essays have appeared in *Critical Inquiry, South Atlantic Quarterly, Harper's, DoubleTake,* and *Transition.*

Lucy Soutter is a Ph.D. candidate in the Department of the History of Art at Yale. She has published articles and catalogue essays on photography and twentieth-century art and is currently at work on a dissertation examining the uses of photography in Conceptual Art during the 1960s and 70s.

Amy Werbel, assistant professor of Fine Arts at St. Michael's College, where she has taught courses on American art, architecture, and material culture since 1993, received her Ph.D. from Yale in 1996. Her current research focuses on Thomas Eakins, and includes a recent article, "Art and Science in the Work of Thomas Eakins: The Case of *Spinning* and *Knitting*," in *American Art* (fall 1998).

Weili Ye, assistant professor of History, Women's Studies and East Asian Studies at UMASS-Boston, is currently a research fellow at the Fairbank East Asian Research Center of Harvard University. She received her Ph.D. from Yale in 1989, and is the author of *Becoming Modern, the Experience of Chinese Students in the United States, 1900–1927* (Stanford University Press, forthcoming).